PLUNDERED

SKULLS

AND STOLEN

SPIRITS

PLUNDERED

SKULLS

AND STOLEN

SPIRITS

Inside the Fight to Reclaim Native America's Culture

CHIP COLWELL

The University of Chicago Press • Chicago and London

The University of Chicago Press, Chicago 60637
The University of Chicago Press, Ltd., London
© 2017 by Chip Colwell
All rights reserved. No part of this book may be used or reproduced in any
manner whatsoever without written permission, except in the case of brief
quotations in critical articles and reviews. For more information, contact
the University of Chicago Press, 1427 E. 60th St., Chicago, IL 60637.
Published 2017.
Printed in the United States of America

26 25 24 23 22 21 20 19 18 17 1 2 3 4 5

ISBN-13: 978-0-226-29899-3 (cloth)
ISBN-13: 978-0-226-29904-4 (e-book)
DOI: 10.7208/chicago/9780226299044.001.0001

Library of Congress Cataloging-in-Publication Data

Names: Colwell, Chip (John Stephen), 1975– author.
Title: Plundered skulls and stolen spirits: inside the fight to reclaim native
America's culture / Chip Colwell.
Description: Chicago; London: The University of Chicago Press, 2017. |
Includes bibliographical references and index.
Identifiers: LCCN 2016036898| ISBN 9780226298993 (cloth: alk. paper) |
ISBN 9780226299044 (e-book)
Subjects: LCSH: Indians of North America—United States—Antiquities. |
Indians of North America—Material culture—United States. | Human
remains (Archaeology)—Repatriation—United States. | Cultural property—
Repatriation—United States. | Museums and Indians—United States. |
Anthropological museums and collections—United States. | Archaeology—
Moral and ethical aspects—United States. | Anthropological ethics—United
States. | United States. Native American Graves Protection and Repatriation Act.
Classification: LCC E98.M34 C65 2017 | DDC 973.04/97—dc23 LC record
available at https://lccn.loc.gov/2016036898

♾ This paper meets the requirements of ANSI/NISO Z39.48-1992
(Permanence of Paper).

CONTENTS

List of Figures vii

Introduction 1

I. RESISTANCE: WAR GODS

1. Only After Night Fall 13
2. Keepers of the Sky 20
3. Magic Relief 26
4. Tribal Resolution 33
5. All Things Will Eat Themselves Up 46
6. This Far Away 55

II. REGRET: A SCALP FROM SAND CREEK

7. I Have Come to Kill Indians 67
8. The Bones Bill 74
9. We Are Going Back Home 89
10. Indian Trophies 96
11. AC.35B 103
12. A Wound of the Soul 121

III. RELUCTANCE: KILLER WHALE
FLOTILLA ROBE

13. Masterless Things 131
14. Chief Shakes 143
15. *Johnson v. Chilkat Indian Village* 154
16. Last Stand 166
17. The Weight Was Heavy 178
18. Our Culture Is Not Dying 185

IV. RESPECT: CALUSA SKULLS

19. The Hardest Cases 199
20. Long Since Completely Disappeared 205
21. Unidentifiable 216
22. Their Place of Understanding 225
23. Timeless Limbo 234
24. Before We Just Gave Up 251

Conclusion 263

A Note on the Terms American Indian, Native American, Etc. 271
Acknowledgments 275 Notes 277 Index 333

FIGURES

Figure 1. An Ahayu:da shrine in 1898 18

Figure 2. Mary and Francis Crane, about 1950 27

Figure 3. Perry Tsadiasi exits the Laboratory of Anthropology in Santa Fe with a War God 50

Figure 4. Group portrait of the Camp Weld Council in 1864, with Black Kettle seated in middle row, third from left 72

Figure 5. George Cuneo's display of "Indian curios" at his Denver home 101

Figure 6. Bench overlooking the Sand Creek Massacre reburial area 126

Figure 7. Chief Shakes VII wearing the Killer Whale Flotilla Robe 145

Figure 8. Interior of Whale House of Klukwan, Alaska, about 1895 157

Figure 9. The first repatriation ceremony at the Denver Museum, with Bob Pickering (*far left*), Mark Jacobs Jr. (wearing the Killer Whale Hat), and Harold Jacobs (*far right*) 187

Figure 10. Hugh N. Davis Jr., Hilda Curry Davis, and George B. Stevenson in an excavation pit at the Tallman Site 214

The plunder of our people's graves has gone on too long. Let us rebury our dead and remove this shameful past from America's future.

Suzan Shown Harjo (Cheyenne/Muskogee), American Indian activist[1]

We're doing important work that benefits all mankind. . . . We're not going to return anything to anyone.

Frank Norwick, museum director[2]

INTRODUCTION

Past the moon rock, past the roaring *Tyrannosaurus rex* and the smoker's black lungs, past the eight-pound nugget of crystallized gold and the Egyptian sarcophagus, past the Russian gem carvings and the grizzly bear diorama, and through an unmarked door is a room filled with the bones of Native Americans.

The narrow storage room at the Denver Museum of Nature & Science is lined with steel cabinets stuffed with Indian skulls and the skeletal fragments of legs and ribs and hands. Each bone is labeled like a library book with a tracking number, wrapped in coarse white muslin, and packed in a cardboard box. Long ago a staff member with a sense of irony hung a complete skeleton in the closet.

Many times Native visitors have come here to speak with the dead—praying to their ancestors through songs and drumming, filling the room with the silk curls of burning sweet grass, an offering to the spirits. But most days the room is silent and dark. The skeletons linger in a kind of purgatory—waiting for repatriation. Over the last twenty-five years, this room has slowly become vacant, the cabinets emptying shelf by shelf, like a cemetery in reverse. The bones have been going home.

Only two employees at the Denver Museum have keys to the room. I am one of them. This summer day, I enter the room to send twenty-six people back to their graves. After dozens of letters, calls, e-mails, and meetings with Native American religious and political

leaders, the remains of these twenty-six people have finally been claimed by a consortium of tribes from across the Great Plains who wants them returned and reburied.

With two museum colleagues, I carry the bones from the storage room to a larger one nearby, concealed behind the Denver Museum's exhibit on Native American cultures. Through the wall we hear the murmur of laughter and chatter. The crowd enjoying the exhibit suddenly makes me feel shifty. The visitors are clueless that just on the other side of the dioramas of wax Indians are dead Indians now lying in neat rows.

We begin unpacking them. The work proceeds methodically, purposefully—surgeons transplanting organs in the hushed gallery of an operating theater.

One coworker notes the museum tracking number for each set of human remains. Another hands me the bones. I wrap them in a traditional blanket, decorated with geometric shapes in hues of reds and blues, and soft as feather down. I tenderly lay the bundle of bones into a coffin of creamy unadorned pine, handmade by a local carpenter.

Most of the remains are fragmentary. Shattered ribs. Random fingers. Broken teeth. The single bone from a child, a clavicle, fits into a pine coffin the size of a sardine can. Some of the most damaged bones are packed into Ziploc bags. As I pour the fragments into the coffin, someone comments on the singularly sad sound that human bones make as they tumble out of a bag—a metallic ring, like a wind chime swinging in a gentle breeze. I tap the upturned bags, but static keeps the inside of the bags coated with fine bone powder mixed with dirt. I become distracted by the thought of these bags as a metaphor for repatriation—how hard it is to purge ourselves of the troubled past. The remnants of human lives cling stubbornly.

Three Native Americans stand by, scrutinizing the macabre task unfolding before them. After all of the pine coffins are filled, one of the white-haired elders steps forward. He is dressed like a cowboy but has the bearing of a high priest, full of quiet dignity. While chanting a muted prayer, he brushes the bones with a thick bundle

of sage, which blesses them and broadcasts a soft scent of grass. He asks me to fasten the lids in place. He does not want to touch the bones. He has already put himself at awful risk. The ancestral spirits have been stirred. He could become very sick.

The elder says he is worried that we museum people, we non-Indians, have also endangered ourselves. I let him bless me with a fan of lustrous eagle feathers, which he grazes across my face and the outline of my body. I want to prove I respect this medicine man. But his beliefs are not mine. I do not fear bones. I am an anthropologist and a museum curator, trained to balance a curiosity about religion with science's cold view that human remains are only devices for decoding history. For me, bones are no different from shards of pottery to be pieced back into beautiful vases.

But I know for these Native American traditionalists, the bones in the boxes are pulsating with power. For them, the dead are not really dead at all. The museum's collection has interrupted the natural order of the world, threatening the health of the living and the spiritual journeys of the ancestors. My museum has unleashed a chaos that only might be contained if the remains are returned to the earth. For them, repatriation is a religious duty, not a political victory. Although these Native Americans did not ask for their ancestors to be excavated, they have accepted the burden of reburial, to become my museum's reluctant undertakers.

o o o

"Repatriation" derives from the Latin *repatriatus*, meaning to go home again. In the last several decades, repatriation has become a global controversy as communities and nations struggle to reclaim their stolen heritage from museums and private collections. The debates are now familiar, if not often well understood: the ancient Parthenon Marbles (known also as the Elgin Marbles) in the British Museum claimed by Greece; the priceless artifacts of the Incan capital Machu Picchu at Yale returned to Peru; the *momokai* (mummified tattooed heads) in natural history museums claimed by Maori

traditionalists in New Zealand; art looted by the Nazis claimed by the descendants of Holocaust victims.[3] These disputes pale in comparison to what has transpired in the United States. Hundreds of tribes have confronted 1,500 museums over the fate of more than 200,000 Native American skeletons and 1 million grave goods and sacred objects.[4]

Who owns the past? This is the question that often frames these battles, which have exposed the dark colonialist histories of museums, cast doubt on the morals of collecting, and shifted the control over humanity's common heritage. The query means who *really* has the right to decide the fate of collections—the things that make up, in the provocative phrase of historian Douglas Cole, "procurable culture."[5] Museums that care for the objects of history or the communities whose ancestors made them?

Yet this basic question raises many more. Why do museums collect objects? Why stones and skulls? Why is it so offensive that some things are stored, studied, and exhibited in museums? What are the legal rights of museums? And the moral claims of tribes? How can a museum decide why it should return a human bone or sacred object to its homeland? What do we lose when artifacts go home again? What do we gain?

Often I have sat in the Denver Museum's storeroom of the dead and pondered these raveled questions. As an anthropologist and museum curator, it's my job to untangle them.

My interest in the past was not always so complicated. In high school, in Tucson, Arizona, I discovered archaeology, which perfectly melded my love of exploring wild places with an honest but naive fascination with the noble Indian, romanticized in pop culture, like one of my favorite childhood books, *Ishi: Last of His Tribe*, about the last surviving Yana Indian in the aftermath of California's gold rush. A high school teacher set up a lab for me to analyze animal bones excavated from a nearby Hohokam site. I started going out to the desert to discover windswept ruins. I even dug Indian graves, as part of a team to remove the skeletons before they were destroyed by highway construction. I thought then it would be great fun to pursue a profession that involved playing in the dirt.

In college I learned that some people see archaeology as, well, dirty. I was shocked to learn that Native Americans saw my love of the past as ravaging their heritage, making a hobby of their dead.

By pursuing archaeology, I had unwittingly inherited a conflict that stretched back 500 years. Ever since Columbus believed he had arrived at the outer edges of India and misnamed the Taino he met *Los Indios*, Europeans have marveled at but invariably misunderstood these people of the "New World." I learned that during some of the first moments of North America's colonization, Native American graves were looted. In the autumn of 1620, not far from Plymouth Rock, the Pilgrims despoiled the grave of a man and a child out of curiosity, taking away "sundry of the prettiest things."[6]

By the early 1800s, researchers became especially entranced by the skull—which they imagined proved the inferiority of Indian intelligence and character, a justification for destroying Native cultures and taking Native lands. Along with Indian bones, millions of relics were taken, too, first filling the "curiosity cabinets" of aristocrats—eclectic collections of exotic objects of wonder, like precious gems, rare shells, fanciful weapons, curious fossils—which later became the foundations of the modern natural history museum.[7] At the onrush of the twentieth century, believing that Native American societies were doomed to extinction, anthropologists—scientists dedicated to the study of human cultures, languages, biology, and history—dashed across the continent to collect biological specimens and the objects of fast-fading religions.[8] The ends of science justified every means. My fantasies of anthropology's innocence were shattered when I read the true conclusion to Ishi's tragic life.[9] In his final days, the last Yana Indian begged that his body be respectfully buried. Instead Ishi's museum friends dissected him "for science," shipping his brain to the Smithsonian's National Museum of Natural History. It sat on a storage shelf for decades in a jar of formaldehyde.

As I learned these stories, I became profoundly unsettled to discover how museum collections violated the dignity of Native Americans and often hindered, rather than honored, their cultures. Museums suddenly seemed to me less a triumph of Western science and more a breach of Native American human rights.

In the 1960s, a handful of American Indian activists launched a crusade for a new kind of social action: *repatriation*. It would become one of the defining political movements for twentieth-century Native Americans. According to one scholar, repatriation even stands "on a paramount footing with the valiant struggles of African Americans for civil rights and women for equality."[10] Native Americans argued that looted collections debased their ancestors and impeded their religious freedom. Many blamed the social ills devastating their communities—poverty, alcoholism, crime, violence—on the ancestral spirits that haunted the halls of museums. Militant Indian groups interrupted archaeological digs and organized sit-ins at museums. Native leaders publicly demanded the return of objects and the reburial of their ancestors. "It's conceivable that some time in the not-so-distant future there won't be a single Indian skeleton in any museum in the country," a lawyer for one tribe proclaimed. "We're going to put them out of business."[11]

And yet in college I was learning that the kind of antiquarianism that passed for "science" in the nineteenth century was radically different from today's science of archaeology. Whereas skulls were once measured for crude arguments of race, the contemporary study of human remains provides vital insights into environmental change, gender roles, human health, migration patterns, ancestral identities, and much more. American Indian remains have provided luminous insights into 12,000 years of American history and a broader shared human experience. The technological leaps in DNA research alone provided a strong argument for keeping human tissue stored for future researchers. Although Indian objects were once collected as trophies of colonial domination, by the 1990s most museums were starting their transformation into educational centers that embraced Native perspectives, voices, and values. In college I still hadn't met many Indians, but I gained deep respect for them through the Arizona State Museum's *Paths of Life* exhibit on the state's tribes, one of the country's first exhibits to be co-produced with Native Americans.

By the time I was in college, this battle was supposed to be over.

In 1990 the U.S. Congress passed the Native American Graves Protection and Repatriation Act.[12] With NAGPRA, Native Americans could reclaim skeletal remains and funerary, sacred, and communally owned objects, but museum officials would determine the validity of their claims. A short seventeen pages, NAGPRA has impacted more than 1,500 museums, a dozen federal agencies, and essentially all of the nation's 566 tribes. It established the human rights of more than 5 million Native Americans living in the United States today.

Despite the accord of law, dread was the mood that pervaded my training in archaeology. Museum professionals feared that the new law would empty their shelves. Native Americans worried that museum people wouldn't really give anything back. A good number of Native Americans had taken to calling trained archaeologists "looters," "thieves," "gravediggers." Many archaeologists grumbled about those Indians stirring up trouble for no good reason at all. It was an education in the ethics of science and the politics of history.

It was also an enigma that was hard to decipher. Why were Native Americans, who want to preserve their culture, so willing to bury it? And how could scientists who spend their lives studying dead Native Americans care so little about living ones?

o o o

The morning starts badly.

The large group of Native American religious leaders who came to collect the twenty-six sets of remains had driven twelve hours through the night from Oklahoma to Colorado. When they arrive tired but cheerful, my staff and I welcome them into a conference room to enjoy some coffee. As we chat, one of the men asks where the twenty-six remains came from. I explain that we know these are the skeletal fragments of Native Americans from the Great Plains, but we don't know from which tribes. The room plunges into silence.

Quickly, I realize that not all the tribe's religious leaders had heard what their tribe's political leaders had agreed to with us. The

men erupt into a heated deliberation. They came to rebury their kin—not strangers. Yes, all human bones should be returned. But what if these bones were those of enemies? Perhaps the dead would harm the living, bringing disease and death to the tribe. They agonize over how to balance their religious responsibilities with their anxiety about the dangers of death. Finally, one leader stands up. He walks out, warning us that only witches and lunatics fool with the dead.

In 2007 I was hired to be a paradox. I came to the Denver Museum as a curator, charged with protecting and preserving 20,000 objects representing the cultural life of more than 400 Native American tribes. But I was also the museum official put in charge of administering NAGPRA, which meant that I would also have to return many of those same objects, knowing they would be forever lost to science and the public. My job was to both protect and return the collections I oversaw.

Initially, I was convinced I could show how the interests of museums and Native Americans are not antithetical. I was determined to find common ground. But after my first days on the job, I learned that common ground is so elusive because every object contains within it the seeds of conflict that have germinated over the decades between religious freedom and academic freedom, spiritual truths and scientific facts, moral rights and legal duties, preserving historical objects and perpetuating living cultures. When I followed the biography of each object, I saw the bright line between right and wrong fade to shades of gray. I learned that sometimes it was tribal members who stole objects and sometimes curators who wanted to give things back. Sometimes it was Indians who worked for museums and non-Indians who worked for tribes. Sometimes keeping an object in a museum destroyed it, while allowing it to naturally decay gave it life. As I was learning this summer morning, some of the hardest fights are those *within* a tribe. Repatriation, I discovered, is a tangled web.

As the religious leader exits the conference room, I brace myself for several years of effort to be flushed down the drain. But then

three of the tribal representatives agree to do the reburial by themselves. They bravely accept the spiritual risks. The work is too important, they insist. The twenty-six people might be enemies, but they also might be kin. In any case, they were human beings deserving to be at peace. The rest of the tribal delegation sets off for Oklahoma.

By midday I affix the final top to its pine box. I am relieved that today these last remnants of twenty-six men, women, and children will go home again. The living will bury the dead in the ancient soil of the Great Plains, yielding souls back to the earth's embrace.

We are done. Yet as I watch the boxes head out the museum's door, I feel little sense of finality. It then strikes me how repatriation is not an endpoint so much as a process. Each case is a choice between resistance and respect. Each case is a new struggle to meaningfully come to terms with history. Each case is the attempt to diminish the culture clash between museums and tribes. Each case offers a hope to finally answer who should control the future of the past.

Every repatriation is not an end but a chance for a new beginning.

I. RESISTANCE

War Gods

1. ONLY AFTER NIGHT FALL

They call it scientific research. They call it educational opportunity.
But if it happened to any other people, it would be called grand larceny.

Michael S. Haney, United Indian Nations in Oklahoma[1]

The Indian—as a savage—is soon to disappear.

R. Stewart Culin, 1900, museum curator[2]

At the end of the dirt road, at the edge of a desolate mesa, we approach the sacred shrine. It looks like a beautiful one-room prison. A windowless building made of heavy burnt-orange sandstone blocks. Sharp steel spikes shoot vertically from the roof, threaded with jagged barbed wire.

We park the car and step into the New Mexico summer. There is no one around, just a hawk circling high in the far distance gazing down on the Zuni Indian Reservation. I have worked with Perry Tsadiasi for a decade, but never before had he invited me to visit this shrine dedicated to the twin gods of war. "I want you to see this," Perry tells me now. "To have it in your mind when you write your book."

As we near the shrine, Perry points out a small mound of thin, delicate flakes of dazzling turquoise covering the ground like emerald snow. These are sacred offerings—along with finely ground cornmeal that has since blown away or been eaten by insects—made

by Zunis who regularly visit the shrine. On the structure's east side is a narrow doorway made from heavy steel and thick rebar. Perry takes the bulky lock into his left hand while removing a key from his pocket. He is the keeper of the only key.

Peering inside, I can see the structure's walls are lined with flat, neatly trimmed sandstone pieces. Perry explains how a steel cage was constructed off-site, and then lowered into position with a crane. Sandstone was built up around the cage, but it was left roof-less— unless you consider the spaced bars and barbed wire a "roof"—to ensure that the War Gods are protected from theft but left exposed to nature. The building is an architectural contradiction: a conscious attempt to ensure that the War Gods are safe as they decay.

We enter and stand before an altar surrounded by the War Gods.

Dozens of *Ahayu:da*, as they are called in the Zuni language, are tightly packed together, standing upright, like passengers in a sub-way car at rush hour. Made from pieces of wood cut about waist high, the Ahayu:da are carved into abstract human form with a pointed cap, heavy brow, deep-set eyes, sharp nose and chin, and a protruding umbilical cord. The feathers and other regalia that once clothed the twin brothers are long gone, lost or rotted away.

"There are 106 Ahayu:da here," Perry says. "I helped bring all them back home."

I notice that the statues are ashen gray, in different stages of de-composition, worn down from years of sun and heat, rain and snow. Some have retained their cylindrical form. Others are little more than fragments. As a museum curator, I'm supposed to be incensed to see these precious artifacts—these gods—disintegrating into lit-eral dust.

Instead I can imagine no better place for them. I see the power of this shrine reflected in Perry's eyes. This holy site means the world to him. It means the survival of his people.

o o o

The theft of the largest number of War Gods to be held by a mu-seum began, in large part, with R. Stewart Culin's ambitions.[3] With

only a high school diploma, Culin ascended the ranks of the mu-
seum world, first preparing exhibitions for the hugely successful
world fairs in Spain, in 1892, and in Chicago the next year. At just
thirty-four years old, Culin entered the Ivy League, appointed di-
rector of the University of Pennsylvania Museum of Archaeology
and Anthropology. He took full advantage of the post, laboring to
transform the quiet, embryonic museum and bring it to interna-
tional prominence. Photos made at the height of his power show
Culin as dapper in a crisp three-piece suit, with shining eyes and a
sly smile.

Culin wanted most to understand "the language of things," an
obsession that fed his acclaimed exhibits of decorative arts. He evan-
gelized that a museum should not display mere relics but, through
careful presentation, preserve "the seed of things which may blos-
som and fruit again."[4] By the turn of the new century, the amateur
academic was accepted as a leading member of the new science of
anthropology, the study of humankind.

In 1903 Culin left Philadelphia to become the inaugural curator
of the newly established Department of Ethnology at the Brooklyn
Museum.[5] When he arrived in New York, Culin was charged with
rapidly enlarging the museum's modest collections. Culin accepted
the mission with zeal.

When he considered the most fertile collecting grounds, Cu-
lin was drawn to the unfinished business of his friend Frank H.
Cushing, the legendary anthropologist who died suddenly in
1900. Twenty-one years earlier, Cushing had arrived in Zuni and
stayed for nearly five years, immersing himself in Zuni culture.[6] He
learned the language. He became a clan member and was even initi-
ated as a novice into the Priesthood of the Bow, a secret religious
order whose members protect the Zuni people. Cushing docu-
mented his controversial metamorphosis into a "White Indian"
in thick academic tomes and spellbinding popular articles. Cush-
ing helped invent the science of anthropology by showing what
could be learned if a scholar became fully immersed in a different
culture.

Just two months after he began his job in Brooklyn, Culin took a

train for Albuquerque to follow Cushing's path. "It led me to leave the East and turn my own steps to the Southwest and try to pick up and recover the broken clue," Culin declared in the dark months following his friend's death. "It became the dream of my life to go to Zuni and complete the work."[7]

o o o

When Culin disembarked in western New Mexico at Zuni pueblo, he was troubled to see a culture fast expiring. Much had changed since Cushing's departure in 1884. The Zuni were now hemmed in by American settlers, their water sources diverted to neighboring farms and ranches. Their traditional culture was under relentless pressure from middling bureaucrats, schoolmasters, and missionaries. Just five years before Culin arrived, government officials had tried to prevent Bow Priests from carrying out their duties of maintaining order in the pueblo. To intimidate the priests, more than 100 troops from nearby Fort Wingate were dispatched to Zuni.[8] The soldiers set up a camp for a year, flaunting their 12,000 rounds of ammunition and aiming a Hotchkiss gun at the defenseless mud and stone village. Four Bow Priests were arrested and imprisoned. After thirteen months, they were released without charges.

Culin was distressed enough by such events to protest an order by the Bureau of Indian Affairs that prohibited certain Indian traditions, like long hair for men and "face painting" for religious ceremonies. Culin condemned the order as cruel. (Although his main objection seems to have been that the edict would end Zuni customs before "the student of aboriginal customs and religion" could complete his work.[9]) Culin became convinced that the Indian race would vanish in less than a generation.

Such a crisis presented certain opportunities, however. Culin was exceedingly pleased about the collecting prospects at Zuni. During his collecting trips in 1903, 1904, and 1907, he sought to buy just about anything that was old, drawing on New York's deep pockets. Culin gleefully reported that the Zuni were "crazy to sell" almost

everything for just "five cents, the smallest coin."[10] Culin picked
up scores of games, musical instruments, agricultural implements,
weapons. In 1903 alone, Culin brought back 4,615 objects to the
Brooklyn Museum.[11] One of Culin's colleagues, and a competi-
tor, Matilda Coxe Stevenson of the Smithsonian Institution, com-
plained that "Zunis have had their heads turned by those who have
more money than we have." She pointed her finger at the Brooklyn
curator. "Mr. Culin," Stevenson said, "has made the Zuni half crazy
over money."[12]

Because of his obsession with relics, Zunis caustically gave Culin
the nickname *Inotai*—Old Thing.

Fueling Culin's goal was a series of misfortunes besetting the
tribe.[13] A smallpox epidemic had recently killed nearly 300 Zunis,
20 percent of the tribe's population. Then a severe drought struck
and harvests failed. The Zuni had lost more than 80 percent of their
traditional lands, limiting their ability to hunt and gather wild
foods, long a safety valve for bad farming years. The people desper-
ately needed money to buy food. In order to ensure their survival,
Zunis sold what they could. "Many of the Indians had nothing to
eat," Culin noted, "for my purchases were all presented to buy food
each day."[14]

Although desperate, the Zunis were reluctant to sell Culin what
he desired above all: sacred objects. "The things which the scientific
collector most admires," Culin wrote while at the pueblo, "cannot
be legitimately disposed of."[15] He was warned that sacred items were
cared for by individuals but belonged to religious secret societies.
They were not for sale. Even Culin's closest Zuni assistant made
"a point of not selling masks, dolls, prayer sticks, and other sacred
things."[16]

When Bow Priests learned that Culin was trying to buy cere-
monial objects, they ordered sentries to stop him. A missionary con-
fided to Culin that in 1903 "men deputized for the purpose were
constantly watching my purchases to see that no one sold me masks
or ceremonial objects."[17] He complained that a messenger "was sent
through the village who shouted from housetop to housetop cau-

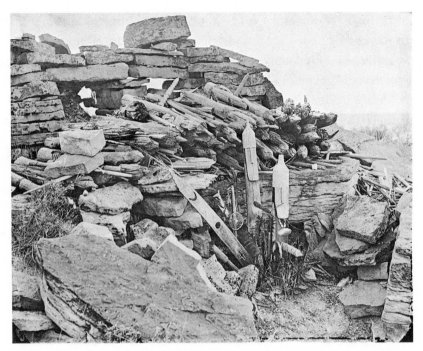

FIGURE 1. An Ahayu:da shrine in 1898. Courtesy of National Anthropological Archives, Smithsonian Institution, BAE GN 02367B 06390200.

tioning all against disposing of masks to me." A religious officer later went house to house to ensure that no masks were missing.

At first, Culin seemed to understand the limits of his grand ambitions. When he first saw a shrine of the War God in 1902, even Culin, the insatiable collector, insisted it be left intact. "He would be an iconoclast indeed," the Brooklyn curator wrote, "who would disturb this altar."[18]

<p style="text-align:center">o o o</p>

"It was only after night fall," Culin revealed, "when muffled figures would waylay me with whispers and gestures of secrecy, that I could conduct any important negotiations."

Despite the measures taken against him, Culin found ways to collect sacred objects. Cultural demise and food shortages were good

for the collecting business. "With the decline of the old traditions," Culin claimed, "incidental to the influence of white contact and the Government school, the old shrines had been neglected, and only recently despoiled by Indians and their contents sold to traders. These sacred objects, which for the greater part remained in Zuni, were secured."[19] In the end, Culin gathered for Brooklyn's storeroom thirteen War Gods—more than any other museum in the world.

Culin was particularly focused on collecting the War Gods that he believed came from one unguarded shrine on Dowa Yalanne, or Corn Mountain, situated just east of the pueblo.[20] He believed all these Ahayu:da should belong together in one museum. He tracked down all of the Ahayu:da taken from that shrine and purchased them. Eight of the thirteen War Gods came from Andrew Vander Wagen, who arrived at Zuni in 1897 as a missionary but succeeded mainly in converting himself into a trader.[21] Vander Wagen had reputedly taken the entire contents of three shrines and had paid Zunis to manufacture him nearly 100 ceremonial objects. The Brooklyn Museum purchased it all for $1,028. Culin relished that Zuni leaders were incensed over the contraband collection. Outrage was proof of its value. Culin sent Vander Wagen's collection thirty miles north to the town of Gallup, under the cover of the night, "when the outcry became so great."[22]

2. KEEPERS OF THE SKY

Zuni call their home the Middle Place. It is easy for me to see why they believe it is the center of the world. It is a landscape of unsurpassed beauty—expansive plains interrupted by towering sandstone cliffs that rise like medieval citadels, encircled by pine-covered mountains, all under the sanctuary of a perennial azure sky.

According to tradition, the Zuni's most ancient ancestors emerged in the Grand Canyon. They climbed from beneath the earth, arriving at a sinuous waterfall that pours over a colossal boulder encrusted in green moss. There the ancestors began an epic journey in search of their destined homeland, the Middle Place. Scholars similarly believe in an ancient origin for the Zuni. Linguists estimate that the Zuni language—what is called an "isolate" because it has no relationship to any other known language—developed about 8,000 years ago.[1] Archaeologists can trace Zuni culture through the centuries, their life as farmers settled in pueblos across the American Southwest, until they were forever changed in the summer of 1540. The Spanish conquistador Francisco Vásquez de Coronado, in his search for the fabled Seven Cities of Gold, arrived at Zuni. A battle ensued, igniting a clash with colonial powers that would last generations.

I am sitting in a decrepit hospital, converted into an office for the Zuni's historic preservation program, to speak with two religious leaders. Perry Tsadiasi wears a buttoned shirt and spotless white ten-

nis shoes. Dense black hair, slicked back, frames his lined face. Perry is short, belying his religious stature in the tribe. More than seventy years old, he is a medicine man, a member of the Big Charcoal Medicine Society, and holds the high titles of a Rain Priest and the leader of the Bow Priesthood. Several decades ago there were forty *A:pilha:shiwani*—Bow Priests—at the pueblo.[2] Today Perry is one of just two.

Next to him is Octavius Seowtewa. Approaching elder status at sixty years old, Octavius is built like a linebacker, though any intimidation is tempered by his soft voice and kind air. When not working on cultural projects or fulfilling his many religious duties, Octavius is busy making traditional jewelry and leading hunting expeditions. His hands and arms are covered in enigmatic tattoos, markings from his religious doings. He is descended from the Corn and Crane Clans, belongs to the Wide Wall Kiva, is a member of the Eagle Plume Down Medicine Society, and is a leader of the Galaxy Fraternity.

"Tell me about the Ahayu:da," I begin, careful to pronounce each syllable, *ah-ha-YOU-dah*.

Octavius answers that the Ahayu:da are twins, the children of Father-Sun and Mother-Water.[3] The brothers were born in the foam of the ocean, before humans existed. Eons passed. Then, during their sojourn to the Middle Place, the people endured hardships and faced dangers. The twins' hearts were changed to the "medicine of war" to safely guide the Zuni to their pueblo home. The war gods became the Zuni's invincible guardians and created a society of warriors called the Bow Priesthood.

Each year on the winter solstice, wooden images of the twins are made. (In years past, they were also made for other Bow Priest ceremonials.) Octavius relates that a complex set of rituals conducted by a range of the tribe's religious men infuse the entire process—many of which can't be shared with an outsider like me—but he can broadly describe the process. The Deer Clan carves *Uyuyewi*, the elder twin image. The Bear Clan makes *Ma'a'sewi*, the younger brother. Offerings are made when the trees are selected. As they are carved—being *born*, as Octavius describes it—prayers are made and

songs are sung. Zunis speak to the images just as they do to people; their development is described like a human, from infancy to adulthood.[4] In turn, the War Gods speak the Zuni language. "Only the Zuni people and the Ahayu:da really understand one another," Octavius says.

After the Deer and Bear Clans make their "children," the twins rest at an altar in a Zuni religious house, and different rituals across the fraternities and societies are completed. The twins are also the patrons of games; offerings of ritual toys are placed at the altar as gifts. When the Ahayu:da are prepared to be moved, the Galaxy Fraternity purifies them. As dawn approaches, Bow Priests carry them to their shrine homes in the mountains—one in the east and one in the west. There the twins reside to protect the Zuni people. The next year, the process is repeated. The new ones replace the old, which are ritually "retired," reverently laid adjacent to the shrine. This process of creation shows how the Ahayu:da are intrinsically sacred. From the Zuni viewpoint, they are unlike "sacred" artifacts most Americans might be familiar with (the Liberty Bell, for example) because they are not historical things whose meanings can evolve over time, but living beings who have one enduring, spiritually sanctioned function.[5]

"I don't like the English translation 'War God' for the Ahayu:da," Seowtewa tells me as our conversation ends. "Because the Zunis were never aggressors, never made war." Also, they are not "gods" in the Western sense of the word, he says, but protectors who keep the world in order. Seowtewa prefers the Galaxy Fraternity's term for them: *Deyalan Illon A:chi*. Keepers of the Sky.

Even the very words in English used to describe the carvings, Seowtewa is telling me, are based on misunderstanding.

o o o

Starting in 1879, thousands of cultural artifacts left Zuni.[6] Most of these objects were headed for the Smithsonian Institution, when the museum began gathering anthropological objects in earnest, after

its Bureau of Ethnology was formed. The bureau's first director, the one-armed Civil War hero turned anthropologist, John Wesley Powell, recruited researchers to document the Indians before they vanished in the young nation's rush toward the new century.

With urgency, the bureau dispatched the first of many expeditions to Zuni in 1879, to document fading lifeways and gather cherished objects before they were forever gone. The expedition was led by James Stevenson. He was joined by his wife, Matilda Coxe Stevenson, a photographer named John K. Hillers, and Frank H. Cushing, then a brash twenty-two-year-old with no anthropological experience but intense determination. This trip began a collection that would eventually number more than 10,000 Zuni objects, curated at the Smithsonian's National Museum of Natural History.

The methods of the Stevensons, Cushing, Culin, and their contemporaries dictated that the best objects had to be secured at nearly whatever cost. For many anthropologists, their ambitions outpaced their humanity. Scholars like Culin were tutored by the likes of George Dorsey, who unapologetically endorsed trickery and larceny in the name of science. Dorsey, the first PhD in anthropology from Harvard University and a curator at Chicago's Field Museum, mentored Culin in the summer of 1900.[7] He instructed one of his assistants during that time:

> When you go into an Indian's house and you do not find the old man at home and there is something you want, you can do one of three things: go hunt up the old man and keep hunting until you find him; give the old woman such price for it as she may ask for it running the risk that the old man will be offended; or steal it. I tried all three plans and I have no choice to recommend.[8]

These were the choices open to the anthropologists in New Mexico, although they all understood that in Zuni tradition, severe corporeal punishment or even execution were the penalties for the crime of trading in religious objects.[9] The Zuni placed Cushing himself on trial for taking sacred items.[10] He was lucky to escape with his life.

Stewart Culin fully acknowledged that one of the "chief crimes" in the community was "the selling of sacred objects to outsiders."[11] Only once did Matilda Stevenson give back a sacred object so that the Zuni seller would avoid a "severe whipping."[12] Stevenson explained that the Zuni woman's "mental suffering was so great."

The Stevensons and others repeatedly visited one War God shrine—every year between 1881 and 1884—leaving behind notes in a tin can proving they had been there, found nearly a century later by Bow Priests. An 1881 note left behind by Gilbert Thompson, a topographer with the U.S. Geological Survey, states, "It is desired that all [visitors] will not disturb the Zuni shrine."[13] The same year, James or Matilda Stevenson also left a note: "In deference to the well known feelings of Prof. Gilbert Thompson and his special reverence for Idolatrous worship we do not molest the Zuni goods—I meant *Gods*." It is unclear if this was an honest slip or a winking quip that emphasized the Ahayu:da's novel shift from sacred object to museum specimen.

Thompson was not always there to prevent thefts. Many other times while at Zuni, Matilda Stevenson used subterfuge and cunning to gather anthropological data on the secret traditions of Zuni religion and occasionally to steal sacred things.[14] Both James Stevenson and Frank Cushing took War Gods that ended up in the Smithsonian's collections.[15]

o o o

As we finish the interview, Perry Tsadiasi uses a cell phone to call the tribal police. He wants me to see the place where the Ahayu:da have been returned. Speaking in Zuni, he gives the dispatcher my license plate number and also a secret code word. The shrine is closely monitored. We get into my rented Chevy and head down the road.

Entering the shrine with Perry, I first notice several handmade bowls sparely decorated with tadpoles, sitting on a thick blanket of turquoise flake offerings. On the altar's sandstone ledge is a plastic package of new T-shirts, left as a modern offering to the ancient gods. Zunis who need blessings come here to speak with the War

Gods and ask favors of them. Scattered around, too, are small pieces of pottery and beads collected from ancestral archaeology sites and seashells Perry collected in Maine during a repatriation. After the seashells were placed in the altar, he tells me, it rained in the high desert here for four straight days.

Under the piercing heat of midday, we fall into silence for a few moments, enjoying the tranquility of the shrine. I feel at peace until I suddenly remember Frank Cushing.

From the Zuni viewpoint, the shrine's serenity obscures a lurking danger. The War Gods are protectors but also troublemakers. The Ahayu:da often appear as "disobedient children," the anthropologist Ruth L. Bunzel wrote, "masking their great powers behind obscene and ridiculous exteriors."[16] When respected, they keep the world in balance. When disrespected, they unwind the world into chaos. After Culin's purchases, terrible weather suddenly engulfed the pueblo—sandstorms, blizzards, and extreme cold. Zunis said it was "all due to the wicked sales which some of the Zunis made by parting from these old relics."[17]

Some Zunis believe that Frank Cushing received a far grimmer penalty. Cushing pilfered one War God from its shrine, which eventually made its way into the collections of the Smithsonian.[18] He also made several replica statues, selling one to Berlin's Museum für Völkerkunde and giving away another that ended up at Oxford University's Pitt Rivers Museum.

Sixteen years after his time in New Mexico, while working in Florida, Cushing ate a meal of fish. One inattentive bite included a bone, which lodged in Cushing's throat. Within days, an infection led to fatal hemorrhaging. Cushing's sudden death at forty-two years old has been blamed on the War Gods—punishment for revealing their blessed secrets.[19]

Standing before the 106 Ahayu:da, I see them for the first time as more than inanimate objects. I understand them as the potential troublemakers they are, when they are secreted away from their shrine homes. What trouble they have made for the Zuni, as much as the museum people who collected them.

3. MAGIC RELIEF

In 1951 Mary Winslow Allen Crane and her husband, Francis, took a road trip. They were looking for a little adventure. Or, at least, their minds were open to something new. Although both were only in their late forties, Francis would retire the next year from his family's thriving leather business, in Massachusetts. With a serious heart condition, Francis was ordered by his doctor to stay at sea level and avoid northeastern winters.

Perhaps the Cranes were initially not thrilled by this prescription. Both were "dyed in the wool New Englanders," as Mary once said in an interview, adding, "I'm even Life Member No. 2164 of the Massachusetts Society of Mayflower Descendants!"[1] They found a quiet corner of the Florida Keys, where the fishing was excellent and they could buy a large piece of verdant mangrove forest that gave a peaceful sense of escape.

Not having any children, and with money and time to spare, the Cranes regularly rummaged for pursuits. They dallied in birdwatching, gardening, orchid growing, stamp collecting. Mary had graduated with honors from Wellesley, a dual major in sociology and natural resource conservation; she would be a strident environmentalist throughout her life. Their most successful hobby had been dog breeding. Starting in the 1930s, they gained prominence for introducing America to a gentle giant of a dog called the Great Pyre-

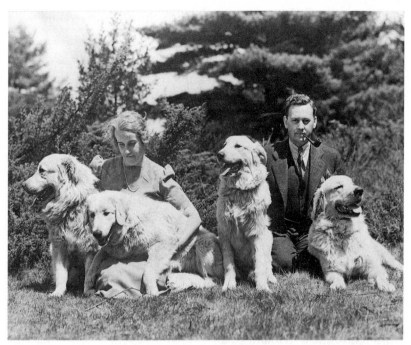

FIGURE 2. Mary and Francis Crane, about 1950. Courtesy of DMNS, CR85-008.

nees.[2] The problem was that with their pending move to Florida, the heavy-coated dogs, used to snowy mountains, wouldn't fare well. The dogs stayed in Massachusetts. Mary and Francis would have to find a new diversion down south.

Before moving to Florida, they took a road trip to explore the American West. It was supposed to be a simple vacation. But the journey changed their lives.

It's difficult to determine what object inflamed their hearts for Native American things, but it seems to have started with their first purchase of artifacts in April 1951, from Smith's Museum in central California, run by an elderly man who charged twenty-five cents for admission. The Cranes bought a handful of baskets and arrowheads for $55. By the next month, the spark of collecting had turned into a wildfire. They crisscrossed the West, driving from California to New Mexico and back again, north to Montana then south to Arizona. Spending hundreds of dollars each day, they cleaned out

trading posts and chased down Native American artists to buy from directly.

Both of the Cranes came from New England families who had done a little collecting. Mary had inherited her grandfather's collections of arrowheads. Francis's father had a few Indian baskets and jars. But never before had Mary or Francis set out to collect Native American objects. Yet they now saw a chance for an adventurous new pursuit that would also allow them to contribute to their adopted community in Florida. "We wanted to do something or build a collection in some way that we felt would be of benefit," Mary later recalled. "There's really no fun in just keeping it to yourself, I mean. You want to have it go where it will be seen and appreciated and do some good."[3] Joyce Herold, a Denver Museum curator who later worked with Mary, believed that their collecting fever was born largely from a desire to make a contribution to educational pursuits, a deep appreciation for Native American objects, a zest for negotiation and deal making, and a class outlook that demanded that their money be used to benefit society.[4]

For those without any instinctive drive to collect, it can be difficult to understand such monomania, such a pressing need to refine a collection to the very best of things. The psychoanalyst Werner Muensterberger has suggested that this "unruly passion" is a way to make up for a loss experienced in childhood, which is then channeled in adulthood through a restless attempt to fill an emotional void—to find a temporary though satisfying "magic relief"— through material objects.[5] The historian Susan M. Pearce has shown that collecting of the kind the Cranes enjoyed also has deep roots in Western traditions of ownership, conquest, and display.[6] The Cranes may not have been collectors had they not nurtured upper-class, Euro-American ideals about property, curiosity, and beauty. As Mary Crane once explained, "I came by collecting naturally."[7]

Whatever the source of the passion, its symptom was clear enough. In the spring of 1951, the Cranes left for the West with several bags. They returned home in late summer with 2,864 Native American objects. It was a beginning that eventually led them to the War Gods.

o o o

In September 1968, after a long week of packing, four large moving trucks left the Florida Keys. As he watched them go, Francis Crane knew that a chapter in his life was closing, his beloved collection gone. His eyes welled with tears. A week later the trucks arrived at the Denver Museum of Nature & Science's loading dock.[8] They were stuffed with the Cranes' donation, 12,000 Native American artifacts—nearly their entire collection.[9]

After their first road trip out West in 1951, the Cranes established a nonprofit organization and spent the next seventeen years amassing thousands of Native American objects. They began with unusual and pretty things that caught their eye, but the couple became savvy collectors, patiently laboring to acquire the most precious artifacts. "Unless the items are *old*, *rare*, and *unusual*," Francis wrote in 1967 to the Gallup Indian Trading Company, "we probably won't be interested."[10] Eventually, the couple didn't even need to seek out the best dealers: the best dealers all came to them.

Wanting to share their treasures, in 1959 the Cranes opened the Southeast Museum of the North American Indian on their property in Marathon, Florida.[11] The hurricane-proof building was a modest 3,000 square feet, but the front featured a dramatic steel-and-glass tower that presented a three-story-high totem pole from Alaska. They hung out a sign by the road: "Genuine Indian Museum, Not a Tourist Trap."

Despite these efforts, few passersby took the lure. "People who come there come to play and go fishing," Mary groused about the Keys, "and do not intend to spend their days in a museum."[12] The Cranes could only hope for visitors on rainy days. The collection was also becoming ever bigger and more unwieldy, and the Cranes were getting older. They also learned that delicate artifacts should not be brought into Florida's epic humidity.

As they were pondering what to do with their collection, by chance, Mary met Roy E. Coy, then a museum director in Missouri, at an Audubon Society event. With their shared interests in birds and museums, a friendship blossomed. The Cranes began to dream

of moving their museum to Carefree, Arizona, and have Coy run it. The idea tempted Coy, but instead he became the assistant director of Denver's natural history museum. Coy still saw an opportunity: the Denver Museum had just built a new exhibit hall but had nothing yet to fill it. Coy knew, he later said, "Indian artifacts are pretty hard to acquire these days."[13]

By the fall of 1968, the 500 cardboard boxes of artifacts sat in the Denver Museum's storeroom. With no anthropologists on staff, the collection was assigned to two Denver Museum employees in the graphic design department, Robert Akerley and Arminta "Skip" Neal. Eager to share some of the museum's new treasures, in 1969 they put together a small temporary exhibit.[14] It featured Northwest Coast potlatch materials, Hopi kachina carvings, Plains Indian clothing, and two scalps.

o o o

In the dead hours of night, a telephone call woke up Francis Crane. It was Tom Woodard. He owned a booming trading post in Gallup.[15] The two men had made a few small transactions before. Most recently, in 1963, the Cranes had bought several pieces, contemporary paintings of little importance. What Tom now possessed deserved a call in the middle of the night. And Francis definitely wanted to see it.

The next day, Woodard went to a Greyhound bus station and shipped to the Florida Keys a package of two Zuni War Gods, an accompanying ceremonial wand, and three prayer sticks. The "items sent to you are authentic in every detail and origin," he insisted, collected on Corn Mountain, east of Zuni. One had been made not more than fifteen years ago, the other not more than six. Francis mailed a check for $450.

Just the previous year, the Cranes had acquired the first War God for their museum, though it's not entirely clear that they understood what they had bought.[16] For $4,095 they got a batch of fifty-one objects from a collector in Los Angeles. In the Cranes' catalog,

they assigned the War God the number 6986—their 6,986th object, thirteen years into their collecting spree—and indecisively wrote in the catalog: "Zuni War God?"

The Cranes would buy three more. In the fall of 1968, just a month after the Crane Collection had been moved to Denver, the couple received a letter from Claire Morrill at the Taos Book Shop.[17] The Cranes first met Morrill in 1954 when they had undertaken another massive collecting trip that ended in the Southwest. "Remembering your wish to be advised of any old Indian ceremonial objects of really special importance," Morrill now wrote, fourteen years later, "we think we should tell you of a group of Zuni War Gods we have just acquired."[18] Immediately, Francis wrote back. He explained that their collection had just been moved to Colorado. They planned to continue to add to the collection, however, though they would now need some time to get approvals from the Denver Museum staff.

In her reply, Morrill noted that the collection's move to Denver could prove difficult. She had hoped to send the War Gods far away, where they could be put on display. You see, she said, "the Zuni are somewhat sensitive about ceremonial objects of this kind," even though she added that the Priesthood of the Bow "is fast dying out and some shrines have been abandoned."

Although she offered no proof, Morrill assured the Cranes that she "obtained the group of figures in an entirely legitimate way— they had already been sold by the Zunis before they came into our possession." Nevertheless because of Denver's proximity to the Pueblo, she had to insist that they be bought "at the purchaser's risk and with the stipulation that they are not to be publicly displayed for ten years." Such an approach was common, she hastened to say. Museums in Santa Fe and elsewhere assumed that "the time will come when ceremonialism will break down to the point where such figures can be safely displayed." Like Stewart Culin, but six decades later, this was an argument still anticipating the end of Zuni culture.

Mary was late in replying because Francis suffered a heart attack just after Thanksgiving. He was convalescing in a Maine hospital.

Mary still found the time to write back. "I intend to step up myself," Mary committed, "and make the purchase to save this valuable and rare collection for the Museum, because I realize their scarcity and know that they should be preserved in the archives of the Museum!" She asked Morrill for any more information—of course to be kept secret by the museum for ten years—and enclosed a deposit of $500.

The War Gods would be the last earthly objects Francis bought. Five days after the check was sent, he died. Like Frank Cushing, Francis's abrupt end is another strange, fatal coincidence surrounding the War Gods.

A week into 1969, Roy E. Coy signed his name to a contract drawn up on Taos Book Shop letterhead. The museum accepted "full responsibility of ownership." At the bottom of the page is a footnote, seeming to justify this unprecedented agreement for the museum: "Explanation of above stipulation of postponement of display is that certain Zuni tribesmen resent exhibition of these sacred items and might make trouble."

With the contract, the museum officials agreed not to display the three Ahayu:da until 1979—hoping by then the Zuni would have forgotten about their gods.

How wrong they would be.

4. TRIBAL RESOLUTION

Some things, if they are very powerful, come back. Remember that.

N. Scott Momaday (Kiowa), from the poem "The Shield That Came Back"[1]

One day in 1977, the maker of the younger brother Ahayu:da, a Zuni Bear Clan leader named Alonzo Hustito, and his son, Charles, came across the book *American Indian Art*.[2] They paused when they turned the page to an illustration, plate 88, featuring a rare object at the Denver Art Museum. Founded in 1893 as the Denver Artists' Club, the museum grew to be one of the largest art collections between Chicago and Los Angeles. Ideally situated between the Great Plains and Southwestern tribes, DAM developed a substantial collection of Native American artwork. Plate 88 featured one of DAM's prized possessions: a Zuni War God. Many art historians judged this Ahayu:da in Denver "to be one of the finest examples of its kind in a public collection."[3]

After the first wave of anthropologists had accumulated War Gods, collectors continued to seek the sculptures. By the 1910s, some War God shrines were completely empty, but new Ahayu:da were made every year—a new crop for harvesting by thieves.[4] Inciting the War God market was an influx of cash from the art world. Uyuyewi and Ma'a'sewi became especially prized among the Modern Art elite. The surrealist Man Ray was inspired by the War Gods he saw at the Brooklyn Museum for his 1914 painting *Totem*.[5] The

Swiss artist Paul Klee was influenced by a War God he saw at the
Berlin Museum für Völkerkunde (the one Cushing sold).[6] Later,
Andy Warhol owned one. Joining many traditional objects from Af-
rica and Oceania, "primitive" art forms found a home in the most
sophisticated Western institutions, comfortably exhibited next to
Picasso and Brancusi.[7] The flowering of Native art also increased the
monetary value of Ahayu:da on the market. By the 1970s, War Gods
were selling for thousands of dollars.[8]

Zunis began to consider all the War Gods taken from their lands
through the years. Zunis were fed up because no one had the right
to take the Ahayu:da. As Charles Hustito once explained it, after
his Bear Clan makes the younger brother War God, it is turned over
to the Bow Priests, who place it in the shrine. "From that point on,"
Hustito said, "it becomes communal property. It is left there for
people to go in and ask for blessings."[9] The Zuni religious leaders
finally resolved to get the War Gods back.

In 1978 the Zuni leaders called a meeting to develop a strategy
for recovery, inviting the tribe's lawyers, as well as Richard Hart,
a historian who worked for the nonprofit Institute of the North-
American West, and T. J. Ferguson, an archaeologist employed by
the tribe's heritage management program. Decisions did not come
easily. Although outsiders may see Zuni religion as a small homog-
enous community of believers, in fact, at the time of these delibera-
tions, there were six kivas, twelve medicine societies, fourteen clans,
and several more priesthoods and religious fraternities at the pueblo.
Each group has its own responsibilities and sphere of knowledge.
Complicating the discussions further was Zuni religious organiza-
tion—a theocracy with a complex hierarchy and lines of author-
ity that serve to heal the sick, bring rain to the world, and keep the
forces of creation in balance.

But the crisis unified the tribe's leadership. They settled on six
points:

1. Religious objects are important to Zuni religion.
2. Through religious knowledge, a living spiritual life can be imbued in
 inanimate objects.

3. Communally owned objects cannot be removed from Zuni land.

4. The removal of objects and religious persecution (starting with the Spanish conquistadors) has created a "spiritual imbalance" that can be restored through the return of stolen objects.

5. Thefts have happened because the art world and museums want the objects, and thus these institutions bear primary responsibility.

6. Museums and others should return stolen items and help prevent future thefts.

Before the Zuni's efforts, Native Americans had only tried to reclaim sacred objects in fits and starts. Rarely were they successful. In 1883 Apaches demanded the return of looted objects that several cavalrymen had taken from a cave in central Arizona.[10] Around the same time, an entire village of Hopi in northern Arizona begged a trader to return items stolen from a shrine.[11] The earliest nationally celebrated case of repatriation concluded in 1938, when Hidatsa elders from North Dakota convinced George Gustav Heye and the board of his Museum of the American Indian to return a sacred bundle.[12] By the 1960s, these claims became increasingly confrontational. In 1967 the Iroquois of New York revived efforts from the late 1800s to regain stolen wampum belts. Protests outside the state capitol led to the "Wampum Bill" in 1971, which returned the belts on the condition that a museum be built on the Onondaga Reservation to house them.[13]

In contrast, although the Zuni were "determined to recover what they knew belonged to them," Edmund J. Ladd, a tribal member and a trained anthropologist, wrote, they never made demands because Zuni priests are not supposed to bring rancor to their positions.[14] They just said, "We respectfully request that you return them." The method the Zuni used to explain their arguments about humanitarian and ethical judgments was based on Zuni ideals of conflict resolution. "In Zuni culture a reasonable person with a grievance goes to an adversary four times to attempt a peaceable resolution of the problem," it was explained. "Only after this good-faith attempt at resolution is made should stronger action be taken."[15] They had faith that if museum professionals listened to their views, then adminis-

trators would voluntarily return what the Zuni alone could care for properly.

On September 23, 1978, the Zuni political leadership passed Tribal Resolution M70-78-991. This law from the tribal government recognized the authority of its religious leaders and asked museums and others to work with them. The struggle to rescue the War Gods had begun.

o o o

Quietly, in the first month of 1978, Zuni Governor Edison Laselute wrote a letter to the Denver Art Museum explaining the power of the War Gods, asking to visit Denver, and seeking a conversation with the director "concerning the future disposition of the war god."[16] By chance, around the time Alonzo Hustito read *American Indian Art*, two Bow Priests discovered a tin can left by government surveyors at a War God shrine. A Bureau of Indian Affairs investigator was soon on the trail of Arthur C. Clark, who was in Zuni between 1899 and 1901 and had taken a War God and sold it an art collector from Tulsa, Oklahoma. The collector donated it to DAM in 1953, receiving a $150 tax deduction.[17]

The museum's curator of primitive art, Richard Conn, replied to Governor Laselute two weeks later. Unfazed, Conn said that the Ahayu:da image was on display so the tribal leaders were welcome to see it during the museum's regular hours, and that the museum director was available for a meeting.

In March, three Zunis—Police Chief Gordon Peywa, Head Tribal Ranger Barton Martza, and Bow Priest Dexter Cellicion—traveled to Denver. They met with Conn, the DAM director Thomas Maytham, and the museum's lawyer. Since DAM had their lawyer present, the Zunis invited a lawyer named Timothy LaFrance, of the Native American Rights Fund, in Boulder, Colorado, to represent them as counsel. These two groups then began a discussion neither had ever engaged in before—and in fact that had hardly ever happened in the history of American museology. They talked about repatriation.

The talk didn't go well. The museum representatives were guarded and evasive. The Zuni delegation felt they had failed to be convincing and were disappointed that the museum had not simply returned the Ahayu:da then and there. They didn't yet understand the extensive legal and administrative process museums have for "deaccessioning"—legally transferring—objects from collections. The presence of the lawyers, and some words said that pointed to the Zuni's legal grounds, made the summit feel adversarial. The only point everyone could agree on was to meet again at a later date.

The visit to DAM nevertheless reaffirmed the rightness of the Zuni's crusade, at least in the mind of Barton Martza. "When I first went up to Denver, and I saw this War God on display in a square glass case," Martza recalled, "to me it appeared there was a sigh of relief from the idol. And I guess in a way he said, 'Finally, somebody, some Zuni, contacted me.' But I could see the facial features on the War God itself, it was—it looked like it was sad."[18] Even in the radical re-contextualization—600 miles from home, preserved behind glass, presented as "art"—Martza had no doubt that the Ahayu:da was a breathing being in need of aid.

DAM's response to the initial meeting was to ready for battle. In a confidential internal memo, Director Maytham emphasized that the War God acquisition was made in good faith to preserve an important artwork and make it publicly accessible. He acknowledged that Zuni may want to keep such cultural pieces secret, but "the object has in reality entered the public realm of world art" and thus the museum could not "deprive the world public of further access to it." He wondered why the Zuni took eighty years to claim the object and worried about the precedent the return of the War God would establish. "To return the object," Maytham concluded, "will be directly contradictory to the museum's major responsibility to preserve objects in its care."[19]

The museum's board of trustees had a subcommittee overseeing collections, which also discussed the crisis.[20] One committee member insisted that the museum's efforts were not antithetical to the Zuni's interests since "museums preserve culture," while another member suggested that the art museum could create a "sacred

ground" that would house sacred objects. Everyone agreed that the matter would likely end in a lawsuit. Maytham soon wrote the entire board, suggesting "why claims of this kind should not override the greater obligations of museums to maintain our artistic and cultural heritage for the benefit of all."[21]

In their first meeting at DAM, the Zunis were told more War Gods could be found in museums around the country. The Smithsonian and the Brooklyn Art Museum were mentioned. (Denver's natural history museum three miles away, then with six Ahayu:da, seems to have gone unmentioned.) As their negotiations with DAM churned slowly, the tribe decided to focus on the Smithsonian because of its stature as "America's attic." If they were successful, the Smithsonian could help establish a crucial national precedent for repatriation.

The Zuni entered into negotiations with the Smithsonian. They quickly found an ally in William Merrill, a sympathetic anthropology curator with a specialty in Native languages of northern Mexico. Merrill fought with his administration, spending a full year marshaling arguments that the Zuni's demands should be met. Another curator, William C. Sturtevant, also asked hard questions. "There are legal and ethical questions involved, but it's not so simple," Sturtevant told a reporter. "You have to ask a lot of questions. Where did the object come from? What was its use? What were the circumstances of its leaving? And it's possible for the meaning of ownership to change over time. Legally the situation may be clear, but morally it may not be as clear."[22] Despite the potential for resolution, the process lost pace when the museum and the tribe agreed to review the thousands of Zuni objects in the Smithsonian and deal with them collectively rather than piecemeal.

Still, by October 1978, the dialogue with the Smithsonian bore its first fruit. Merrill notified the tribe about a pending auction at Sotheby Parke-Bernet, which included a War God. Springing into action, six Bow Priests and the clan members who make the War Gods wrote the auction house. The four-page letter explained their beliefs in exacting detail. "It is demeaning to the Ahayu:da and of-

fensive to us that you would place a crass material and monetary value on so priceless a religious being," the letter concluded. "The psychological and physical damage this does to the Zuni people, and to the world we share with you, should weigh heavy on your conscience."[23]

The auction house responded promisingly, removing the wooden image from the sale and offering to cooperate, even telling a Zuni official the company wanted to be "friends" not enemies.[24] Knowing the importance of this moment, the Zuni retained a lawyer, who argued that the War God had been *necessarily* stolen, because "to the degree that they can be regarded as property at all, they are owned communally by the tribe."[25] Persuaded by this argument, the U.S. Attorney's office ordered the FBI to confiscate the War God using the law 18 USC 1163, "Embezzlement and Theft from Indian Tribal Organizations," which states that stolen tribal property must be returned and could lead to substantial fines and imprisonment. Museum administrators now understood that behind the Zuni's restrained diplomacy was a powerful legal instrument at their disposal. Observers warned that this whole episode was "ominous news to War God owners."[26]

Just several days later, the collector trying to auction the War God, a doctor in Los Angeles, contacted the Zuni Tribe.[27] He explained that he didn't know the object's true meanings. He wanted to return it to them with no legal contest. T. J. Ferguson, an anthropologist helping to coordinate the tribe's efforts, woke up at dawn and traveled to the Elder Brother Bow Priest's sheep camp to share the good news. More religious leaders were conferred with, who told Ferguson "to go slow and do everything right."[28]

The FBI offered to confiscate all the Ahayu:da in museums and galleries. While this must have tempted some Zuni—a single and swift solution to a complex and time-consuming problem—they asked the FBI to refrain. The Zuni tribal council formally coordinated its efforts with eight government agencies—ranging from the Zuni Tribal Rangers, to the FBI, to the National Park Service—and gave the Zuni religious leaders final control over this novel process.[29]

The Zuni leadership still wanted "to pursue the recovery of the images in a culturally appropriate manner."[30]

On January 3, 1979, three Bow Priests and Ferguson drove to the U.S. Attorney's office in Albuquerque. Since the previous fall, the Ahayu:da that had been living in Los Angeles was now residing in a vault, in case it was needed as evidence for a lawsuit.[31] Once the doctor's deed of gift was received, the evidence was no longer needed. The Zuni men quickly headed back to the reservation. The first stolen War God was on its way home.

o o o

A week earlier, Bow Priests and the pueblo's local radio station, KSHI, had announced a religious council was to be held at 10:00 p.m. Twenty religious leaders convened. For four hours they talked buoyantly about all the progress over the year. They mostly spoke in the Zuni language, but broke into English when Ferguson presented a slide show of the Smithsonian's collections. The meeting concluded "with a long prayer and good feelings."[32]

At the meeting, six Bow Priests also signed a five-page letter to the DAM board of trustees. "We would now like to resolve this matter in as quiet and as dignified way as possible," the letter said. "As we approach you to ask for your voluntary return of our Ahayu:da, we are trying to be reasonable men. We are willing to talk with you, and to listen to you, if you in turn are willing to listen to us."[33]

In Denver, the museum staff strategized how to keep the War God. The curator Richard Conn wrote one confidential memo to argue that the Zuni had still not proven their legal title.[34] He questioned the Zuni's motives, even suggesting that they were targeting DAM because they thought it owned the most valuable Ahayu:da ($50,000, he estimated) and would sell it as soon as it was returned. He recommended that the board not relinquish the War God. Maytham agreed. "The museum," Maytham wrote to the board, "could not legally or in good conscience give away an important and valuable asset."[35]

On January 9, 1979, the Zuni tribal council paid for Alonzo Hustito, Chester Mahooty, Edmund Ladd, Victor Niiha, and T. J. Ferguson to travel to Denver.[36] The next day the group—joined by their attorney, Timothy LaFrance, and several state officials—spoke before DAM's thirty-member board of trustees. A trustee spoke first, informing the Zuni that the purpose of the meeting was to listen, not to debate the matter. No decision would be made that day.

Mahooty stepped forward. He began a prayer.

The curator Conn likely bristled at this start to the discussion. He had noted a week earlier in an internal memo that Governor Laselute had asked "permission to hold a prayer meeting or whatever." Conn wrote, "I am opposed to permitting this at all," not wanting to cede any ground to the Zuni.[37]

After the prayer, Mahooty explained yet again why the War Gods are so important to the Zuni people. Hustito was introduced as the maker of Ma'a'sewi, the younger brother War God. He spoke in Zuni—Ladd translated. "The War Gods have been taken, which accounts for the world's suffering—tornados and floods," Ladd said. "He wishes that the War Gods could be returned so that bombs will not fall; that wars will not occur; that the land will produce a livelihood; and that peace will be in the land."[38]

Niiha told the trustees the role of the Bow Priests and said he was happy to see his "child." Ferguson spoke about management issues and the tribe's plans for securing the War God shrine. LaFrance gave his legal theories but emphasized that the Zuni were asking the trustees to return the gods voluntarily, on humanitarian and moral grounds. Hustito offered a final prayer. Nothing was resolved.

Exactly a month later, DAM circulated a press release, which led to an article in the *Rocky Mountain News* titled "Zuni War God Spurs Clash"—provoking exactly the kind of public fracas that the Zuni had worked to avoid.[39] The article outlined the year-long dispute over the "27-inch piece of wood," liberally quoting from LaFrance and Maytham. The Zuni argue, it said, that the War Gods are communal property and thus cannot be legally separated from the tribe. (Under federal law "communal property cannot be sold without the

consent of the plural owners.")[40] The museum's counterargument
was that since the War God now is "part of the museum's collection,
the object is owned communally by all the people of Denver."

o o o

Perhaps DAM's administrators misjudged the political moment.

In 1978 the U.S. Congress passed the American Indian Religious
Freedom Act. Although the law would come to lack teeth, it was ev-
idence of history's pendulum swinging toward Indian rights. As one
legal observer wrote at the close of the decade, "The 1970s proved
a time of transition in central attitudes about Indian culture on the
part of the federal government, and recent legislation has ensured
Indians of religious rights once expressly denied them."[41] LaFrance
wrote a letter to director Maytham noting that, under AIRFA, if the
museum did not comply with the new law, then its funding from
federal grants might be cut.[42]

Colleagues and supporters encouraged DAM to remain stead-
fast. The director of the Cleveland Art Museum wrote to Maytham
recommending that the Zuni's request be denied. "The precedent
established," he wrote, "would be devastating."[43] Others, like one
local resident, praised the museum for not "inviting the dismantling
of the heart of its primitive art collection."[44]

But public sentiment was rising against the museum. Conn was
contacted by unhappy Coloradans who penned "nasty letters, made
obscene phone calls, and all sorts of other outrages in the name of
justice."[45] "It seems peculiar to me," one Denver resident wrote to
Maytham, "that your museum could display American Indian art
and at the same time have little or no concern for the creators of this
art."[46] Letters appeared in newspapers in support of the tribe. "It
does not take a heightened moral sense to realize that the denial of
a religious artifact from those to whom it has religious significance
is an unjust denial," one member of the museum wrote. "How can
our enjoyment of the sculpture take precedence over the desire of
others to worship it?"[47]

The Zuni also received support from newspapers. The *Colorado*

Daily argued that "the museum has no right to cling to that which is not absolutely theirs."[48] An editorial from the *Rocky Mountain News* strongly supported the return of the statue and lambasted the art institution. "The museum is refusing and gives several reasons, none of them convincing," the paper's editorial board wrote. "Museum officials say, for instance, that returning the object . . . could cause other tribes to make demands for artifacts they produced. Well, it's highly doubtful that there would be other circumstances approximating this particular situation. How many gods populate the museum?"[49]

The Zuni religious leaders appreciated the public support. But they were unsettled by the contentious tone. They felt, it was later said, "that the Ahayu:da deserved more respectful discourse."[50]

o o o

The oilman and chairman of the DAM board of trustees, Frederick Mayer, called T. J. Ferguson on March 14, 1979.[51] Mayer was deeply invested in the museum. He would go on to serve for decades on the board and would donate $11 million and 1,800 works of art to DAM.[52]

Mayer explained that the eighteen-member board was split. Some board members adamantly opposed the War God's return. Some wanted to loan the War God to the tribe.[53] Other board members were willing to consider repatriation but feared a lawsuit from the anti-repatriation faction. Still others worried about precedent. Mayer asked Ferguson if yet another Zuni delegation could travel to Denver to negotiate some kind of bargain.

"I have discussed your phone call with the appropriate people," Ferguson told Mayer on a call five days later. "They have decided continuing discussions would only be evading the issues."

Ferguson closed by saying the Zuni leaders expected a "definite answer" at the upcoming board meeting.[54]

o o o

On March 21, 1979, DAM trustees voted to give the Ahayu:da in its collections back to the Zuni. Over the previous month, the collections committee had met multiple times, and after considered debate, they had decided it was in the best interests of the museum, the public, and the Zuni to release the War God. Fifteen trustees voted in support of these measures. Three trustees abstained.[55]

Although it is unclear what finally swayed DAM's leadership, with their decision, they clearly sought a cordial conclusion. "It is true that the War God is a deity and a present, animated object of worship rather than a symbol or an art object," a DAM press release admitted.[56] In a personal letter to LaFrance, Maytham wrote that the newspaper stories had published erroneous statements, and he wanted to correct and apologize for his "inaccurate understanding."[57] Later in the year, the museum received an award from the Americans for Indian Opportunity, an advocacy group, "for the excellent job for the safe return of the Zuni War God to the Zuni people."[58]

However, with lingering concerns about the precedent of their decision, the DAM trustees did not authorize the War God's return, but only its "presentation" to the tribe. As part of the agreement, the tribe immediately began planning the construction of a new shrine. The high-security holy place was finished in 1980 by a crew of sixteen young Zuni workers. In the meantime, DAM officials located two more Ahayu:da in their storeroom that had been overlooked. That fall, the three War Gods were placed in their new abode under the New Mexico sky.

The first museum had returned the Zuni gods. Quickly, more followed. In 1980 the Wheelwright Museum of the American Indian and the nearby Museum of New Mexico in Santa Fe returned six Ahayu:da altogether. In 1981 the Millicent Rogers Museum in Taos, New Mexico, returned one, followed by the University of Iowa Museum of Art. There were now a dozen Ahayu:da back at Zuni.

Meanwhile, Denver's natural history museum decided it would hold on to its War Gods, despite closely following the DAM controversy.[59] Having just completed its new exhibition featuring the

Cranes' donation, the museum staff did not want to do anything to jeopardize the Crane Collection. They also implicitly trusted the Cranes. "They had a very strong motivation to preserve materials of American Indian culture to be used in the public trust—all of those museum things, museum principles," Joyce Herold, the Denver Museum's longtime curator, told me in 2011. "They had no motive of taking inappropriate things or stealing anything."

Mary Crane's own response to the repatriation controversy was equally ambiguous. In the summer of 1979, just three years before her death, Mary was asked about repatriation in an interview. "You can't blame them for wanting to keep secret and not exposed to White man many of their religious beliefs," Mary said, "and, therefore, we don't dare show medicine bundles for instance, or Zuni War Gods."[60] Pressed further, Mary suggested she might be okay with repatriation if the items went back to tribal museums with professional storage facilities.

The interviewer seemed surprised. "A great many of the things in your collection I'm sure," she said, "would not have been preserved had you and Mr. Crane not been interested in collecting them."

"I just don't think it's something that can be quickly answered," Mary said, her final words on the subject. "It has two sides to it."

Mary's response suggests her own ambivalence about the culture clash that repatriation claims had sparked. She believed unwaveringly in the mission to preserve Native American objects, which she had set out for herself. Everything in Mary's life affirmed the value of her collection. And yet even Mary could understand Native interests in protecting their own culture from outsiders like her. But Mary could not offer a solution for the collision of worldviews her collection provoked. Like the Denver Museum staff who inherited the legacy of her judgments, during the height of the debates about the Zuni War Gods, Mary stayed silent, hoping to keep the collection intact and avoid the fray.

5. ALL THINGS WILL
EAT THEMSELVES UP

*Putting a War God under glass is not preserving culture. The way you preserve
Zuni culture is by using the War Gods in the ritual for which they were created.*

Edmund J. Ladd, Zuni tribal member and anthropologist[1]

*The Smithsonian Institution . . . could not in good conscience turn over any
objects without assurances that they would be afforded the care
and security required by modern museum practices.*

Report on the negotiations between Zuni and Smithsonian officials[2]

By 1991 the tide had turned. War Gods were coming home in waves.
The previous year, the Zuni governor wrote to hundreds of muse-
ums across the United States formally requesting the return of all
Ahayu:da. Then the passage of the Native American Graves Protec-
tion and Repatriation Act (NAGPRA) in 1990 legalized a process the
Zuni had already been using for more than a decade. Still, although
the Zuni had been the most successful tribe in history in getting back
stolen sacred objects, previous to NAGPRA, only forty-one stat-
ues, or about 20 percent of the War Gods in U.S. museums, had been
returned.

Prior to NAGPRA, many museum administrators remained

stubborn. Like James G. E. Smith, a curator at the Brooklyn Museum, who said that his museum would consider a repatriation request, but nevertheless warned, "We're not in the business of giving things away."[3] Smith, who was in charge of Stewart Culin's collection, suggested, "I think it has to be assumed that the museum collected things in good faith." A year after NAGPRA became law, the Brooklyn Museum, following a protracted negotiation, returned all of their thirteen War Gods. Within six years of NAGPRA's passage, thirty-two museums returned fifty-four Ahayu:da.[4]

The negotiations with the Smithsonian took nine years. The Zuni later described the museum's efforts as "genuine and well-intentioned," but they dragged on because of the comprehensive approach the museum took to their collection of religious objects. However, it ultimately proved unworkable; the Zuni religious leaders simply could not arrive at a consensus for such a wide range of materials.[5] In 1987 everyone agreed that the Smithsonian should just begin with the return of the two War Gods.

After the Smithsonian agreement, the War God campaign continued with the battle against Sotheby Parke-Bernet, which intended to auction an Ahayu:da that had belonged to the pop artist Andy Warhol. The Zuni blocked the sale with the help of the U.S. Department of Justice. The Warhol Foundation returned the War God to the Zuni, but the process drained the tribe's entire repatriation budget for 1987 and 1988.[6]

These efforts helped the Zuni achieve one of their early goals: to entirely stop the trade in War Gods. As T. J. Ferguson said in 1980, "The Zunis would prefer to render the war gods literally unmarketable. Every time a dollar value is placed on an object thefts are encouraged."[7] After the Warhol repatriation, a Sotheby's official flatly stated, "There is no market for Zuni war gods anymore. They are simply too much trouble to handle."[8] Perry Tsadiasi told me that now when he goes out to the old shrines, he sees all of the Ahayu:da there in retirement. "It never used to be like that," he said.

o o o

After six hours driving south on I-25, Joyce Herold and her new boss, the mustached and happy-go-lucky Bob Pickering, arrived at the Laboratory of Anthropology in Santa Fe, New Mexico. Along for the trip in the backseat were six War Gods. The Zuni had instructed the curators on how to pack the gods: they should only be handled by men; they should face a particular direction. Otherwise, the Zuni were simply happy to have them back.

Herold had persuaded administrators at the DMNS that the time had come to return its six Ahayu:da—the second biggest single collection, after the Brooklyn Museum. This decision was hard for a woman who had spent her adult life dedicated to museum collections. Herold was born in 1933, in rural Texas.[9] Her father was a Czech immigrant; her mother came from a large hardworking family of farmers. Herold escaped, she later recalled, the "quite class-ridden and of course racist-ridden" 1940s Texas with a full scholarship to the University of Colorado. There she met her future husband, who introduced her to Earl H. Morris, a legendary, pioneering archaeologist who quickly converted Herold to the field. She received her bachelor's degree, then master's at CU, with a focus on archaeology. After graduation, she was invited to work on a basketry collection at the Denver Art Museum. When the Crane Collection arrived at the natural history museum down the street in 1968, Herold visited Skip Neal, who was surrounded by unpacked boxes. She would spend the next thirty-seven years of her life curating this collection.

Herold had closely followed the Smithsonian mediation. As the Zuni negotiating team had correctly surmised, once this esteemed national museum decided to return the War Gods, others would follow. Herold was convinced by the Smithsonian's judgment and how NAGPRA's language matched much of the Denver Museum's own policies. And yet, even then, the Denver Museum did not start the process of returning the War Gods until early 1991, nearly four years after the Smithsonian repatriation.[10] When I asked Herold why the Denver Museum took so long to act, she couldn't give a full accounting. "We took no action for a long time," she admitted, "and

I can't explain that in any way except that NAGPRA was in process and there was a lot of 'wait until the guidelines are in place and we have the legislation and be guided by the legislation.'" In addition to the passage of NAGPRA in the fall of 1990, the Denver Museum's decision was sped up by the newly hired Bob Pickering. Now a senior curator at the University of Tulsa's Gilcrease Museum, Pickering told me that he didn't want to delay the return unnecessarily. "Part of my attitude," he said, "was if there are things that we have that are sacred to the tribe and they want it back, take it now."

The museum's trustees agreed and quickly approved the deaccession. The press applauded the Denver Museum's resolve.[11] An editorial in the *Denver Post* concluded, "The decision by the Denver Museum of Natural History to voluntarily return the war gods to the Zuni is laudable not only because it demonstrated proper professional conduct. It simply was the right thing to do, by any civilized standard." Although, with NAGPRA, the War Gods' return was now inevitable, Herold saw the museum's decision to move so swiftly after the new law as affirmation of the Zuni's moral arguments. "The actual repatriation of the Zuni war gods," she told me, "was a statement that there do exist materials that need to go back."

On March 19, 1991, Herold and Pickering found themselves formally dressed and standing before Perry Tsadiasi and five other Zuni representatives. Many museum officials found it easiest to travel to the Laboratory of Anthropology in Santa Fe, or just to mail a package there, as a staying point, where the War Gods could be picked up by a Bow Priest.[12] At the Laboratory of Anthropology, Pickering laid out the six War Gods on a long table. Tsadiasi examined them briefly then wrapped them in a cloth and offered a prayer in a low voice. The Zuni leaders signed a receipt for the museum's file and presented the museum representatives with a certificate of appreciation. A few photos were snapped. The Zunis exited the room, their path sprinkled with cornmeal. As the Zunis hastily left homebound, Herold was "struck by a sense of inevitability and completion."[13]

Pickering thought the transfer, he told me, was "very mechanical and very short." He felt good but remembered, "It just was sort

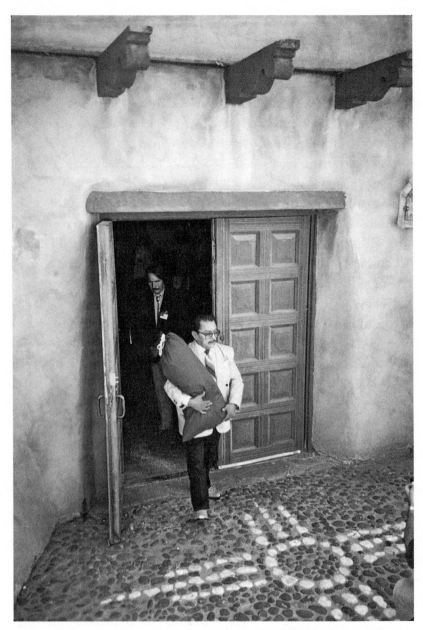

FIGURE 3. Perry Tsadiasi exits the Laboratory of Anthropology in Santa Fe with a War God. Courtesy of T. J. Ferguson.

of like two ships passing in the night, and then you go in different directions."

o o o

For their part, the Zunis often expressed their feelings of these exchanges as *tsemeti*. Sadness. Sorrow is for them the feeling that accompanies the repatriation process.[14] When Bow Priests went to New York to pick up the War God from Andy Warhol's collection, they told a reporter that they felt sad because the statue had been damaged during the theft or under Warhol's custody. "We feel sorry for him because he's been abused and misused," William Tsikewa Sr. said, "and there's no telling where he was."[15]

Octavius Seowtewa told me that the process of repatriation is disheartening because the War Gods are created so they can live in their shrine homes and maintain the balance of the universe. Recovery is only a weighty responsibility. Still, the process involves fleeting moments of happiness. "When I started doing this it was very sad to see them in museums," Octavius said. "But bringing them back is like having a family reunion together. I know that they are happy coming back and seeing some of their older brothers, their younger brothers."

Perry Tsadiasi also recounted to me several homecomings he could smile about. One time he had to leave the War Gods in the car, so he locked the doors but left the windows cracked so they could breathe. Another time he recalled how the FBI once swiftly escorted him through an airport, bypassing security, so that he could hand-carry a bundle of War Gods on the flight. The War Gods even had their own first-class seat.

"Did you order them drinks?" I asked.

"No. Not the drinks. Because we use them to pray for the rain, you don't give water to Ahayu:da. But I got them peanuts."

"Did you feel happy then?"

"Inside my heart real happy," he answered. "They are coming home. That is the way my feelings are, coming home."

When the first repatriations were planned, the Zunis faced a co-nundrum. There were no precedents for returning War Gods. They could not simply put a War God in any shrine. If one was taken from the northern shrine for the younger brother Ahayu:da everyone agreed it should go back there. To intermix the War Gods from different shrines might make them feel like strangers at home.

This is in part what inspired the creation of the new shrine that I visited with Perry. This shrine would be for the returned Ahayu:da where they would understand this shelter was made especially for them. The Zuni decided that the new shrine would have to be for-tified, to ensure that the gods were not stolen again, but open to nature so they could naturally decay. In the Zuni belief system, reli-gious objects are "ritually disposed of," meant to naturally disinte-grate back into the earth as "gifts to the spirits."[16] Zuni believe "that is the natural course of things, and the Zunis do not think humans should intervene in the process."[17] They insisted that even with their tireless conservation efforts, museums could not forestall decay for-ever. With time, wisdom says, everything perishes. "All things will eat themselves up," Zuni say.[18]

Such ideas fundamentally contradict the premise of museums. As Thomas Maytham said about the War Gods' eventual decay, "This possibility is antithetical to the entire philosophy of the mu-seum world: to preserve and protect art objects for the future."[19] He would have objected far less to DAM's repatriation, he said—an echo of Mary Crane's argument—if Zuni had wanted the War Gods to go back to a museum of their own. From this view, museum people saw themselves as the true protector of Zuni culture. Muse-ums spent countless hours and dollars on conservation—protecting their collections from enemies of time like insect infestations and light damage. "We in museums have cared for them and preserved them," James Van Stone, a curator at the Field Museum, once ar-gued, "and without our efforts they might have been lost."[20]

Perhaps no other point in the repatriation debates would so per-fectly capture the culture clash between museums and tribes. "In effect," one observer has noted, "the Zuni were entitled to destroy

the objects that the museums had so carefully preserved."[21] Or, said another way: the museums felt they were entitled to preserve what the Zuni had so carefully made to decay.

o o o

Zuni leaders have discovered that these conflicts, which seemed to have been mostly resolved by the early 1990s, were not fully resolved. Repatriation is a process without end, like driving in the fog, the distance to the destination unknown. It is untrue, as some newspaper headlines pronounced, that the "War Gods are finally at peace."[22]

Even the Denver Museum of Nature & Science had more to give back. In 2008 the anthropology collections manager at the Denver Museum was cleaning out some old files and discovered a tattered old envelope containing a feather, broken beads, slivers of wood, and a short frayed section of twine—parts of the War Gods, somehow forgotten and left behind after the restitution to Zuni in 1991. (Several weeks later, Octavius traveled to Denver to get them.) When the Harvard Peabody Museum first inventoried their collection, they did not identify any Zuni War Gods. Administrators later found one misidentified as a "carved Hopi (?) wooden post to represent a figure."[23]

Other gods have vanished like, and perhaps into, smoke. In 1990 Frederick J. Dockstader, a scholar and museum director, wrote from New York to the Zuni governor explaining that he had once proudly exhibited an Ahayu:da in his home entryway.[24] Dockstader explained that he sent it to a friend who admired the sculpture. The friend in turn got rid of it. "I believe it was burned," Dockstader could only say, "but I am not sure."

In the 1980s another War God was stolen from storage rooms of the Southwest Museum of the American Indian in Los Angeles during a slow poaching of the collections that reaped more than 100 pieces worth $2 million. The museum's director was later convicted of embezzlement and grand theft, but the FBI never recovered the

Zuni's sacred being.[25] In 1990 three Ahayu:da were stolen from one of the unfortified shrines.[26] The FBI couldn't trace those gods either.

In other cases, museums that have already returned Ahayu:da might still acquire new ones. Two decades after the Denver Art Museum first met with Zuni leaders, in the summer of 1999, they met again.[27] A few months earlier, the museum had received a bequest from the estate of Charles J. Norton, which included two Zuni War Gods he had apparently obtained before 1972. These Ahayu:da were also eventually returned.

Still other Ahayu:da are in known collections but remain unobtainable. These are beyond the jurisdiction of NAGPRA because they reside outside of the United States. As I would soon learn, it is clear that even thirty-five years after the first Ahayu:da's repatriation, the struggle goes on.

6. THIS FAR AWAY

*It is likely that the Zunis will not be successful in recovering Ahayu:da from foreign
museums. . . . Despite this, I doubt if the desire nor the need will decrease for the
Zuni to have all of the Ahayu:da home.*

Thomas LeRoy Larson, art historian, in 1989[1]

I struggle to breathe. The thick mask is tight around my nose and
mouth, thin air seeping in and out of a small respirator valve. At
least the mask conceals the room's odor of time and decay, stale and
chemical, like a hospital. Octavius Seowtewa and I were asked to
wear the disposable white masks because of all the hazardous preser-
vatives, like arsenic acid and paradichlorobenzene, which linger in
the museum's storage room. For our protection, we are also wearing
rubber surgical gloves.

"This way," the curator says in her Austrian-inflected English.[2]
She turns on the light, the darkened room cast in a bluish-silver
glow. Dressed in a clean white lab coat—the universal symbol of
a scientist at work—the curator leads us around the corner, to long
neat rows of wooden cabinets with glass doors. We walk halfway
down one row, stop, and see, on the top shelf standing next to sev-
eral ceremonial masks, a painted Ahayu:da.

When the curator opens the door, we suddenly notice not one
Ahayu:da but two of them. Octavius turns to me; his eyes flare in

surprise, then a wave of sadness washes over him. Confronted by the presence of these sacred spirit-beings, it hits him how abandoned and lost these Ahayu:da are here in Germany. Cached at the Ethnologisches Museum, the Keepers of the Sky are out of their element, divorced from the Zuni world. "Now they're here in different countries, surrounded by different languages," Octavius later confided to me. "Seeing them so far from home was heartbreaking."

During the interview with Octavius Seowtewa and Perry Tsadiasi in 2010, they told me how essentially every museum subject to NAGPRA with Ahayu:da had returned them. But they had heard some were outside the United States. I began to wonder: Exactly how many Ahayu:da lay in museums beyond the reach of U.S. repatriation laws? A research assistant and I compiled a list of 100 of the world's largest art and anthropology museums, and then sent out inquiries asking if they had any War Gods in their collections. Most did not reply. Many of those that did reply said no, or that they didn't know because they don't have full inventories of their collections. But six museums—in Berlin, Paris, Leiden, London, Norwich, and Oxford—answered yes. I bought plane tickets for Octavius and me to travel across Europe to discover exactly what these museums had.

The Zuni campaign for the Ahayu:da usually stopped at the U.S. border. The only international repatriations to date have been from Canada, when the Winnipeg Art Gallery quietly returned a War God in 1990, and the Museum of Anthropology, in Vancouver, voluntarily returned one in 1997, after several anthropologists visiting the museum had alerted the tribe to an Ahayu:da on display there.[3] In contrast, museums in Europe have been exceedingly reluctant to return anything.[4] Only in the last few years have European museums begun to return human remains (the first to the United States came in 2012). The return of sacred and communally owned objects has been limited to a few instances—a totem pole returned from the Museum of Ethnography in Stockholm to the Haisla First Nation in Canada (after fifteen years of negotiation), and several sacred items returned from museums in Scotland to Plains tribes.

One early morning in Berlin, Octavius and I take a train to the

suburb of Dahlem. After a few minutes' walk from the station, we approach the Ethnologisches Museum, a large building with Greek columns arrayed between arching windows. The building, crafted to look as if it had been there for centuries, belies the museum's itinerant history.[5] The collection's origins stretch back to 1794, when it was organized as the Prussian-Brandenburg Kingdom's Royal Cabinet. In 1873 the anthropological objects were separated to form the Königliches Museum für Völkerkunde (Royal Museum of Ethnology), which in several decades grew to then hold one of the world's largest anthropology collections.[6] The museum's operations were stunted during the two world wars, and after the second one, the Soviets took 55,000 objects to Leipzig, in Eastern Germany. After the fall of the Berlin Wall, the collection was reunited and renamed the Ethnologisches Museum, which entered a consortium of seventeen national museums run by the German state.

I push a buzzer at a side entrance. The door clicks open. Octavius and I ascend a wide creaking staircase. At the top we are warmly greeted by the Ethnologisches Museum's assistant director and by the curator who oversees the 30,000-piece North American collection. The curator explains that the Ahayu:da in the Berlin collection was likely made by Frank H. Cushing himself, who was initiated as a Bow Priest. She wonders whether this made the Ahayu:da "authentic." If not, why would the tribe want a "copy" back? Octavius answers that the knowledge to make the Ahayu:da is the intellectual property of the Deer and Bear Clans, not the Bow Priests. He also says that this Ahayu:da might still have power because it was made in the *likeness* of the real thing. He suggests that the preservation of even a "copy" undermines the purpose of the Ahayu:da, which is to live on a shrine so it can protect the Zuni people—not to be studied and put on display.

Despite the fact that the Ethnologisches Museum has yet to return a single cultural object to any Indigenous group anywhere in the world, the curator clearly thinks Octavius's appeal is persuasive. "You were the first in the United States," she says brightly. "Maybe you'll be the first here."

Later, in the collection storage room, Octavius studies Cushing's

Ahayu:da. Along with the War God is a box of offerings, a long tab-
let, and prayer sticks, all of which he deems authentic. Unlike any
other known Ahayu:da in a museum collection, this one is painted
like the real ones are when they are created. But Octavius notes sev-
eral irregularities, like the direction of the lightning bolt on top of
the head, the use of a red hawk wing feather instead of a tail feather
piercing the nose, the use of a commercial green paint, and what ap-
pear to be three chicken feathers shooting from the chin. The curator
pulls out a card from the catalog and translates the German for us.

This Ahayu:da has had a hard life. One of its feathers was broken
and glued back on; its necklace made of shell was stolen in 1958 (it's
unclear if it was recovered, but there is a necklace now, stapled—
presumably for security—to the god's body); the three feathers in
the chin were added by an overly enthusiastic curator sometime af-
ter 1979; and it was spirited away to Leipzig by the Soviets only to
return to Berlin in 1991 or 1992 after Germany's reunification.

Far less is known about the second Ahayu:da we found on the
shelves, an Ahayu:da deeply weathered, to the point of stark gray.
We're only told it arrived in 1976 from a Santa Fe art dealer named
Rex Arrowsmith.

After more discussion, the Berlin museum's staff was sympa-
thetic but increasingly discouraging. Any decisions would have to
be made at the highest levels of the national government since the
collections are owned by the state. The museum has never given
anything back. At stake for the museum are more closely guarded
treasures, such as dozens of Benin sculptures taken as war booty in
1897 and claimed by Nigeria, and a stunning 3,300-year-old painted
bust of Nefertiti, excavated by a German archaeologist in 1912, and
claimed by Egypt.[7] Even the most egregious cases of cultural theft
in Europe itself during World War II—resulting from the Nazis'
vast looting of private and public collections—does not always re-
sult of restitution.[8] Octavius received a similar warning in London:
any decision about repatriating the Ahayu:da would be shaped by
the British Museum's decades-long dispute with Greece over the
Parthenon Marbles, which Lord Elgin had appropriated in the early

1800s from the acropolis perched over Athens. Curators kept warning us that any claim from Zuni, no matter how straightforward or valid, could soon be entangled in larger global politics.

However, in a public statement, a British Museum official said these concerns were misplaced. "It is not about the precedent set, but about the fundamental purpose of the British Museum and its collection," a museum spokeswoman insisted. The museum exists "to tell the story of human cultural achievement from two million years ago to the present day," she said, and its trustees want the collection "to remain as a whole."⁹ This statement, at least, is consistent with the British Museum's formal policy for returning objects, which, reminiscent of the Denver Art Museum's position in 1979, refuses to even use the term "repatriation." The policy gives three narrow conditions in which objects may be transferred—if it is a "duplicate," "unfit," or "useless" because of damage to the piece. The policy goes on to explain that even most duplicate objects are worth keeping; that most objects will never be "unfit" or "useless"; and even if they are, it must be shown how disposing of them can be done "without detriment to the interests of students or the wider public."¹⁰ In short, the British Museum's deaccession policy provides not a justification to return artifacts but to retain them.

As we part ways, the Ethnologisches Museum's curator is friendly but cautious. "It's long way to go," she said, her smile fading. "I don't want to give you any hope. It will take time, before changes."

o o o

In France and England, Octavius is not given much hope either. The conversation repeats itself. Octavius explains why the Ahayu:da are needed at Zuni. Sympathetic museum administrators explain that there is little to no precedent for returning items. They warn that collections are owned by the state: any Zuni claim will become ensnared in national politics.

NAGPRA only applies to U.S. federal agencies and museums that have received federal funds. Although there are some inter-

national treaties that facilitate the return of cultural property, in the Zuni case, these are difficult to apply. For example, a 1970 UNESCO treaty—with the long-winded title of the Convention on the Means of Prohibiting and Preventing the Illicit Import, Export, and Transfer of Ownership of Cultural Property—is mainly implemented in the United States through bilateral agreements with particular countries. None have been established to address the fate of stolen Ahayu:da. Another international treaty, the 2007 Declaration on the Rights of Indigenous Peoples (DRIP), adopted by the United Nations, is also so far ineffectual for American tribes. In the spring of 2013, lawyers representing the Hopi Tribe tried to prevent an auction in Paris of sacred Hopi items, in part deploying Section 12 of DRIP, which affirms that Indigenous peoples have "the right to the use and control of their ceremonial objects" and that "States shall seek to enable the access and/or repatriation of ceremonial objects."[11] Although France voted to establish the treaty, the French judge hearing the case found that the pieces were "works of art" not "living spirits," and thus nothing in the law prevented the auction from proceeding.[12] In the end, sixty-five sacred objects were sold for US$1.2 million.

While we were in Paris, Octavius and I were invited to the U.S. embassy, an elegant mansion flanking the Champs-Élysées. There we met with Ambassador Philip Breeden and his staff. Breeden said that the curators in France fear that Indigenous communities will start calling everything "sacred" to empty entire museums. He also indicated that the French felt secure in their role as self-proclaimed stewards of other people's cultures. Plus, he said, French laws protect the rights of the art market and museums over source communities. Europe, in other words, is like the United States was in the days before NAGPRA.

Only the Museum Volkenkunde gave Octavius hope. In Leiden, twenty-five miles southwest of Amsterdam, we met with Pieter Hovens. Twenty-three years earlier, Hovens had been hired as a curator and learned the museum held an Ahayu:da. When he checked the museum's documents, he found a letter from the collector ad-

mitting that the Ahayu:da had been "surreptitiously taken" from its shrine—essentially a confession that the wood image was stolen. In 1991 Hovens wrote a letter to the Zuni tribal council.[13] "Opinions varied widely," Hovens shared about the discussions with his staff, "but it was agreed that the statue would be part of the first group of artifacts to be considered for deselection." He hoped to return the Ahayu:da within several months.

Twenty-three years later, the Ahayu:da remained in Holland. The Zuni Tribe received Hoven's letter, but for lack of funds, the case was put on the back burner until eventually the burner was switched off and the letter was forgotten altogether. Now the connection has been remade, and Hovens has offered to help the Zuni navigate the numerous bureaucratic steps to have the Ahayu:da, which is the state property of Holland, to be returned. The fate of this War God is now in the hands of the Zuni Tribe, which must make a formal claim for Hovens to begin the process.

At the end of the meeting, Octavius makes the same request he did at every meeting: to be allowed to pray to the Ahayu:da. He takes a leather pouch from his bag, opens it, cups a handful of sacred cornmeal, mixed with tiny fragments of turquoise. Holding the offering, he tenders a prayer to the Ahayu:da, with the museum staff standing back, heads bowed, respectfully listening but not able to understand anything Octavius says. He concludes the prayer and scoops up the offering. He will find a river to place it into before we leave Europe. "Putting the offering before the Keepers of the Sky and then in the river reconnects them," Octavius explains to the staff, "links the single Ahayu:da to the others back home. Because all rivers are connected, the waterways are the umbilical cords that connect the whole world."

On our last day in Europe, Octavius and I wake up early to find the nearest waterway. We're in Amsterdam and don't have to go far to find a canal, which we're grateful for because our feet are blistered from so much walking during our trip abroad. The first canal we come across happens to be in front of the Rijksmuseum, the famous museum dedicated to Holland's artistic history. Octavius walks

down a small dock and stands perfectly still before the canal, his silhouette framed by the brilliant spring sun shimmering off the calm water. He stands there a long time, praying. Finally, he tosses the cornmeal into the canal, like sowing seeds in a field. He returns to where I stand. "Okay," he says, "it's done."

In the shadow of the museum, I ask Octavius what he prayed for. He says that he thought about the abundance of water here in Europe and the need for the blessing of rain at home. He also appealed to the Ahayu:da. "My prayer is for them to still protect the world," Octavius says, looking pensively across the street, out at this foreign country, the sleek tram speeding by and the bicycling cosmopolitans, scarves fluttering behind them. "I told the Ahayu:da that even though they are this far away, they are not forgotten."

o o o

Back in the Pueblo of Zuni, Octavius Seowtewa tells me to go wait by the bridge, where I'll see people gathering to welcome the kokko, the ancestral spirits also known as kachinas, as they enter the village for a ceremonial. I sit for several hours in the summer sun, leaning against a fence. Waiting, my skin roasting, I contemplate how this afternoon I will witness what all of the struggles for the Ahayu:da have been for—for the endurance of Zuni culture.

The sun settles to the horizon. Zunis begin to congregate. Old and young, men and women. People are smiling, happy. Many of the men wear sneakers and T-shirts advertising pro sports teams, but also traditional Zuni headbands with a thick knot framed to the side and leather pouches holding the cornmeal offerings slung over their shoulders.

Several hundred people have gathered when I hear the faint sounds of the spirits approaching on the wind. The kokko arrive in a single file, led by principal religious leaders. These particular kokko spirits wear kilts and body decorations, but are most distinctive for the silky black hair descending from their faces to their waists like a dark monsoon rain. Many are barefooted; they will dance through

the cold night and into the next day on hot sand. They will not eat for many hours, just dancing and singing, which for Zuni is really just praying and praying. The dance is a prayer for the blessing of rain and moisture in this high desert.

The line of kokko draws near the old village's outskirts. The crowd turns quiet, reverent, then parts to make way for the kokko. The Zunis reach out and gently brush the shoulders of the spirits, welcoming them. The kokko follow a trail of cornmeal and turquoise laid before them. They pause for a song outside the village, along the main asphalt road, next to centuries-old houses crowned with satellite dishes.

I stay on the bridge, far away from the crowd. But I can hear their song, the forceful voice of dozens of kokko singing in unison. Through the crowd I occasionally see the bobbing heads of the kokko dancing and the blur of spinning bullroarers, a wood slate that is spun on a string to make a deep whirring sound. The song ends and the crowd disperses. Some Zunis return to their homes. Others follow the kokko as they enter the village.

I follow one group to a plaza, where we wait for the kokko to arrive. An elderly man approaches me and politely asks that I remove my baseball hat, in respect. After thirty minutes of waiting, I get a call from a Zuni friend inviting me to dinner. I delay for another few minutes, in the hope of catching at least a glimpse of the dance. But the kokko don't arrive, though I can hear them singing in a nearby alley. I decide I better leave for dinner, disappointed.

But as I walk through the early night, the first stars sparkling through the violet firmament, I reflect on how anthropologists have so often, so long come here to intrude upon Zuni culture in the desire to take some precious object away. I suddenly feel good knowing that I have come and left Zuni culture to the Zuni. My time at Zuni can be spent enjoying a shared meal, finding common ground—not plotting an anthropological conquest. Unlike those before me who came away with War Gods and other prizes, I would not even see the kokko but from a far distance. I would take nothing back with me.

II. REGRET

A Scalp from Sand Creek

7. I HAVE COME TO KILL INDIANS

Gordon Yellowman and I drive slowly down a lonely country road in central Oklahoma. "Park up there," he tells me, pointing to a low hill. I turn the car into the open field. Even though I'm following his directions, I feel uncomfortable parking here on the trimmed grass, just a dozen feet from the first row of graves.

A fitting day to visit the dead, I think, as I step from the car into the overcast afternoon. Gordon's slate Oxford shirt, dark skin, and silver-streaked hair blend into the charcoal sky. The heavy, moist air is cut by a stiff breeze. I'm struck by the lingering quiet of this spot in Concho, on the Cheyenne and Arapaho Reservation. Just a low melody of singing insects and the rustling of leaves from a stand of trees lining the nearby creek.

We walk into the field, wandering among a handful of scattered graves. "Tribal members can bury their loved ones here for free, if they can't afford to pay the $800 for a plot in town," Gordon nearly whispers in his measured southern twang. Many graves are marked with little more than a knee-high cross and a bundle of plastic flowers. Some have simple, squat marble tombstones. A few are mounds of dirt encircled by mismatched cobbles painted white.

The graves of the massacre victims are different.

Instead of the usual cemetery rows, they are set in a large circle. Gordon explains that the eighteen graves are evenly spaced out like posts in a massive, invisible tipi. At one side is the place of honor in

the tipi, where a scalp, claimed to have been sliced from the head of Chief White Antelope, was buried. The tombs have nearly been swallowed by the earth. We could have easily missed them except for the broken ring of small, fluttering American flags—one over each grave, a complicated symbol of patriotism when the U.S. military was responsible for these deaths—left here by the groundskeeper.

"It wasn't supposed to be like this," he says, staring downward, a shadow darkening his usual affability. The remains were brought here from far away so they could be regularly visited, the graves a memory made tangible, for tribal members to remember what their ancestors had endured. Instead, the gravestones are cracked and crumbling, covered by a thick matting of wilted cut grass. No one would know by looking at these graves their tragedy, or their importance in bringing a basic human right to all Native Americans.

The gravestones are two tablets, horizontally laid, above each set of remains. The larger tablet is close to square and has abstract symbols engraved by an artist when the remains were buried six feet below twenty years before. The smaller tablet is rectangular and offers an epitaph, what little is known about each victim, gleaned from sparse museum records.

Using the side of his Nike sneaker, Gordon gently scrapes away the shell of stiff, dried grass from one gravestone. We read together in silence:

Cheyenne Male
1864
Sand Creek

o o o

This is how the massacre began. Nearly 700 soldiers of the U.S. Army under the command of Colonel John Chivington, galloping in the early dawn like a stampeding herd of buffalo, tendrils of thick clouds heaving from the mouths of men and horses in the icy air, charging toward the sleeping village of Cheyenne and Arapaho.

Possessed by a wild fury, the soldiers' hearts beat faster when they saw on the horizon the scores of buffalo-skin tipis huddled at a gentle bend along Sand Creek.[1]

The leader of the Cheyenne, Black Kettle, awoke to the thundering cavalry. In a panic, he leapt outside and saw the gathering force, stopped at the village's edge. Black Kettle ordered the longest pole that could be found to be brought to him and then raised a thirty-three starred American flag, to show that the Cheyenne and Arapaho in the village were under the protection of the United States government. Beneath it was a smaller white flag as a sign of surrender. Black Kettle quickly conferred with the chiefs Left Hand, Standing In The Water, and White Antelope. Many would later recall the flags quivering in the winter morning wind as the chiefs walked toward the mounted soldiers.

For several years before that morning, Colorado had been at the precipice of Manifest Destiny, the exact point where America's dreams of westward expansion crashed into the reality of Native American nations who bore no willingness to relinquish their lands or ways of life. The Cheyenne and Arapaho—buffalo hunters, traders, warriors of the Great Plains—stood in the way of a mighty country that had resolved to unite its Atlantic and Pacific coasts.

An 1851 treaty promised eastern Colorado and parts of Wyoming, Nebraska, and Kansas to the Cheyenne and Arapaho. But ever since the gold rush of 1859, thousands of men flooded the Rocky Mountains and its broad eastern plains, turning a dusty camp along the Platte River into the raucous Denver City. New trails cut through tribal lands. The ancient migration routes of the buffalo were interrupted. Congress dispatched ever more military forces to pacify rebellious Indians. By 1864 Coloradoans and tribes like the Cheyenne and Arapaho were in the grip of a mutually reinforcing cycle of fear and anger and murder. Americans newly settled in the West welcomed, even begged for, the wholesale slaughter of all Indians.

At Sand Creek, as the chiefs approached the soldiers, the first bursts of gunshots cracked. Colonel Chivington ordered the howitzers unleashed. The artillery boomed. The cavalry swept in amid

screams and chaos. The Cheyenne and Arapaho fled, most scrambling to escape up Sand Creek to the north. The Indian warriors formed a fragile battle line, their weapons occasionally finding their mark. Most of the sixteen American soldiers who died, though, were killed in their own crossfire.

Chief White Antelope, an old man and wearing a peace medal, a token of friendship President Abraham Lincoln had given him to wear around his neck, ran directly toward the soldiers. "Stop!" White Antelope howled in English, "Stop! Stop!" Then he halted before them with his arms folded to show he would not fight. The soldiers shot him down.

Others huddled under Black Kettle's flags in the false hope that these symbols of peace would afford protection. Women ran toward the soldiers with hands raised. They were all shot down. One group of women and a few men found a hollow and cowered there. They sent out a six-year-old girl carrying a white flag. But the soldiers shot her, too, and then all of the others in the hollow, who, offering no resistance, were consumed by death like parched grass in a wildfire.

The causes of the massacre were many, but the fuse was lit by the Hungate family's gruesome murder. Outside Denver, the rancher Nathan Ward Hungate, his wife, Ellen, and two golden-haired daughters were killed during a stock raid. Nathan's body was found peppered with bullets, and the rest of the family mutilated and thrown into a well. Some blamed a Northern Cheyenne chief; others blamed Arapahos. But who actually killed the Hungates is unknown and unproven, and irrelevant anyway since the actions of just a few Indians could be used to justify punishing them all. To further stoke the flames of hate, the murdered family was put on display in Denver. "The bodies were brought to town and placed in a box, side by side, the two children between their parents," one settler remembered, "and shown to the people from the shed where the City Hall now stands."[2]

After the Hungate murder, Colorado governor John Evans issued a decree to kill all hostile Indians. This was the realization of

a plan long brewing in Colorado. "Shall we not go for them, their lodges, squaws and all?" the editors of the *Rocky Mountain News* proclaimed in 1862, just a year after the Territory of Colorado was founded. "We support a few months of active extermination against the red devils."[3]

The man most responsible for the bloodbath, Colonel John Chivington, would insist all his life that the killing was justified. "Chiv," as he was called, was not dashing. A rangy beard. Thinning hair. He was, one contemporary said, "hardly short at six foot four, two hundred sixty pounds, barrel chest, and neck of a mature male bovine."[4] But he was a born leader, a former Methodist pastor, an ardent abolitionist, a Civil War hero. Shortly before Sand Creek, Chivington ran for the U.S. Congress and declared a straightforward and popular Indian policy to "kill and scalp all, little and big."[5] He raised the Third Colorado Regiment of volunteers and promised to let them spill blood.

In midsummer 1864, Denver was in hysteria. Indians were supposedly on the warpath, marching from the north and east, like a scene from the fall of the Roman Empire, the savages at the gates of America's western outpost of civilization. "Denver was to be sacked and burned," the historian Robert L. Perkin recounts. "Governor Evans slapped a 6:30 p.m. curfew on all business houses and ordered every able-bodied man to assemble daily for drill."[6] However, by the end of September, glimmers of peace could be imagined. Cheyenne and Arapaho chiefs—including Black Kettle, who had long advocated for concord—came to Denver seeking an end to the interminable war. The failure of their overture was a warning of the waiting catastrophe. Governor Evans explained that only the U.S. Congress could give them a treaty, and, anyway, he privately knew Colorado's long-term prospects were better if there was war. Only then could the territory be cleansed of its Indian problem. That is, its Indian population. "What shall I do with the Third Colorado Regiment if I make peace?" Governor Evans rhetorically asked when planning for the peace conference. "They have been raised to kill Indians, and they must kill Indians."[7]

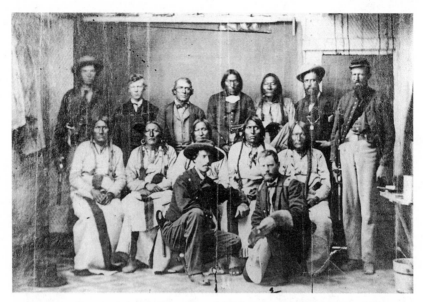

FIGURE 4. Group portrait of the Camp Weld Council in 1864, with Black Kettle seated in middle row, third from left. Courtesy of the Denver Public Library, Western History Collection, X-32079.

After the failed peace talks in Denver, the Cheyenne and Arapaho went on to Fort Lyon in southeastern Colorado. They gave up their guns and were given food in exchange at the garrison. Encouraged to find a quiet spot to repair, Black Kettle moved his village some forty miles to the northeast, along the trickling waters of Sand Creek, and was joined by a band of Arapaho, to settle in peace for the winter. Meanwhile, Chivington pressed his Third volunteers through snow toward Sand Creek. The colonel knew exactly where Black Kettle had located his people. He knew they would be easy targets. He gathered more troops and ordered them to ready for battle. "I have come to kill Indians," he said, "and believe it is right and honorable to use any means under God's heaven to kill Indians."[8]

The attack unfolded without much order, though it proceeded with the calculated logic of genocide. As Major Scott J. Anthony recalled, a three-year-old child was left behind, naked, trying to run after his family.[9] A cavalryman dismounted and shot at the child, missing.

"Let me try the son of a bitch," a nearby solider swaggered. "I can hit him."

He shot wide, too.

A third soldier stepped forward, insisting he could do better and fired his rifle. The child collapsed to the ground, dead.

Some of Chivington's men would later recall November 29, 1864, not as a lopsided massacre but a glorious battle. "They opened the fight," Captain John McCannon reported. "After the onslaught the Indians ran to their rifle pits and began firing in on us with great rapidity. The arrows flew lively, let me tell you, and the air was just filled with them—they looked just like little blue streaks."[10] The *Rocky Mountain News* embraced this version of the "battle." The members of the U.S. Army, the newspaper reported, "who collectively 'cleaned out' the confederated savages on Sand Creek have won for themselves and their commanders, from colonel down to corporal, the eternal gratitude of dwellers of these plains."[11]

The bullets somehow missed Black Kettle in the opening volley. He grabbed his wife and ran. She was struck by a bullet and fell, the cavalry riding over her and shooting her eight more times. Black Kettle reached her again and carried her to safety, up a ravine. They miraculously survived, along with dozens of others who hid until nightfall in the banks of Sand Creek or took flight across the frigid open plain. The escape into the night was miserable. Frozen blood covered dirty wounds. They couldn't risk fires for warmth or light. Most were without clothes or shoes. Without food or water. All slowed by the injured, the young and the old. No one could return to Sand Creek to bury the dead.

8. THE BONES BILL

*A Cheyenne elder told us our nations couldn't heal and couldn't regain
our strength and we as individuals couldn't heal until we recovered
our dead relatives from these places.*

Suzan Shown Harjo (Cheyenne/Muskogee), American Indian activist[1]

*We rifle their graves, measure their skulls, and analyze their bones. . . .
Nothing is sacred to us; and yet nothing to us is vile or worthless.*

**Daniel G. Brinton, 1895, anthropologist and president of the
American Association for the Advancement of Science**[2]

John Melcher had spent his life climbing Montana's political lad-
der. He started at the low rung of Forsyth city council alderman in
1953 and didn't stop climbing until he was elected to the U.S. Senate
in 1976.[3] In his service to government, Melcher learned a thing or
two about Native Americans. His state of Montana is today home
to seven federally recognized tribes. In the Ninety-Sixth Congress,
Melcher served on the Select Committee on Indian Affairs.

One day in early 1986, a call came into Melcher's office from Wil-
liam Tallbull, a Montana constituent and a Northern Cheyenne el-
der. Tallbull wanted to visit the Smithsonian's National Museum of
Natural History.[4] He had long been searching for a sacred bundle,
which was taken in 1869 when his grandfather, Chief Tall Bull, was

killed by U.S. Army soldiers and their Pawnee scouts after the chief had kidnapped two women in Kansas. The bundle was needed for the sacred rituals of the Northern Cheyenne's Dog Soldier Society. Tallbull had found some U.S. Army records that led him on a trail to the Smithsonian. That spring a Melcher staffer of Cheyenne descent, named Clara Spotted Elk, helped facilitate a visit by Tallbull and a group of chiefs and relatives to the museum.

During the visit, Tallbull found one of the important parts of his grandfather's bundle, the stem of a sacred smoking pipe. Elated with the discovery, the Cheyenne delegation was leaving the museum when they happened to pass a massive set of floor-to-ceiling cabinets. Someone guessed aloud that they probably held a lot of Indian stuff.

"Oh," a curator escorting the guests replied, "this is where we keep the skeletal remains." To be exact, the curator explained, the avocado green cabinets—custom built nearly a century before by the anthropologist Aleš Hrdlička—held the human remains of 18,500 Native Americans. The Cheyenne chiefs suddenly realized, as so many Indian leaders would in the years to come, that the "Smithsonian Institution is the largest Indian cemetery in the country."[5] "Everyone was shocked," Clara Spotted Elk later recalled. "The chiefs were quite alarmed because we had been sitting there all day with those restless spirits. So we really beat it out of there."

Tallbull marched back to Melcher's office, alerting the senator to his discovery of Hrdlička's cabinets brimming with Indian dead. Melcher was outraged. "I was just absolutely shocked to find out that the Smithsonian had a bunch of bones stored away in the attic," Melcher remembered. "I think it is highly disrespectful to treat the dead as curios and is contrary to all the values I hold dear."[6] Melcher didn't hesitate. "I'll do what I can," he promised Tallbull. The senator then set out to navigate the tribal politics of the U.S. Congress.

The first draft of Melcher's "Bones Bill," as it was informally called, was titled the Bridge of Respect Act. "The museums say, 'We own the stuff.' The Native American tribes are saying, 'No, you can't own human remains,'" Clara Spotted Elk explained. "It is a

classic example of two cultures clashing."[7] Melcher introduced the legislation on the last day of the Ninety-Ninth Congress in 1986, in order to initiate a dialogue on the issue. In the end, it would take four years and sixteen different numbered bills before a national repatriation policy could be established.[8] The stalemate would not be broken until the sudden discovery of five skulls taken from the massacre site of Sand Creek.

o o o

The story, now near myth, of Tallbull's discovery and Melcher's revelation are only two moments that explain why the repatriation debates took hold in the U.S. Congress. In fact, for more than a century, Native Americans had objected to the disturbance of their ancestors' burials. But it was not until the tumultuous 1960s that Native Americans began to work together, to demand the same kinds of equal rights lobbied for by women, African Americans, and other political minorities. Within a decade, Native Americans were regularly conducting sit-ins at museum exhibits, interrupting archaeological digs, and demanding the return of their ancestors. What had been a faint protest for much of the twentieth century rapidly coalesced into a pan-Indian movement and a national question demanding an answer from the American conscience.

For example, on September 27, 1971, about forty members of the American Indian Movement—the infamous militant organization advocating for Native American rights—burst into the Department of Anthropology's offices at Colorado State University.[9] Led by an Ojibwe activist named Clyde Bellecourt, the members of Denver's AIM chapter tried to serve a citizen's arrest to an anthropology professor and eleven students for the grave-robbing of burials excavated on a ranch nearby. Bellecourt demanded that the anthropologist stop all digging and surrender any Native American human remains. The AIM protestors then found a laboratory with skeletal fragments, grabbed them, and ran from the building after scuffling with the professor and a campus security guard. The professor later

said that the remains taken were animal bones and teaching skeletons of non-Indians. After a week of impassioned discussions, the activists returned the bones to the university.

This was not the first time Bellecourt, who had co-founded the American Indian Movement in 1968, used brash tactics to challenge archaeology's unfettered access to Native American human remains. Just several months earlier, Bellecourt and other AIM members "invaded" an archaeological excavation near Welsh, Minnesota.[10] The ancient Indian village, about 500 years old, was being excavated by a large group of students. The activists filled trenches, took shovels, and burned field notes. Bellecourt offered to compensate the students for the stolen equipment but insisted that the excavations end.

"I do not endorse destruction of property," Vernon Bellecourt, Clyde's brother and the AIM national director, explained, "but I say to you, if to destroy a small amount of your possessions is the only way to make you listen, then maybe it is time we made you listen!"[11] Such protests were part of a national movement that was gaining momentum.[12]

Native Americans accused archaeologists of colonialism.[13] They charged American museums with racism, in collecting mostly Indian remains and in placing Indians in natural history museums next to dinosaurs and dodos. They were bewildered over why, if human remains were so scientifically valuable, the graves of other ethnic groups were not equally disturbed. They questioned why, under the Fourteenth Amendment, the Constitution did not provide them equal protection under the law. They pointed out that the intellectual freedom of anthropologists threatened their religious freedom—their cherished beliefs of culture and the spirits of their ancestors. They said that their ceremonies could not be held or revived without the return of sacred and communal objects in museums: their culture was dying. They saw this battle as an expression of their human rights, the right for everyone to rest in peace and the near universal right of kin to care for their own dead. They expressed dismay at the spiritual consequences of museum work;

many blamed the social unrest across reservations on the restless
souls in museums.

Panicked museum officials around the country began to remove
remains from display. Some even began to quietly return them.[14] In
Iowa, the Mathias Ham House museum returned remains for re-
burial; in Oregon, the Clatsop County Historical Society returned
the skull of Chief Comcomly to the Chinook Indian Nation in
Washington; in New York, the Lewis County Historical Society re-
turned a skeleton at the request of a Mohawk chief.

Staff members at the Denver Museum of Nature & Science fol-
lowed these events. The head of exhibits, Arminta "Skip" Neal, was
ready. When the Crane Collection came to Denver in 1968, Skip,
who had been at the museum for eighteen years, was put in charge
of the new exhibit hall.[15] Because her background was in fine arts,
Neal went back to school in her fifties to secure a master's degree in
anthropology. She was as protective of the collections as a mother
over her brood and had resolved to keep the human remains at the
museum on display until a formal objection was offered. It soon
came.

One day in 1970 an AIM representative called the museum and
threatened the Denver Museum unless it removed a skeleton on dis-
play and handed it over to him for burial. The skeleton was that of a
thirty-five-year-old ancestral Pueblo woman, buried 800 years ago,
who had been discovered mummified in an Arizona cave, wrapped
in rabbit skin and cotton blankets.[16] Later Neal said that she had felt
the request was "kind of silly," that the AIM members were "just
out for publicity."[17] She admitted that as a white Anglo-Saxon
Catholic woman, it was hard to fully grasp what was at stake for Na-
tive community members. "It's very, very difficult for anyone," she
said, "no matter how sensitive that they may hope they may be, to
put their head inside another culture." Still, Neal had once visited
the Mütter Museum of the College of Physicians of Philadelphia
and witnessed the display of the Soap Lady, a women exhumed in
1875, whose body became grotesquely encased in a fatty substance.[18]
The ghoulish experience pressed her to begin "to understand why

people say you're showing our ancestors as a piece of pottery." She could understand how "Indian people, who remember the really hard times, the really early reservation days, are sensitive to having their kin displayed, you know, kind of naked, you might say, in a museum."

Neal knew the telephone call had just put the museum in a difficult situation.[19] Within five minutes, she ordered the skeleton back in storage. The exhibit window was covered with brown wrapping paper and a statement that the remains were off display at the request of the American Indian Movement. Members of AIM continued to call, however, seeking the mummy's reburial. Neal refused, explaining that the mummy was on loan from the Arizona State Museum and so not owned by the museum; it couldn't be handed over. Eventually, the calls stopped. Neal established a museum policy that no Native American human remains would be put on display, without the permission of Denver's Indian community.[20]

The call also helped prompt Neal to create the museum's Native American Advisory Council in 1973. The council formalized a partnership with the Denver Indian community, "who wanted the exhibits to display the continuity between their ancestors and themselves with dignity and respect."[21] When Crane Hall opened in 1978, it included a photography exhibit on the urban Indian experience, and numerous lectures on contemporary political issues. The council was coordinated by Patty Harjo, who was of Seneca and Seminole ancestry. Harjo was just one of several Native Americans then employed by an American museum.

Despite these positive changes, the museum still did not alter its core policies on collecting human remains. On the same day that Denver's AIM chapter took over the anthropology department at Colorado State University in 1972, the city and county of Denver coroner wrote to Denver Museum staff.[22] The coroner had excavated an Indian skeleton and wanted to release it to the museum on one condition. A week prior, an activist had asked for the remains for reburial. The police had ably deflected the request. "The group is not aware of where the material is," the coroner wrote, "and we will

not apprise them of this fact should they recontact us." He wanted to ensure the "archaeological value of the material" was preserved. The bones quietly came to the museum and were accessioned as A786.2A-D.

The attacks on anthropology and museums provoked a fiery defense.[23] Scholars argued that constraining research because of religious beliefs restricted *their* right to freedom of speech.[24] They insisted that archaeology benefited Native Americans by understanding their history through scientific methods and sharing the results in public museums. They suggested that if anthropologists hadn't collected so much, then most of Indian material culture would have been destroyed. They worried that repatriation would empty museums, ruining one of Western society's great institutions.

A good number of anthropologists presented themselves as the true keepers of American Indian history—even more than the Indians who seemed bent on destroying the history of their own ancestors. Repatriation and reburial, by their very nature, meant that the world's scholarly community would no longer have access to these precious historical resources. Some defenders argued that they alone dispassionately understood what was in the best interest of American Indians. Few if any Native Americans then held a PhD in archaeology. Few tribes had museums of their own. In one letter to the editor in the scientific journal *Nature*, E. J. Neiburger claimed, "This loss to the world, caused by greed, ignorance, and shortsighted zealotry, will unfortunately harm the very people it is meant to help."[25]

Museum professionals contended that archaeological resources, including human remains, do not belong to any one group but are of universal value, the heritage of everyone. They asked how a person today could legitimately claim a kinship to someone who died 1,000 or 12,000 years ago. They said reburial was like book burning: that in human bones is knowledge, and thus destroying bones is destroying knowledge. "If Native American collections were gone," one professor of anthropology argued, "it would be comparable to losing a

major section of the Library of Congress."[26] Another declared that
reburying a skeleton "is akin to taking an unread manuscript and
throwing it on a fire."[27]

A minority of anthropologists and museum professionals bravely
spoke up to advocate for Native American rights.[28] In turn, some
tribes showed their willingness to engage archaeologists. Even
some of the most resolute Native advocates—such as Walter Echo-
Hawk, Bob Peregoy, Suzan Shown Harjo, Jan Hammil, and Maria
Pearson—met with archaeologists to talk about the possibilities of
compromise and cooperation. As early as 1967, anthropologists fa-
cilitated an agreement with the Nez Perce, in which the University
of Idaho would fully analyze any graves disturbed during projects,
and then the human remains would be reburied (funerary objects
could either be reburied or kept at the museum, as the tribe chose).
The next year, a group of archaeologists tried (and failed) to submit
a resolution at the Society for American Archaeology annual meet-
ing "expressing the need for greater respect of American Indian
wishes."[29] By the 1980s, a second generation of archaeologists sym-
pathetic to Native concerns emerged. Many of these scholars were
even employed by tribes, which had created their own archaeology
programs.

The promise of these efforts was largely eclipsed by the seeming
majority of anthropologists who condemned repatriation as "scien-
tifically indefensible."[30] Several even filed lawsuits to stem the rising
tide of return. "All that wandering souls stuff is dramatic for the
media," an anthropologist in New York complained. "We're doing
important work that benefits all mankind, and we're portrayed as
grave robbers."[31] These were the archaeologists who said, "The only
good Indian is an unreburied Indian."[32]

Academics collectively saw repatriation as the triumph of reli-
gion over science—the victory of irrational beliefs in a "demon-
haunted world."[33] For them, it was anthropology's own chapter of
the Culture War sagas—political correctness leading to anti-science
policy.[34] The repatriation debate was just the creationism-evolution
debate veiled in buckskin. "The whole history of science," the an-

thropologist Frank Norwick contended, "is a fight against religious darkness."[35]

They also noted that many sites were excavated with American Indian laborers who had never before complained much. "As late as the 1960s," the archaeologist Philip Walker maintained, "Inuit people in the Northwest Territory of Canada, with whom I worked, seemed little concerned about the excavation of ancient skeletal remains. In fact, they were extremely cordial to the members of the expedition I was on and assisted us in any way they could."[36] (Although, Walker allowed, they did express "mild concerns about carrying human skeletons in their boats.")

After a scientist was charged with a felony while carrying out an environmental assessment (he allegedly didn't contact the coroner when he first found human remains), some defenders of science took to pasting bumper stickers on their cars: *Archaeology Is Not a Crime*.[37]

o o o

Shortly after a heated congressional hearing on July 20, 1989, about the need for a national law on repatriation, a dinner reservation was made at the Coyote Cafe in Santa Fe, New Mexico—a fateful choice given that in many Native American traditions, the coyote is a trickster.[38] That day pointed testimony came from Native leaders and scientists alike, but the Secretary of the Smithsonian, Robert McCormick Adams, felt that a compromise for the country's first repatriation law was drawing near. As Smithsonian Secretary, Adams was in charge of thirteen national museums and the National Zoo. As an eminent archaeologist, Adams was particularly invested in the outcome of the repatriation crusades.

By the late 1980s, almost every museum in the country had taken Native American human remains off of display.[39] Some institutions had even gone further. The University of Michigan, the University of Washington, Stanford University, the Field Museum, the Smithsonian, and others had all collectively given back hundreds of skeletons (although many of them kept thousands more). On one

project, the Arizona State Museum gave control over remains to To-
hono O'odham political and religious leaders, who requested basic
studies to be completed before reburying them. Archaeologists in
North Dakota returned about 14 percent of the state's collection—
twenty-four boxes of bones—to tribes for reburial without scien-
tific analysis.

There still was no uniform national law to protect American
Indian graves.[40] But Secretary Adams, like many close observers, also
saw that there was growing outrage over unrestrained looting of
sites, and that nearly half the states had already passed laws to grant
equal rights of protection to Indian burials.[41] In May 1989, Nebraska
even passed legislation that required state-sponsored museums to
repatriate identifiable skeletal remains and associated funerary ob-
jects to tribes for reburial.[42] The museum and science representatives
increasingly understood that a national repatriation law was inevi-
table. The Smithsonian Institution had already opened the door to
repatriation with the return of the Zuni War Gods in 1987. "When
this came to the court of public opinion," Adams admitted, "we
were going to lose."[43] One poll showed that only 19 percent of re-
spondents were opposed to returning Native remains.[44]

And yet Adams faced intense pressure from his colleagues to de-
lay an agreement. Many feared that if the Smithsonian, as the coun-
try's largest museum, gave in to Indian demands, then all museums
would have to concede, and the repatriation wars would be lost.

In the hope of reaching an accord, Adams invited several high-
powered Native leaders to break bread in Santa Fe, including Suzan
Shown Harjo, who was then the president of the National Congress
of the American Indian, the country's largest pan-Indian organiza-
tion. Born in 1945 of Cheyenne and Muskogee descent, Harjo was
raised poor in Oklahoma.[45] A year before her thirtieth birthday,
Harjo moved to Washington, D.C., and became involved in fight-
ing for Indian rights, particularly for religious freedoms and land
rights. When the repatriation battles climaxed in the 1980s, Harjo
became an eager warrior. One of her first experiences with the is-
sue came one day when she was just a girl visiting the Museum of

the American Indian, founded in 1916 by George Gustav Heye, an
obsessive collector who gathered nearly 1 million Native American
objects. She recalled standing before one exhibit case and seeing
burial moccasins that her own mother had made, which somehow
had found their way here to New York City but were meant only
to be in a grave. "You do something about this, you tell them that's
wrong," Harjo remembers her mother telling her. "These things
should be given back to the people, they should be put back in the
ground."[46]

On her flight from D.C. to New Mexico, Harjo prepared for the
dinner meeting with Secretary Adams by reading several reports on
the Smithsonian's collections. Flipping through one, she was con-
fronted with a bill for a cargo shipment of human skulls. They had
been collected from Sand Creek.

o o o

General William Tecumseh Sherman wanted to see the site of the
Sand Creek Massacre. In 1868 he was on a tour of the American West
and was curious about the notorious tragedy. He was led there by
Samuel W. Bonsall, a second lieutenant stationed at Fort Lyon, Col-
orado.

When they arrived, Sherman ordered that all the men search the
area and collect anything of value. "He wanted to take the relics
back to Washington," Luke Cahill, an infantryman accompanying
the general, recalled in his recently discovered memoir. "We found
many things, such as Indian baby skulls; many skulls of men and
women; arrows, some perfect, some broken; spears, scalps, knives,
cooking utensils and many other things too numerous to mention.
We laid over one day and collected nearly a wagon load."[47]

Some of these remains were headed to the Army Medical Mu-
seum, a peculiar, macabre museum. Founded in 1862 in the midst
of the Civil War, Union medical officers in the field were ordered
"diligently to collect and to forward . . . all specimens of morbid
anatomy."[48] Initially, the main objects of study were soldiers killed

in battles between North and South. With Lee's surrender at Appo-
mattox, however, the museum began looking westward, focusing
on the fresh bounty of the Indian Wars. In 1867 the Army Medical
Museum officially formed a craniological collection, begun with the
skulls of 143 Indian "specimens." The next year the U.S. Surgeon
General ordered military personnel to "aid in the progress of an-
thropological science by obtaining measurements of a large num-
ber of skulls of the aboriginal races of North America."[49] The com-
mand noted that medical officers stationed in Indian country were
uniquely positioned to contribute to this undertaking, and encour-
aged them to "evince even greater zeal" in collecting for the mu-
seum. Stockpiling Indian bodies had become a national policy.

Some showed great zeal, indeed. Like a U.S. Army surgeon
named Z. T. Daniel. Stationed in Montana, Daniel would wait un-
til the cover of night to rob the graves of Blackfeet Indians. Daniel
knew that the Blackfeet would object to his activities and wrote that
he had "the greatest fear . . . that some Indian would miss the heads,
see my tracks and ambush me."[50] Daniel procured 144 skulls for the
Army Medical Museum.

Although it seems unlikely that Native peoples fully understood
the nation's new policy on collecting their bodies, they often tried
to prevent such thefts. In 1869, for instance, a U.S. Army surgeon
aimed to collect some heads of Pawnee warriors after a battle. "I had
already obtained for the museum the skull of one of the Pawnees,
killed in the fight," the surgeon wrote from Fort Harker, Kansas,
"and would have had all had it not been that immediately after the
engagement, the Indians lurked about their dead and watched them
so closely that the guide I sent out was unable to secure but one."[51] In
the end, though, most tribes couldn't stop the army of scavengers.

Over decades, thousands of bodies and funerary objects were
amassed from battlefields, prisoner camps, cemeteries, hospitals,
and archaeological sites—all part of the national project to gather
Indian bodies in the name of scientific progress. This formal project
of collecting Indian bodies merely extended a longer American tra-
dition. Since the first European settlers arrived in North America,

they understood their new country was covered in graves and earth-works of ancient peoples.[52] "America is the tomb of the Red Man," a scholar noted in 1846.[53] These were flattened as easily as the tide washes away sand castles to make way for new farm fields and towns, the bones and other relics often gathered and placed on mantelpieces as curiosities, and increasingly as part of scientific collections. En-lightenment ideals had shifted Western society's changing attitude toward the human body. With advances in medicine and biology, the body was no longer an organic enigma wrapped in a mysterious soul; it was hard evidence of environment, disease, adaptation, and heredity. "Depersonalized and desacralized, the body became data," the historian Robert E. Bieder has written. "It was redefined sym-bolically, politically, and scientifically and was seen more as a speci-men for observation than as the temple of the soul."[54]

The analysis of human skeletons fed growing debates about the hierarchies of race and the natural character of countries. When in the late 1700s a French naturalist claimed that North America was inherently degenerative and American Indians were "all equally stu-pid, ignorant, and destitute of arts and of industry," Thomas Jef-ferson responded by excavating a burial mound on Monticello to prove the equality of America.[55] These debates inspired a generation of "Craniologists," who measured and classified skulls to create a kind of map of personality, which, it was thought, could be read to discern intelligence and behavior of entire races.[56] The collections of skeletons allowed science to "prove," as Dr. George A. Otis, cura-tor of the Army Medical Museum, said in 1870, "that, judging from the capacity of the cranium, the American Indians must be assigned a lower position in the human scale than has been believed here-tofore."[57] Essentially, the insult of robbing Indian graves was com-pounded by the injury of science's racist conclusions about Indian character.

The craniologists' work inspired generations of Americans to ransack Indian sites to create "cranial libraries." Traders, settlers, sol-diers, Indian agents, and others were enlisted to gather Indian bod-ies from both ancient and recent graves. As museums became more

formalized as public institutions, collecting the Indian dead became a casual transaction. Louis Agassiz, among his generation's greatest scientists and the founder of the Museum of Comparative Zoology at Harvard, wrote to the Secretary of War in 1865 asking for "the bodies of some Indians" to be mailed to him express. "I should like," Agassiz requested, "one or two handsome fellows entire and the heads of two or three more."[58]

Samuel W. Bonsall perhaps saw himself as contributing to this movement of science when he collected at least two skulls from Sand Creek, likely in 1870, and had them deposited in the U.S. Army's museum.[59] "Crania from the Indians of Colorado are very rare and I need hardly assure you how much those you have sent are prized," Army Medical Museum curator George A. Otis wrote in 1870 in recognition of the donation, "and how glad I should be if you could send others."[60] He got his wish, with three more Sand Creek skulls sent by other U.S. assistant surgeons.

In 1904 the Smithsonian's National Museum of Natural History, which had just established a physical anthropology department, convinced administrators at the Army Medical Museum to transfer most of its Native American holdings. This included the skulls from Sand Creek.

o o o

By the time Suzan Shown Harjo's plane landed in New Mexico, she was so riled by the shock of the documents she couldn't wait to speak with Secretary Adams. These were her very own Cheyenne ancestors who had been plundered in the aftermath of one of the nation's most outrageous acts of unjust violence. Harjo telephoned Secretary Adams.

"Do you realize," she accused, "that you preside over an institution that has the heads of my dead relatives from Sand Creek?"

Adams was aghast. He hadn't known.

Enough was enough, Harjo decided then. She threatened to file a lawsuit against the Smithsonian to regain *all* of the human remains

in its collections. When Adams said he needed to check on a few things and hung up, Harjo felt she had irrevocably blown months of negotiations.

Instead Adams called back minutes later and agreed to Harjo's remaining terms for the proposed law. The final obstacle to the country's first federal repatriation law—the National Museum of the American Indian Act focused on the Smithsonian, with NAGPRA focused on all museums and federal agencies to follow the next year—had been overcome.

Later the two went to dinner at the Coyote Cafe, the trickster's work completed, joined by the Cheyenne senator Ben Nighthorse Campbell and the Pawnee lawyer Walter Echo-Hawk. The group relaxed knowing that the future of the Smithsonian—and soon all American museums—had been changed.

Harjo told the men around the table, "My ancestors from Sand Creek made this possible."

9. WE ARE GOING BACK HOME

Tom Killion was hired as the director of the Smithsonian's newly formed Repatriation Office but not especially qualified to run it.[1] When he applied for the job, Killion was three years out of a PhD program at the University of New Mexico, still looking for permanent employment in his specialty, the ancient archaeology of Central America. Luckily for him, it seemed that few qualified anthropologists wanted to risk their careers on repatriation. In late 1991, Killion accepted the Smithsonian post, moving directly to D.C. from Guatemala, where he was conducting research amid the country's brutal civil war. From one kind of war to another.

Before Killion's arrival, the Smithsonian Repatriation Office had just one staff member. She was readying for the flood of claims that were anticipated in the wake of the National Museum of the American Indian Act of 1989, which included provisions for repatriation from the Smithsonian's holdings. The museum had just conceded to a four-year-old claim for nearly 1,000 sets of human remains that Aleš Hrdlička had excavated on Kodiak Island, Alaska, in the 1930s.[2] As Killion settled into his new office, he found twenty more claims on his desk that needed to be addressed. Among the letters was one from the chairwoman of the Cheyenne and Arapaho in Oklahoma, asking "in the name of humanity" for the return of the "friendly Indians" killed at the Sand Creek Massacre.

"I thought the case was a no-brainer," Killion later wrote, "a non-controversial return that would quickly show progress."[3]

But any desire among the Smithsonian staff to act swiftly on the claim was soon confused by a second, competing claim. Less than a month after the first letter was penned, a group calling itself the Sand Creek Cheyenne Descendants of Oklahoma, Inc., wrote to Secretary Adams. This private group of descendants objected that the tribal government did not communicate with them about the repatriation effort of their ancestors from Sand Creek. The group argued that *they* were the proper recipients of the dead.

The conflicting claims—one by the official tribal government, one by a legitimate group of people directly descended from the Sand Creek victims and survivors—were difficult for the Smithsonian administrators to adjudge. In the fall of 1991, the United Indian Nations in Oklahoma tried to set up a meeting of all the parties to broker an agreement. The meeting was canceled when it became clear that the different sides were not willing to work together. Killion and his staff traveled to Oklahoma, consulting with all the parties to keep them informed of the Smithsonian's efforts. Still, no compromise emerged.

In May 1992, Killion and his staff finished their formal report on the Cheyenne remains at the Smithsonian. The museum's official position, citing its lack of experience and the complexities of the problem, was that it "would not attempt to engage in the resolution of the Cheyenne multiple claims in any way."[4] The victims from Sand Creek would remain skeletons in America's attic.

o o o

Killion later explained that the delay was necessary to the Smithsonian's effort to create a wholly new process of evaluating claims and negotiating with claimants. In those first years, the staff had a steep learning curve, an on-the-job trial to implement a radical new law within the constraints of a skeptical institutional environment, all while under intense scrutiny from all sides. The Sand Creek nego-

tiations, he added, were especially emotional. The hardest work involved consultation—the formal meetings and exchanges between the Smithsonian and the tribes. Killion has said how even this return, uncontested by the museum, "involved multiple meetings, false starts, a great deal of patient listening to the perspectives and expectations of the people involved."[5]

As 1992 turned into 1993, a third group wanted to make a claim: lawyers. Two different lawyers sought blanket powers of attorney from the Cheyenne so they could request the return of tribal sacred objects and ancestral human remains, including those from Sand Creek.[6] To obtain this authority, the lawyers contacted the Cheyenne Peace Chiefs, the council of forty-four men drawn from the tribe's eleven bands that provide the tribe traditional leadership during times of peace. The lawyers' requests prompted a group of Cheyenne leaders to convene. The chiefs also invited a young Cheyenne woman named Connie Hart Yellowman. It was a rare honor for a woman to be included at the chiefs' and society leaders' deliberations, but Connie Yellowman had a new law degree and had worked for Gover, Stetson, and Williams—a powerful law firm, which the Southern Cheyenne lawyer, Richard West, left in 1990 to become the founding director of the National Museum of the American Indian. The chiefs wanted her legal advice.

At the meeting Yellowman read aloud to the assembled leaders the documents that the lawyers had provided outlining the Smithsonian's collections. It was decided that these ancestors should come back, but that Cheyenne leaders, not lawyers, should be the responsible party. Given the chiefs' authority in the community—and the fact that many chiefs were themselves descendants of massacre victims—they were able to make the most authoritative claim for the remains. The chiefs appointed Yellowman's father, Lawrence Hart, a sixty-year-old former U.S. Marine fighter pilot and Peace Chief, to help lead the tribe in this new thing called repatriation.

On April 25, 1993, the Cheyenne chiefs and society leaders met again in Clinton, Oklahoma, in a traditional tipi. After a long discussion, all of the men signed a formal letter asking the Smithson-

ian to return the victims from Sand Creek. Three weeks later, Tom
Killion found himself in Oklahoma, sitting in a tipi hashing out the
details of an agreement. The museum would return the five skulls
from Sand Creek, as well as thirteen more taken from various parts
of Kansas, Colorado, and Oklahoma. When it came to the specif-
ics of return, Killion said that if the Smithsonian shipped them to
Oklahoma, then it would need to pack them in museum-standard
materials, to ensure that they arrived undamaged. The Cheyenne
felt disheartened by the idea of wrapping their ancestors in sterile
museum packaging. Instead they planned to travel to D.C. to pick
up their ancestors.

Tribal members donated money as well as tanned hides and Pend-
leton blankets to be used to wrap the remains. An Amish carpenter
in Pennsylvania was contracted to hand-make eighteen pine boxes.
These objects were blessed at a ceremony in Concho, Oklahoma,
at a Sun Dance Lodge. Joe Antelope—the oldest Cheyenne chief
and the grandson of White Antelope, who was murdered at Sand
Creek—empowered the thirteen Cheyenne representatives, a mix
of religious and political leaders who would make the journey to
Washington.

In the middle of summer, the Cheyenne delegation arrived.
The remains were laid out on a long table in the National Museum
of Natural History.[7] On the morning of July 1, a Cheyenne crier
entered the room and ritually called the people to gather. Several
dozen people—museum staff, reporters, and Cheyenne tribal mem-
bers wearing "visitor" stickers—shuffled into the room. They stood
shoulder to shoulder, encircling a long table covered with a pure
white cloth. A Cheyenne priest brushed each person with a bundle
of sage, and then a Christian prayer was offered in English. "God
grant us your mercy," the man said, his voice breaking. "Our rela-
tives, we are now here. We have come for you."

The cloth was peeled back. Silence engulfed the room as the
Cheyenne saw for the first time the bones of their ancestors. Eigh-
teen skulls were neatly lined up, each perched on a multicolored
Pendleton blanket. "That was a difficult moment for all of us," Hart

later recalled. "You could see the bullet holes in some of the skulls."[8] Other skulls seemed to be stained with blood. A drummer started a deliberate beat, then joined to it his wavering, plaintive voice. The priest brushed each skull with a bundle of sage, and then lifted the skull as it was wrapped in the blanket and placed within the un- adorned pine box. One man with long, gray-streaked hair broke down—anger at the massacre and anger at the museum fusing into uncontrolled sobs.

Connie Hart Yellowman and a cousin, a sister to the Elk Scraper Society, were invited to swathe the remains of the only female, a girl about thirteen killed at Sand Creek. Yellowman, dressed in a pretty lavender-colored skirt and paisley blouse, approached the table. Her hands neared the skull three times without touching it, and on the fourth time she lifted the skull up, her hands trembling so badly it looked like she might drop it. But she held on. The room was mute except for her sniffling. The top of the girl's head was bashed, look- ing to Yellowman like a saber wound. She kissed the girl's skull and held it for a moment before placing it into the pine casket.

"*Naevahoo'ohtseme,*" she told her ancestor in the Cheyenne lan- guage. "We are going back home."

o o o

The yellow Ryder moving van left Washington the next day. The fourteen-foot van, rented one-way, carried the remains home to central Oklahoma. A few cars followed, so the men could take turns driving the twenty hours through the night. Four times—a sacred number to the Cheyenne—the van stopped so the men could smoke long-stemmed pipes, to offer prayers to the Creator.

The return of these human remains presented yet another new challenge for the tribe: according to their traditional ways, there was no reburial ceremony. In fact, this concern was not lost on many tribal leaders. "We are so ritual oriented," Tessie Naranjo once said about her Santa Clara Pueblo, in New Mexico. "There is no ritual for reburial, so we're kind of stuck. We can't just dream up a ritual

on the spot so we can accommodate the reburial of remains."⁹ For
the Sand Creek reburial, according to Richard West, the Cheyenne
chief and museum director, the chiefs "had to get together and fig-
ure out how they did something, in a totally different context than
they were accustomed to."¹⁰

Gordon Yellowman explained to me that the leaders decided to
distinguish between a burial versus a reburial. If the remains had
never received a proper burial—like the Sand Creek victims—then
the full burial rites had to be given as they would be for any liv-
ing tribal member. However, if the remains had already been buried
once—like many remains excavated archaeologically—then the re-
burial ceremony is just an honoring ceremony to put the individual
"back on the spirit world track."

"It's nothing invented, nothing we haven't done before," Joe Big
Medicine, a religious leader, similarly told me about the later buri-
als. "It's just an Indian burial." There are memorial songs, "Indian
food" like buffalo stew and fry bread, and a giveaway of blankets and
shawls to elders and other honored guests. Although times change,
the duties to one's ancestors had not.

A week after arriving in Oklahoma, the burial began. A tipi
sheltered the eighteen pine boxes, which were then carried out in a
single-file procession of elders and leaders, as traditional songs were
sung. A small crowd watched, the men wearing jeans and button-
down shirts, the ladies in long pleated skirts. The coffins were low-
ered into graves that were dug in a circle with an opening facing
east, like the tipi whose opening greets the morning sun. Between
the remains of two men was the grave of the young woman Con-
nie Hart Yellowman had kissed, protected now in death by the men
of her tribe. Yellowman helped lower the girl into the grave. More
speeches, songs, and prayers followed, until at last all present cast a
small handful of dirt on the graves, and then sat together for a meal.
The first, but not the last repatriation of the Sand Creek victims had
been completed.

o o o

I am sitting through an insufferably humid day, on a folding chair, in Colony, Oklahoma. Preparations for the Powwow have begun. Tents and campers are spread around the grounds. A friendly volleyball game is under way. Dancers lay out their feathers and clothes. Next to me is a tipi, where inside the council of peace chiefs are meeting. I am waiting to interview Gordon Yellowman, one of the chiefs.

After several hours of waiting, I meet up with Gordon's wife, Connie Hart Yellowman. She wears short, close-cropped hair and a serious expression that belies a friendly charm. I ask her about repatriation, and she speaks for a long time about her experiences with the Smithsonian. She recalls the moment when they were packing the remains into boxes, being asked to lift the skull of the young woman.

"It was like an emotional, maternal instinct that came out," Connie says of the moment she wrapped the girl's skull in a Pendleton blanket. "That is one thing I will probably never forget."

"Why did you kiss and hug her?" I ask.

"I just wanted to hold the remains," she answers, "because she had never been held for years." The girl had just been sitting alone in a vault drawer for more than a century. "She needed and deserved affection."

"What were you feeling then?"

"Just sadness," she says, her eyes unfocused, reliving that day seventeen years ago.

Later, during the burial in Concho, she began to feel more than sorrow.

"It was sadness because that was the end of our connection on that journey," Connie adds. "But then joy because she was finally at a resting place."

10. INDIAN TROPHIES

The voice of Colorado asked, why are not the Indians killed—men, women, and children? The people said kill everything that wears a red skin.

Rocky Mountain News, January 4, 1865[1]

This is how the massacre ended. The metallic odor of fresh blood hung in the air. The killing on Sand Creek had reached its crescendo, but murder was not enough. The soldiers, incandescent with hate, started to desecrate the dead.

The majority of the men, women, and children—upward of 200 counted in the end—were scalped.[2] "In many instances," First Lieutenant James D. Cannon later testified, "their bodies were mutilated in the most horrible manner." Cannon saw soldiers taking the genitals of women. One labia was pierced with a stick and placed upright on exhibit. Some were stretched over saddles. Others decorated hats.

"They were followed up and pursued and killed and butchered," Samuel G. Colley, a soldier there testified. "They were cut to pieces in almost every manner and form." One pregnant woman was murdered; her stomach slashed open; the unborn child pulled out.

John S. Smith, an interpreter and Indian agent, reported seeing much the same thing: bodies cut to pieces, mutilated with knives, scalped, brains knocked out, children only a few months old lay

dead. After all was quiet on Sand Creek, Smith was asked to iden-
tify any chiefs who died that morning. Smith remembered, "Most
of them in the bed of the creek, dead and dying, making many
struggles. They were so badly mutilated and covered with sand and
water that it was very hard for me to tell one from another."

The descendants of the massacre victims have also held on to
their own stories. Mildred Redcherries' grandfather survived Sand
Creek. He only had a bow and arrow to defend himself. He was shot
and had to flee, though he saved a baby along the way. "He wanted
to save an elderly woman wandering aimlessly as well," Redcherries
said. "But when he got close to her, he saw it was hopeless. She had
been scalped."[3]

Some of the Native leaders were singled out for special punish-
ment.[4] It was said that the ears of White Antelope, one of the tribe's
biggest proponents for peace, were cut off. His genitals were cut off
and later made into a tobacco bag.

Fingers and ears were amputated, in some cases for grisly souve-
nirs, in other cases to remove rings and earrings as loot. Much of this
work proceeded not amid the heat of war, but the next morning,
on November 30, after it was clear the army had secured the slaugh-
ter. The stiff bodies of dead women were taken out in the open and
posed in indecent positions. Corporal Amos C. Miksch saw the next
morning a little boy who had survived the massacre by staying hid-
den in the banks of Sand Creek. When the soldiers discovered him
alive, a major in the Third regiment drew his pistol and blew off the
top of the child's head.[5]

o o o

Chivington's Third was slow in returning to Denver, it was re-
ported, because they were "loaded down with buffalo robes, scalps,
strings of silver dollars, etc.—plunder taken from the Indians."[6] On
December 22, the Thirdsters finally arrived in the city to a grand
homecoming. Denverites rushed to the streets to greet them and
thank them. One article gushed, "Colorado soldiers have again cov-

ered themselves with glory."[7] A parade of ten companies snaked through downtown, "the admired of all observers."[8] The scalps of the victims from Sand Creek were raised to cheers.

"Cheyenne scalps are getting as thick here now as toads in Egypt," the *Rocky Mountain News* proclaimed, and added a pointed statement to federal officials in D.C. who had reacted to the massacre with revulsion. "Everybody has got one, and is anxious to 'get another to send East.'"

That Christmas in Denver, citizens enjoyed a performance by Seignor Franco, the great stone eater, and Monsieur Malakoff, the celebrated sword swallower. Joining them on the stage were three child captives—taken alive from Sand Creek.[9] They were exhibited along with a rope of 100 scalps of their relatives. The audiences, it was said, "applauded rapturously."[10] Just a month after the massacre, the Denver Theater presented "the great Indian drama of 'Wept of the Wish-Ton-Wish,'" which featured "new and splendid Indian costumes, trophies taken in the big battle of Sand Creek."[11] Unlike real life, the play ended in a comedic farce.

At least one soldier opened his own exhibit. Captain Joseph A. Foy, Denver's paper announced in early 1865, "has any amount of Sand Creek trophies on exhibition at this place—arrows, buffalo spoons, calumets of war, scalps and so forth."[12]

Coloradans named a town Chivington, in the colonel's honor. It is located just fourteen miles southwest of the massacre site. Even today, "defenders decorate his grave with flowers every November, calling him Colorado's most neglected hero."[13]

In many ways, Chivington did win Colorado for its new settlers. Less than a year after the massacre, Cheyenne and Arapaho leaders were forced to give in. In October 1865, they signed the Treaty of Little Arkansas. Article Six did express the government's acknowledgment of "the gross and wanton outrages perpetrated against" them at Sand Creek and offered "suitable reparation for the injuries done" in the form of land, animals, goods, provisions, and "other useful articles."[14] However, in return, all of their lands in Colorado were relinquished. The tribes were dispersed into small parcels of their once vast empires—the Northern Cheyenne in Montana,

Northern Arapaho in Wyoming, and Southern Cheyenne and Arapaho in Oklahoma—hundreds of miles from Sand Creek.

The bloodlust in Denver can in part be explained by a sense of revenge. As Major Scott J. Anthony, who testified against Chivington, said, the people of Colorado believe "the only way to fight Indians is to fight them as they fight us; if they scalp and mutilate the bodies we must do the same."[15] Undeniably, Cheyennes took scalps as part of their views of gaining honors in war.[16] Many citizens recalled the murdered and mutilated Hungate family. Chivington and his cronies even claimed that they had found the scalp of a white man not more than three days old at Black Kettle's camp—later multiplied to nineteen scalps as well as a shirt worn by a Cheyenne child with six white women's scalps.[17] Although plainly false, such stories no doubt helped assuage any guilt Denver's citizens might have felt about the massacre's victims.

But the unbridled butchery of Black Kettle's people, in its scale and viciousness and genocidal purpose, was unparalleled in Colorado history. And unlike the settlers who mostly could bury their dead, for the Cheyenne and Arapaho, their past could not so easily be put behind them. For Colorado's Natives, this history would not end in 1864 or even 1890 at the close of the Indian Wars, because for generations the remains of the victims—their forebears—continued to circulate around Denver and beyond.

"In Denver, many years later, there was a persistent rumor that one of the surviving Thirdsters had a tanned Indian breast that he carried in his pocket as a coin purse," the historian Robert L. Perkin wrote. "How much of the testimony is truth and how much lie," he commented, "no one can say."[18]

o o o

Based on various sources—from soldiers, articles, memoirs—it would seem that there were likely around 100 scalps taken at Sand Creek. What happened to them after 1864 is mainly a mystery. The historical record contains only hints and whispers.

One story goes that not long after the massacre, a Cheyenne war

party attacked and killed a group of soldiers that served in the Third Colorado Cavalry.[19] It was said that during the attack, the Cheyenne found in the soldiers' baggage two scalps. In retribution, the Cheyenne mutilated the soldiers' bodies. Presumably, the scalps would have been taken away or left to the elements.

More definitively, we know a scalp was kept by Major Jacob Downing, of the First Colorado Regiment, then just thirty-four years old.[20] Downing "mustered out" of service in December 1864 and went on to become a prominent citizen in Denver. Just a year after the massacre, in the 1865 elections, the soldiers of Sand Creek formed the Vindication Ticket and nominated Downing to the state Supreme Court.[21] Denver's Downing Street is named in honor of him. In 1911, four years after he died, Major Downing's wife donated the scalp to the Colorado Historical Society—Denver's third major museum, located between the city's art and natural history museums.

Another scalp was taken by Corporal William B. Jacobs, a Thirdster who was eighteen years old in 1864.[22] He later moved to Georgetown, Colorado, where he found work as a miner. He married Emma, a librarian, and had two sons. Possibly he sold the scalp directly to George A. Cuneo, a devout Catholic Italian American who bartended in Georgetown in the late 1870s.[23] Cuneo's interest in Native American artifacts was likely spurred during a brief stay in Deadwood, South Dakota, where he saw Plains tribes up close and had passing friendships with Lakota chief Red Cloud and Buffalo Bill Cody. Cuneo collected "Indian trophies," with a particular interest in weapons of war. When he later moved to Denver, he decorated the entryway to his house with a cornucopia of bows, shields, hatchets, headdresses, pipes, guns, and more.

When Cuneo died, his nephew, George Turre, inherited the collection of 400 pieces. Initially, Turre lent the entire collection to the Denver Art Museum while he entertained offers. George Gustav Heye—of New York's Museum of the American Indian—was interested in buying several items, including "1–4 scalps."[24]

The collection stayed at the Denver Art Museum for nearly two

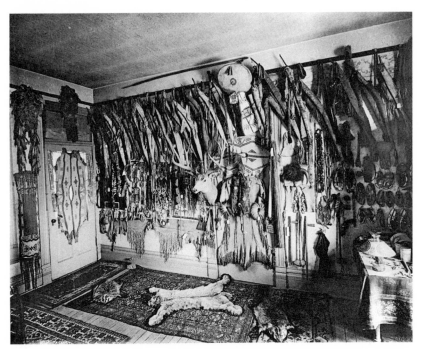

FIGURE 5. George Cuneo's display of "Indian curios" at his Denver home. Courtesy of Native Arts Department, Denver Art Museum.

decades, until Erich Kohlberg, who owned the oldest and most prominent Indian trading post in Denver, was asked to evaluate it in 1956. Kohlberg appraised the collection—and then bought the entire lot at the price he had set. Hoping to resell the collection for a profit, Kohlberg wrote to Mary and Francis Crane.[25] He had remembered the couple who two years earlier, on one of their country-wide collecting trips, had stopped in Denver. They spent four days and $4,000 at Kohlberg's trading post.

Kohlberg had sold a quarter of the collection to walk-in customers but sent the Cranes a list of eighty-five items of the best pieces on approval.[26] The Cranes carefully itemized the list. Next to each item is a check mark or a circle indicating a problem. On the second page is "370C Human Scalp, small . . . $50.00." The Cranes would eventually collect five scalps, a tiny fraction of their total holdings. They did not seem to put any special weight on the scalps; they were

just one more type of object any legitimate anthropology museum should have. Their main concern, as was often the case, was getting a good deal. Francis wrote in pencil next to Kohlberg's price for the scalp: "That $35.00!" Kohlberg defended his prices. "Every year," he complained, "this material gets scarcer, and every year, more collectors and museums want it."[27] The Cranes bought everything, including the scalp for $50.[28]

The Cranes unboxed their latest purchases, examining each thing closely and assigning it a new number to fit their catalog system. It was when they were renumbering 370C to AC.35B that they probably first paused to read the old tag, faded yellow, about as small as an oversize stamp, tied around the long black hair, almost like a snipped ponytail. In Cuneo's looping, fancy cursive, a pale brown ink scrawled on one side of the tag reads, "This scalp was taken from an Arapahoe Indian by W.B. Jacobs (over)." The other side continues: "at the Sand Creek Massacre Nov. 29th 1864."

o o o

Another story, although I could not confirm it, suggests the fate of more scalps from Sand Creek. Two somehow ended up in a motel lobby in Kremmling, 100 miles west of Denver.[29] Joe Big Medicine told me that an Ojibwe woman named Connie Buffalo heard about the scalps and traveled to the motel. She went in, asked for them, placing an open scarf on the check-in desk. She was rebuffed. She tried again. Again she was rebuffed. The third time, however, the owner said, "I've been offered a lot for these scalps, even an RV. But I'll give them to you." He placed them in the scarf. Buffalo then drove the five hours to Sand Creek, where she laid the two scalps to rest while singing a mourning song. If true, it was the first Sand Creek repatriation.

11. AC.35B

*The problem for American Indians is that there are too many laws of the
kind that make us the archaeological property of the United States
and too few of the kind that protect us from such insults.*

Suzan Shown Harjo (Cheyenne/Muskogee), American Indian activist[1]

In the summer of 1990, panic set in.[2] The Denver Museum of Nature
& Science's director, John G. Welles, was in daily contact with other
museums across the United States. The various drafts of the pro-
posed repatriation bills bouncing around the nation's capital were
threatening to undo more than a century of museum work. As Jer-
emy Sabloff, president of the Society for American Archaeology
from 1989 to 1991, groused, it "looked like we were going to get
trampled."[3]

After the passage of the National Museum of the American
Indian Act on November 28, 1989—one day short of 125 years after
the Sand Creek Massacre—Native American leaders quickly began
to organize a lobbying effort to press forward with a law that would
address all of the country's museums. "As we suspected," Loretta
Neumann, a lobbyist retained by the Society for American Archae-
ology, wrote, "the Smithsonian bill was just the beginning of the
next wave of efforts to enact sweeping reburial legislation."[4]

Progress toward a new law was made after a Senate hearing in

March 1990, when the Panel for a National Dialogue on Museum/ Native American Relations presented its final report. The panel, consisting of fourteen members from all sides of the issue, had convened over the previous year. Although it had begun contentiously, positions began to soften as the members' dialogue unfolded. The panel presented six recommendations, nearly unanimously agreed upon, with the exception of three archaeologists who objected to its recommendations on cultural affiliation and other issues. Still, the panel's report was heralded as a "great compromise."[5] The panel's findings were only strengthened by the growing number of revisions to state reburial laws and a letter from fourteen major Christian organizations urging congressional action. "Clearly, this legislation is inevitable," Senator John McCain of Arizona reacted at the spring hearing.[6]

By the summer of 1990, various bills were swirling around Capitol Hill. One sponsored by senators John McCain and Daniel Inouye of Hawaii was especially sweeping. The Denver Museum's lawyer warned that if their S. 1980 passed into law, most of the Crane Collection would be deemed "ceremonial" and would have a "devastating impact."[7] Amendments to a proposed bill in the House, H.R. 4739, would have reburied all unclaimed remains within three years. A coalition of museum and archaeology professionals lobbied hard to have it withdrawn. "It's time to take off the gloves," Loretta Neumann wrote. "We need to get his amendment killed."

Another proposed bill in the House, introduced by Representative Morris Udall of Arizona in July 1990, looked to many scientists just as dangerous. During congressional hearings, archaeology and museum representatives philosophically supported the bill's goals, but urged a more "balanced" approach between respecting human rights with the scientific interests and museum's public trust responsibilities. The reaction of individual museums, however, was much stronger. To protest H.R. 5237, the Denver Museum aligned itself with the country's largest museums—the American Museum of Natural History in New York, the Field Museum in Chicago, the Harvard Peabody Museum in Cambridge, the University Museum

in Philadelphia, the Los Angeles County Museum, and the Bishop Museum in Hawaii. A letter from the coalition stated that the proposed law would "set up a ruinously expensive, adversarial, and lawyer-dominated process that would financially cripple the museums, remove uniquely valuable collections from the public domain, and deprive future generations, including Native Americans, of knowledge of an important part of human history."[8] As late as September 25, 1990, a joint letter was sent from Denver's art museum and its natural history museum to a dozen members of Congress arguing that the pending legislation would lead to the "impoverishment" of Colorado's citizens, tourists, children, and even Native Americans "because of reduced access to the objects."[9]

Unlike most other museum directors during this period, John Welles had very little personal stake in the repatriation debates. He was part of a new movement to hire directors with skills in business rather than museology. Welles was an engineer with an MBA. When he was hired, the museum's board president explicitly said that Welles was "chosen from a pool of 300 applicants despite his lack of previous museum experience."[10] As a result, Welles relied heavily on his curatorial staff to navigate the ethical and practical implications of the pending legislation, while he focused on its political and financial implications.

Director Welles personally felt that if there was a better than fifty-fifty chance to craft "satisfactory language" in the pending legislation, then he wanted to work with Congress.[11] If not, then he would join other museums in the "stonewalling strategy." Like most directors, Welles hoped to convince Congress that museums were already voluntarily addressing the crisis. As a curator from the Field Museum tried to convey to Congress just months before NAGPRA became law, "we are actively doing something very positive on our own, that legislation is not necessary"[12]

The Denver Museum staff was particularly defensive about their efforts.[13] They pointed out that human remains had not been displayed since 1970, that it had involved a Native American advisory group since 1973, that it allowed offerings and ceremonies in its

storage facilities. Even its official collection policy, revised in 1984, stated that curators must be willing to consider the "possible return of culturally sensitive materials."[14] To further demonstrate its goodwill, the Denver Museum, like many museums in America that summer, voluntarily established a formal repatriation policy. In order to balance the museum's public obligations and the concerns of Native Americans, the museum would be willing to repatriate if there was "clear historical, archaeological, or ethnographic evidence that the human remains are of ancestors."[15]

The fears Welles felt were understandable.[16] He worried that repatriated objects would be sold back onto the market, that returned objects would not be properly cherished by communities, that the law would be a field day for unscrupulous lawyers, that repatriation would fundamentally undermine the museum's civic duty to care for objects held in the public trust.

Yet as the law's final version approached, Welles, working with his management team, began to consider the crisis in a new light. Jane Day, his vice president of research and collections, proclaimed that she was "not against returning certain cultural items."[17] Perhaps repatriation was not an end but a new period of collaborative stewardship. "Are we at the point in history where the museum role is changing," Welles wondered aloud in a meeting with museum trustees, "and can direct its energies toward working with Indian tribes to reconstruct and revitalize their traditional culture?"[18]

o o o

In the late summer of 1990, Native American leaders felt that many archaeologists and museum leaders were against the proposed legislation. But they sensed that scholars were feeling public pressure and saw a small window to negotiate. One set of negotiations began between Walter Echo-Hawk, Jack Trope, and Suzan Shown Harjo with archaeologists, represented by Keith Kintigh of the Society for American Archaeology, focused on Senate bill S. 1980. Another set of negotiations unfolded with leaders of the American Associa-

tion of Museums over the House bill H.R. 5237. After more than a month of successful negotiations, the House of Representatives voted on H.R. 5237, the Native American Graves Protection and Repatriation Act.

Representative Udall, the original author of H.R. 5237, urged passage of the bill. "This legislation is about respecting the rights of the dead, the right to an undisturbed resting-place," he said on the floor of the House. "It is a good bill, and long overdue. What we are saying to American Indians today, Mr. Speaker, is simply that your ancestors and their burial grounds are sacred, and will remain so. In the larger scope of history, this is a very small thing. In the smaller scope of conscience, it may be the biggest thing we have ever done."[19] In a stunning reversal of years of antagonism, the Society for American Archaeology and three major American Indian organizations wrote a joint letter in support of the legislation. Although many archaeologists were still reluctant to accept repatriation, the discipline's leadership acknowledged the inevitability of the law and NAGPRA had been tempered enough through successful lobbying. The SAA's Keith Kintigh argued to his colleagues that NAGPRA was "repatriation we can live with."[20]

The Senate took up H.R. 5237, with Senator McCain hailing it as a "true compromise."[21] For his part, Senator Inouye said, "For museums that have dealt honestly and in good faith with Native Americans, this legislation will have little effect. For museums and institutions which have consistently ignored the requests of Native Americans, this legislation will give Native Americans greater ability to negotiate."[22]

NAGPRA passed the House and Senate with essentially no dissent; it was placed on the desk of George H. W. Bush. On November 2, 1990, a three-sentence letter stating that the bill was the result of careful compromise was sent to President Bush, signed by the leaders of three national Indian organizations and nine anthropological organizations.[23] The president's staff contemplated whether to recommend he should sign it.[24]

In seventeen pages, NAGPRA created a process for Native Amer-

icans and tribes to claim human remains, funerary objects, sacred objects, and objects of cultural patrimony (meaning communally owned items) from museums and federal agencies.[25] The law also established the custody of human remains and other cultural items discovered on federal lands after 1990. Penalties for non-compliance and illegal trafficking were enacted, and the law authorized a grants program to fund the efforts of museums and tribes.[26] Finally, a seven member Review Committee (made up of three museum/scientist representatives, three tribal representatives, and one by mutual consent) would be set up to monitor the law's progress, facilitate dispute resolution, and make recommendations regarding regulations and a process for the disposition of unclaimed and culturally unidentifiable human remains.[27]

Since 1620, when the Pilgrims first dug into an Indian grave not far from Plymouth Rock out of curiosity, Native Americans had lost control over the graves of their ancestors. In the wake of colonialism, they had lost so many sacred things that gave their culture its meanings and its strength. For generations, Native Americans were outsiders to their own heritage as scientists and curators were entrusted to decide the fate of their material culture. Indian skulls and scalps were collected with impunity. All of this changed on November 16, 1990, when President Bush signed NAGPRA into law. With a swift stroke of the president's pen, the United States government reversed 370 years of history.

The question now was how museums and tribes would implement a law of such radical change.

o o o

Gordon Yellowman, the modern-day chief, greets me at his front door in gray sweatpants, a white T-shirt, and flip-flops. He has invited me to his home in Oklahoma. Stepping inside, I meet his mother, who is watching TV, and I say hello to Gordon's wife, Connie, who is finishing Sunday chores. Gordon and I go out to a table on the deck he built, next to an aboveground swimming pool. I pull

out my digital recorder and ask Gordon to start at the beginning, how he got involved in repatriation work. Gordon tosses a pack of Marlboros in front of him and draws a cigarette.

Back in 1979, fresh out of high school, Gordon started a family and he needed work to pay the bills. Through a federal program, the tribe employed him doing maintenance, mostly janitorial work. He soon went on to college, starting at a tech school and then transferring to Oklahoma State University on scholarship. After graduation, the tribe employed him in its home improvement program.

About 1991 the tribal government started getting more involved in cultural work, and some elected officials began to look to Gordon, because he is a Cheyenne chief and a Sun Dance priest. Gordon was interested in this new law called the Native American Graves Protection and Repatriation Act. With no tribal office to handle NAGPRA, the letters were given to Gordon. In 1993 the tribe started receiving dozens of "summaries" from museums. Soon they were stacked several feet high on Gordon's desk.

These summaries were long lists of cultural objects from collections, which museums are required to send to tribes under Section 6 of NAGPRA. The purpose is to itemize artifacts—transparent information sharing—which tribes can use to decide what sacred, unassociated funerary, or communal objects they might claim. Every museum and local and state government in the United States that received federal funds as well as all federal agencies had to send every tribe their lists by November 16, 1993. Under NAGPRA's Section 5, museums and agencies had to mail their inventories of human remains and associated funerary objects by November 16, 1995. (For any new collections obtained after these dates, museums have six months to furnish tribes revised lists.)

When NAGPRA became law on November 16, 1990, administrators at the Denver Museum of Nature & Science were uncertain what it would all mean. Still, the Department of Anthropology staff set to work.[28] A first step was to build a new database system that would allow staff to track the collections more rigorously, creating a digital record for every object. Six days before the November 16,

1993, deadline, the museum sent out its last inventories to 420 Native American tribes. The museum's form letter to each tribe tried to strike an optimistic tone, highlighting the museum's history of working collaboratively with tribes and scholars. "We see the NAGPRA process as a new opportunity to cooperate and enhance cultural understanding," the letter concluded. "We will continue that tradition of openness and cooperation."[29]

Some museums had even more tribes to contact. The Denver Art Museum, down the street, though with a much smaller collection of 17,000 objects, sent summaries to more than 700 Native tribes and communities.[30] It's easy to understand how daunting the prospects were for a museum like the Harvard's Peabody, with a collection topping an estimated 8 million archaeological objects.[31] (In fact, 58 museums, including the Peabody Museum, received extensions to complete their inventories.)[32]

Tribes began to visit Denver. In March 1994 the Denver Museum of Nature & Science had its first NAGPRA consultation—with Maria Pearson, a celebrated Native activist. In Denver, Pearson identified seven Yankton Sioux objects—a horse blanket, pipe bags, a baby cradleboard, and amulets—that she felt should be returned under the law. Pearson's visit was followed the next year by representatives from the Jicarilla Apache, Navajo, Menominee, Miwok, Eastern Shoshone, Dakota Sioux, Winnebago, and even Plains Cree from Canada who had no standing under NAGPRA but were interested in how the new law might affect the care of their cultural objects.

These visits must have been difficult for many of the Native visitors. At least it was not particularly pleasant for Gordon Yellowman. "I never did spend time in museums," he tells me in his Oklahoma twang. "Every time I went, there was always a smell. In some museums it is greater than others. It is a foreign smell. It is not the smell of life, it is not the smell of spirit, it is not the smell of beauty, it is not the smell of freedom. It is the smell of death. I learned later on that a lot of the objects were covered with chemicals for preservation."

The law's first five years was unquestionably transforming anthropology at the Denver Museum. A huge amount of work was undertaken just to comply with the law's first directive to create inventories. Still, the changes were not negative.[33] Thanks to NAGPRA, the department finally had a complete inventory of its holdings, documented using cutting-edge software. "These massive documentation achievements greatly enhance access by museums, researchers, and the public," Bob Pickering, the department chair, wrote proudly in his 1994 annual report. "Its impact is far-reaching for future scholarship, exhibits, and programming."[34] And nearly all the costs, aside from staff time, were covered by federal grants.

The involvement of Native peoples at the museum also had never been stronger. The museum's Native advisory group became only more invested in the museum's success; they ensured that the museum did even small things, like regularly placing sage in the storage area to purify the sacred objects there. After 1990 the department started regularly having Native interns, and hosting a continuous string of Native visitors for consultations was an opportunity to make new connections with the very people whose heritage the museum sought to honor. "We can be bureaucratic and say that it's a lot of paperwork," Pickering explained. "Or we can be humanistic and say that this is a great opportunity to work with some tribes we've never worked with before."[35] And Pickering knew, five years after NAGPRA became law, the museum still had not returned a single object or human remains under the law.

o o o

As much work as NAGPRA was for museums, tribes were only beginning to face the flood of paperwork that marked the beginning of repatriation. Consider the summary from the Denver Museum that landed on Gordon Yellowman's desk. It consisted of fourteen separate lists, totaling 1,595 objects.[36] The law didn't require clear definitions or explanations—just summaries. He had a difficult time

deciding what to prioritize and where to begin as he read simple descriptions from the Denver Museum:

OBJECT NAME	TALLY
Scraper	3
Scrapers	4
Seed jar	I
Sherd	I
Sherds	3
Unsorted archaeological material; lithic materials	4
Worked bone	3
Worked groundstone	I
Worked stone	2

Yellowman, without training in anthropology or museum work, had all kinds of questions. What is a *scraper*? Or a *seed jar*, *sherds*, *lithics*, and *groundstone*? Is the worked bone *human* bone? Why is the archaeological material unsorted? Why were some items listed in the singular (scraper, sherd) and others in the plural (scrapers, sherds)? Where did these objects come from? How old are they? To whom did they belong?

Yellowman became nearly paralyzed as he faced not just the Denver Museum's lists, but hundreds of lists from hundreds of museums. He felt the emotional weight of the task, but also the sheer difficulty of deciphering the language of museums; it was as if he had been tasked with translating Egyptian hieroglyphs.

"I read the law, over and over again, and it just seemed to me that I didn't know where to begin," he tells me, lighting another cigarette. "I didn't know how to address it." He started visiting museums for consultations and slowly started to learn the language of anthropology. "I had to learn how to read records, accessions, catalog information, catalog numbers," Yellowman remembers. "I had to learn parts of the body: femur, mandible—to understand what they were actually talking about."

Some tribes nearly gave up on repatriation before it even could begin. "The number of letters we received was amazing," Alan Downer, a Navajo Nation representative, complained in 1994. "We stopped counting after 300."[37] Downer made it clear that the tribe wanted objects and remains returned, but simply didn't have the staff to make it happen. He estimated that it would cost the Navajo Nation a blistering $450,000 each year to fully address the legacy of museum collecting. "Clearly," as Pickering wrote to one colleague, "the redundancy of work and correspondence on both sides (tribes and museums) is staggering."[38]

On May 19, 1994, the Denver Museum staff sent out its inventory of skeletal remains—well ahead of the November 16, 1995, deadline for human remains and associated funerary objects—to the Cheyenne and Arapaho Tribes. The inventory described the remains of nineteen individuals, including AC.35B, the scalp from Sand Creek. Several weeks later, the tribe replied back, saying that it received the inventory and should communicate in the future with Gordon Yellowman.

Several of the Denver Museum's staff assumed that the return of AC.35B would be, as Tom Killion said of the Smithsonian's Sand Creek collection, a "no-brainer." An easy, quick repatriation. But from the first exchange, there were signs of trouble. The summaries and inventories that the Denver Museum sent to the Cheyenne and Arapaho Tribes' offices in Oklahoma were somehow lost.

o o o

It was not until three years later that Gordon Yellowman caught the problem and contacted Bob Pickering, asking him to resend the museum's lists.[39] Soon there were almost weekly communications, as Yellowman indicated that he wanted to request the return of numerous items: a bear medicine bundle, a painted bison skull, a ceremonial "clown" mask, a coup stick, a medicine bag hide, a rattle, and a tubular pipe. However, the first priority would be the human remains.

On August 1, 1997, Yellowman showed up unannounced at the

Denver Museum, hand-delivering a letter from his tribal chairman notifying the museum that he would soon make a formal request for repatriation on behalf of the traditional leaders of the tribes for twenty-one sets of human remains and associated funerary objects. The letter explained that the previous year, an array of Cheyenne chiefs, religious leaders, and tribal members had met in Colony, Oklahoma. They talked at length about the human remains of their ancestors in museums across the United States. All agreed that their ancestors had to be returned, with the tribal government taking the lead on behalf of the tribe's spiritual leaders. Gordon Yellowman was affirmed as having the proper authority to do this work. Several weeks later, the chairman wrote again making a formal claim to the ancestral remains in Denver.

The Denver Museum staff took several months to decide what to do. Pickering wrote back to the tribal chairman asking for more information. It had been decided that the simple claim—the mere assertion that these twenty-one human remains were Cheyenne or Arapaho—was not enough.

In the meantime, Yellowman wrote to Pickering again, this time asking for a letter of support for a grant to conduct facial reconstructions to help connect ancestral skeletons to living tribes. He was acutely aware, Yellowman tells me, that many museum people feared that "the Indians are going to take all of the stuff and we can't do research anymore." In his opinion, the museums had almost always had more than enough time—often decades—to study the remains. Still, he was willing to experiment with new solutions to the problems that repatriation had made his people confront. Yellowman wanted to show that NAGPRA could be a way of *gaining* information through collaboration, instead of only *losing* information through repatriation.

As far back as the Cheyenne's first consultations at the Smithsonian in 1991, tribal leaders had shown a willingness to consider different results than repatriation. As Tom Killion, of the Smithsonian's Repatriation Office, describes those first meetings, the Cheyenne leaders, led by Lawrence Hart, showed that they had no in-

terest to "clean out the collections."[40] In one case, they asked that funerary objects be left at the museum for educational purposes; in another case, that a sacred object should be "decommissioned" but left at the museum; and in a third case, museum and tribal officials traveled together to observe a Sun Dance ceremony, which led to a shared curatorial agreement that benefited both sides.

Perhaps Gordon Yellowman's boldest project involved the study of the Sandman.[41] In 1973 in Woodward, Oklahoma, a local was digging the foundation for a new house when he discovered a burial in a layer of sandy soil (hence the name). He called archaeologists, who removed the entire grave in a block of earth, like a piece of cake, which would give future researchers the chance to understand the burial's entire context. When Gordon learned through a NAGPRA inventory from the University of Oklahoma about the grave, he decided that the skeleton should be studied collaboratively to understand how the Sandman lived and died, before he was reburied.[42] Yellowman tells me that his attitude has always been "to come together and work together, and we're all going to learn through this process."

A physical anthropologist from the Smithsonian, Douglas Owsley, was brought in. The team discovered that the burial contained a man, about thirty years old. He had broken his left arm, and his back was in bad shape from a lifetime of riding horses. He wore earrings that had come 300 miles east from Missouri and had a parasol that likely had come from Bent's Old Fort, a nineteenth-century trading center, 300 miles west in Colorado. The team deduced that the man probably died in the Battle of Wolf Creek in 1838, a major campaign between the allied Cheyenne and Arapaho against the Kiowa and Comanche Tribes. Yellowman also secured a grant to hire a police expert and fellow peace chief, Harvey Phillip Pratt, to produce a facial reconstruction.

"He was telling us his life story without us even asking," Yellowman tells me. "All of this forensic evidence and physical characteristics, what science is can really give you a very powerful understanding of that guy's life." He felt that by learning from his ancestor's

remains, "it increases the value of his life." His interest and willing-ness to use science to learn about his tribe's past broke down the sup-posed divide between archaeologists and Native Americans. Here was a tribe's NAGPRA representative willing to do research on an-cestral remains, so long as it was collaborative and mutually ben-eficial. In the age of repatriation, the Sandman became one of the best-documented historic burials in the southern Plains.

Although Yellowman embraced using scientific methods to doc-ument his ancestor, he did not see the skeleton coldly, as mere pieces in a historic puzzle. One day the team was setting up photography equipment to document the remains, but the gear kept malfunc-tioning. Yellowman thought that something wasn't right, that he needed to conduct a prayer. As he began, thunder suddenly boomed outside. The lights flickered. Yellowman had a realization.

He turned to the photographer, a young woman. "I need to ask you something personal," he said. "Are you pregnant?"

"Yes, I am," she replied, amazed, because she was not yet show-ing. "How did you know that?"

"Because in our traditional ways, pregnant women are not al-lowed to view the dead," he explained. "The Sandman was letting you know."

Yellowman blessed her with sage and completed his prayer. The team successfully completed its work.

"That is the power of repatriation," he tells me. "The spiritual power is beyond our control."

○ ○ ○

Back at the Denver Museum, in the autumn of 1997, the staff de-cided that they needed to meet again with the Cheyenne and Arap-aho leaders to fully consider the claim of the twenty-one human remains. However, both the museum and the tribe were short of funds. Another delay was needed to apply for a grant from the Na-tional Park Service.

The museum received the NPS grant but could not arrange for a two-day meeting until November 1998. Gordon Yellowman ar-

rived with a Cheyenne elder named Alfrich Heap of Birds, a for-
mer arrowkeeper—a religious priesthood that oversees the Sacred
Arrows, one of the Cheyenne's most holy possessions, which are
filled with "the supreme power of the Creator himself."[43] (An Arap-
aho representative was also slated to attend but backed out at the
last minute.) When the two arrived, Heap of Birds went to the col-
lections area and carried out a smudging. Over the two days, the
tribal representatives and the museum staff carefully examined 460
objects, one by one, from the collection. As the two Cheyenne made
comments about the objects, curator Joyce Herold and her staff furi-
ously scribbled notes.

Two months later, Yellowman sent a letter to the Denver Mu-
seum and also a 28-page packet that included sophisticated legal ar-
guments, extensive explanations of Cheyenne culture and history,
and detailed maps and figures. His report concluded that all claimed
objects and remains "are in a class that meets or exceeds the tradi-
tional burial customs, rites and rituals of the Cheyenne and Arapaho
Tribes." Furthermore, since there is a "direct and unbroken relation-
ship" between the human remains and the tribe today, the remains
must be repatriated for reburial.

The report was given to Herold. She reviewed it. "I agree that
the Museum should proceed with repatriation of all materials in-
cluded in this claim," she wrote two months later to Bob Pickering.
According to NAGPRA—in a section of its implementing regula-
tions titled 43 CFR 10.10(a)(3)—with this decision, the Denver Mu-
seum now had just ninety days to complete the repatriation.

But by 1999 the anthropology department was undergoing
changes. That year Pickering exited the Denver Museum; he was
replaced in 2000 by Ella Maria Ray, who was appointed department
chair and the museum's NAGPRA officer. Ray was genuinely sym-
pathetic to repatriation; however, unlike Pickering, who had train-
ing in physical anthropology (the study of human biology) and had
a decade of NAGPRA experience, Ray was a cultural anthropol-
ogist who had worked in Jamaica and so had never dealt with the
complex law.

In the summer of 2002, the U.S. Secretary of the Interior, Gale

Norton, received a letter of complaint from Karen Wilde. Wilde was then the Executive Secretary of the Colorado Commission of Indian Affairs, an agency in the Lieutenant Governor's office responsible for being a liaison between the state's Indian peoples and the government. She was also a member of the museum's own Native American advisory committee. Wilde charged that the Denver Museum was out of compliance with NAGPRA, mainly for not making determinations of cultural affiliations for human remains— meaning formally deciding whether sets of remains could be linked to tribes. Under the law, civil penalties can include fines of thousands of dollars.

Wilde told me during an interview that she had several inside sources at the Denver Museum. One told her that a senior curator was purposefully stymieing repatriation, behaving as if the collections were the curator's private property threatened by tribes. More disturbingly, Wilde was informed that during one consultation a Pueblo group left an offering of cornmeal next to some sacred objects. After the Pueblo men left, a curator came in and—perhaps annoyed by the risk the food posed to the collections, because it can attract insects, which then destroy the objects—said, "Clean that shit up." Wilde claims that museum administrators refused to share any information with the advisory group. Wilde felt she had no choice but to protest the museum's failings by writing to the Secretary of the Interior, the federal official with ultimate oversight over NAGPRA.

Although the Secretary of the Interior is supposed to investigate charges of non-compliance, in this case, Secretary Norton's office never did so. Wilde learned a hard lesson: under the law there is almost nothing an individual can do to force a museum to undertake the work of NAGPRA. This lack of oversight is the norm. Between 1990 and 2010, of 69 allegations of failure to comply with the law reported to the National NAGPRA Program, only 31 were investigated. Of these, 15 museums were found to be out of compliance; and of these, only 8 museums had to pay civil penalties, totaling a paltry $42,679.[44]

Although Wilde's letter did not result in an investigation, it did

alert the Denver Museum's administrators to a crisis in the making. Curator of archaeology Steven R. Holen, who had been an ardent NAGPRA supporter at his previous job in Nebraska, took over compliance. Ray soon left the museum to become a university professor.

Although this controversy did not explicitly deal with the remains from Sand Creek, it helps explain why the remains were ignored for so long. Even after Gordon Yellowman's thorough report and Joyce Herold's concurrence with it, no one from the museum ever wrote back to the Cheyenne and Arapaho about returning the twenty-one remains. They were not returned in 90 days, as the law requires. Instead, it would take 2,271 days—and involved the remains of just one ancestor.

Karen Wilde was right. Repatriation at the Denver Museum had begun to slip.

o o o

In 2003 the Denver Museum staff was contacted by members of the Northern Arapaho Tribe, from the Wind River Reservation, in Wyoming. The museum had some leftover funds from a previous National Park Service grant and was able to reallocate the money to pay for two elders to come to Denver.

Notes from the consultation on file document that the visitors took a keen interest in AC.35B, the scalp from Sand Creek. It was of "great concern" to them, a "high priority." Steve Holen shared with them the museum's documentation on it and also expressed the museum's eagerness to repatriate the scalp. Despite this mutual agreement that the scalp would be returned, there was still much work to do.

It would be five more months before the Cheyenne-Arapaho Business Committee's chairman, Robert Tabor, would write the museum formally asking for repatriation.

Seven more months before a Notice of Inventory Completion— the public notification of the museum's conclusions about a finding under NAGPRA—was finalized and submitted.

Two more months before the notice was published in the *Federal Register*, which only says that the tribes may make a claim after thirty days if no other claimants come forward.

Two more months before the Cheyenne and Arapaho could submit yet another letter now asking for the return of the scalp since no other claims were made.

Three more months before Holen could write a memo to the museum's internal Curatorial Review Committee—made up of all the curators with authority to "deaccession," or to formally disclaim objects in the collections—asking it to vote on the return of the scalp, which the CRC approved unanimously.

Only then could nine men—traditional leaders, a Pipe Keeper, Sun Dance Priests, elders—drive from Wyoming and Oklahoma to Denver. On June 13, 2005, the men stopped downtown by the Colorado Historical Society and picked up the scalp that Major Jacob Downing had taken from the head of a Sand Creek victim. They then stopped by the Denver Museum to pick up the scalp that Corporal William B. Jacobs ripped, he thought, from an Arapaho chief. The nine men drove together three hours east out onto the open plains.

But they did not keep driving to Sand Creek. They stopped at Bent's Old Fort, now a historic site run by the National Park Service. At the fort, they pulled up to a metal shed that served as a collections facility. After an alarm was turned off, they went through three sets of doors, at last arriving in a climate-controlled room, cold and airless like a cave. Cabinet number 42 was unlocked and opened, the scalps placed within. After smudging the room with an offering of smoke, they left a final offering of water, tobacco, and dried fruit and meat outside the shed.

Even fifteen years after NAGPRA's passage, the scalps' odyssey was not over. They would have to remain here at Bent's Old Fort because the Sand Creek massacre site was not yet ready for their burial. The scalps were still three years and 100 miles from peace.

12. A WOUND OF THE SOUL

*Repatriation is the most potent political metaphor for
cultural revival that is going on at this time.*

Richard West, Southern Cheyenne chief and museum director[1]

"Can repatriation heal?"

Joe Big Medicine doesn't answer my question. He just sips his
steaming coffee, then draws a paper napkin across his sparse mus-
tache. Joe's eyes are masked behind sunglasses with large dark lenses.
A Cheyenne Sphinx. Whenever I ask a question, Joe serenely pauses,
like he is pooling his stream of thoughts into eddies before releasing
them in brisk, lucent sentences. Yesterday Joe told me that the time
is right to share his story. But now I sense that he doesn't know if he
can trust me. I'm a museum curator, after all.

It is also possible he is skeptical of the claims that healing is an
integral part of repatriation law. Some have described the collection
of the Indian dead as a "wound" between museums and American
Indians, which the U.S. Congress wanted healed through the man-
date of repatriation.[2] The Cherokee scholar Russell Thornton has
drawn from the field of "postcolonial psychology" to argue that
without resolution, historical traumas like massacres are "intergen-
erationally cumulative, thus compounding the mental health prob-
lems of succeeding generations."[3] Thornton suggests that only by

directly and systematically confronting the past, through activities like NAGPRA, can the wounds of shared traumas start to heal. In Australia the government's 2011 policy on repatriation insists that returns must be "a vehicle for healing and justice."[4]

And yet the cataclysm at Sand Creek was so horrifying, I wonder if Joe believes healing is possible. "We'll never forget our holocaust," Lawrence Hart, the Cheyenne peace chief, once said. "It's part of our psyche. How do you heal a wound of the soul?"[5]

Maybe it's an unfair question—or at least a question without an answer. But if anyone can answer it, I think it must be Joe. We sit in the café staring at each other an uncomfortable moment longer.

"NAGPRA doesn't heal," he says finally, and I sink in my seat to hear that this Cheyenne leader does not believe repatriation can repair the damage left in the massacre's wake. I have a fleeting thought of hopelessness, doubting why we bother with repatriation at all.

But then Joe adds, "The process does."

○ ○ ○

For all of his adult life, Joe Big Medicine had never even heard that clunky five-syllable word—*re-pa-tri-a-tion*—before. For that matter, he had never imagined that museums would collect the skulls and scalps of his ancestors. Then, at a traditional ceremony in Watonga, Joe was asked to become the Southern Cheyenne's NAGPRA representative. Although he knew nothing about the law, Joe is a priest of the sacred Sun Dance and a leader of a Cheyenne warrior society—hinted at by the crisp black baseball cap he's wearing over close-cropped hair with "Vietnam Veteran" stitched in front. Joe has the ritual authority to bury the dead. He accepted the position and has now reburied more of his ancestors than he can remember.

Joe's first forays into repatriation centered on Sand Creek. "The state of Colorado came along to tell us that the government had lost Sand Creek," he says, "and asked if we would be interested in helping to locate it." In the late 1990s, Joe worked with Laird Cometsevah, a prominent Southern Cheyenne elder, and the National Park

Service, to locate where the massacre had occurred. Based on their successful research, the U.S. Congress, with sponsorship from the senator and Cheyenne tribal member Ben Nighthorse Campbell, passed the Sand Creek Massacre National Historic Site Establishment Act of 2000.

The law directed that a portion of the land be set aside and protected exclusively for repatriated remains and objects. Despite some differences between the descendant tribes, as the historian Ari Kelman described, they "worked together, cutting red tape and putting aside rivalries, ensuring that the massacre's victims would no longer be housed in soulless repositories, where they sometimes were subject to academic study and idle curiosity."[6] The final location of the repatriation site was chosen by Joe Big Medicine, who one day visited the site and used his cell phone to speak with Chief Cometsevah, sick at home. They chose the spot where the Sacred Arrow Keepers held a ceremony in 1978 in which they "reclaimed the land," to make it again "Cheyenne earth."[7]

In 2008, a year after the Sand Creek Massacre National Historic Site was opened, tribal leaders gathered the remains of six victims— one scalp from the Denver Museum, one scalp from the Colorado Historical Society, a cranial fragment collected after the massacre and donated to the University of Nebraska, and three sets of remains from a private collection—from Bent's Old Fort.[8] The remains were purified with prayer and smoke, and a police escort led the remains from outside La Junta to the massacre site, 100 miles away. At each turn, two police officers stood and saluted as the cavalcade passed.

A gathering of sixty or so people waited at the repatriation area. The National Park Service worked closely with the tribe to prepare the site and host the funeral. Gordon Yellowman attended, his last burial of some twenty-five that he completed under NAGPRA, before he was removed from his post by the latest tribal government. An American flag and a white flag—recalling Black Kettle's signs of peace—were raised to the fluttering wind. A descendant of a soldier named Silas Soule, who was assassinated for publicly denouncing the massacre, read one of Soule's damning letters. There was a

prayer, and a drum group sang a death song that White Antelope had wailed as he was murdered. The coffins made of deadfall cottonwood trees from along Sand Creek were then lowered into the ground.

Joe Big Medicine emphasizes to me that the creation of the historic site and the burial ceremonies are just parts of a larger effort to remember Sand Creek and honor the ancestors.[9] There is a small annual dance for remembrance held in Oklahoma; there have been protests over roads and buildings named after Colonel Chivington and his Thirdsters; there have been formal apologies from Methodists and a recent Colorado governor; there have been demands that a statue honoring the state's soldiers be changed to redact Sand Creek from a list of its glorious battles; and requests to change the mascot of the nearby Lamar High School "Savages." Upward of 15,000 living descendants from Sand Creek have been in a decades-long clash with the federal government over whether compensation was ever given to them, as stipulated in Article 6 of the 1865 Treaty of the Little Arkansas. Then there is the annual Sand Creek Spiritual Healing Run, which began in 1998. The run starts at the massacre site and culminates in Denver at the steps of the state capitol building, where Governor Evans had issued his decree in 1864 to kill all hostile Indians.

o o o

I leave my office in Denver for Sand Creek. The city quickly surrenders to the open, desolate plains, embellished only with the occasional small cluster of houses huddling against wind and time, herds of cattle, fallow fields, and a few oil derricks patiently pumping up and down. Three hours later, I pass the town of Chivington, Colorado—though really not much of a town, just a few decaying houses tossed together, which makes me feel reassured about the fortunes of a community named after a mass murderer—then turn left onto Chief White Antelope Way.

Thick stands of brilliant yellow wild sunflowers line the road and

spill out onto the rangeland. Three chestnut horses watch me drive by, their tails lazily slapping at flies. Flying along the dirt road, the car vibrating against the washboard, kicking up billowing clouds of dust, I am alone. There is nothing out here but the Great Plains, only the vast undulating prairie and the big blue sheltering sky.

Eight miles later the entrance to the park is announced by a NPS sign, low and framed in simple stone masonry. Not far away are an oversize garage and a mobile home for the ranger's office. I pull into a small dirt parking lot, with two other cars. Only 4,000 people visit here every year—about the same number my museum gets on a decent day. Opening the door, I'm hit by a piercing chorus of cicadas and the late summer heat, nearly 100 degrees.

I walk down a sandy two-track road with no shade, passing only a large sign warning of rattlesnakes. The half-mile pilgrimage ends at a low hill perched above the winding Sand Creek, lined with cottonwoods. I wander, reading the few interpretive panels there, pausing before a section of fence, a half-dozen long strips of red and blue cloth wrapped around a horizontal bar, left as prayer cloths to honor the dead. At the end of the trail are signs asking visitors not to go to Sand Creek itself. "Help Respect Sacred Ground," one pleads.

I turn around. Descending the hill, I see the open field—the repatriation area. It's much larger than I had imagined, maybe the size of four basketball courts. There is a panel titled "Returned to Sand Creek" that briefly explains the repatriation process. Next to it is a marker, a short fence, and a plain bench. I sit down and look south, facing away from Sand Creek, out onto the rolling plains scattered with sunflowers amid dense blue gamma grass. I hear the cottonwood leaves trembling.

I recall a conversation I once had with the mother of a 9/11 victim. She objected to the $700 million museum and memorial created at the former World Trade Center. She wished the city's administrators had simply planted Ground Zero with a field of wheat. She could imagine watching the wheat grow slowly with time, and once fully ripened, waving in the wind, golden in the summer sun. In the autumn it would be harvested as a eulogy for what was lost. In

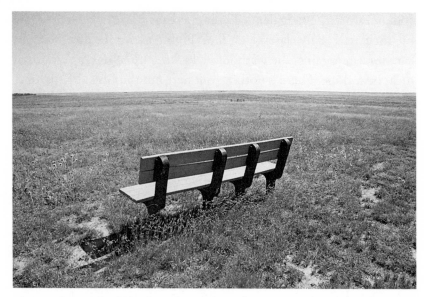

FIGURE 6. Bench overlooking the Sand Creek Massacre reburial area. Photo: Chip Colwell.

spring seeds would be sown as a prayer for the future. For her, only a field of living wheat could be a healing place.

The repatriation area—with no headstones, no tomb, no memorials, just a field of rippling grass—perhaps achieves what this 9/11 mother had dreamed of, but here in Colorado at another site of incomprehensible violence.

I can imagine the souls, after their murders and the indignity of their stay in museums, finally at rest. The ghosts of November 29, 1864, seem gone from here, replaced by the spare tranquility of the land, I decide, watching a delicate orange monarch butterfly dance above the grass.

o o o

Sitting at Sand Creek, my mind also goes back to that other place of repatriation, in Concho, Oklahoma, where the first five massacre victims were buried in 1993. I suddenly feel closer to understanding why the gravestones are cracked and crumbling, seemingly aban-

doned. I suspect many Cheyenne and Arapaho learned what Joe Big Medicine was trying to tell me: that repatriation can give peace to his ancestors, but does not easily heal the living. "I myself will never be healed," Karen Little Coyote, who filled Gordon Yellowman's position, told me. "It's like a close family member, one near and dear, who has died. Once you learn about it, and think about it, your heart doesn't heal. I'll always have that scar of what happened to our people."

I think Joe Big Medicine was saying that these wounds of the soul are not healed by the results of repatriation, but are lessened by the struggle itself to bring kin home. Repatriation is part of the larger battle for cultural survival, joining the fights over street names, and demands for apologies, and the arduous spiritual runs between Sand Creek and Denver. The Cheyenne and Arapaho are not victims. They are survivors—regaining control over their lives by regaining power over their past. NAGPRA does not heal; the process does.

This work of healing is also not yet done because material reminders of the massacre continue to circulate, ensuring the wounds of history stay open. The Thirdsters passed down their scalp trophies as heirlooms.[10] Locals used to scour Sand Creek for artifacts after rainstorms. Plunder from Indian massacres continues to be sold at auction—beyond the reach of NAGPRA because they are privately owned.[11] In other cases, like a blanket that was taken from Chief White Antelope's body, objects are held by museums subject to NAGPRA but are kept because they do not fit the legal definition of "funerary object," which requires that they are "placed" with remains as part of a "death rite or ceremony."[12]

This hill of wild grass is the massacre's beginning point, but not its endpoint. True, finally the place for burial was established here. The Cheyenne and Arapaho can now bury their dead 150 years past that horrifying winter day. But the repatriation area is so large, still so empty. There are more scalps and skulls out there, somewhere. The cemetery is waiting to be filled.

III. RELUCTANCE

Killer Whale Flotilla Robe

13. MASTERLESS THINGS

The concept is profound; for a Tlingit person at.óow embody history, ancestry, geography, social being, and sacred connection. They symbolize who we are.

Rosita Worl, anthropologist and member of the Shungukeidí Clan from Kaawdliyaayi Hít (House Lowered from the Sun) of Klukwan[1]

I have had the greatest difficulty in persuading people to sell. There are endless claimants to the purchase money and I nearly had a serious fight on my hands last Saturday.

Charles F. Newcombe, in a 1901 letter to Franz Boas[2]

Harold Jacobs has a corner office in a nondescript building not far from the airport in Juneau, Alaska. One window opens on to an empty parking lot. The office is dim, with the lights turned off. Outside, the sky casts a steady drizzle. Every horizontal surface in the office is covered with piles of paper. Several heavy wooden crates sit in the corner. These are repatriated shaman objects, so spiritually volatile that the tribe's leaders don't know where else to keep them.

For several hours Harold has been sitting behind his desk, the monitor swiveled so we can both see, scrolling through photographs he has taken of different parties. A party, I was learning, is not a simple social gathering. Rather, it is an everyday phrasing for what is also called a potlatch—a traditional ceremony used to mark signifi-

cant occasions, like deaths, totem pole raisings, name givings, and the transfer of cherished heirlooms. Harold is normally reserved. But prompted by these photos, he is telling me a string of stories about the efforts to perpetuate his Tlingit culture by reclaiming from museums the clan regalia worn at these parties. He has been described by Sergei Kan, a prominent anthropologist, as "better versed in the old customs and . . . more involved in the traditional ceremonial system than most members of his own generation and even some of the older people."[3] Harold Jacobs is among the most successful tribal repatriation workers in the United States. He has repatriated scores of irreplaceable clan objects that would be worth millions of dollars on the open art market.

This clan hat, he excitedly tells me, was repatriated from the National Museum of the American Indian. That robe, Harold laments, he hasn't yet gotten back for the clan, but the Alaska State Museum still loaned it for the party. The images are filled with people young and old, outside in the shadow of totem poles and inside in school gymnasiums. Sometimes people smile while they talk or eat. Other times people are solemn as they dance or give speeches. The hundreds of photographs illustrate Harold's simple but important point: that these objects shouldn't be frozen under glass in a museum, but given to the people who breathe life into them.

Harold suddenly remembers a party from 2008. He taps out a Web address, bringing up YouTube. He searches "Wrangell Stikine Kwaan Mourning Song." The YouTube page loads. Two rows of two dozen people stand shoulder to shoulder in a light-filled hall, the sun gleaming off a polished wood floor, a crowd gathered behind them. Everyone is wearing a traditional robe, most colored midnight blue, decorated with lines of mother-of-pearl buttons, and trimmed in blood-red wool. The video plays. A drum beats out a slow rhythm. The dancers dip to their right and then sway back to the left standing erect, not quite in unison, a serpentine line, the rows gently waving ribbons. It takes a few moments to realize that the people are also singing, a low chant in Tlingit that grows in strength, each voice taking comfort in the one next to it. "This was

the first time," Harold speaks over the video to say, "that the song had been sung at a potlatch in 104 years."

In the Library of Congress several years before, Harold had discovered songs that an anthropologist had recorded on wax cylinders. Harold provided a transcription of the song, so it could be learned by the clan members for this party, which was also a kind of revival, the first potlatch in Wrangell in sixty-eight years. The reason for the party was to welcome home the Killer Whale Flotilla Robe, which had been sold a generation earlier and ended up at the Denver Museum of Nature & Science. The robe was to be received by John Feller—a descendant of the robe's caretaker and the great-grandson of the singer recorded in 1904.

When the video ended, I was struck by how much this moment said about the modern repatriation movement—how it bridges time and transects cultures, how it tangles the lines of good and bad, how museums can be both the cause of cultural harm and a fountainhead for cultural survival: a lost song barely preserved in an archive for a century was used to revive a clan's traditions, sung at a potlatch held in honor of the original singer's great-grandson, YouTube documenting traditional dancers clad in tennis shoes and clan robes, the party held at a new cultural center in a community that hadn't had a potlatch in generations, organized because a natural history museum had curated a sacred robe that was returned to a tribe through a federal law and was ceremonially restored into the care of a descendant whose own ancestor had lost the robe because it was sold against cultural tradition.

o o o

The Alaska Airlines flight from Denver is a roller-coaster ride; it gets even bumpier when we descend into Juneau through swollen clouds. I see the steel-blue ocean meeting a shoreline of snowcapped peaks. The plane threads its way between two craggy pine-covered mountains. Southeast Alaska is a holy alliance of land, sea, and sky.

Several hours later, Harold Jacobs is driving me around, intro-

ducing me to Juneau. Harold is stocky, with a buzz cut and a thin
beard. His most distinctive feature is his speaking style. In response
to each question I ask, he waits an uncomfortably long time, then
answers in a quiet, deadpan tone. I soon learn his intense seriousness
masks a biting sense of sarcasm. Soon enough he is making hilarious
comments, breaking into a wide grin.

As we cruise along the coast, Harold is teaching me about the
Tlingit, a tribe with more than 10,000 members spread across 400
miles of Alaska's southern coastline. Our conversation shifts to his
battles with museums, a conversation punctured every few minutes
when Harold points out where city officials razed this or that tradi-
tional Tlingit communal house over the last century.

"How many are left in Juneau today?"

"None," Harold answers.

The antagonism against Tlingit culture isn't entirely gone. Har-
old tells me about the city's seething racism. Stories of Natives not
being able to rent a place in town. Stories of hate mail in response
to news articles about repatriation. Stories of kids spray painting
"KAN" around town: *Kill All Natives*.[4]

But there are many people fighting back, fighting for Tlingit cul-
ture. After several days of interviews, a friend of Harold's invites
me to a "party" at her son's elementary school, which has launched
a program to incorporate Tlingit culture into the daily curriculum
from kindergarten to fifth grade. When I arrive at the potlatch, fre-
netic kids are playing, wearing Tlingit-patterned headbands and
shirts. There is dancing and singing. Elders give short speeches. Gifts
are handed out to the guests. It's a remarkable event, not in its cul-
tural authenticity but the fact that it's happening at all. Just a genera-
tion before, Tlingit culture and language were actively discouraged
in public education.

At the school party, I am introduced to Nora Marks Dauenhauer,
an admired Tlingit elder, clan leader, poet, and a scholar with an an-
thropology degree. The next day, I arrive at her house on Douglas
Island across the channel from Juneau. We sit at her dining room
table surrounded by family photos on the walls and talk. Nora's

round face is framed by short, gray hair and is often lit by a quick, warm smile. Her intense wisdom and the hints of a regal disposition make me sweat slightly.

"NAGPRA is a good law but lacks teeth," Nora begins. "I was excited by the law because so many of our things are gone." In 2002 Nora had arrived at the Denver Museum with a large group of Tlingit leaders to study the collections. She planned to claim two of her clan's pieces that had been illicitly sold off. A defining memory of the trip for her was when a robe decorated with killer whales was placed on the shoulders of John Feller, another clan leader. "When John wore the robe," she says, "it came alive. The killer whales moved like they were swimming in the sea. Later, I wrote a poem about it." Nora also admits to me that she felt envious because John was ready to take the robe home, while her own clan's materials in Denver hadn't yet been formally claimed.

Although I have never met Nora before, I know her celebrated academic work, which has focused on Tlingit oral tradition. Just before my trip to Juneau, I read one particularly important article she wrote, which explained the Tlingit concept of *at.óow*—pronounced, she said, *utt-oow* (rhyming with: cut two).[5] At.óow, Nora wrote, literally translates as "an owned or purchased thing." The "thing" can be intangible or tangible: the cosmos (like the Milky Way galaxy), a spirit-being, a geographic place, a personal name, an artistic design, a traditional story, a particular object, even the ancestors themselves.

Nearly every communally owned Tlingit object that has been repatriated from a museum is considered at.óow. These things often begin their lives as simple objects, but then are transformed into at.óow through ritual use and ceremonial dedication. They are typically introduced at a potlatch, accompanied by speeches, and publicly "purchased" through exchanges of money, goods, titles, or even in years past with a life when a slave would be killed. When the owner or caretaker dies, the thing becomes *l s'aatí át*—a "masterless thing." That is, "an object with no owner." The thing then is cared for by the *híts'aatí* (housemaster), a formal position typically passed from uncle to nephew. Although one person is the formal caretaker,

the object is considered the property of the entire clan. "By this process," Rosita Worl, a Tlingit with a Harvard PhD in anthropology has written, "the transmission of property parallels the transmission of office."[6]

Nora goes on to say that one may wear one own at.óow—for at.óow like robes and hats—but it is a greater honor to invite others to wear it. Especially when it's placed on children, they learn about their culture; it connects them to their ancestors, and thus strengthens the ties of community and family. "When we put the at.óow on our grandchildren, we wrap them in our care," she says. "When we wear at.óow, we know that our ancestors are present." As one scholar has observed, at.óow "effectively constitute a fourth dimension of Tlingit personhood"—meaning that "these adornments literally extend and project the person as a social being."[7]

To the Tlingit, at.óow is beautiful art, but it is much more. It is entwined with oratory, song, and dance. It is identity made material. When Nora asked her mother, Emma Marks, why at.óow is so important, she simply answered, "At.óow is our life." Actually the Tlingit phrase Emma used was *haa ḵusteeyí*, which can be translated as "our culture," "our way of life," or even simply "life."

For good reason, the party at the elementary school the previous day pleased Nora. "The kids were so happy yesterday," she tells me. "It's their history. Art is the identity of our people. When the kids learn about it they grow. They grow taller." It's not surprising that Nora doesn't like seeing clan objects in museums. "It makes me feel bad," she says. "It's just *silent* on the dummies." She means on the manikins in dioramas. Nora tells me that repatriation has a special role to play in the survival of Tlingit culture. She explains that the Tlingit are already connected—culturally, spiritually—to their past. They just need to connect to the at.óow that is hidden away from them in museums.

But, I ask, wasn't it the Tlingit themselves who often sold at.óow to art dealers and museums?

"When there was a shortage of money, they'd sell them," Nora admits.

But she insists that I have to put such decisions into the context of the times. Poverty. Boarding schools. Elders who didn't believe in their children. Children who didn't believe in their elders. Everyone believing their culture had taken its final breaths.

"And the churches thought that at.óow were the works of Satan!" she exclaims. "Even twenty-five years ago, the churches would get people to burn at.óow." She shakes her head in disbelief. Her eyes flare. "That's burning your identity—burning your soul!"

o o o

In 1741 Russian explorers "discovered" Alaska—the year Europeans finally met the Native peoples who had been living along the northwestern shores of North America for more than 16,000 years.[8]

By the early 1800s, hundreds of European ships had come to trade with the Tlingit and their neighbors, bearing iron and copper tools, wool blankets, and tobacco, and left laden with furs—otter, beaver, wolves, wolverines, fox, bear, lynx, muskrat, mink, and squirrel.[9] During these encounters, some of the foreign traders also picked up, as they called them, "artificial curiosities"—Tlingit objects of art, ceremony, and everyday life—which were then dispersed throughout Europe, placed in curiosity cabinets or added to the first national museums.

Soon after Russia sold Alaska to the United States in 1867, the Smithsonian moved to obtain Tlingit objects to represent the nation's newest territory. The museum sponsored a thirteen-month-long collecting expedition for an exhibit on "Indianology" at the upcoming centennial exhibition in Philadelphia, celebrating the United States' 100th birthday. The 8,000-square-foot exhibit— which included 500 Northwest Coast objects presented in orderly columns of glass-fronted walnut-cases—appalled visitors. Most had never seen or even imagined objects that presented such a stark contrast to their own cultural vision of the world. As the editor of the *Atlantic Monthly*, William Dean Howells, opined, the exhibition proved that the American Indian was not artistic but on the contrary

"a hideous demon, whose malign traits can hardly inspire any emotion softer than abhorrence."[10]

Yet such repugnance to the exotic otherness of Northwest Coast art ultimately compelled, rather than stemmed, more collecting. Prices rose, increasing the incentive for Tlingit to help gather pieces. By the 1880s, the region was targeted by most of the world's major museums, leading to intense competition between curators. One of the most avid collectors was Lieutenant George T. Emmons, who was posted aboard the USS *Adams* in 1882 to patrol southeastern Alaska's waters. A collector and freelance dealer, he sold thousands of items to the Smithsonian, the American Museum of Natural History, and George Gustav Heye's Museum of the American Indian, everything from masks to baskets to instruments to even "a small box containing only human excrement, a son's first stool left by the mother in the forest so that the boy might grow up strong and powerful."[11]

In a kind of catch-22, modern civilization was destroying the very culture that the modern museum hoped to preserve. In the 1880s numerous social, political, and environmental pressures were diminishing the Tlingit's options for survival. Canneries began opening, undermining traditional fishing and forcing the Tlingit to stop their seasonal fishing rounds and enter the cash economy as laborers. Soon there were teachers moving children to boarding schools, lumberjacks liberating the mountains of their forests, and prospectors forging a path to gold rushes. Tourists began pouring into the area, thanks to Canada's recently completed Pacific Railway, leading to the growth of a "curio market" for local artists but also creating so great a demand for Native objects, it was reported in 1889, "that the natives had commenced to despoil the graves of their own relatives" to loot for salable belongings.[12] All of these interactions with outsiders amplified diseases (such as smallpox, tuberculosis, and influenza). To make matters worse still, the Tlingit had no reservations, no special government protections. They were not even American citizens and so couldn't vote, acquire land or mineral rights, or even get a mariner's license.

Christian missionaries started to convert Tlingit and often encouraged them to discard the sacred instruments of their old religion.[13] In other cases, collectors considered themselves lucky to find villagers "just abandoning heathenism and selling off their ceremonial property."[14] In Alaska the government helped the Tlingit in Kasaan move to a new village with a cannery, on the condition that they abandon their dances and the potlatch.[15] More objects entered the market after the potlatch became illegal in Canada in 1884.[16] The anthropologist Franz Boas lambasted the Canadian law, arguing that the ceremony is "so intimately connected with all that is sacred to the Indian that their forced discontinuance will tend to destroy what moral steadiness is left in him."[17]

The potlatch lies at the cultural heart of Northwest Coast cultures. As the Kwakwaka'wakw chief Robert Joseph once said, "The potlatch gives definition to our world."[18] A ceremony found in tribes spread more than 1,500 miles between Washington and central Alaska, the potlatch is an extravagant feast in which ancestors are remembered, the living are celebrated, social bonds are reaffirmed, and clan regalia is publicly presented. The word *potlatch* is an Anglicization of the Nootkan phrase *p'alshil'* meaning "to give." In Tlingit the events are called *koo.éex*, which translates as "invitation," pointing to the ceremony's social ends. Years can be spent preparing for a koo.éex, which can last a day or a week of near-constant speeches, songs, dances, feasts, and gift-giving. Hosts and attendees use the potlatch to garner prestige through their acts of generosity. Giving is the central feature of the potlatch, in which debts and credit are received and paid. "The more lavish the food and gifts," one scholar has noted, "the more respect earned for the host."[19]

Throughout, the koo.éex involves the balancing between the Raven and Wolf-Eagle moieties (the two-part division of the Tlingit people; "moiety" means one of two parts), and the smaller social groups, the clans (*naa*) and the communal houses (*hít*) owned by each clan. (The notion of a unified Tlingit "tribe" is a modern invention.) Unlike Western convention, the Tlingit are matrilineal—individuals trace their descent through their mothers. Clan prop-

erty is not passed from father to son, but from uncle to nephew. The potlatch affirms this social and political order, honors the ethics of mutual support between communities, redistributes wealth, and reflects a deeper belief in the balance that must be maintained in the universe.

The potlatch is also where at.óow—in the form of button blankets, Chilkat robes, headdresses, hair ornaments, war helmets, daggers, shields, masks, drums, rattles, ceremonial spoons, carved boxes—are presented. Songs, stories, and recounted lineages accompanying these objects serve to affirm their status and validate clan rights to them. "The more often the group presented its crest objects at potlatches, the more worth those objects accrued—and the greater the prestige of the family that owned them," the art historian Aldona Jonaitis has described.[20] The presentation of at.óow by the opposite moiety "bound together the two moieties in an ongoing series of validations of each other's worth."[21]

The Canadian ban on potlatches threatened to crush the social order of the Northwest Coast tribes. Although the ban was not strictly enforced for several decades, in 1913 the first Indians were successfully prosecuted under the law. The real threat of prosecution turned some traditionalists into willing sellers, since they assumed clan objects could not be used again.[22] The most dramatic intercession occurred at the end of 1921, among the Tlingit's neighbors, the Kwakwaka'wakw in British Columbia, when Dan Cranmer held a massive six-day potlatch in which thousands of dollars of goods and cash were given away. The local Indian agent, William M. Halliday, enlisted the Royal Canadian Mounted Police to arrest twenty-nine participants. A plea bargain was made with the magistrate—a position Halliday himself also happened to occupy—in which the prison sentence was suspended if all the potlatch materials were surrendered. The 450 objects were soon on display in Halliday's woodshed. New York collector George Gustav Heye, who just happened to be passing through at the time, bought five pieces for $291. The rest of the materials were shipped to the National Museum in Ottawa. An anthropologist valued the collection at $1,456, and the

government dispensed this amount to community members. Halliday later noted that some Indians regarded the payments as "entirely inadequate."[23] The potlatch ban in Canada was not lifted until 1951.[24]

o o o

The anthropologists, collectors, and museum men entering Tlingit country in the late 1800s believed they were not a brood of vultures but vital witnesses to a swiftly fading culture. "The old houses have disappeared, the old customs are forgotten, the old people are fast passing," Emmons decried, "and with the education of the children and the gradual loss of the native tongue, there will be nothing left to connect them with the past."[25] The famed anthropologist Frederica de Laguna deftly defended Emmons, noting that it was "the Native themselves who sold the artifacts" and arguing that Emmons saved many precious clan treasures that otherwise would have been lost, blithely sold to tourists, or destroyed in the wildfires that plague Alaska. "It was in museums," she finally concludes, "that the beautiful art of Northwest Coast tribes, and of other Native Americans, was discovered by the outside world. This brought international respect and honor for its creators."[26]

The Northwest Coast became a magnet for nearly every serious art and natural history museum. In 1905 R. Stewart Culin took a break from collecting in New Mexico at the Pueblo of Zuni and traveled to Alaska because he believed the Tlingit "could give immediate results" to expand the Brooklyn Museum's storehouses.[27] He was not disappointed: he purchased 182 pieces.

However, after more than a century, Alaska was quickly becoming "thin country" for collectors, as historian Douglas Cole has recounted. "The great harvests of the museum scramble, the ravages of fire, climate, and pests, and the breakdown of traditional societies and usages, meant an inevitable decline of supply," Cole writes. "The pace of culture change, of the integration of the Northwest Coast natives into European economic and cultural systems, seemed remorseless."[28] When he returned several years later, Stewart Culin,

among America's most rapacious collectors, could find little that interested him. He left empty-handed.

Although a few communities—especially those isolated by the sea, mountains, and cold—could cling to cherished traditions, most were forever changed. Ironically, just as Tlingit culture was on the verge of fading, its material expression gained prominence in the "primitive" art market, with the success of early exhibits at the Brooklyn Museum and the Denver Art Museum, and later at the Museum of Modern Art in New York. By the 1940s, the Northwest Coast art market was largely restricted to recycled and resold older collections and new tourist pieces. Although the most intrepid dealers could still find a few hidden treasures.

14. CHIEF SHAKES

Under a dark stormy sky, the fifty-foot war canoe approached Shakes Island.[1] More than a dozen Tlingit men dressed in their finest regalia sang and chanted while rowing the boat into Wrangell's placid harbor. Charley Jones stood at the stern of the canoe, which had a killer whale painted on its underside. At seventy-six years old, Jones remained stout and steady. He wore round eyeglasses and had a wispy graying mustache. He held a staff and donned a wooden hat, both carved into killer whales. Jones had the noble air of a prince waiting for his coronation.

As the war canoe neared the shore, Jones turned his back and placed his hands on his hips to show the waiting crowd his magnificent Chilkat robe, worn over a suit and tie. Flowing over his back, the robe presented twelve killer whales swimming together in a flotilla. The robe's long fringes, which alternated in bands of natural white and dyed copper green wool, swayed and danced around his ankles. Although the robe belonged to his clan, it had been sold years before. To wear it now, he had to borrow it from a local curio dealer.

In this summer of 1940, hundreds had gathered for a potlatch, in which Charley Jones would become Shakes VII, a title handed down through the generations. The white people in the audience now gathered before him in the auditorium believed Jones was the new "chief." It was a poor translation for the three traditional leadership positions Jones held: he was a *lingit tlein* (big man), *hits'aati*

(housemaster), and a *naa shaadeihani* (one who stands at the head of his people). Jones was a "big man" of his clan and community; he was the keeper of the Mudshark House's treasures; he was his clan's leader. Additionally, "Shakes" was a hereditary title he was to receive.[2]

From the stage he gazed out over the hushed crowd, standing room only, packed into the hall. Jones counted maybe 100 Tlingit there; the rest were white faces, including a few important ones, he was told, like the Alaska governor, a federal judge, state politicians, and top officials from the U.S. Forest Service and Bureau of Indian Affairs. It must have struck Jones how peculiar this moment was—an extraordinary confluence of government control, economic opportunism, and a last-ditch effort at cultural preservation.

Rising to speak before the crowd "stately and dignified," as one reported recalled, Jones reluctantly accepted the title.[3] "It is not my wish to be elevated to the venerable position of Shakes," he said, a translator conveying his words in English, "but would agree to the wishes of my people and accept that honor."[4] He promised to be a fair leader and concluded by telling the Tlingit they should be content as Americans, given the terrible world war that was brewing. He sat back down, now as Shakes VII.

The title of Shakes reaches back three centuries. In the 1700s, the Tlingit were at war with the Nisga'a and Tsimshian Tribes.[5] During a climactic battle, the Tlingit clan leader, Gushklin, outmaneuvered his enemy, Wiisheyksh. Rather than becoming Gushklin's slave, Wiisheyksh surrendered his name—shortened to *Sheyksh*—along with his hat and war canoe, both adorned with the killer whale.

In the decades that followed, the Shakes lineage was celebrated for its powerful leadership; it was a title that only grew in prestige with the fur trade. In 1822, according to traders, Chief Shakes was considered "the greatest chief of the Northwest Coast."[6] In 1833 the Russians built a fort, Redoubt St. Dionysius, in Wrangell Harbor. Wanting to assert his own presence, consolidate forces, and establish trade relations with the Russians, Chief Shakes IV moved his entire clan, the Naanya.aayí, to an island in Wrangell Harbor and

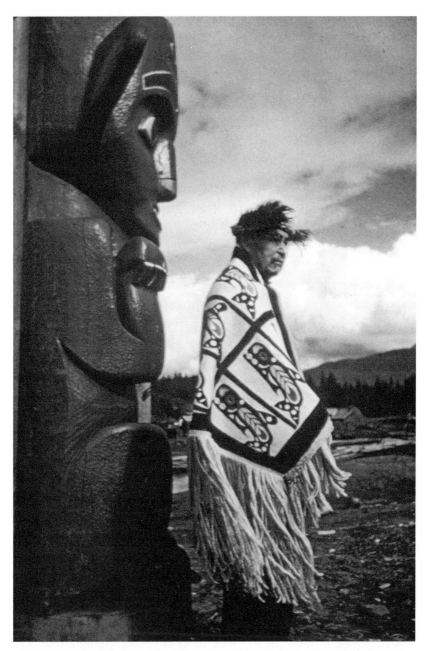

FIGURE 7. Chief Shakes VII wearing the Killer Whale Flotilla Robe. Courtesy of Alaska State Library, Dora M. Sweeney Collection, ASL-P421-237.

built a new clan house. The chief thrived and grew powerful. He was so rich that even some of his 200 slaves owned slaves. It was said this Chief Shakes held eight potlatches in his lifetime, more than any other Tlingit. The house's magnificent art—totem poles, a giant carved screen of a bear, and house posts—publicly linked the clan to the mythic creatures and lineages that legitimized the clan's territorial rights.

The power of the Shakes line began to decline after the Americans arrived in 1867. Chief Shakes VI received his title in 1878 and immediately faced challenges to his authority. Slaves were then among the most important symbols of wealth. But the Emancipation Proclamation had ended all forms of slavery in the United States, including the Shakes's slaves, who were members of enemy tribes. Potlatches, the event in which power was secured by giving away one's wealth, were now infrequent, due to the influence of missionaries. Shakes VI was himself particularly swayed by the missionary S. Hall Young, who railed against traditional religion and shamanism.[7] By 1888 Young bragged that the "old fashions" had been eliminated, potlatches and other practices completely "put down," the old community houses replaced by "neat cottages."[8] Shakes VI tried several times to advocate for Tlingit land rights, but he failed.[9] In 1916 Shakes VI died, a man torn between his elevated role as a traditional leader and a new society that diminished the traditional at every turn.

<p style="text-align:center">o o o</p>

Following Tlingit tradition, when Chief Shakes VI died in 1916, his maternal nephew (his sister's son) Charley Jones ensured that the departed chief received proper respect by organizing the funeral. "I was chosen by the people of the Naanya.aayí family to be the new chief," Jones, known among his Tlingit kin as Kudanake, later said. "It was the custom, by our tribal law, for the newly chosen chief to pay all the funeral expenses of the late chief, give a feast, and then inhabit the old Shakes community house on Shakes Island."[10]

Just as Jones was preparing to receive the title of Chief Shakes VII, a lawsuit was filed that pitted U.S. law against tribal law. In the early 1900s, Christian reformers sought to end various Tlingit traditions, among them matrilineal inheritance—the passing of property from uncle to nephew.[11] Tlingit oral history, as Harold Jacobs explained, records that Chief Shakes VI "was ordered to will his estate to his children, and told that if he willed it to his nephew it would not be honored."[12] A newspaper article from the time affirms that Mary Shakes wanted the Shakes line to go to her son, George, rather than to her nephew, Charley Jones.[13] The lawsuit established that according to U.S. property law, it was Shakes VI's wife, Mary Shakes, who should inherit the estate.

"I did not know that Chief Shakes had made a will," Jones explained about his predecessor. "He often told me, in the presence of witnesses, that it was already decided by the people that I was to succeed him. That will was made secretly, and the man who wrote the will was J. C. Clark, the Presbyterian minister. He was appointed executor of the will. We Naanya.aayí people believe Clark persuaded Chief Shakes to make his will that way but that it was not Shakes's true desire to renounce his tribal customs and friends."[14]

Jones was hardly a person not to fight for his rights. As early as 1914, he was campaigning for a school for Native children in his hometown and became the "father" of the Wrangell Institute, a boarding school.[15] In 1922 Jones went to vote. He was denied a ballot because he was Tlingit and arrested for "falsely swearing to be a citizen."[16] (Until 1945 an Alaskan version of "Jim Crow" held sway—banning Natives from many public buildings, jobs, and schools.)[17] In the trial that followed, the prosecution argued that Jones was not an American because he was "an illiterate who took pride in being the successor of Shakes."[18] Jones's lawyer in turn argued he had become "civilized" since he paid taxes, sent his kids to school, purchased bonds, and donated to the Red Cross. Jones won the criminal case and the right to vote, two years before all Native Americans were granted citizenship and enfranchised. (Even then, many state constitutions prohibited Native Americans from voting; it was not until a

definitive 1962 court case in New Mexico that Native Americans in every state gained the right to vote.[19])

Jones may also have strategically avoided the mess of the lawsuit with Mary Shakes. According to one source, "Kudanake gained stature by remaining aloof from the court litigation over the old chief's property."[20]

Jones believed his title would eventually be recognized. He recounted that when Shakes VI died, he had been away from Wrangell but had returned immediately. Jones later testified that Mary Shakes, the chief's widow, "told me she was going to leave everything in my hands. She sent out for other Natives to witness this agreement. William Shakinaw and William Tamaree were the witnesses. The Chief was laying there in the house without a coffin, so I bought him a coffin. I got people to dig the grave. I hired people to sit up and watch the body, which is our custom. After I furnished everything and paid for everything, then they ignored me."[21] Jones lost the case.

In the years that followed, Mary's family lived in the clan house on Shakes Island, "showing tribal relics to tourists for a fee."[22] Around 1935 she sold part of the island to Axel Rasmussen, superintendent of Wrangell Public Schools. The house served as Rasmussen's studio and then as an exhibition space to display his magnificent collection of Tlingit artifacts. Rasmussen eventually abandoned the island. "The house looked as if marooned and forsaken in the midst of a cannery town," one passerby remarked in 1939, "and the people considered it a crestfallen memorial of the past."[23]

o o o

The dilapidated clan house on Shakes Island soon became the focus of a New Deal program. The Civilian Conservation Corps was formed to offer work to the unemployed and preserve the American landscape amid the Great Depression. John Collier, the director of the Bureau of Indian Affairs, embraced the CCC as a jobs program as much as a way to promote Native arts. In the Northwest Coast, one of the CCC's major efforts, administered by the U.S. Forest Service,

was to restore, duplicate, and create 121 totem poles.[24] Many of the young Tlingit men who were hired were reintroduced to their culture by this government program—since totem poles raisings had petered out in the early 1900s, largely due to government pressure to end the traditional practice.

In Wrangell the Women's Civic Club and Library Association pushed for restoration of the Naanya.aayí clan house and its four poles on Shakes Island, crafted by a famous early nineteenth-century carver named Kaajísdu.áxch. The Wrangell City Council bought Shakes Island and then transferred ownership to the Bureau of Indian Affairs. A non-Native architect with the U.S. Forest Service was put in charge. He hired a number of local Tlingit, including Charley Jones, to bring the building and totem poles back to life.[25]

When the work was completed, government administrators decided that a potlatch should be held to reopen the island and dedicate the restored house—a ceremony the Tlingit call *hít wóoshdei yadukícht* (dancing the joints of a house together).[26] And perhaps, they reasoned, it would be a bigger and better event if Charley Jones could be installed, finally, as Chief Shakes VII. Jones was approached.

"I don't understand white people," Jones confided to a friend. "A few years ago, they arrested me for voting, telling me I was only a Native. I had to prove I had given up our old Native ways. Now they want me to be a Native. They call me 'Chief' Shaksh. Can you explain it?"[27]

Still, Jones agreed.

"I am willing to forget," he said about the furor surrounding his predecessor's will. "I want to see the government have the Shakes Island, so that our things will be saved for the future generations."[28]

A company, Wrangell Potlatch, Inc., was formed to oversee the event and was guided by a committee of twenty prominent local citizens. Ed Keithahn, a non-Tlingit anthropology student turned journalist, was hired to run it. Dances were held to raise the $2,000 needed for the event, but most of the money came from the local Chamber of Commerce. An official invitation was mailed to President Franklin D. Roosevelt, whom Jones called the "Big Chief of

White Brothers."[29] A U.S. Forest Service boat was put at Jones's disposal as he was ferried around southeast Alaska to personally invite Tlingit to the potlatch.

The potlatch doubled Wrangell's population. More than 1,500 people—including 500 from nearly every Tlingit village in Alaska—arrived in Wrangell on June 3, 1940, for the potlatch's two days of speeches, games, dancing, and feasting. It was hugely successful. The restored clan house looked magnificent. A new massive screen carved into a bear rose at the entrance. Three fully restored totem poles stood as sentinels. The governor of Alaska, Ernest Gruening, ignored his government's history of suppressing Tlingit culture and celebrated the moment. "You are keeping alive an ancient culture which should never be permitted to be forgotten," the governor said.[30] Jones gave the governor the Tlingit name Kush and adopted the entire Wrangell Chamber of Commerce into the Naanya.aayí Clan, a cultural mechanism to balance their generous financial support.

Supporters hoped that the potlatch would become an annual event, but the momentum faded. Only a few more intermittent efforts at restoration in the following decades led to sporadic celebrations.[31] In the late twentieth century, it was possible for a Tlingit child to grow up in Wrangell and not even associate the potlatch with her culture at all.[32]

o o o

The Killer Whale Flotilla Robe that Jones wore for his coronation was made sometime around 1890, during the reign of his predecessor, Shakes VI. In Tlingit the robe is named *Kéet Xaa Naaxein*. Killer whales (*kéet*), abundant in the North Pacific, are revered by the Tlingit for their intelligence, devotion, and strength. Traditionally, the animals are considered akin to humans, the reincarnations of chiefs.[33] The word *xaa* has a double meaning that reinforces the symbolic link between the killer whale and man's embodiment of the animal's power; *xaa* refers to a pod of killer whales—and a flotilla of canoes, a Tlingit war party. *Naaxein* means "fringe around the body," the

Tlingit word for the shoulder-style robe with its distinctive sweep-
ing tassels. The robe recounts the Tlingit's battle with the Nisga'a
and Tsimshian, in which Chief Shakes took his name.[34]

In English the robe is called a Chilkat-style blanket, named be-
cause of its master weavers in the Chilkat Valley, the river valley
that includes the villages of Klukwan and Haines, which became
celebrated for their art in the 1800s.[35] Women from high castes as-
sumed the role of weavers, while men typically created the designs
and hunted the mountain goat for its downy wool. The weaver spun
the wool with shredded cedar bark, creating an intensely soft and
lustrous yarn. The black color was a dye of charcoal or graphite. The
blue-green came from copper salts. The pastel yellow yarn was dyed
from lichens or fungi. (Although by the 1890s, many of the yarns
used in the traditional robes were made with commercial dyes.) The
robe was woven on an upright loom by twining the yarn into a dense
textile, with thin raised ridges for the designs of animals, spirit-
beings, and symbols. It is believed Kéet Xaa Naaxein was woven by
a woman named Cacaydayat. It would have taken her a year of ardu-
ous, patient work, weaving the robe with her fingers, creating the
intricate motif of twelve killer whales. Chilkat blankets are among
the most prized objects in Tlingit society. They are worn at public
ceremonies and drape the dead at funerals.

Kéet Xaa Naaxein was made at.óow, belonging to the Shakes
line, the property of the Naanya.aayí Clan, Mudshark House of
Wrangell. But when Chief Shakes VI died in 1916, his wife, Mary
Shakes, not only inherited the clan house on the island, but also all of
the clan at.óow. Even just days after his death, Mary's family was ne-
gotiating for the sale of the chief's war canoe.[36] It is unclear if she was
motivated by need or greed, or despair about the Tlingit's future or
a genuine rejection of Tlingit matrilineal tradition. In any case, most
of the prized pieces were sold to Axel Rasmussen and Walter C.
Waters, a curio shop owner in Wrangell.[37] By the time Mary died in
1937, more than eighty years old, all of the Naanya.aayí Clan's trea-
sures under the stewardship of the Shakes line were gone.[38]

The Chief Shakes pieces collected by Rasmussen and Waters

ended up at Seattle's Burke Museum, the Portland Art Museum, and the Denver Art Museum.[39] The bear screen that once graced the clan house's interior is still prominently on display at DAM. (Other clan items from Chief Shakes ended up at DAM, including a hat depicting a raven, a shirt, a button blanket, and an elaborately carved bentwood box.[40])

The disposition of other pieces has been more tortuous. A rattle that had belonged to Chief Shakes was stolen from the Burke Museum's exhibit hall in 1964.[41] In 1954 DAM traded a different Shakes rattle, which was later sold, then stolen, and finally recovered in the ski resort town of Aspen, Colorado, during an undercover sting in 2002.[42] Still today, pieces from the Walter C. Waters Collection occasionally appear at auctions, selling to the highest bidder.[43]

o o o

The art dealer Michael R. Johnson, who eventually sold Kéet Xaa Naaxein to the Denver Museum of Nature & Science, claimed that Charley Jones—Chief Shakes VII himself—sold the Killer Whale Flotilla Robe. Johnson signed a contract affirming that Jones sold it "around 1945–46 to a Seattle dentist" named "Mr. Waters."[44]

But if the 1945–46 date is correct, then Jones could not have sold the robe. He died in 1944.[45] Given this blunder, it is also suspicious that the unknown Seattle dentist that Johnson refers to ("Mr. Waters") shares the same name as the known curio dealer in Wrangell (Walter C. Waters). Walter C. Waters was also the chairman of the Display and Exhibits committee for the 1940 Wrangell potlatch.[46] It is well established that Walter C. Waters bought and sold Chief Shakes regalia and even the war canoe that Jones rode to his coronation in 1940.[47]

"Mr. Waters" was also more likely in Wrangell than Seattle because the next owner was Amy K. Churchill. Amy lived in Wrangell and likely purchased the Killer Whale Flotilla Robe out of sentiment. Her father, James Bradley—also known as X'a.áxch and

Keishíshk'—was a claimant to the Shakes VIII title. Around 1965 Amy passed the robe on to her daughter, Emma Frost.

In 1970 a man named Jonathan DeWitt—a nephew of Charley Jones—took the title of Chief Shakes IX.[48] DeWitt raised a forty-five-foot totem pole at the event and was able to borrow Kéet Xaa Naaxein from Emma Frost. A photo from the event shows DeWitt smiling blissfully, wearing the clan robe.[49] It was the last time it was worn ceremonially. In the summer of 1973, Emma Frost sold the robe to Michael Johnson. Three months later, Johnson sold it to the Denver Museum for $25,000. The museum immediately set out to create a new exhibit case that would feature the magnificent robe.

Michael Johnson's claim that Charley Jones originally sold the robe is not insignificant. Its truth would establish whether Jones considered the weaving as clan or personal property. The art dealer used his claim to argue that the robe's title was undisputed when he was negotiating with the Denver Museum. "Since the blanket was originally sold by Chief Shakes," Johnson wrote, "there is no clan or tribal claim to the piece which would encumber its ownership."

It seems that the Denver Museum staff believed him.

15. JOHNSON V.
CHILKAT INDIAN VILLAGE

*Property becomes part of our very being, and cannot be
wrested from us without wounding to the quick.*

Jeremy Bentham, *Principles of the Civil Code*[1]

Michael R. Johnson waited in a room at the Thunderbird Hotel, in
Haines, Alaska, on the night of April 22, 1984. He must have been
anxious. For nearly a decade, Johnson had stalked this rare collec-
tion of artifacts. Now they were almost in his hands.

While Johnson waited, Bill Thomas cautiously drove his truck
down Klukwan's main street. He parked in front of the Whale
House.[2] Klukwan was quiet. Most of the village's 140 residents were
in Haines playing bingo. Bill was soon joined by his great-uncle
Clarence Hotch, his brother, and several other villagers. The Tlingit
men hurriedly entered the concrete building and stood before the
objects that had been the center of more than a century of conflict:
four elegantly carved posts and a massive wood panel, twenty feet
long and ten feet high, called the Rain Screen.

Then thirty-six years old and the village's chairman, Bill never
saw himself as a thief. Rather, he was a Tlingit traditionalist. "We
were raised under an uncle system that was very strict," Bill later

testified in court. "We did what the uncles told us." Bill was also motivated to rescue the carvings from the derelict Whale House and have them preserved as museum art pieces. Though, of course, his family's decision would also make them very rich.

In Klukwan, a tiny Tlingit village nestled against the Chilkat River, most of the clan houses were built in the late 1800s in an ornate Victorian style; a century later most were crumbling, rotting. The Whale House's own decay belied its illustrious origins. In the early 1800s, Xetsuwu, a prominent leader, decided to erect a new council house to reunite his fractured clan, the Gaanaxteidi.[3] Xetsuwu commissioned a famous carver named Kaajísdu.áxch, who had gained renown for the posts he crafted for Chief Shakes, 275 miles south in Wrangell. Residing in Klukwan for a year, the carver was paid in scores of blankets, fifty cured moose skins, and ten slaves.

Four spruce trees were felled and sawed into nine-foot-long posts. Day by day, human, animal, and spirit figures emerged from the wood—each post telling a clan legend.[4] Then planks were cut and sewn vertically together into a single colossal screen. Kaajísdu.áxch etched the smooth surface in low relief to represent the spirit of the rain. The posts were raised to support the house's roof; the screen, erected in the house interior, separated the public area and the sleeping chamber of the housemaster. The screen was entered through a round hole in the navel of the rain spirit—a symbolic boundary, one art historian has written, "like a passage into its womb" so that when the chief "enters into that womb, he becomes engulfed by the crest-being, and separated from the profane world."[5]

Soon after the Whale House was completed in the early 1800s, the Gaanaxteidi Clan along the Chilkat rose to become among the most powerful in southeast Alaska, controlling a vital trade route between the northern interior and the southern sea. In 1899 the next leader, George Shotridge, began construction for a new Whale House. A mudslide obliterated it a decade later, although Kaajísdu.áxch's irreplaceable sculptures were miraculously unscathed. In 1938 a lavish potlatch opened the next iteration of the Whale

House, this one made of concrete. It would withstand decades of mudslides and fires, but not, ultimately, the desires of collectors.

Bill Thomas, Clarence Hotch, and the other men gingerly lowered the house posts and dismantled the Rain Screen, packing them in rolls of old carpet and loading them onto their idling trucks. They tried to lift a fourteen-foot-long communal serving dish, but it began to disintegrate, so they left it behind. The men, still nervous but relieved that no one saw them, sped twenty-one miles south along Highway 7 to the town of Haines until they reached the Thunderbird Hotel, where Michael Johnson was waiting. He planned to sell the pieces for more than $1 million.

o o o

The events surrounding the Whale House treasures provide a unique view into the methods of Michael Johnson and others, whose dealings also led to the acquisition of objects by the Denver Museum. The controversy that the Whale House inflamed tells the story of how the Tlingit have long had to struggle between the temptation of money and the demands of culture. The conclusion of the Whale House saga would also establish important legal precedents that could be used to claim Tlingit clan property from museums across the United States.

Michael Johnson succeeded where many before had failed, beginning with the collector-anthropologist Lieutenant George T. Emmons, who declared that the Whale House's Rain Screen was "probably the finest example of Native art in Alaska."[6] Emmons vainly struggled to secure the Whale House's treasures. He found the prices exorbitant, the myriad ownership claims too complex to reconcile, and many items simply not for sale. "Another generation will have to go," Emmons concluded, before they could be acquired for a museum.[7]

But the next generation of Tlingit caretakers proved just as frustrating. In 1902 Charles F. Newcombe traveled to Chilkat country and was offered the contents of the Whale House for $1,500 (a price

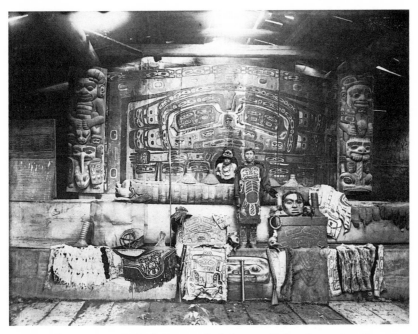

FIGURE 8. Interior of Whale House of Klukwan, Alaska, about 1895. Courtesy of Alaska State Library, Winter and Pond Collection, ASL-P87-0013.

he thought laughably excessive), and, anyway, like Emmons he soon discovered there were rival claimants in Klukwan "who still threaten trouble to the seller and to myself" and that still other items could not be sold, according to Tlingit custom.[8]

Perhaps the closest anyone came to removing the Whale House's prizes to a museum was Louis Shotridge, who had the distinct advantage of birth. He was born to George Shotridge, the keeper of the Whale House in Klukwan for the Gaanaxteidi Clan.[9] In 1905, when he was twenty-three years old, Louis met George B. Gordon—Stewart Culin's replacement as curator of ethnology at the University of Pennsylvania Museum.[10] Gordon purchased sixty-seven objects from Shotridge and began corresponding regularly. After a short tour as a tenor with an Indian opera company, in 1911 Shotridge was hired as a staff member. He took business courses at the university while cataloging the museum's Alaskan collections and creating new exhibitions. Shotridge even found the time to go

hunting with Theodore Roosevelt.[11] Four years later, his training complete, Louis was promoted to assistant curator and was sent to Haines, where he became the first Native American ever to lead an ethnographic expedition.[12]

Shotridge was a success. Using his family's privileged connections, the museum's capital, and his ability as a cultural broker, Shotridge was able to acquire some of the rarest and most sought-after clan objects over the next seventeen years. "I know where most of the important things are," he bragged to Gordon, "and my only obstacle is the everlasting esteem of the native owner for them."[13] As early as 1906, Shotridge was boasting that he could acquire the Whale House's best items, asserting that his father's position as híts'aatí (housemaster) would facilitate a sale. But the purchase would also need more than his father's authorization. Emmons had warned long before that the Whale House's clan objects "could only be purchased through the consent of all and by the payment of each one."[14] Every clan member would have to agree to the sale. Shotridge's determined efforts to obtain clan treasures in spite of these cultural protocols would perhaps cost him his life.

In 1922 Shotridge called together the Gaanaxteidi. Shotridge offered to buy the Whale House's contents for the University of Pennsylvania Museum. He was authorized to pay them $3,500. Shotridge argued that the money would help the Gaanaxteidi build a new clan house, and that placing items in the museum would "put these old things to do the best part in presenting our history to the modern world."[15] With his father now passed on, Shotridge claimed his patrilineal inheritance rights (under U.S. law) and also tried to have his uncle (his father's brother) installed as the Whale House keeper.

The Gaanaxteidi refused to buy his arguments that they should sell their culture. They saw Shotridge as an interloper since he belonged to his mother's Kaagwaantaan Clan. Shotridge fumed until at last he resolved to steal what he believed was rightly his. Once the objects had shipped from Alaska, he knew the clan members could never recover them.

Shotridge's methods were harsh, but he embraced the vision

of museums "saving" objects, earnestly believing that museum exhibits publicly validated Tlingit culture. Shotridge was used by the museum community because of his insider status, but he also "turned this imposition of an authentic identity into one more appropriate to his own ambitions."[16] "Like all men who have a desire to accomplish something," Shotridge once wrote, "I hope to live to see the day when these old things (each of which has long held the reverence of my people) will help to bring the true character of their makers into the White man's light."[17] He also genuinely believed that amidst American colonialism, the Tlingit would be better off embracing their collective tribal future rather than clinging to their clannish past. "The ceaseless roar of modern civilization," Shotridge wrote, "is now too great."[18]

Still, Shotridge was often acutely unsettled by his occupation. He once recounted buying his own clan's oldest object, a wood helmet carved into an image of a shark. After paying the keeper, an old woman, $350, Shotridge bewailed that she "could do nothing more than weep when the once highly esteemed object was being taken away." "The modernized part of me rejoiced over my success in obtaining this important ethnological specimen for the museum," Shotridge reflected in a letter, "but, as one who had been trained to be a true Kaagwaantaan, in my heart I cannot help but have the feeling of a traitor."[19]

After the failed vote for the Whale House at.óow, Shotridge allowed the community to "quiet down." The next year he furtively arrived in Klukwan, but his co-conspirator, his uncle, had left the village for the summer. On the storehouse door was a notice that the true keeper of the Whale House's possessions was a relative named Yeilxaak.[20] The following spring, Shotridge was again conniving with his uncle. They schemed to take the Rain Screen and four house posts on the Fourth of July, when most of the villagers would be out celebrating the holiday. Shotridge wrote that he would take the objects "regardless of all objections of the community."[21]

The plan was dangerous. "Our rival party more than once have made known to us," Shotridge worried, "that we take away the

old things only over their dead bodies."[22] When Shotridge arrived just before the holiday, once again his uncle had ditched him. Anyway, he found clan members living in the Whale House to guard its contents.

Shotridge finally gave up. He felt it was "the only way to maintain the friendship between my people and myself."[23] The community had become so splintered over the controversy, a Peace Ceremony was held to reconcile the sides.

Shotridge's surrender did not entirely assuage the fury he had provoked. Several years later, an anthropologist learned that the Tlingit museum employee was widely reviled because of his efforts to empty the Whale House.[24] In 1937, after he had been furloughed by the University of Pennsylvania Museum due to the Great Depression, he took a job guarding streams for a salmon cannery. One day Shotridge was found nearly dead. He had fallen, his neck broken. Ten days later he died in a Sitka hospital. Forgotten and marginalized, there was no obituary. Shotridge's death was officially recorded as "unknown."[25] In Klukwan, people said he was murdered for taking away the clans' things.[26]

o o o

Michael Johnson had been captivated by the famous black-and-white photographs of the Whale House since he was a teenager.[27] Living in Seattle, Johnson first became interested in Native Americans as a Boy Scout. He even took an Indian name and participated in a dance troupe of white children who imitated Indian ceremonies. In 1968 Johnson opened a gallery in Seattle and was soon trawling the Northwest Coast for art. When he finally arrived in Klukwan, Johnson found the keeper of the Whale House, Victor Hotch, and convinced him to take him inside. "Don't tell my son about this," Hotch told the dealer. "Joe made me promise a long time ago that I won't sell it."

Standing before the objects, Johnson was mesmerized; they were even more beautiful than he had imagined. Johnson's dealing in-

stinct kicked in. He took out a piece of paper. "I wrote out the figure $100,000," he later recounted. "A huge amount in those days. Boom. I didn't say anything, I just wrote this out on a little piece of paper and put it in front of him." This kind of money for Tlingit objects was unprecedented to be offered directly to a Tlingit living in an impoverished village at the edge of Alaska. Hotch didn't say anything. But he took the slip of paper.

Johnson was only pursuing what generations of collectors had already sought. It was not without reason that the Whale House's clan objects were considered the "most extraordinary artwork in all the Northwest Coast."[28] The Whale House collection was the "Tlingit Holy Grail" and the "King Tut treasures of the Northwest Coast," and the objects were compared to the brilliance of Leonardo da Vinci's *Mona Lisa*.[29]

Like his colleagues in the art world, Michael Johnson genuinely loved the beauty of the Whale House treasures. And he appreciated Tlingit culture. But he was also an entrepreneur driven by the laws of supply and demand. "I'm willing to admit that, because we were dealers, we were out there," Johnson later said. "We knew the heritage situation and all that. We had a conscience. But of course we were out there to make money. That is what we were in business for."[30]

o o o

After the Gaanaxteidí prevented Louis Shotridge from taking the treasures, the Whale House was falling into such disrepair that the four famous posts and Rain Screen were moved outside and stored under a tarp. In 1938 Louis's aunt, Millie Shotridge DeHaven, the next hits'aatí (housemaster), completed a new house and the cherished objects were brought inside. When Millie died six years later, Victor Hotch was chosen to be the new hits'aatí.

By the 1970s, Victor Hotch was caught in a now familiar predicament. One faction, which included his son (Joe Hotch), demanded that the Whale House be left intact. The opposing faction, which

included his sister (Mildred Hotch Sparks) and brother (Clarence Hotch), wanted the treasures sold and money divided among family members. Some members of Victor Hotch's family were concerned about the lack of care for the pieces, although tradition dictated they should be left to rot naturally. "We basically want to see the artifacts preserved," Bill Thomas later said. "The money has never been the main thing to us."[31]

In the spring of 1976, artifacts from another Gaanaxteidi house in Klukwan, the Frog House, were sold to a different art dealer named Howard B. Roloff. A lawsuit followed, alleging that the sellers did not have the consent of all clan members. A compromise several years later returned four posts but allowed Roloff to keep the rest, which he sold to museums and collectors.[32] (Roloff offered the Frog Hat to Mary Crane, but she balked at the $80,000 price tag.[33]) This sale helped illustrate how, as the historian Douglas Cole has written, individual Native suppliers were "not naïve" but reacted to market forces "quickly and adroitly."[34] Still, most transactions were inherently unequal, with cash and power in the hands of dealers and collectors, who rarely obtained the consent of all clan members. In the aftermath of the Frog House sale, the worried Klukwan village council passed an ordinance "prohibiting trespassing on Village land for the purpose of removing artifacts."[35]

Just several weeks later, Joe Hotch was tipped off that Michael Johnson was sending a truck to the village to collect the Whale House's carvings. The anti-sale faction felled trees across the only highway leading into the village and parked a garbage truck in the middle of the road. The clan members manning the roadblock started a fire to stay warm, which somehow spread to the truck, which exploded. Several of the men were hurt, but Johnson's hired hands were successfully turned back.

For this latest effort, Johnson had begun to work with another potential claimant to the Whale House treasures, Estelle DeHaven Johnson (no relation to the art dealer), who had left Alaska as a young woman. She was the only daughter of Millie Shotridge DeHaven, Louis Shotridge's aunt who had helped build the new clan house in 1938. After the roadblock incident, Estelle and Michael Johnson

sued the village in federal court—*Johnson v. Chilkat Indian Village*—claiming that Joe Hotch and his allies were interfering with her legitimate right to sell the Whale House objects. Many questioned Estelle's traditional rights since she hadn't helped with the Whale House's upkeep through the years. Estelle's lawyers were paid by Michael Johnson. "I wanted to sell them, yes," she once said at her home in Puyallup, Washington. "What good are they up there?"[36]

In 1977 the dealer paid for Estelle Johnson and her husband to travel to Klukwan. With the support of at least one clan leader, they hired a moving van and drove the 1,700 miles from Washington to the village. When they arrived at the Whale House, they cut a lock and started to load the truck. They were caught in the act. The village's fire alarm was sounded. Scores of angry people streamed out of their homes and interceded. "I didn't talk to any of them," Estelle remembered. "I just left town."[37] The next year, a U.S. district court dismissed Estelle's lawsuit, ruling that the tribe could not be sued.

This latest scheme turned Victor Hotch against Michael Johnson. Hotch signed a statement that he would no longer deal with the art dealer. Hotch called for a potlatch to celebrate the village's foiling yet another attempt to empty the Whale House.

The art dealer, however, refused to give up. In the summer of 1981, Johnson learned that Victor Hotch had died. "The future of the Whale House is now in your hands," he pressed Clarence Hotch, the new keeper. "Victor told me many times that he believed the old carvings should be saved. He knew what had to be done, but was not strong enough to do it. I know that you want to save the great old carvings so the future generations will be able to appreciate them, and so that your names will be remembered for saving them."[38] He concluded with an offer of a half-million dollars.

o o o

When clan members realized that Bill Thomas and his relatives had successfully emptied the Whale House, they contacted the Alaska State Troopers. The artifacts were discovered in Seattle, stored in a climate-controlled art warehouse. After months of interviews,

however, investigators concluded that ownership of the clan items was "so clouded that a crime would be hard to prove."[39] Howard B. Roloff, the collector who had managed to buy the Klukwan Frog House collection, told the investigator that even he—known, as Johnson wrote of him, "for treading a thin line between chicanery and illegal practices"—wouldn't try to pursue the Whale House because of the confusion over ownership.[40] "He told me there is no one person who owns it," the investigator said after speaking with Roloff.[41]

Meanwhile, Johnson secured an offer for the five Whale House pieces: $2 million, the most money then ever to be paid for Northwest Coast art.[42] The purchaser was a moneyed New York philanthropist, Adelaide de Menil, who had photographed the Whale House in the 1960s. Her husband was Edmund Carpenter, a famous anthropologist, who arranged to donate the Whale House collection, after its purchase, to the American Museum of Natural History. Carpenter felt a personal connection to the pieces, claiming to have once stopped children from damaging the Rain Screen during a feast and wanting to ensure they were not sold to collectors in Europe or Japan.[43] "It was a generous offer," Carpenter said defensively. "The only thanks we got, we were attacked in the press. I found myself attacked on the front page of the *New York Times* for receiving stolen goods. All we had done was offer to buy them subject to court approval."[44]

A federal judge ordered an injunction to temporarily halt the sale. However, since the Alaska State Troopers had suspended their criminal investigation, the Klukwan village council was forced to file a civil suit—*Chilkat Indian Village v. Michael R. Johnson*. Quickly, one journalist observed, "the epic saga of the Whale House artifacts grew into epic litigation."[45]

The U.S. district court ruled that it lacked jurisdiction, but on appeal the U.S. ninth circuit court reversed the decision. On the second round in the district court, the judge ordered that the case be heard in the village's tribal court—a landmark decision in which a federal court deferred to a tribe's court. Klukwan, however, didn't

have a court; it had to create one, blending Tlingit and Western property and family law.

For four weeks the case unfolded in Klukwan, pitting family against family, to determine people's genealogies, the role of clan housemasters, who had the right to sell clan objects, and whether nephews must follow their uncles' commands. Michael Johnson refused to participate in the trial. In the end, Judge James Bowen—a Klallam Indian lawyer from Washington State who wore a Tlingit ceremonial robe instead of a black robe while presiding—found that the Whale House objects belonged to the entire Gaanaxteidi Clan: Johnson and the thirteen family members did not hold the right to sell them.

Bill Thomas, who had loyally followed his uncle's order to take the at.óow that summer night in 1984, disagreed with much of Judge Bowen's ruling. But even Thomas welcomed the chance to fix up the Whale House so the artifacts could be returned there.[46] At the close of the trial, Joe Hotch hugged his cousins and declared that he harbored no bad feelings toward his kin. Within weeks a ceremony reinstalled the four posts and the Rain Screen in the Whale House.[47]

o o o

Michael Johnson was forced to accept that he was the latest—and perhaps last—collector in a long line who had tried, and ultimately failed, to possess the treasures of the Whale House. He later would say that the whole affair left him bitter and financially ruined. But Johnson continued to dismiss any notion of wrongdoing. "There are legitimate, sincere differences over whether art like this should be in a national museum for a national audience, or in its place of origin," Johnson's lawyer said after the return. "It doesn't have to be black and white, with one side evil and the other side good."[48]

Such a view no doubt directed much of Johnson's career. Outside of Indian communities, it was often met with approval. Like when Johnson sold other cherished clan items to Denver's natural history museum.

16. LAST STAND

Just a year after NAGPRA became law, on December 11, 1991, Harold Jacobs sat down at his manual typewriter in Sitka, Alaska. A friend had given him some important information. Harold pounded out a letter to Joyce Herold, the Denver Museum of Nature & Science's curator of ethnology. He asked for the return of a carved hat owned by the Dakla'weidi Clan in Angoon, Alaska. Harold's claim was personal. In 1974 his own grandmother, Annie Jacobs, had sold the hat for about $1,000 to Michael R. Johnson. Now Harold's father, Mark Jacobs Jr., wanted it back.

In the letter Harold explained the hat's history. The original hat, known as *Kéet S'aaxw*, was destroyed in 1882 after the U.S. Navy shelled and burned the village of Angoon to punish the Tlingit for seeking compensation for the accidental death of a medicine man on a whaling ship. A copy of the Killer Whale Hat was made and became clan property. Harold detailed which caretakers held the hat through the 1900s, until it eventually came into the possession of his grandmother. "My grandfather needed some money in 1974 as he was ill," Harold wrote. "Over the protests of my father, Mark Jr., [grandfather] sold his artifacts and my grandmother sold what she had as well."[1] Three of the pieces they sold to Johnson ended up at the Denver Museum.

Because Harold's father, Mark Jacobs Jr., did not have the hat and other regalia, he could not assume the title of clan caretaker. He

could not even participate in potlatches. "Without the hat it was impossible to 'speak' with authority as should be," Harold explained. "The most important object any clan could have was the wooden hat with the carved crest of the clan on it. Each hat has its own song and to not have a hat was considered a great shame." In 1983 Harold made yet a second copy of the hat so that his father could receive his title. But, Harold insisted, this copy could never take the place of the one in Denver.

Harold said his grandmother "always felt guilty about selling the things," which is why she likely told her family that the first copy from the 1800s was buried in the casket of one of her sons, Ernie, who died in 1975. Harold so desperately wanted this "cherished hat" for his father's clan, he laid plans to have Ernie's grave exhumed.

Fortunately, before he disturbed the grave, a friend named Steve Brown, an expert on Tlingit art, happened to visit the Denver Museum in the spring of 1991. After the visit, Steve excitedly telephoned Harold. About a decade earlier, Harold had consulted with Steve about making a copy of the hat, based on photographs. Steve explained that he was looking through the collections in Denver when he noticed a dust-covered bag.

"What's in that bag?" Steve inquired. When it was opened, he immediately recognized the long-missing hat. Annie Jacobs had misled her family about burying it. Steve exclaimed, "I know someone who's been looking for this!"

"Oh," the museum staff member with Steve grumbled. "They're probably gonna want it back."

Now Harold was writing to say his father wanted *Kéet S'aaxw* back. With this letter, the first formal repatriation claim under NAGPRA had arrived at the Denver Museum. The staff had to figure out what to do.

o o o

On March 18, 1992, Joyce Herold wrote a memo to the museum's president and a board trustee.[2] She advised the administration about Mark Jacobs Jr.'s repatriation claim. She estimated that the hat was

now valued at $150,000. The hat, she said, was not a sacred object under the new federal law, NAGPRA, but could be an "object of cultural patrimony"—communally owned.

Herold had found the claim credible, particularly as the killer whale was a known crest for certain Tlingit clans and family lines. The crest, typically in the form of an animal or spirit-being, is the clan's totem, records the clan's history, and serves as a title to places and objects. The crest also embodies the sacred relationship between the clan's members and the animal or spirit embodied in the crest. As the anthropologist Sergei Kan has written, the crest is "the most important symbol for the matrilineal group, as well as its most jealously guarded possession"[3]

Still, Mark Jacobs Jr.'s claim required further research, Herold cautioned. "Whether this is the only hat of its type," she wrote, "the exact status of this hat, the family lines, possible competing claims to clan or family lines, and their prerogatives in Tlingit Society are all matters to be determined." She would start an investigation by sharing information with the Jacobs family, speaking to other museums, considering loaning the piece, and contacting Michael R. Johnson. When Johnson was eventually contacted about the hat, he was contemptuous. "It's a bunch of bunk," Johnson told a staff member, according to notes from the telephone conversation. "Such objects were not ever owned by a clan."[4]

Two months later Bob Pickering, the department chair, wrote to Harold Jacobs, explaining that the claim could not be considered because NAGPRA's implementing regulations—the law's specific and detailed rules on the repatriation process—had not yet been promulgated by the Department of the Interior, the federal agency tasked with creating the regulations.[5] Jacobs bristled. He insisted that the bureaucratic delay "does not diminish the claim presented."[6]

A year and a half passed. The draft regulations came out in late 1993. At the beginning of 1994, Pickering wrote to Jacobs that the claim had to be resubmitted by the Tlingit tribe—formally known as the Central Council Tlingit and Haida Tribes of Alaska—and that they needed to re-explain their arguments.[7] Under the new

regulations, communally owned objects could not be repatriated to individuals, only to federally recognized tribes. Two days later the tribe's president faxed the claim.[8] The museum staff restarted its investigation. Pickering would later tell me that his approach was neither to stonewall the tribe nor to hand over everything. "For me the key was: can a trail be made?" he said. "Is there a chain of evidence, essentially, from the family to the museum? And did the person who alienated it, did they have the right to do that?"

The cruel phrase "Indian giver"—a person who gives a gift then takes it back—perhaps came to mind for some of the Denver Museum staff.[9] But the Whale House story helped explain how the lucrative market for Tlingit treasures seduced impoverished clan leaders. Although the objects were sold by two Tlingit, their tribal membership was irrelevant. Most often it was an individual choice to sell objects against the wishes of others with equal rights. Money twisted priorities, pitted family members against each other, divided a clan against itself. Harold Jacobs's story was little different.

While the claim on the killer whale hat progressed, a second one on another piece in the Denver Museum, a sleeveless shirt woven in the Chilkat style, hit a wall of anger, frustration, and competing claims. The tunic's history began four generations ago with a daughter of Chief Shakes IV and could be traced to a line of caretakers that included Harold Jacobs's grandfather, Mark Jacobs Sr. He sold the shirt to Michael Johnson, who in turn sold it to the New York collectors Adelaide de Menil and Edmund Carpenter. In August 1976 it was transferred to Howard B. Roloff, the dealer and rival of Johnson, through an exchange requested by Mary Crane. Roloff ended up handpicking twenty-six objects valued at $45,000 from the Denver Museum's collection—all in exchange for the one Tlingit shirt.

Harold Jacobs wrote to the museum that the shirt was clan property. The story told to him was that his aunt asked Mark Jacobs Jr. if the at.óow could be sold. "I don't want to have anything to do with the sale of it," Harold's father answered her.[10] Mark's words were misinterpreted. It was reported to the family that the objects could be sold because "Mark Jr. said he doesn't want anything to do with

those things." But Mark meant that he didn't want to have anything to do with the sale *because* he didn't think they should be sold. By the time Harold's father realized what had happened, the items were already in Seattle. "My dad refused any money from the sale of those things," Harold reported, "and never accepted a dime."

Harold's family wanted the shirt back. But in July 1994, Harold gave Pickering notice that his father was withdrawing his claim for the killer whale hat.[11] In a phone conversation with Joyce Herold, Harold Jacobs said there was disagreement in the family over the hat's ownership. Clan members who collectively owned the shirt could not agree on next steps either. Jacobs was frustrated. "I'm going to back out of everything—quit carving, quit dancing, quit researching family history," he said. "I'll help only if asked from now on."[12]

Meanwhile, the museum's investigations of the killer whale hat had not progressed. More than two years after the last formal claim, a tribal resolution was passed on May 9, 1996, that made what was now the third claim on behalf of the Dakla'weidi Clan, Killer Whale House, and affirmed that Mark Jacobs Jr. was the "current recognized caretaker."[13] This was soon followed by a seventeen-page "formal petition" for *Kéet S'aaxw* (now the fourth claim), which elaborated on Mark Jacobs Jr.'s original claim from 1991.[14] Pickering replied, acknowledging the latest claim and asking if the piece had in fact been communal property when it was sold.[15] Chairman Edward quickly replied: yes. As evidence, he pointed the museum to the court's recent judgment in *Chilkat Indian Village v. Michael R. Johnson*—the final lawsuit in the Whale House battle in Klukwan—which determined that "Under Tlingit law, all [clan] members have an interest in clan property."[16]

o o o

In 1994 the Denver Museum's newsletter published an interview with Bob Pickering about repatriation.[17] The piece was titled "Crane's Last Stand?"—comparing the Cranes to a statue in the Denver Museum, "Grizzly's Last Stand," commemorating the killing of the

last grizzly bear in Colorado, a title that in turn referenced George Armstrong Custer's infamous "Last Stand" at the Battle of Little Bighorn in 1876, an event burned into the American psyche symbolizing civilization's crusade against hostile Indian forces. The article emphasized how the law signaled a loss for the institution. Pickering insisted that the museum did not hold any stolen objects.

Four years into NAGPRA, some local Native Americans doubted the Denver Museum's commitment to repatriation. A heated letter from Ben Sherman, chairman of the Western American Indian Chamber, in Denver, insisted that the museum "has a bad relationship with the local Indian community."[18] Among his complaints was that the Denver Museum said it would comply with NAGPRA but not that it would repatriate *all* of the funerary items and sacred objects in its collections. Sherman, for one, refused to work with the museum, he wrote, "until the remains and burial items of tribal ancestors are no longer claimed as property."[19]

Later, museum staff convened a meeting with the board of trustee's legal committee.[20] Already John G. Welles, the director, had contemplated filing a lawsuit to challenge NAGPRA's constitutionality.[21] He decided against it because of a lawsuit's "political-incorrectness" and the "PR damage" it would do to the museum.[22] "We must be very careful," Welles warned the museum's upper management, "to 'feel our way' through the legal mazes that face natural history museums with respect to this law."[23] At the meeting the staff outlined their extensive efforts to comply with the law—explaining that NAGPRA was consuming up to 45 percent of the department of anthropology's staff time—to deal with the 5 percent of the collections that were deemed "at risk" of being requested for return. (As it would turn out, twenty-five years after NAGPRA, still only about .02 percent of the anthropology collection had been repatriated.) The staff was still genuinely struggling to come to terms with competing moral claims: "the positioning of Indian religious rights above scientific rights" and the museum's responsibilities to the objects, donors, audiences, and public trust. The trustees were supportive and insisted the museum follow the law. But they also won-

dered how far the museum would have to go. "How hard should we fight?" one trustee asked.

The fight was very real to many of the combatants. Early in 1994, an archaeologist serving on the NAGPRA Review Committee told a gathering of science museum directors that at the last public hearing he had been "pilloried for two days" by Native Americans.[24] "He felt physically threatened," Welles noted, the archaeologist being "the only non-Indian for a while in the room and feared for his safety." The museum directors concluded that "this whole subject area seems to be in turmoil and probably will become worse before it gets better."

o o o

Despite its vast collection containing religious objects, the Denver Museum had long escaped public scrutiny. By happenstance, in 1978 the Zuni had focused on the Denver Art Museum, instead of the natural history museum down the street, which held twice the number of War Gods. When the Denver Museum's Crane Hall opened in 1978, it had taken a strategic approach to the display of a wampum belt and sacred masks from the False Face Society, which came from the Iroquois nations (a confederacy of six tribes in New York and Canada, also known as the Haudenosaunee). Just four years earlier, the Iroquois Council of Chiefs had prohibited the sale of wampum, ritual masks, and other religious paraphernalia, and made explicit its wishes to have these materials removed from museums and collectors.[25] Repatriations began when the Buffalo and Erie County Historical Society returned several thousand wampum beads to the Onondaga Nation in 1975.[26]

Anticipating objections from the Iroquois, Joyce Herold secured City of Denver funding to bring Avery Jimerson Sr., an Iroquois medicine man, and George Abrams, then the director-curator of the Seneca-Iroquois National Museum, to serve as exhibit advisers.[27] The main concern was the ceremonial masks of the mystical False Face Society. Tribal leaders argued that the masks "were often

given up by the Christian relatives of a deceased mask owner" and then during the 1930s a federal jobs program encouraged commercializing mask-making even though traditionalists objected.[28] Over time some carvers felt they had the right to make commercial masks if they were not carved directly from a living tree and then consecrated. The traditional council railed against the practice, insisting "that masks, by their very nature, are sacred and that the process of the creation provides inherent power that is augmented if carved in a tree or processed in a ceremony."[29] Tribal elders felt that even casts and reproductions contravened the masks' spiritual intent. Leaders declared: "There cannot be a non-sacred Iroquois mask."[30]

Mere days before Crane Hall opened in 1978, Avery Jimerson Sr. ritually blessed the False Face masks on exhibit and in storage, "ensuring their proper, respectful treatment under museum guardianship," the museum's annual report gushed.[31] According to an internal museum memo, this invitation had been intended to respect Iroquois' "deep feelings about these ritual masks," but also to neutralize a recent "delegation of other, more radical, Iroquois . . . who indicated extreme sensitivity to display of the masks."[32] The memo concluded that the ritual "should not be viewed as complete capitulation to unreasonable demands of Indians. Far more stringent requests on the subject have been made, i.e., for the return of all masks to the Iroquois."

In March 1981 the request for the masks' return finally came, from the Grand Council of the Haudenosaunee.[33] The council had forbidden the sale of masks since 1974.[34] Denver Museum administrators sought advice from colleagues at the Smithsonian's National Museum of Natural History, who counseled delay until a uniform national policy could be established.[35] The Denver Museum's internal board recommended that the Grand Council's letter be "ignored . . . until these issues are clarified." Even the museum's advisory council of Native Americans living in Denver decided that nothing should leave the museum without study because "the collections are not only the heritage of Indian people but of all Americans." Museum administrators wrote a simple letter back to the Grand Council in-

dicating that they had received the request and were considering appropriate action.

Not until 1994, thirteen years later, were the masks removed from display.[36] They remain in storage today.

<center>o o o</center>

The Denver Museum could not forever outrun the rising tide of repatriation. Its first return was to the Northwest Coast in 1986, when it was discovered that a 3,000-year-old stone bowl that had been recently donated was stolen from Meares Island, on Canada's west coast.[37] The Royal Canadian Mounted Police tracked the artifact to Denver. Because the theft was well documented, and because the Canadian police were involved, the museum returned the stone to the Nuu-chah-nulth Nation in British Columbia without dispute. The museum's second repatriation followed five years later; the return of the six War Gods to Zuni. Although these returns established good precedent, the Tlingit repatriation claims, in particular, were seen to fundamentally challenge the museum's sense of purpose and its future.

The Tlingit claims were made under NAGPRA. No longer did tribes have to make moral arguments or criminal complaints; federal law had opened the doors to every museum in the country. The claims were for specific objects but also suggested ownership for a general *category* of object. The Tlingit were laying the groundwork to potentially reclaim scores of communally owned objects: robes, hats, daggers, staffs, bowls, boxes, and much more. From the perspective of museum administrators, the proverbial snowball was rolling down from the Northwest Coast and gaining perilous speed as it became clear that the Tlingit would relentlessly seek the return of multiple objects—significant, singular, and irreplaceable pieces worth hundreds of thousands of dollars. When these claims first arose, museum staff struggled to understand their implications. "At this stage of the implementation of the repatriation law," the Denver Museum's archivist worried in a 1993 paper, "questions are more numerous than answers."[38]

Slowly, the answers were coming. The repatriation of cultural objects gathered momentum. Among the most significant was the return of the hundreds of treasures that had been confiscated under Canadian law following the Dan Cranmer potlatch in 1921.[39] Although the descendants had sought the confiscated items for years, in 1963 Chief Jimmy Sewid made headlines when he tried (and failed) to buy back the collection. After long negotiations, in 1974 the Canadian government at last agreed to return the pieces, but only on the condition that two museums be built, which would hold the items in trust for the two families who sponsored the potlatch. The government further dictated that the items could never be sold and that the new museums would have to satisfy museum curation standards. The Kwagiulth Museum at Cape Mudge opened its doors in 1979, and the U'mista Cultural Centre the next year. The National Museum of Man promptly returned the hundreds of items. However, the Royal Ontario Museum did not repatriate the pieces it held until 1988. Treasures from George Gustav Heye's collection in New York followed in 1989, and another batch was returned in 2002. A mask that had been traded to the British Museum was not repatriated but sent to the U'mista museum on long-term loan.

Although the Zuni War God repatriations came to dominate early debates in the United States, several other tribes also found early success. In 1977 the Wheelwright Museum of the American Indian in Santa Fe gifted fourteen sacred medicine bundles to Navajo medicine men, who in turn deposited them in a cultural center at the Navajo Community College.[40] In 1980 the Hopi of Arizona had three stolen masks returned to the tribe. In 1988 Harvard University returned a sacred pole to the Omaha Tribe. Then in 1988 and 1989, after more than a century of seeking their return, nearly two dozen wampum belts from Heye's Museum of the American Indian and the New York State Museum went back to the Iroquois.

By the mid-1990s, it was widely understood that thousands of objects would be returning home to Indian country. Many museum professionals charged with carrying out the law found themselves caught between feelings of anger and acceptance. On the one hand, over the previous two decades, the museum world had staked out

a position that was largely anti-repatriation. On the other hand, NAGPRA was now the law of the land. Repatriation was inevitable, and museums had to get to work to be in compliance with the law or face stiff penalties and public censure. "This was going to be difficult, this was going to be time consuming, this was going to stretch us as a staff and as an institution but it wasn't a choice, it had to be done," Bob Pickering recalled to me. "I am a firm believer that part of the role of the staff is to keep the institution out of jail."

At the Denver Museum, the Tlingit proved to be far more important than the Zuni as a test case for how repatriation would work going forward. The Tlingit not only made the first repatriation claim at the Denver Museum under NAGPRA, but would also make the largest number of claims. Between 1991 and 2008, the Tlingit requested irreplaceable objects from the Denver Museum eleven times. Although the first claim for the killer whale hat was informal and unorganized, by the mid-1990s, the Tlingit's repatriation claims were highly standardized. Harold Jacobs was now employed full-time by the tribe. He worked with clan leaders to find objects in museums and document their histories. For those objects that they wanted repatriated, the tribe's government, the Central Council—as a federally recognized tribe, the only recognized authority under NAGPRA to make claims for communal objects—would submit a claim on the clan's behalf. The Tlingit developed one of the most active repatriation programs in North America.

A prime example of this organized approach is the claim submitted to the Denver Museum for Chief Shakes's Killer Whale Flotilla Robe.[41] The twenty-one-page document, sent at the end of 2001, includes a formal letter by the tribe's president, details of Tlingit ownership laws using anthropological scholarship, sophisticated explanations of kinship and genealogies, copies of relevant resolutions passed by the Central Council government, and historic photographs. The packet even includes an affidavit by Cynthia DeWitt Paul, a great-granddaughter of Chief Shakes VII, swearing that she had been taught that a man named John Feller is the "rightful heir to the title of Shakes" and "is of the proper lineage and caste to assume

this position."[42] DeWitt insists that the robe belonged to the clan through its caretaker, Chief Shakes VII, and had been sold without the clan's consent.

But in most cases, even thorough claims were not enough to persuade the administrators at the Denver Museum who depended as much on factual documentation as the persuasiveness of claimants. Regularly, tribal members had to come to Denver to plead their case, to reconnect with objects before the curatorial staff, to shed tears over their heritage, and to beg for the return of what they believed was already rightly theirs. The success or failure of a claim depended on how convincingly tribal members could translate their culture—how they could articulate their authentic sense of loss and real need for these objects to be home—to museum administrators. The answer to a claim depended on how well claimants could perform during the museum consultation.

17. THE WEIGHT WAS HEAVY

*When they sit in a museum or on storage shelves, they are no different
than a dead body; lying in a cabinet, they have no life in them.
When we bring them out, they have life in them.*

Harold Jacobs, Yanyeidí Clan from Hít Tlein (Big House) of Sitka[1]

*To those who come along asking, "Where is your history?"
I answer, "We wear our history."*

Austin Hammond, Łukaax.ádi Clan from Yéil Hít (Raven House) of Haines[2]

"They're more than spiritual objects," Nora Dauenhauer said. "They
have power. When we touch them, we know they have power. I
could feel them when someone puts them on me. I don't know if
you can, but it's strong—strong for us. It gives us strength."[3] She
explained that the objects' power is how they feed a sense of identity
and belonging. Clan regalia remind the Tlingit of their ancestors,
stories, and places. The objects offer "spirit-power for our people."

The words "consult" and "consultation" appear eighty times in
NAGPRA and its regulations. It is the law's linchpin, because the
NAGPRA process requires museums and tribes to share informa-
tion and perspectives. But the law offers no script to structure a con-
sultation. In each meeting, both the museum and the tribal repre-
sentatives must find a way to be understood. The fate of museum
objects is often decided in these dialogues.

More than a dozen people were tightly packed around a table in the windowless conference room at the Denver Museum of Nature & Science for a two-day consultation in 2002. A video camera recorded each moment. Each of the Tlingit visitors introduced himself or herself, offering thoughts on the consultation ahead. They had come from Alaska to review the collections, to reclaim their at.óow.

Nora Dauenhauer, the Tlingit elder and writer I interviewed in 2010, opened this consultation. Her poetic words filled the room. She thanked the museum for bringing the large group to Denver but pointed out that the trip was shaded with grief. "I'm very pleased, and very sad I'm doing this," Nora said, her voice quavering. She was eager to visit her clan pieces, but distraught to even be in the position of guest to her own heritage. "We're here to try to get our artifacts, our at.óow," she explained, "because we have a lot of descendants who need to see these, who need to learn about them, to learn about their connection to them. We wish to take them home."

o o o

The group was now assembled in a storage area, sitting shoulder to shoulder, a small table in front of them. They had been going through the Denver Museum's Tlingit collections. Most of the items were not clan property. But when they arrived at a piece that the Tlingit felt was theirs, a serious conversation would begin. A tribal representative would argue for its status as communal property or sacred object. The museum staff would ask probing questions and defend its own right of possession.

Ryntha Johnson, the department's collections manager, wearing white cotton gloves, stood by the table and took the lid off of a square box. She pulled out *Yéil Shádaa*, the Raven Headdress. The oblong hat is made of woven spruce root, decorated with fox and ermine fur, and topped with a raven head carved in wood. It is said that the headdress is at.óow of the Łukaax.ádi Clan, Yéil Hít, the Raven House, to which Nora Dauenhauer belongs.

The elder George Bennett directed Ryntha to give the hat to

Mark Jacobs Jr. "because he is an Eagle"—meaning that because the hat is Raven it should first be handled by the Raven's opposite, the Wolf-Eagle moiety. Mark—who was wearing a black baseball cap reading "World War II Veteran, I served with pride!"—put on his own white cotton gloves and took the headdress, holding it in both hands at shoulder height.

Nora had a photograph of a clan member, Austin Hammond, wearing the hat long ago. She said that Hammond's mother taught her the song that had been composed for the hat and was sung whenever the hat was to be brought out to be worn. Everyone rose from their chairs, solemn. Nora held a small drum in her left hand. By singing this song now, she was asserting her clan's right of ownership over the Yéil Shádaa. As the formal claim for the piece would argue, "Nobody else can sing this song or tell the history or lineage" associated with the headdress.[4] The museum staff would have to admit that, unlike Nora, they could not sing the hat's song.[5]

Nora paused a long moment with her head bowed. She lightly tapped on the drum a few times, then stopped. A loud burst of singing followed. After a few measures, the drum joined her voice. The song was melodious, an undertone of fierceness, a preternatural strength arising from the small woman.[6] The words in Tlingit meant:

> Here is a story told
> of my grandfathers.
> you Yéil Shádaa
> stories should be told about you.

Throughout Mark continued to hold the headdress aloft. After several minutes, the singing trailed off and ended with a series of quick taps on the drum.

"I'll say this in English so you can hear what I can say," Harold Jacobs, the tribe's repatriation official, said, as he stood up. To most, Harold was intimidating: exuding intelligence, burly, long hair held back by a black bandanna, tinted glasses, and a resolute bass voice.

"These are the most valued objects a clan could have, the hat." To "balance" the song for the Raven, Harold then sang a song for a wolf hat. The song was slow, reminiscent of a ballad.

"*Gunalchéesh*," Nora said when it was done. Thank you.

"*Gunalchéesh*," all the Tlingit echoed.

o o o

"I'm very happy to find it," Nora spoke up after a few moments of silence, the group taking in the scene, "with the help of Harold Jacobs who has been watching out for things like this. He told me that this hat was here. And I have no idea of how to go about getting it. I don't know anything about the NAGPRA laws. It seemed far away from my reach, our reach, our clan."

The curator Joyce Herold addressed Nora. The rest of the museum staff stood in the corners of the room. In Joyce's hand was a printout of museum records. In 1976 the hat was purchased for $4,000 from Michael R. Johnson. The art dealer claimed that the piece was "a very rare type" dating to the late 1800s, and that he had acquired it directly "at Haines, Alaska, from a Tlingit family."[7]

Nora alone stood, facing Joyce. They had a long exchange, as Joyce asked Nora specific questions about who made the hat, who owned it, who used it, and who sold it. Joyce was trying to ascertain whether the hat was subject to NAGPRA. Nora insisted that it belonged to the entire clan, used for ceremonies.

"I think some of the crucial points, of course, in repatriation is who the legitimate owner is and who has the right to sell," Joyce responded, referring to the records that indicate the hat was sold by a clan leader.[8] "It is very difficult for museums to understand how something could have been sold by someone who didn't have the right to sell. According to our records, a dealer, Michael Johnson—"

"We know of him," Nora interrupted.

"Yeah," Harold Jacobs added.

George Bennett jumped in to defend Tlingit law about clan ownership. He pointed out that the burden of proof of ownership is

always on the tribes.[9] Yet museums are reluctant to accept the very proof they can offer—stories, songs, explanations of Tlingit beliefs.

"We cannot prove ownership in the lineage, in the song-way, or any of these other ways, and we would never pretend or try," Joyce continued, calmly, slowly peeling off each word. "We have protected it, and we have preserved it, and tried to have an educational process that people would know about the Tlingit people, at least partially from that time on. And I can't—that is the story we have." Joyce shrugged, running out of explanations. "The NAGPRA law gives you rights that you didn't have previously, which is all for the better. We one hundred percent support the law and we will abide by it."

"*Gunalchéesh*," several of the men said.

"When things are taken out of their context—you see, this is what happens," Joyce added. "Because someone made a very grievous mistake. It was taken out of its rightful place of origin and with people who understood and had access to all these ideas, traditions, knowledge, its great deep knowledge, that has been passed down. But there was a break in that chain and I only wish some of you had been present in 1975"—Joyce scanned the room, exasperated—"to have lectured the caretaker not to sell it! We could have avoided all of this, you see! I can't go back and re-create history." She shrugged and let out a deep sigh. "If people who deal in these things would have more judgment, you know? It's just such a shame."

"It's unfortunate you got caught up in the dealings of Michael Johnson," Harold reassured Joyce. "When we look at these things we're not blaming the museum for having them. We know how they left our hands sometimes, and we wish they could have stopped that. But we had no way of getting them back until NAGPRA came along. So we're not saying to you, 'You took it from us!' You've taken good care of these for years and you still have them. And there's evidence of that right there: it's in great shape. Now they want to come home."

"Thank you for taking care of them," Nora added, sincerely, looking right at Joyce.

o o o

There was one last object to review.

Mark Jacobs Jr. spoke in Tlingit, his voice raspy and aged, as all of the Raven Clan members, six people, wearing pure white gloves, collectively lifted Kéet Xaa Naaxein onto the back of John Feller, who was bent over at the waist.

After discussing the Raven Headdress, the consultation had moved on to the Killer Whale Flotilla Robe that belonged to the line of Chief Shakes. John adjusted to the weight of the heavy robe, the fringes pooling down his legs, and then stood tall, with his back to the room, displaying the robe's grandeur—not unlike how Charley Jones, Shakes VII, stood like royalty on the war canoe approaching Shakes Island in 1940. John spun around, holding two cords by his neck, to keep the cumbrous robe on his shoulders. Mark spoke again in Tlingit for several minutes, and then the Raven Clan carefully removed the robe from John and placed it on the table.

The Tlingit began to sing the song "Here Come the Killer Whales." Drumming started quietly and grew louder; voices joined in, singing; arms moved up and down slightly, to the beat.

After the song ended, Joyce Herold asked again about ownership. The Tlingit insisted that the sellers were not following their traditions. They also spoke of the potency of these objects—to harm people if mishandled, but also to come alive when respected. George Bennett described the "indescribable power" of these objects. During the song, he said, he was transported back to the Alaskan sea, where he saw the whales swimming in front of the clan village. "You heard the song," he said. "Believe it or not: we're in Denver, Colorado, but we made that connection. It took us back. Colorado all of a sudden became part of Alaska."

Finally, John Feller was given the chance to speak. "I'm grateful for everybody's help," he began. "I'm the humble caretaker of this blanket, this powerful robe. I too have gathered a lot of information today although I do know the lineage of the Shakes." He said that if he was destined to have the robe, he would feel honored. He

apologized for being at a loss of words. "The weight was heavy, of that robe," he said. "Hundreds of years of history overwhelmed me. Thank you, thank you, thank you."

"May I say a few words?" Joyce broke in. "I want you to witness that I have been sitting here weeping, since he began talking"—her voice breaking—"because I have thirty years with this piece. And I'm mourning it." She shook her head.

In that moment, Joyce embodied the conflict of many curators struggling to come to terms with NAGPRA. Joyce had cared for the Killer Whale Flotilla Robe as if it was her own cherished heirloom, but she had just witnessed the deep cultural connections that motivated the museum's possession of the piece to begin with. As a curator, she wanted to keep it. As an anthropologist, she knew that to allow the robe to serve its original meaning, she would reluctantly have to let it go. Several Tlingit later told me that they were touched Joyce treasured the clan pieces as much as they did.

"I will get through this," Joyce concluded. "And I will be happy for you. But I'm mourning."

The room was silent as Joyce continued crying faintly.

18. OUR CULTURE IS NOT DYING

You dance
to an ancestor's song.
The sea of killer whales
splashes on your back.

Nora Marks Dauenhauer, from her poem
"Repatriation," dedicated to John Feller[1]

Finally, the Denver Museum of Nature & Science said yes. After the fourth formal claim for the Killer Whale Hat, Kéet S'aaxw, in May 1996, the department chair, Bob Pickering, took several months to conduct research—consulting with the museum's lawyer, asking the tribe more questions, and investigating whether any other museums had yet repatriated communally owned objects. In September the Denver Museum's anthropologists met and unanimously agreed to accept the claim. The museum's president presented the decision to the board of trustees, who consented without debate. The Denver Museum's first repatriation under NAGPRA had been formally approved.

A year later, on June 26, 1997, a delegation of six Tlingit, led by Mark Jacobs Jr. and his son Harold Jacobs, assembled in the Denver Museum's atrium.[2] Before them was a large audience of museum employees, reporters, and local guests. Bob Pickering began the

ceremony by noting that the return of the Killer Whale Hat had been "a long time coming." He read the museum's formal acceptance of the claim and noted that there were no counterclaims filed.

The Tlingit then took charge of the ceremony. Bob told me that at this point everyone was trying to figure out how to do this right. "My sense was they had some experience with repatriation," he said, "but they were still making some of it up as they went along."

Harold Jacobs spoke first in the Tlingit language, while an elder named Cyril George explained in English the meaning of at.óow. The Tlingit visitors dressed themselves in their robes and hats (including one loaned for the day from the Denver Art Museum). The Killer Whale Hat was then ritually placed on Mark Jacobs Jr., and family lineages were recounted and clan songs sung that proved the clan's ownership of the hat. Mark declared the importance of the hat to him. He ended by exclaiming, "Our culture is not dying!"

Encouraged by the success, Harold Jacobs began preparing more claims for the Denver Museum's holdings. On October 8, 1997, Harold submitted two more claims—for a Chilkat shirt and a button blanket, both belonging to clans in Angoon. Several weeks later, Harold mailed a photo of Charley Jones wearing Kéet Xaa Naaxein at the 1940 potlatch. The Chief Shakes robe, Harold was intimating, would be next. Amid these pending claims, Harold invited the museum's anthropology department to a koo.éex, a party, in Sitka, for the Killer Whale Clan. Joyce Herold and the department's collection manager, Ryntha Johnson, attended, bringing with them the claimed button blanket, so it could be worn during the koo.éex. These events were starting to touch the museum staff as much as the Tlingit. As Joyce enthused in a report, they attended the koo.éex not only as museum representatives, but also as "family."[3]

During the repatriation ceremony in Denver the previous June, Mark Jacobs Jr. had bestowed Tlingit names on Bob, Joyce, and Ryntha. Mark had done this before, adopting the ethnographer Sergei Kan as his younger brother.[4] Over the years, more museum people around the country would be given names. The Tlingit names gave the Denver Museum staff a sense of connection to a Native com-

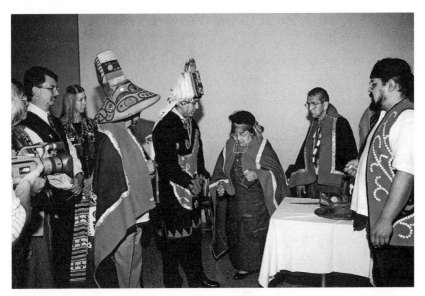

FIGURE 9. The first repatriation ceremony at the Denver Museum, with Bob Pickering (*far left*), Mark Jacobs Jr. (wearing the Killer Whale Hat), and Harold Jacobs (*far right*). Courtesy of DMNS, MAS10-9-11-e.

munity, and perhaps even a growing sense of obligation to them. Joyce started to list her name, Xwaansán, on her résumé under the "honors" section.[5] By the fall of 1997, the department chair asked Harold to call him "Bob . . . or even Gushduteen."[6] Ryntha told me that she felt the naming was "very politically astute" by drawing the museum staff into the tribe. No one spoke of this as an overt strategy, however, because it was such an honor. "I still feel obligated," Ryntha confided. "If Harold called and said he needed me there, I would go."

Into 1998 Harold was corresponding regularly with the department, becoming ever less the adversary and ever more the collaborator. In the summer, Harold and Bob e-mailed back and forth about poisonous chemicals that museum staff had previously used to preserve objects.[7]

"First you take them away long enough to destroy our cultures," Harold erupted in an e-mail, suddenly threatening their budding

friendship. "Then you put arsenic on them. Then you offer to give them back!? PROOF of genocide if I EVER saw it!!"

Bob immediately replied with a heartfelt apology.

"It was a JOKE!" Harold quickly wrote back, bemused and at ease.

Bob apologized for being "so thin skinned." He suggested they come up with new jokes. He offers, "There were two Tlingit, a missionary, and an archaeologist walking down a street together . . ." letting Harold finish the joke.

"If they were Tlingit, they might be with a missionary," Harold answered, "but they wouldn't be caught dead with an archaeologist."

Harold soon said in an e-mail he, too, considered Bob, Joyce, and Ryntha "family."[8]

The Denver Museum staff was not alone in recognizing that NAGPRA could inspire new and meaningful relationships. "I am on the front lines of this issue. Every single day I am working directly with Indians from across the country," said Jonathan Haas, one of the country's leading curators, at the Field Museum, and then serving on the seven-member national committee that oversees NAGPRA. "The message I get consistently is not that they want everything back or want to stop all exhibits and research. Rather, what they are asking for is input. They want to be consulted. They want us to talk with them about what happens to the collections."[9]

As NAGPRA's tenth anniversary neared, it became clear that although the Denver Museum had long been reluctant to fully accept repatriation, now it not only complied with the law but embraced it. By the end of 1999, under Bob Pickering's leadership, a total of fifty-three Native American delegations, funded by grants totaling nearly $200,000, had visited the museum to consult on the repatriation of objects and human remains. The museum had returned the Killer Whale hat, as well as 164 sacred objects (masks, dance items, prayer sticks, medicine bundles, and a ceremonial vessel) to Arizona's Hopi Tribe.[10] When a sensationalizing article about repatriation was published in 2003, Harold Jacobs wrote a letter to the editor defending Denver's natural history museum, declaring it "the most cooperative" he had worked with.[11]

By then the department of anthropology was no longer char-
acterizing the law as creating the need for a "last stand." In a retro-
spective article she wrote for the museum's newsletter, Joyce Her-
old celebrated the law for revolutionizing the relationship between
Native peoples and the institution.[12] Because of the law, the mu-
seum had created a computer tracking system, inventoried its en-
tire collection, created a sacred storage space for 7,000 objects, and
established policies to allow tribal visitors to conduct rituals there,
including burning sweet grass (which required temporarily turning
off the entire building's fire detection system) and placing corn and
tobacco offerings (which violated conservation principles because
they attract insects that can infest the collections). Joyce emphasized
the mutual benefit of repatriation. Through the consultation pro-
cess, she said, Native Americans created new "encounters" with
their heritage while the tribal visitors "provide new information for
museum collection records and interpretation." She later empha-
sized during an interview that the 1980s was an important learning
period before change could happen. Joyce joked, "I call it sensitivity
training."[13]

As more and more Tlingit repatriation claims were sent in, the
Denver Museum staff was increasingly responsive. When the Chief
Shakes Killer Whale Flotilla Robe was finally returned to Wrangell
in 2008, it was met by several at.óow that had already returned from
Denver. Finally, repatriation, as the law prescribed, had begun to
reverse the flow of objects, relocating them from museums to tribal
communities. But in the process, the museum's view of itself and
its relationship with source communities had fundamentally been
transformed, too. The law's "spirit"—its implicit goal of bringing
tribes and museums together to discover common ground—had
infused the repatriation process in Denver. "Implementation of
NAGPRA has profoundly impacted the DMNS," Joyce Herold
concluded her article looking back over the 1990s, "yet the spirit of
the law has changed us even more."[14]

o o o

Although NAGPRA had brought together tribes and museums, the return of clan property at times only fostered divisions within Native communities. In a strange twist, in order to protect at.óow that had been repatriated from being misappropriated again, these items were placed right back into museums.

The Sheldon Museum and Cultural Center lies in the center of Haines, Alaska, surrounded by trees and overlooking the Lynn Canal, the longest fjord in North America. Founded in 1980, the museum records the Chilkat Valley's history, arts, and cultures. The Sheldon is housed in a modest angular building, across from the dilapidated Hammer Museum (showcasing 1,500 pounding tools) and a restaurant advertising "bear-itos."

I am sitting in the Sheldon Museum's basement with its director, Jerri Clark, a kind, soft-spoken woman with a generous smile. As early as 1993, local Tlingit leaders had asked if the Sheldon Museum and Cultural Center could be a holding repository for at.óow. The leaders did not trust their own people to keep the items protected. The Sheldon's then-director agreed, as an act of solidarity. "We're part of the community," Jerri says. "We want to lend that support to our neighbors and our friends." In Haines the museum was not the cause of enmity but a modern-day participant in traditional culture.

By 2011 the clan leaders had deposited six objects in the Sheldon Museum for safekeeping. One is on display, while the rest remain in the storage room. In this arrangement, the objects are entirely owned by the Łukaax.ádi Clan. Other museums around Alaska have taken on the same role. A memorandum of agreement is signed restricting how the Sheldon Museum staff can use and access the pieces. When the items are needed for ceremonies, they can only be checked out with the permission of one of three clan leaders that Austin Hammond chose before he died in 1993.[15] When the Denver Museum returned two items to the local Raven House—the Raven Hat and a long-sleeved navy-colored wool shirt known as *Lingit Tlein Kudas'* (Big Man's Shirt)—they were taken to the Sheldon Museum for safekeeping. Jerri doesn't see this arrangement as an institutional burden. On the contrary, "I'm really kind of honored and pleased," she says, "that the museum gets to be part of it."

"Right now everything is in a good safe spot so I'm not too worried about it," Raymond Dennis Jr. confirms about his clan's arrangement with the Sheldon Museum, when I later interview him in Juneau. Ray is the *hít s'aatí* (housemaster) and a *naa shaadeihani* (one who stands at the head of his people)—the keeper of the Lúkaax.ádi Clan's Raven House in Haines, the person responsible for the Raven Hat and Big Man's Shirt. Coming directly from work, he's wearing a security guard uniform. He has close-cropped hair, a handlebar mustache, and horn-rimmed glasses. Ray explains that the recent history of the Raven Hat and Big Man's Shirt—filled with complexities and sad contradictions—is why it is in the Sheldon. Ray acknowledges that it was his clan's own beloved leader who had secretly sold the two clan objects, which eventually ended up in Denver. Like many in the clan, Ray did not even realize the pieces were missing for a long time. "I just thought somebody in our clan had them," he says. "The last time that I saw our hat was on my uncle John who had worn it '74 or '75."

"How did you feel when you learned that they had been sold?" I ask.

"It was heartbreaking." But, he says, "there had to be a reason why items were chosen to be sold." Ray has been told that one key factor was that, in the 1970s, the clan house was in desperate need of repairs. When the previous caretakers passed on, Austin Hammond took a vow to save the clan house in Haines. "Don't let your grandfather's house fall to the ground," an uncle had enjoined Austin. "Make a big fire, and let people see you living in there. Take good care of your grandfather's land."[16] In 1962 he moved in. But money to care for the house was hard to come by. Ray thinks Austin had to choose between selling at.óow to raise funds to preserve the clan house—or to keep the at.óow but allow the house to fall into grave disrepair. "He took it upon himself to go ahead and sell some of our things."

In another twist, it was Austin himself who arranged for the first clan items to be stored at the Sheldon Museum in 1993. Clan members became upset when Austin's second marriage was not to a woman from the opposite moiety, a serious violation of tradition.[17]

Someone threatened to burn down the clan house in retribution. Ray tells me that Austin responded by saying, "Well, let's take them to the museum, let them sit in there and when you need them we'll create a way for you to get them out." In a strange circle: Austin had sold the clan pieces to raise money for his clan house; but once the clan house was restored and items were repatriated, they were no longer safe there. Instead, they went back into a museum.

When Harold Jacobs first showed Ray pictures of the Raven Hat and Big Man's Shirt in the Denver Museum, Ray recognized them immediately.

"Let's draft it up and let's go after them," Ray told Harold.

"Well," Harold replied, "it could be fast or it could be a long, drawn-out process."

"I ain't going nowhere."

When Ray heard about the Denver Museum staff and their stewardship for the objects, he felt moved that the museum "was taking care of them, that they treated them like they were family." For him, the objects *are* family, the embodiment of his ancestors. As Nora Dauenhauer—one of the three trustees that Austin Hammond selected—once observed, the at.óow in the Raven House "are inseparable from clan history."[18] In 2008, when the pieces finally arrived in Haines, Ray says, it was "like looking at a relative you never thought would be back." He laid the two clan items in the clan house for some days, sitting them alongside other at.óow. "It was like they were having a 'welcome back home' party for them." The following autumn, the clan hosted a potlatch for them, bringing them back out "officially." Then the hat and shirt were deposited in the Sheldon Museum for safekeeping.

Ray describes the arrangement with the Sheldon Museum as "double-edged." He acknowledges that the at.óow are safest in the museum, with its fire- and theft-prevention systems; and its loan process limits the possibility that the objects could be misappropriated. (Although it appears to be exceptionally rare, in at least one case, in Arizona, two ancient ceramic vessels that had been repatriated were purportedly sold back to collectors.[19]) Yet he finds it frus-

trating that he needs permission from the other trustees every time he wants to take them out, which he has done about a dozen times. Around 1999 Ray moved into the clan house, spending tens of thousands of dollars on renovations. He believes that the clan house is where the at.óow ultimately belong. "The responsibility of taking care of those things, that comes back to the clan," he insists. "We have to create our own avenue to ensure the safety of them." His dream is for one day to have all of his clan's at.óow under one roof—the roof of his clan house.

"It's not beyond me to believe that if I can see it in my mind, it can be done," Ray concludes. "A lot of these other things that we've got out there, I see them coming home."

o o o

In late morning, on November 9, 2008, for the first time in sixty-eight years, guests gathered on Shakes Island for a potlatch.[20] They came to Wrangell from across southeast Alaska, from Kake, Saxman, Ketchikan, Sitka, Haines, and Juneau. The guests entered the cedar community house buoyant, smiling. Joy filled the room. This koo.éex was not to be a memorial party, to remove the people's grief after the death of a loved one, but a "happy time," to properly celebrate the return of Kéet Xaa Naaxein, the Killer Whale Flotilla Robe, from the Denver Museum of Nature & Science.

For a long time, it seemed as if this moment would not come. Although the Denver Museum had made enormous strides in NAGPRA's first decade, at the start of the law's second decade, it began to fall apart. The same problems that plagued the museum's dealings with the Cheyenne and Arapaho beset its relationship with the Tlingit. Between 1997 and 2002, the Tlingit had claimed eight objects for repatriation. But by 2006 none of these claims had been addressed. The Denver Museum loaned the items to the Alaska State Museum, so they could be checked out like library books for ceremonies, but the ownership was retained in Denver. Joyce Herold explained to me that the museum wrongly took its time evaluating the

claims. "I think that if there is something I would redo," Joyce said, "it would certainly be to move faster on many things." In 2006 the Denver Museum's administration, aware of these problems, over-hauled the anthropology department. (I arrived in 2007.) Within a year, all eight clan items were returned, including the Killer Whale Flotilla Robe.[21]

To commence the thirteen-hour potlatch, the people began with a "warming of the hands" ceremony. When the brief welcoming ceremony concluded on Shakes Island, the participants and guests made their way to the James & Elsie Nolan Center, a modern build-ing housing a museum and visitor center, perched facing the sea on the northern tip of Wrangell Island. In the light-filled auditorium, the hosts—the Naanya.aayí Clan—stood on one side of the room, joined by members of their Wolf-Eagle moiety. On the other side of the room were the guests of the opposite moiety, the Ravens. Before each moiety were long tables overflowing with at.óow—clan hats and robes—a cavalcade of crests. After the attendees were welcomed again, the guests were invited to ceremonially dress the hosts by placing their treasured hats on them.

Once all the hosts were adorned in their ancestors' clothes, John Feller stepped forward. Since his visit to the Denver Museum in 2002, his neatly parted hair had become streaked with gray. For this celebration he wore black slacks, a blue oxford shirt, a black vest with red trim, and earrings from which dangled a large shark tooth. John now stood with his hands at his side, a solemn expression as he stared straight ahead. Behind John, four men held up the glorious Killer Whale Flotilla Robe at shoulder height, the Chilkat robe's fringes rippling like a gentle rain. The head of the local Ravens, holding a microphone in one hand, recited the names of the ances-tors who came before John, the lineage that gave John his right to become the robe's next caretaker. Finally, John was "dressed up" in the robe, as he was during the 2002 consultation at the Denver Museum. The robe was now his to protect, although when the day's ceremony was done, he would protect it by placing the robe in the Wrangell Museum for safekeeping.

The celebration continued with the song recorded in 1904 and rescued by Harold Jacobs from the Library of Congress.[22] Two rows of two dozen people danced in Chilkat robes and button blankets. When the echo of the singer's voices in the room faded, the Killer Whale Flotilla Robe, was now formally back in the possession of the Naanya.aayí Clan.

Most of the people I interviewed in Alaska ended our conversation by describing the Tlingit concept of *shagóon*. A difficult phrase to translate into English, it refers to the bonds between generations. The term also refers to the clan's totemic crest.[23] As Ben Didrickson, a Dakla'weidi Clan leader from Klukwan, told me, "What it basically means is everything that came before, everything presently and everything left to come." Harold Jacobs translated it as "who we were, who we are, and who we'll be." This phrase was invoked to explain to me that repatriation is about remedying past wrongs and giving people the objects they need in the present, but also about sowing hope for a better future. With each repatriation, Tlingit culture takes one more step back from the precipice of death. "With these objects," Marsha Hotch, who helped repatriate a communally owned hairpiece from the Denver Museum in 2009, told me, "we're trying to teach the next generations how to take care of protocol. Having the objects come back enables us to pass that on to the next generations so they can take more of an active role in their Native community. When we don't have our at.óow, how are we supposed to keep a healthy community? I believe this is one of the things that can help most Native Americans, if those objects mean more than just art."

When the Wolf-Eagle moiety completed their song, the Ravens began their own speeches and songs to "hold up" the Killer Whale Flotilla Robe. Raven guests from the village of Kake even brought out a Chilkat robe and tunics that had been worn at the 1940 Chief Shakes potlatch. As midafternoon wore on, the guests were served their first meal, followed by "fun time dancing" in which members of both moieties join in. Soon the Ravens began to sing "Here Come the Killer Whales." John Feller was asked to stand. Raven

members brought out the Chief Shakes Killer Whale Hat, which Walter C. Waters's wife had sold to the Burke Museum in Seattle. (There is no relation between this hat and the killer whale hat the Denver Museum repatriated in 1997.) The Burke Museum hat is "likened to a crown of royalty."[24] In 2008 the museum rejected the Tlingit's repatriation claim.[25] Yet two Burke Museum staff members had brought it out of storage and flown with it from Seattle to Wrangell for the day.

A Raven on each side of John—one being Ray Dennis Jr.—held the hat over John's head, while clan leaders spoke to him. They said they approved the ceremony. They approved the return of the Killer Whale Flotilla Robe. "When they get their items returned, it strengthens everybody," Ray told me in Juneau. "In our culture, of our spirituality, of our inner healing, that's where all of these things come into their pinnacle of use."

The Killer Whale Flotilla Robe was taken off of John and placed on the shoulders of Clara Bradley Gray, the granddaughter of James Bradley—Chief Shakes VIII. All things being in balance, next it was the host clan's turn to dance. The drumming and singing flooded the room, and soon the killer whales were swimming across the dance floor all surrounded by their kin, the clan crest and the people together again as one.

IV. RESPECT

Calusa Skulls

19. THE HARDEST CASES

Even the unidentified dead are entitled to be buried in this country.

Walter R. Echo-Hawk (Pawnee), lawyer, Native American Rights Fund[1]

Congress time and again rejected the idea of a kind of forced universal repatriation.

Vincas Steponaitis, former Society for American Archaeology president[2]

To meet Fred Dayhoff, I am driving southward on the Florida Turnpike, watching the endless rows of strip malls zip by. Then, like a switch, the buildings recede and I am surrounded by the lush everglades. The narrow highway, known as "Alligator Alley," is as straight as a ruler. I pass a billboard advertising a local show. A man wears traditional Miccosukee dress—billowy cotton clothes patterned in geometric lines of vibrant colors—with his arm inserted, up to the elbow, into the mouth of an alligator.

I pass a Baptist church, then a crowded row of large houses sitting on raised mounds. The evidence of the Miccosukee's good financial fortunes is on exhibit. They are rich, thanks to a booming casino near Miami (and other investments) and just 600 tribal members to reap the profits.[3] The victory of capitalism over colonialism. Having only worked in impoverished tribal communities before, I am stunned by the conspicuous consumption the Miccosukee display in their driveways. Mercedes, Humvees, Porsches. Even souped-up golf carts.

Farther on is a neighborhood of dispersed houses. Fred has left the gate to his driveway open for me. I pull in and open the car door. The air is heavy with humidity, smelling of earth and plants, like a greenhouse. "Hello!" I hear, instantly recognizing Fred's unhurried, southern-hued drawl from our phone conversations. We shake hands. "You better run inside if you don't want to get eaten alive by the mosquitoes."

We enter Fred's house, reminiscent of Robinson Crusoe's, a tidy fort of wood slung amidst a lush five-acre plot of wild green. Fred is wearing a Western-style red plaid shirt, boots, and a wide-brimmed black hat. He has the swagger and syntax of a cowboy. We sit down in his living room. Fred removes his hat, revealing a nearly bald head and a face eroded, over his seventy-one years, by the merciless Florida sun. He sways comfortably in a rocking chair.

I'm surprised Fred is willing to talk with me after all our disagreements. For ten years, Fred struggled against the Denver Museum over one of the most problematic sections of repatriation law: what to do about human remains that cannot be linked to any living tribe. Twenty years after NAGPRA became law, only about 27 percent of the Native American human remains in 650 museums and federal repositories had been affiliated.[4] This left more than 115,000 sets of remains in a kind of legal purgatory. With no regulations in NAGPRA to determine what should happen to them, the remains sat on museum shelves, suspended between the tribes who wanted them buried and the scholars who wanted them kept as artifacts.

This stalemate was created by Congress. In 1990 the question of "culturally unidentifiable" human remains (also referred to as "culturally unaffiliated") was so contentious that when NAGPRA became law, Congress simply left the guidelines for these remains "reserved" to be dealt with later. The process to establish a workable mandate would inflame both sides—reinvigorating old alliances, and showing that the complex historical, moral, and legal dilemmas of repatriation have yet to be fully resolved. If a skeleton is not related to a living people, should it go to Native Americans because their broad ethnic identities confer a special relationship, or

should it go to archaeologists who consider themselves the stewards of America's past? How to construct an answer within the existing legal framework of NAGPRA? In the end, is every human entitled to a burial, or are some humans destined to be archaeological specimens? Many wondered if a solution could ever be found, as both American Indians and archaeologists came to see the culturally unidentifiable issue as the last great battle of the repatriation wars. Many saw these regulations as "truly an end-game."[5]

Although he is not one, Fred Dayhoff represents the Miccosukee Indians. The Miccosukee are relative newcomers to southern Florida but believe they became enmeshed with the more ancient local people—the Calusa. Most archaeologists and museum professionals vehemently disagree. The thousands of Calusa skeletons across Florida and beyond became an exemplar of "culturally unaffiliated" human remains under NAGPRA.

"The big issue from the start was whether we could claim Calusa remains," Fred begins, as he settles in to tell me the story of his career. "And the Denver Museum was one of the hardest cases we had."

o o o

Fred did not seek out these battles. They grew out of his birthplace and into his duty. In the 1840s Fred's ancestors arrived in Florida from Georgia. They lived off the land, whites among the Indians, as hunters and fishermen. They sold hides, furs, and bird plumes. Fred would follow in his family's footsteps. He quit school to become a guide and alligator hunter. He later learned to weld. One day a friend told him about a job with the National Park Service, as a maintenance man and picking up litter. After he took the position, a big fire broke out in the Big Cypress National Preserve. Fred told a ranger how it could be extinguished and was soon in charge of every wildfire. Fred eventually became a park ranger, catching gator hunters not unlike his former self. He also helped inventory livestock and write regulations for the preserve, particularly guidelines for access by the Miccosukee.

After the second helicopter crash, Fred finally had to quit. The first crash had not been too serious, although he was lucky that the little cigars of dynamite he was carrying to break open water channels didn't explode when they hit the rotors. The second helicopter dropped sixty vertical feet and ignited like a beautiful firework display. He and the pilot were far out in the glades, with no radio, and no one knew where they were exactly. Luckily, a worried friend went out looking for them and spotted the fire. Fred's broken vertebrae required surgery and titanium bolts. He wanted to return to work immediately but was convinced to take temporary disability. After he healed, his boss told him the only position available was selling tickets. Fred retired from federal employment instead.

Right about 1990, Fred was called to meet with the Miccosukee tribal council. He didn't know why. When he appeared before them, the council told him he just got hired—for a job he knew nothing about and hadn't applied for. Fred was told he would help the tribe comply with NAGPRA.

"What's that?" Fred asked.

"We don't know," the tribal chairman replied. "But it has to do with dead people."

o o o

After the surprise job offer, Fred went home and read the country's new repatriation law. He returned to the council to discuss next steps. But they refused to talk further: the passage of NAGPRA presented the Miccosukee with a great opportunity but also a great danger. The Miccosukee traditionally believe that a person laid to rest should not be moved again. There are no cultural allowances for the dead to be moved in the first place and certainly not "reburied": it is fundamentally against their culture. Tribal leaders wanted the dead returned to their spiritual journey. Yet they themselves could not risk the spiritual dangers of return.

Their solution was to hire a trustworthy outsider. Fred.

Fred didn't know what to do, really. But he wanted to help.

Growing up with the Miccosukee, he felt obliged to them as a neighbor. He also felt grave robbing was wrong. Fred often reflected about how he'd want his own family members treated in death. And he had restive memories of how in the 1950s tourists could buy Indian skeletons as souvenirs at local gas stations for $25 each. He knew that until their financial destiny started to change in the 1980s, the Miccosukee had no means to contest these past injustices, no way to defend themselves.

Fred cautiously agreed.

"You know our culture," the chairman simply instructed. "You do what's right."

"Okay, I'll do my best."

"Don't worry," one council member offered with a tense smile. "*We* won't come after you. But the *old people* will if you make a mistake!"

The council would support Fred. The real hazard was upsetting the dead.

The first few years of Fred Dayhoff's new job as the Miccosukee NAGPRA coordinator were confusing. No one knew what really could be done—or not done—under the law. Fred decided to first focus on working with archaeologists in south Florida. He already knew the most prominent ones from his time as a park ranger. Some were even friends. He had worked successfully with archaeologists on a few projects preserving burial mounds.

Fred's first interactions with museum administrators were uncertain. At first, he felt museum people would not give anything back. But when he proved a number of collections in museums came from known looters, Fred recalls that attitudes began to soften. Also, as museums inventoried their collections, they found numerous skeletons that came from unknown locations with little documentation. The scientific value of these remains was so limited that soon museums were approaching Fred eager to get rid of them to make space for incoming collections.

Fred began returning first dozens, then hundreds of human remains to the glades. In Florida, as elsewhere, there had been numer-

ous cases of brazen tomb raiding, which had long been allowed un-
der state law. Perhaps the most shocking case was when a college
student stole the head of John Osceola, who had died just two years
before, around 1960, and was placed according to tradition in a cof-
fin aboveground in a secret place in the Everglades.[6] (The student
was caught and prosecuted, but the judge found him innocent be-
cause there was no "substantial evidence" that the student had acted
"wantonly or maliciously.") Repatriation of historical and recent
graves that had been looted proved to be uncontroversial. Muse-
ums began to return these ancestors. But for any Indian human re-
mains in Florida dating to the 1700s or earlier—any remains labeled
"Calusa"—museums would not affiliate them.

20. LONG SINCE COMPLETELY
DISAPPEARED

Due to war, disease and deportation [the Calusa population] has long since completely disappeared, though its traces may yet be discoverable among the Everglade Seminoles.

Aleš Hrdlička, *The Anthropology of Florida*[1]

It is most unpleasant work to steal bones from a grave, but what is the use, someone has to do it.

Franz Boas, 1888, the "father" of American anthropology[2]

Did the Calusa go extinct? Or do the Calusa live on as today's Florida Indians, the Seminole and Miccosukee?

These seemingly straightforward questions raise more complex ones centering on how we think about kinship, identity, and cultural survival. They also lie at the heart of more than a decade of repatriation disputes between museums and tribes over the fate of thousands of Calusa artifacts and human remains.

I have always been skeptical of pronouncements that a Native American tribe has gone extinct. The will to live is a defining feature of life. I find it hard to imagine that even when a tribe was on the verge of the end, when the last handful remained, that they would

stay hidden away and willingly vanish, instead of finding a distant cousin or friend or ally. Humans survive.

I have thought that these arguments of extinction are too often based on antiquated notions of cultures as static and monolithic.[3] For decades, scholars represented Native American cultures as unchangeable. This person was either Navajo or not. Sioux or not. Seminole or not. Today, however, we see how people's lives are kaleidoscopic. Objects are traded. Children are adopted. Women are captured. People move and migrate. Ideas are lent and borrowed, adapted and transformed. Streams of humanity are more likely to intertwine than to dry up. Every human culture contains the traces of infinite predecessors and lineages.

But, after studying the history of Florida, I had to admit: If there ever was a good example of a tribe going extinct, the Calusa might be it.

o o o

Florida's ancient history extends back to the earliest known humans in North America, to the Paleoindian period more than 13,000 years ago.[4] For thousands of years, these Native peoples survived on the abundant wildlife of the coasts and hinterlands. Around 1,200 years ago, a society based on small-scale chiefdoms emerged in southeastern Florida and kept evolving until, centuries later, it had become either "a complex chiefdom or a weak tribute-based state."[5] Spread across southern Florida were fifty villages with thatched houses built on natural hills or artificial mounds made from layers of broken seashells. The people thrived as fishermen, hunters, and gatherers. The society was hierarchical, divided between nobles (royals and military leaders) and commoners who paid tributes of foods and goods to their patrons. The people were said to be tall and fierce. They wore little clothing and decorated themselves in body paint. The wealthy adorned themselves in strands of pearls and gold beads. These were the Calusa.

The Calusa did not welcome the arrival of the men from across

the eastern sea. Their first encounter with the Spanish might have been in May 1513, when warriors attacked a reconnoitering vessel from the expedition of Juan Ponce de León, during his search for the fabled Fountain of Youth. After Columbus conquered Cuba, refugees fled to Calusa territory, bringing with them new diseases, which quickly decimated villages. The Spanish tried and failed to establish a mission among the Calusa in 1567; it was burned to the ground after Spanish soldiers executed a Calusa king. The Calusa remained isolated (likely purposefully) from Europeans for more than a century.

However, by the early 1700s, the chiefdom was fading fast. Diseases were taking a toll; Calusa lands were increasingly impinged upon by settlers and other refugee Indian groups reeling from European expansion. Slavers were forcing Calusas to escape to the hidden coves of the Florida Keys. In 1704 the first Calusa refugees arrived in Cuba, where it was thought they would be safer. Most of these Calusa immigrants quickly perished from typhus and smallpox.

Just as the Calusa world was unraveling, the Lower Creek, with their homes in Georgia, were trying to drive out British colonists.[6] They failed and were forced south into the Florida panhandle. Just as they were pushed from the north by the British, the Creek were enticed south by the Spanish, who wanted them as trade partners, as laborers, and as a buffer against other colonial powers that coveted the dwindling Spanish empire's lands. As groups of Lower Creek moved beyond their northern relatives' sphere of influence, they began to develop their own identity as Seminole, a name given by the Creek meaning "wild, non-domesticated."[7] The region around Gainesville, in northern Florida, became their new (though temporary) heartland, as they herded wild cattle abandoned by the Spanish, farmed, and traded deerskins for valued tools.

The Seminole's success sparked four decades of war. Land-hungry Americans now wanted Florida for their own. In the First Seminole War, Andrew Jackson, leading 4,800 American troops and 1,500 Creek allies, seized Spanish forts in the panhandle and used scorched-earth tactics to destroy Seminole and free-black vil-

lages. This war led to the 1819 Onís-Adams Treaty (ratified in 1821), in which Spain surrendered Florida to the United States. In 1823 a 4 million-acre reservation in central Florida was created for the 5,000 Seminoles, who were to live peacefully within its confines in exchange for protection, rations, tools, and compensation. Most Seminoles moved to the reservation but suffered from isolation, drought, failed farms, and false promises of adequate provisions.

In 1830 the U.S. Congress passed the Indian Removal Act, which aimed to transplant all Indians west of the Mississippi River. Andrew Jackson, by then the U.S. president, gave the Seminole three years to relocate willingly or to be removed by force. Most resisted, leading to the Second Seminole War, one of the costliest Indian wars the U.S. government fought. Finally, after hundreds had been killed and their culture disassembled, 2,500 Seminoles left for Oklahoma. Only a small remnant held on in Florida. Over the next decade, conflicts continued; in the Third Seminole War, the last Seminoles were tracked down and killed or forced onto wagon trains heading west. By war's end, in 1858, only 200 vanquished Seminoles were left scattered in hidden camps along Florida's southern periphery.

When the Seminole were no longer a military threat and nearly all of their land had been taken, the U.S. government finally accepted their presence and gradually sought to assist them with schools, housing, and economic development. By the 1930s most Seminoles had moved to various reservations established for them— there would eventually be six—drawn there by social services and jobs. From the several hundred Seminoles who survived the nineteenth century, the tribe grew to several thousand. Still, development was slow. The first Seminole reportedly didn't graduate from high school until 1957.

Following World War II, the U.S. government launched its termination policy, which abolished tribal sovereignty and compelled Indians to assimilate into the American mainstream. The Seminole vehemently objected. In 1953 Seminoles voted 241 to 5 to create a tribal constitutional government. However, rather than uniting all Seminole, this process cleaved off one group, which disagreed with

the approach to land claims. Discord continued to spread from interpersonal and religious differences. In 1962 this dissident group gained federal recognition as a distinct Seminole people, the Miccosukee Tribe of Indians of Florida.[8]

o o o

The histories of the Calusa and the historic Seminole no doubt became entwined in the 1700s, as both Indian peoples struggled to survive under European colonialism. But how entwined?

It is often said that the last Calusa fled to Cuba. When the British took Florida from the Spanish in 1763 (Spain would get Florida back in 1784 before losing it to the United States in 1819), the last few Calusa were evacuated with Spanish administrators to Cuba. William Marquardt, an archaeologist at the Florida Museum of Natural History and today's leading scholar of the Calusa, insists that "any direct descendants of the Calusa and other southern Florida native people will likely be found in Cuba."[9]

However, even Marquardt says it is possible the Calusa were among the "Spanish Indians"—an ambiguous phrase that emerged in the 1820s that could refer to Calusa survivors or to Apalachee Indians of the Gulf Coast that merged with the Calusa and Spanish. One leading scholar concludes that it is "perhaps easiest to think" of Spanish Indians as a blend of Calusa, Seminole, and Spanish people.[10] But, in the end, the term "Spanish Indian" is just as confusing and uncertain as the very history the term presumes to illuminate.

Still others believe, given the timing of the Calusa's demise by the 1760s and the rise of the Seminole during the same period, that the former were absorbed by the latter.[11] Although the Seminole maintained many of their traditions from the north, they also rapidly adapted their lifestyle, for example, abandoning log homes for open-air thatched houses, a type used by the Calusa.[12] Another example can be found in Seminole oral tradition, which holds "that long ago the Calusa and Seminole camped near one another and the people of each camp visited freely in the other."[13]

But such evidence linking the Seminole and Calusa is fragile, hardly evidence enough for a sound conclusion. It is easy to understand why many would come to see the Calusa most simply as vanished.

o o o

The fate of the Calusa was not studied archaeologically until Frank H. Cushing arrived in Florida. By 1884 Cushing had spent nearly five years among the Zuni in New Mexico as a pioneering ethnologist.[14] Cushing had also become entangled in a dispute with two army officers who were trying to swindle land that belonged to the Zuni. Cushing helped stop the land grab, but his efforts provoked the powerful Illinois senator John A. Logan, whose son-in-law was part of the scheme. Logan targeted Cushing, raising the threat to close the Bureau of Ethnology unless the agency recalled the anthropologist from New Mexico. The shakedown worked. Officially, Cushing was brought back to Washington, D.C., to focus on writing up his research.

In the spring of 1895, gravely ill, Cushing was sent to a renowned Philadelphia physician, William Pepper. It was a lucky introduction. Not only did Cushing's health improve, but the charismatic anthropologist also found a new benefactor. Within months, Dr. Pepper was paying for Cushing to travel to southern Florida, for its salubrious environment and to assess its archaeological potential. Cushing's work there proved revelatory.

When southern Florida became a vacation destination in the 1880s, a few visitors described the scores of "shell heaps" that littered the peninsula and islands. But until Cushing arrived, there had been no systematic, scientific excavations. Cushing focused his efforts around Key Marco, south of Fort Myers, and discovered that the shell mounds were not isolated features but an extensive pattern of Native American settlement. Cushing discerned that southern Florida's ancient peoples were a coastal adaptation influenced by Mississippian cultures to the far north. Here was yet another ma-

jor civilization America could claim as its own. Four years into his Florida research, his work suddenly came to an end when, during a meal, a fish bone lodged in his throat and killed him.

Yet Cushing's research cracked open the door to southern Florida's enigmatic history. The coast and Keys soon drew major scholars. The Smithsonian's Aleš Hrdlička arrived in 1917 and 1918 to survey the vast region and to define which cultural groups were associated with which type of sites. He was among the first to firmly conclude that the mounds in south Florida dating to before the 1700s belonged to the Calusa. "The remaining problems," Hrdlička wrote in 1922, "are just what became of all this population; exactly what these groups were; and whether or not the remains of the Calusas group may have merged with parts of the Seminole Tribe."[15]

Following Hrdlička, archaeological work between the 1930s and 1960s focused on locating coastal and inland sites and excavating burial mounds.[16] Cushing himself dug up more than 600 burials.[17] This resulted in one brief paper that analyzed the marks on the skulls.[18] Cushing found that many skulls had distinctive scarring that suggested a unique hairstyle worn by Calusa warriors to mimic the crest of a bird.

Cushing's work transcended the kind of antiquarianism that passed as "science" in the late nineteenth century, which used Indian bodies to support crude arguments about race. Cushing helped usher in a modern period when archaeologists increasingly understood that embedded within our bones are the stories of our lives.[19] Bones give evidence of health and disease. Bones record people's activities, telling us about social organization: for example, whether men threw spears and women ground the corn (or vice versa). Chemicals embedded in teeth chronicle what people ate. Human tissue can be dated. Over time some of the analytical techniques developed on Native American skeletons proved to have broader applications. The forensic analyses done on victims of wars and disasters are based on methods that were first developed on Native skeletons. From techniques to determine the sex of skeletons to our understanding of environmental and dietary changes in North America over the mil-

lennia, all arose from these first collections and studies. Many more skeletons were used to educate scientists about biology and human variation. When DNA analysis became viable, the wisdom of keeping these skeletons for study was demonstrated in the minds of many. As the Smithsonian's Douglas Owsley claimed, "To say that we have learned all we can from these skeletons is a serious mistake."[20]

Hrdlička had studied most of the 300 Calusa skulls preserved in collections in Germany, New York, Boston, Philadelphia, and Washington, D.C. But he concluded that with a sample this small, little could be said. "In order further to clear the anthropological problem of the Floridian peninsula," Hrdlička advised, "it is highly desirable that more skeletal material be collected."[21]

Hrdlička's wish was granted. The pace of digging up skeletons accelerated, as scientific methods advanced and the field of archaeology gained prominence. By World War II, it was reported that every large burial mound in southern Florida had been discovered and exhumed.[22]

o o o

With the passage of the Antiquities Act in 1906, credentialed archaeologists became the country's stewards of historical sites on federal lands.[23] Scholars of Hrdlička's generation saw themselves as fulfilling a legal mandate and the goals of science by including burials in their studies—bones were just like any other artifact, an integral part of the archaeological record. This work illuminated the rich history of Native America and became the foundation of museums across the country as well as scores of national, state, and local parks and monuments.

Yet the transformation of Indian history into national patrimony required applying a different set of standards to Native American remains. For most Americans, by the mid-1800s United States law had established a "hierarchy of rights" to determine the care of corpses.[24] The rights first reside with individuals who can determine the fate of their future corpse, for burial or donation to science. When an

individual's views are unknown, then the next of kin is given such rights. And when the next of kin's views are unknown, then the state is given the right to the remains. However, even in the case of paupers and unidentified remains, the law came to establish that the state's responsibility is to respectfully bury them.[25]

These laws did not apply to American Indians. Because of the nature of their burial practices (often in unmarked burials, not in formal cemeteries). Because of their antiquity (the older the bones, the less right any specific individual could have to them). Because of racism (Native American views don't count). Because over time museums came to be seen as the ideal asylum for Indian history and culture (Indians should be studied).

But another key reason was the common belief that many Native American tribes had disappeared—were extinct. Consider an 1861 circular by the Smithsonian Institution seeking donations from "officers of the army and navy, missionaries, superintendents, and agents of the Indian department, and residents in the Indian country, and travelers to that end." The Smithsonian lists its first "desiderata" was skulls; its intention was to build "a full series the skulls of American Indians."[26] The circular notes "the jealousy with which [Indians] guard the remains of their friends renders such a collection in most cases a difficult task, but there are others in which these objects can be procured without impropriety." Examples given include the graves of slaves and the friendless. Indians killed on the battlefield. Also: "Numerous tribes have become extinct."

The logic was callous but consistent. If there are no next of kin, no relatives to consult, then the state has the right to determine how the dead are cared for. And if American Indian remains are deemed a national resource, then the government has the right to determine that their remains should not be buried like everyone else but saved for science.

If the Calusa were "extinct," then who among the living could legitimately object to the disturbance of the Calusa dead?

o o o

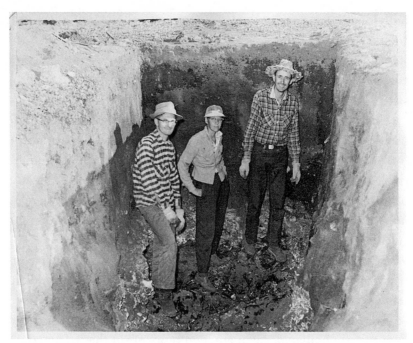

FIGURE 10. Hugh N. Davis Jr., Hilda Curry Davis, and George B. Stevenson in an excavation pit at the Tallman Site. Courtesy of DMNS, 2001-165-30.

One large burial mound had been dug into by Clarence "Pop" Alexander.[27] When he was sixteen years old, Pop left his childhood home in Shellman, Georgia, with a friend for Miami. After Miami they kept hitchhiking south, becoming among the first black Americans to live in the Upper Keys. Pop found odd jobs. While driving a truck for a fish company, he met and fell for Lucienda Williams, who lived on Plantation Key. He moved to the island, becoming the caretaker for a piece of land that belonged to Dr. Maurice H. Tallman, a physician. Pop's shack was next to a large Calusa mound, about 1,000 years old. Pop would sometimes dig into the mound. Years later people would still remember Pop's Indian collection, which was incrementally given away, sold, and destroyed in hurricanes until finally nothing remained of it.

In the years after World War II, professional archaeology in southern Florida was mainly supported by universities and the Na-

tional Park Service. The science of archaeology increasingly fo-
cused on using systematic methods to document Calusa history at
a regional scale. However, across Florida's coast, hinterlands, and
islands, small excavations persisted along roadways and in people's
backyards.

In 1957 what was left of the mound at Dr. Tallman's place was
excavated. A husband-and-wife team, Hugh and Hilda Davis, led
the effort, helped by a man who had a home on Plantation Key,
George B. Stevenson.[28] Initially, the excavated materials were sent
to Miami for storage with an avocational anthropology society. But
a lack of space at the facility inspired the caretakers to start throw-
ing out the boxes of artifacts. Several large cardboard boxes full of
broken ceramics and shell relics were discarded, and then a mem-
ber of the society named Dan D. Laxson rescued what was left and
took it home.[29] Laxson hoped that the Smithsonian would accept
the collection. But Stevenson encouraged him to consider a smaller
local museum called the Southeast Museum of the North American
Indian, just forty miles south of Plantation Key, run by Mary and
Francis Crane.

The collection arrived in Marathon in 1962. Mary and Francis
Crane were delighted to add yet more Florida history to their mu-
seum, although this collection was partial and without much docu-
mentation. They cataloged their latest collection: 177 skeletal frag-
ments and one Calusa skull.

21. UNIDENTIFIABLE

How could anything that I did with the bones of these ancient people harm any living person?

Clement W. Meighan, archaeologist[1]

Staring at the phone, I hesitated. A deep breath. I picked up the receiver. I put it back down. Another try. I found my fingers dialing the number. I heard three rings and then Fred Dayhoff's raspy drawl. It was a phone call that I didn't want to make. I was going to give Fred and his colleague Steve Terry news they wouldn't want to hear.

On just my third day at the Denver Museum of Nature & Science, in July 2007, the collections manager told me about the "really messy" conflict with the Miccosukee regarding a claim for Calusa remains. I immediately called Fred asking him for patience, promising to get the consultation with the Miccosukee back on track. After I settled in, I called Fred and Steve again, inviting them to Denver. They said no; it wouldn't help. They told me to just make a decision about their claim; it had been almost eight years. At least a decision would show the museum's good faith to engage with the tribe. Otherwise, I was told, I might have to publicly defend myself in front of the Review Committee, which oversees NAGPRA disputes—a not-so-subtle threat. And so I did the research and made a decision.

When I became a curator at the Denver Museum, I planned to work closely with tribes. I had hoped that unlike so many museum people before me, I could avoid controversy and discord. Yet now I heard myself telling Fred Dayhoff and Steve Terry that, after months of careful study, I was rejecting their claim. The Calusa could still not leave Denver.

The law bound my hands. NAGPRA defines "cultural affiliation" in specific terms. Under the federal legislation, cultural affiliation can only be established when "there is a relationship of shared group identity which can be reasonably traced historically or prehistorically between a present day Indian tribe or Native Hawaiian organization and an identifiable earlier group."[2] In other words, the law required me to ascertain the relationship between the Miccosukee (the "present day Indian tribe") and the Calusa (the "identifiable earlier group"). To determine this relationship of shared group identity, the law dictates that I had to equally examine ten lines of evidence: geographical, kinship, biological, archaeological, linguistic, folklore, oral tradition, historical evidence, other information, and expert opinion. A positive cultural affiliation is based on the "preponderance of the evidence"—a legal phrase meaning about 51 percent certain.

Of the ten lines of evidence I examined, I found that only folkloric information and oral tradition suggested the possibility of cultural affiliation, and both were tenuous, speculative. Historical evidence, on balance, is ambiguous about the Calusa's end. I concluded that the so-called Spanish Indians were likely not a remnant Calusa population. If there was a meaningful connection, I thought it possible that the last Calusa survivors joined the Seminole as they migrated into Florida in the 1700s. But this was only suggested in the historical record. The Miccosukee claim pointed to statements by several authors ("expert opinion") that imply affiliation, but there are more scholars who argue the opposite. Based on the totality of the evidence, I felt far less than 51 percent certain that there is a shared group identity between the Miccosukee and the Calusa.

o o o

In the final days of 1986, when Senator John Melcher introduced the Bridge of Respect Act, the first of sixteen repatriation bills submitted to Congress, he did not include any language about "cultural affiliation."[3] Senator Melcher's goal was to have the tens of thousands of Native American human remains and sacred objects returned from museums. The process by which this would happen was then only vaguely conceived.

By the next year, as details of the proposed law were considered, various factions began to debate exactly who should be returned to whom. Archaeologists and museum administrators argued that claimed items and remains should only go to descendants with the closest cultural interest, relationship, or affinity. This was a position then well formed by the Society for American Archaeology. The SAA formally adopted a policy in 1984, and revised in 1986, which stated that while diverse viewpoints on death must be recognized and respected, the SAA "opposes universal or indiscriminate reburial of human remains." Instead, any claim must be decided case by case on the basis of scientific and cultural values and the claimants' "strength of their relationship to the remains in question." Similarly, in 1987, when the American Association of Museums convened a task force to create a policy on repatriation, it recommended that the basis of claims should be "a direct relationship" between remains and living tribes.[4] If direct connections could not be proven, then the claimant "must demonstrate that there exist compelling religious or cultural values that transcend well established scientific interests." Most curators and archaeologists then "objected most vehemently to the Pan-Indian movement's view that *all* Native American remains are sacred, even those taken from thousand-year-old burial grounds."[5]

In contrast, many Native American advocates emphasized that, in their cultures, kinship is expansive. Concepts of human relationships are not strictly bound by time or place. "According to our teachings, there is no such thing as culturally unaffiliated Native remains, since we believe that we are related to all that lives," Tex Hall, chairman of the Three Affiliated Tribes in North Dakota, testi-

fied before Congress. "Our teachings regarding the ancient remains taken from our collective aboriginal homelands tell us we have a responsibility to each ancestor, no matter where they lived or died."[6] Walter R. Echo-Hawk insisted, "We don't accept any artificial cutoff dates set by scientists to separate us from our ancestors."[7] Some, such as Daniel Inouye, senator of Hawaii, even began to envision the new law establishing a massive tomb on the National Mall as a final resting place for all of the country's Native human remains in collections.

By 1988 the disparate factions began to coalesce around the idea that when cultural affinity could be demonstrated, the rights of that group should prevail. The battle line then shifted to how such a cultural relationship should be determined. Native Americans emphasized the need to consider oral tradition and customary laws, and advocated for acknowledging the fluidity of human relationships.

Archaeologists emphasized scientific proof and asked that the legal definition of affinity be limited to very close and continuous relationships. "I recognize that if your grandparents or somebody like that is involved, there's no question of your claim to them," Stanford University's Bert Gerow said.[8] But some remains in collections are 5,000 years old, or older, he explained, and that is "like our claiming the ancient Egyptians as our direct ancestors." Numerous archaeologists argued for a specific cutoff date within which remains could be claimed. An archaeology professor at UCLA, Clement Meighan, only conceded to return anything after the country's founding in 1776.[9] These differences epitomized the culture clash of the repatriation debates, in which Western views of ancestry are shaped by direct biological lineages defined by specific dates compared with Native views that generally see all ancestors as deeply interconnected and interdependent, expansive, and timeless.

For many years, the Smithsonian insisted that only next of kin, if demonstrated by "rigorous proof of a blood relationship," could receive human remains from its collections.[10] (Today many European museums facing repatriation claims are taking a similar line: claims are only accepted for named individuals, not "anonymous"

skeletons.[11]) When the National Museum of the American Indian (NMAI) Act was passed in 1989—the country's first federal law with repatriation provisions—the Smithsonian abandoned its earlier position, instead agreeing to "cultural affiliation."[12] This negotiated concept, however, quickly became encumbered. The different sides could not agree on what this implied. Reportedly, the American Indian activist Suzan Shown Harjo assumed the majority would be affiliated, while Smithsonian Secretary Robert McCormick Adams assumed a minority would be affiliated.[13] Publicly, the Smithsonian announced that culturally unaffiliated remains made up the "vast majority" of its collections. Tribes should "lower expectations" that "all of these bones suddenly will be returned."[14]

By September 1990, representatives of the various factions had nearly arrived at NAGPRA's compromise language for cultural affiliation—what would become the law's "axial term."[15] As one of the SAA's representatives, Keith Kintigh, an archaeology professor at Arizona State University, saw it, if "cultural affiliation" was defined too broadly, then archaeologists would protest because it would mean everything would go back.[16] But if it was defined too narrowly, then Native Americans would protest because nothing would go back.

The U.S. Senate concluded that lineal descendants and Indian tribes would need to show a "reasonable connection" to what was claimed, but acknowledged that it would often be "impossible . . . to show an absolute continuity."[17] Determinations of cultural affiliation would need to consider the "totality of the circumstances and evidence" with a claim not being rejected "solely because of gaps in the record."[18] The language was a middle ground: tribes would have to use both scholarly and traditional evidence to reasonably demonstrate substantial but not perfect continuity. Still, by bringing together Western science and Native tradition, the stage was set "for a fundamental cultural and legal conflict."[19]

o o o

Once cultural affiliation had been established as the legal basis for returning remains, one of the biggest obstacles became what to do with those human remains that could not be culturally affiliated at all—the unidentifiable. Some argued that Native American concerns should outweigh scientific interests, and reburial wouldn't hurt anyway, since Native remains without contextual information are not typically of great use to archaeologists.[20] Archaeologists in the SAA conceded to the need to return affiliated remains when proven, but its representative, Keith Kintigh, argued, "In the case of unaffiliated human remains and objects, there is, quite literally, no one to whom they can be appropriately repatriated. Transfer over such remains or objects to any group would be, in our view, an unwarranted destruction of our human heritage."[21]

In early 1989 a fourteen-member panel with representatives from all factions was convened at the Heard Museum in Phoenix, to try to find common ground. The panel largely achieved consensus, agreeing that when a culturally affiliated group made a legitimate claim, then remains should be returned to them. It also recommended that even for unaffiliated remains, "a respect for human rights requires a process be developed for disposition of these remains in cooperation with, and with the permission of, native nations."[22] However, three of the panel's six science/museum representatives dissented. They felt that museums "should make every effort to respond positively to a repatriation request when there is a clear cultural link."[23] But they insisted that scientific views are "equal" to Native views. Returning all unaffiliated remains would not maintain a balanced approach to museum collections. "Making Native Americans the dominant power might make people feel better initially," they concluded, "but will do nothing in the long run for the heritage of the country or for Native Americans."

Even some Native advocates were skeptical of empowering tribes to make the final decision. In the summer of 1989, during a congressional hearing leading up to the NMAI Act, the Cheyenne senator from Colorado, Ben Nighthorse Campbell, convened a discussion about what to do with remains lacking contextual information.[24]

One Native leader shared a story about the return of unidentified remains from South Dakota, based on the collective decision of different religious leaders. It was suggested that lists of unidentified remains be sent to tribes and allow them to decide what should happen. Campbell, however, balked at the proposal. Not because of concerns about the scientific value of the remains, but because this process would be impeded by disagreements within and between tribes. "I know there are tribal conflicts within tribes on virtually every other subject," Campbell said, "and I can perceive a tribal conflict on dealing with remains. I think it is a kind of big, unanswered area that we have to deal with before we *carte blanche* say we will give them all back." The next year Senator Daniel Akaka, a Democrat from Hawaii, said during a 1990 hearing that when the issue of what to do with ancient peoples arose, "I think there should be some consideration in the bill that would speak to this, so that the Government may be . . . the caretaker of peoples who are extinct."[25]

When S. 1980, the senate bill that helped lead to NAGPRA, was being finalized, Arizona Senator John McCain included a provision that charged the Review Committee with creating an inventory for all unidentifiable remains and recommending a specific disposition for them all.[26] The SAA's leadership strongly objected. "We cannot live with this subsection," they wrote in a letter to McCain. "By including implementation of the return of unaffiliated remains, this creates an enormous task that has not been adequately considered. If this must be dealt with, let's do it later, and get on with the business of dealing with the affiliated remains about which there is so much immediate concern."

On such advice, Congress gave up. The future of culturally unidentifiable remains proved too difficult to decide. While definitively establishing the fate of culturally affiliated remains, Congress could only note that there was still "general disagreement" about what to do with culturally unaffiliated human remains.[27] Not wanting this single issue to delay the entire law, Congress held this section of NAGPRA in "reserve" and made the newly established Review Committee—the seven-member advisory body overseeing

NAGPRA—responsible for "recommending specific actions for developing a process for disposition of such remains."[28] This solution enabled NAGPRA to become law but left the unidentifiable as repatriation's "unfinished business."[29]

○ ○ ○

The Denver Museum's first repatriations following NAGPRA were for sacred and communal objects—first the Zuni War God in 1991 and then the Tlingit Killer Whale Hat in 1997. The museum also held the skeletal remains of around 100 Native American individuals. (Some remains were so fragmented that the total number was impossible to determine.) The process for claiming these remains was much slower. The first human remains the museum returned came fifteen years after NAGPRA became law, the scalp from Sand Creek in 2005. The next year followed with two more sets of culturally affiliated remains, one returned to the Rosebud Sioux in South Dakota, the other to the Miccosukee in Florida.

Like so many of the Denver Museum's first repatriations, the consultations with the Miccosukee were uneven, the process prolonged. In 1999 Denver Museum staff first invited Miccosukee representatives to visit the collections. Within several months Steve Terry, working closely with Fred Dayhoff, wrote to the museum making it clear that their priority was the return of human remains. He asked that no further study be done on any human remains and that bones "not be passed around as curiosities."[30] (NAGPRA explicitly states that museums may not transfer cultural items contrary to the law's provisions, and that the law's documentation requirement does not authorize "the initiation of new scientific studies."[31]) After an inventory of the collection was sent to Florida, Terry and Dayhoff explained that they didn't need to visit Denver after all.

Instead, they sent back their own lists of objects divided into four categories: objects needing to be stored in a sacred room (3 medicine horns); objects needing to be returned (108 skeletal remains and funerary objects); objects that they needed additional information

on (20 items, ranging from jewelry to a toy to a child's outfit); and finally objects "obtained in a proper way," which could stay in Denver (an assortment of 87 pieces).[32]

For two years, the Denver Museum did not reply. This was during the museum's tumultuous period in which the department of anthropology began to fall out of compliance with NAGPRA. After museum administrators recognized the problems with the department, the new curator Steven R. Holen was assigned to take over NAGPRA responsibilities. With the claimed Florida human remains, Holen realized there were two distinct groups of remains to consider. First, was a set of human remains, likely a female, that included a skull, scapula, ribs, and vertebrae, collected by an aspiring anthropologist, Jesse H. Bratley, who had lived in Florida in 1910. The woman's remains were unambiguously designated as "Seminole" in museum records.

However, the Miccosukee were also claiming the Calusa skeletal remains. Holen contacted the Florida state archaeologist, who told him that no modern culture is affiliated with the Calusa (although some ancient remains had been returned under the state's unmarked burial law).

Faced with this advice, Holen felt he didn't have much choice. Given the thousands of Calusa remains in Florida museums, the future of the state's archaeological heritage was at stake. Holen was sympathetic to the Miccosukee, but he wasn't going to set a precedent for Florida all the way from Colorado. For the Seminole human remains, Holen formally determined they were culturally affiliated with the Seminole and Miccosukee tribes. The Seminole woman taken by Bratley was returned in 2006.

For the Calusa remains, Holen classified them as "culturally unaffiliated." Although it is not clear if this decision was ever conveyed to the Miccosukee tribal officials, at least in Denver the implication was clear enough. Under the law, the Calusa could not go home.

22. THEIR PLACE OF
UNDERSTANDING

When a White man's grave is dug up, it's called grave robbing. But
when an Indian's grave is dug up, it's called archaeology.

Robert Cruz (Tohono O'odham), American Indians Against Desecration[1]

I don't want that woman to think in any way that if she raises a fuss,
I'll give her a couple of boxes of bones.

Marshall McKusick, Iowa State archaeologist[2]

From the first demands for the reburial of Native American remains, activists hardly focused on cultural affiliation. For them, the outrage was the unequal treatment of Native Americans as a category—the racist assumption that American Indian skeletons should be museum specimens. This perspective can be seen as early as 1971, when one evening a woman named Maria Pearson, who would become a kind of Rosa Parks for Native Americans, was fixing dinner and her husband, John, came home with some news.

"You know, honey, you are going to be upset when I tell you what happened at work today," he reluctantly started. "Remember about two weeks ago I told you that we located a cemetery in the right-of-way of an interstate highway near Glenwood." John was

a civil engineer for the Iowa Department of Transportation. He had been on the scene when the archaeologists arrived at the cemetery and started digging.

"They took out the remains of twenty-six white people," John continued, "put them in new caskets, and took them to the local cemetery in Glenwood where they reburied them. They also found the skeletons of an Indian girl and her baby. They put those bones in a box and took them to the Office of the State Archaeologist in Iowa City for study."

Maria flushed with anger. She was a Yankton Sioux from South Dakota.[3] Among her Yankton family Maria was Hai-Mecha Eunka, Running Moccasins.

"That's discrimination!" Maria raged.

"I told you that you were going to be upset."

Maria finished preparing dinner for John and their six children. She went outside to be alone. She knew it was wrong to violate the sanctity of the grave. She had been taught that to do so interrupts the spirit journey of the dead. But Maria was a mother and house-wife, just thirty-eight years old. What could she possibly do?

A breeze rose through the dark and brushed Maria's skin. She always felt like the wind had something to tell her. She listened. The wind was stalking her, circling around her house, rustling the leaves of the towering cottonwoods nearby so that they sounded like crystal wind chimes. Maria began to think about her family, how her grandmother had told her the cottonwood was sacred. Although she had passed on, her maternal grandmother, Minnie Paji Keeler, had once said, "If you ever need me, I will come to you in the wind. Listen for my voice." Maria breathed in the summer night when her grandmother spoke.

"Girl, I told you that you would have to stand up for what you believe in. You must protect the places where your ancestors lie."

"Grandma, I'm scared!" Maria didn't hesitate to respond, sharing her honest fears. "I live in this 'redneck' country. I have babies— they'll hurt my children!"

"No, your grandfathers are here. They will protect you."

"Grandma, I don't know what to do."

"You are going to start with the very first thing. You will approach the white men from their place of understanding. You will go from there."

"Grandma, I don't know any of our medicine people. You always told me not to go near the graves of our ancestors."

"Well, this is that time when you will need to take all of your strength and all of your courage to do this. But remember, you are not going to be walking alone."

The voice melted back into the wind.

Maria returned inside. The kids were asleep. She went to her bedroom. John was waiting. He could see she was still upset.

"Honey, what are you going to do?" he asked.

"John, it is best you don't know what I am going to do."

o o o

Why do we humans care for the dead?

Death is a human universal. So is attending to the dead. Although other animals, such as elephants and chimpanzees, seem to recognize the mechanisms of death, we are alone in the animal kingdom to recognize the power of the dead in our lives.[4]

This is a primordial tradition.[5] As far back as 100,000 years ago, found in what today is Israel, thirteen early humans were intentionally buried in a cave along with dozens of pieces of red ocher and stone tools. Our near ancestors, the Neanderthals, also buried their dead. Archaeologists have discovered their burial sites across Europe and Asia, dating between 70,000 and 30,000 years ago.

Over the eons, humans developed countless ways of dealing with death and dying. Most conspicuous are the formal monuments that cultures around the globe created—the Egyptian pyramids in North Africa, the cathedrals of Europe, the mausoleums of Chinese royalty.

The formal tomb for the body is just one means of coping with human remains.[6] Looking around the world, the modern Western ideal of cemeteries consisting of orderly rows of buried bodies in caskets is the exception rather than the rule. Many cultures liber-

ate the body by fire, spreading cremated ashes or storing them in containers. Others allow the body to decompose. The Parsi of India, who practice Zoroastrianism, place their dead on open ritual towers, where vultures consume the dead, which allows the body to be disposed while not polluting the world. Similarly, for thousands of years Vajrayana Buddhists in Tibet and Mongolia, believing the dead body is an empty vessel, have disarticulated the dead and placed them on mountaintops where they are eaten by animals and decompose. The Caviteño in the Philippines place their dead in tree trunks. Still others don't leave their dead alone. In Indonesia the Torajan bury their dead only to later exhume them—then washing, dressing, and grooming them—for a ritual ceremony in which the deceased's spirit is welcomed home. In Madagascar, Malgasy tradition holds that every five years the dead are brought out of their crypts for a celebration. They are surrounded by festive music, dance, and stories, and hear the living's latest news.

The human practices of caring for the body in death have always been entwined with beliefs that go far beyond the physical. The soul and spirit. Our affinity to God. To *gods*. The relationship between ancestor and heir. The powers of the dead. Although in contemporary Western society, our relationship with the deceased tends to be personal and introspective, numerous cultures depend on ritual to help individuals navigate the vicissitudes of death. In the Qingming Festival, for instance, Chinese visit the graves of their ancestors, sweeping their tombs and offering food, gifts, and libations. In Mexico and beyond, Día de los Muertos involves the construction of altars to honor ancestors as well as visiting and cleaning the graves of loved ones.

Native American traditions have been just as varied. Among people of the Northwest Coast and Great Plains, the dead were placed aboveground, in boxes on stilts or wrapped in blankets on top of scaffolds. Sometimes they were reverently laid in the branches of trees. Along the coasts, sometimes a canoe was simply placed over the body by the shore. Throughout the eastern half of North America, many ancient cultural traditions involved burying the dead— sometimes cremated—in earthen mounds. Other Native cultures

buried the dead under the floors of their houses, in ceremonial chambers, or amid the debris and refuse piled outside their villages. Starting in the 1500s, with the first European settlements, Native Americans began to incorporate Western burial practices. Today most Native communities believe underground burial is the most respectful method of laying the departed to rest.

Native American views of an afterlife and the soul are equally diverse. In one traditional view, that of the Haudenosaunee of New York, the person's spirit travels to another world but that journey depends on the attachment to one's bones and grave.[7] For the Hopi in the U.S. Southwest, traditional beliefs have death as the beginning of two journeys. One for the body to renew the earth and one for the human spirit to be transformed into a kachina spirit that watches over the community and visits as clouds bringing the blessing of rain.[8] For the Lipan Apache, the ghosts of the dead have immense power to harness evil to inflict the living with illness, misfortune, and even death itself.[9] Traditionally, they quickly bury the deceased, burn every possession, avoid speaking of the individual again, and move far from the place of death. The Pawnee were known to have reopened graves to rearrange funerary offerings, but traditional law held that "disruptions taking place outside of conditions sanctioned by tradition and religion had profound and diabolical implications."[10]

The Calusa of Florida buried their dead in mounds. However, rather than building earthen mounds, like their kin to the north, they used massive heaps of broken shells. Most of the dead were dismembered and their bones dispersed throughout the mounds. Some skeletons were left whole. Frank H. Cushing hypothesized that the mounds were communally organized by clan or other social identity so that all the individuals from one group were assembled together.[11] He thought the bodies left whole—which were invariably accompanied by exemplary artifacts such as pottery, stone tools, bone utensils, ornaments, and weapons—were Calusas of high rank.

Given the amount of attention the Calusa gave to these burial sites, it is unsurprising that the dead exerted a powerful force in their lives. As one Spanish visitor among the Calusa, Joseph Javier Alaña, recorded in 1743:

They have a great fear of the dead and its effect appears in their not suffering their being named; their daily offering to them of food-stuffs, tobacco and plants; the covering of the graves with reed mats and the bestowing of gifts on the graves. They maintain a guard in the cemetery, which they frequent with pilgrimages, and they keep it somewhat distant from the village, fearing the dead should do them harm.[12]

There is little that unites the stunning array of Native American burial traditions. Some believe in a soul and attach little importance to the body. Others believe that the body continues to have as much agency in death as it had in life. Yet what connects these traditions is the tradition itself: every known Native society, just like every human society around the world, has specific practices that help transition the body from life to death.

Maria Pearson did not need to know if the girl taken by archaeologists was her relative. Or even a member of her tribe. She understood that the girl was turned into an artifact only because she was considered Native American. The girl was once buried, once shown the respect of repose, whoever had buried her, using whatever traditions. The details didn't matter to Maria. She would take it upon herself to find a way to make others respect this girl, whoever she was.

o o o

The next morning Maria Pearson arose to make breakfast and get the kids ready for school. Once the house was quiet, she went to the closet and opened her grandmother's trunk. A musty smell of leather filled the room. She took off her clothes and dressed in a white buckskin dress, beaded along the neckline, with swaying fringe around the shoulders, sleeves, and hemline. She put on matching beaded moccasins and plaited her hair into two long braids. Then Pearson got into her car and drove the ninety miles east to Des Moines until she reached the gold-domed Iowa capitol building.

Pearson walked into Governor Robert D. Ray's office.

"Can I help you?" the receptionist asked, startled by Pearson's traditional clothing.

"Yes, I have come to see the Great White Father. You tell him that Running Moccasins is here."

Pearson was both dramatizing her role as Indian emissary and channeling it. Once she started this theater, it could not stop.

A man came out of an office in a suit and black bow tie.

"Can I help you?" he inquired.

"Are *you* the Great White Father?"

"No." He explained that he was an aide to the governor.

"Well, then you cannot help me."

"The governor is a very busy man."

"Well, I am a very busy woman."

"What is it that you want to discuss?" the aide persisted.

"You are not the Great White Father. I need to see *him*. If I were an ambassador from a foreign country, you would have that red carpet rolled out all the way down to the airport. And you would have a delegation there to greet me! Well, I *am* an ambassador. I'm an ambassador for my people. And if this man, the governor, is over everybody in the State of Iowa, then he is over me and I have a right to see him."

The aide retreated to another office. From behind the open door Governor Ray peeked at Running Moccasins. The aide returned.

"The governor will see you."

Pearson walked into Governor Ray's spacious chamber. He stood in front of a massive desk. They shook hands.

"Have a seat," Governor Ray offered.

Pearson considered the big overstuffed chairs.

"No, thank you. I can stand for what I have to say."

"Well, how can I help you?"

"You can give me back my people's bones and you can quit digging them up."

The governor looked at his aide. "Do we have her people's bones?"

The governor's aide quickly exited and made a phone call. He

learned something about the situation with the Iowa Department of Transportation. The governor responded by personally calling the state archaeologist, demanding answers soon. He hung up the phone.

"How long has this been going on?" Governor Ray asked Pearson.

"Let me see. How long have you been here? Five hundred years. For five hundred years you have been digging up our people." Pearson had heard that the governor's mother was ill. She continued. "If your mother died and you buried her, what would you think if I decided to do my home in 'Early White Man' decor, and went to the cemetery and dug your mother up? What if I took her wedding ring? Or her glasses? I might want those glasses she wears. How would you feel?"

"That's a *horrible* thought!" the governor sympathized. "That should not happen to anybody."

"It happens to us and our people," she answered. "And it is time for this to stop."

o o o

After Maria Pearson confronted Governor Ray, meaningful change began in Iowa. The next year, in the face of protests from the American Indian Movement, Governor Ray directed that a Meskwaki chief be removed from display at the Iowa State Historical Society.[13] He had decided that while archaeologists save historical knowledge of sites before they're destroyed, this must be balanced with the injustices of historical discrimination and exploitation. "We do not own or control history, we are merely its stewards," Governor Ray said. "I have concluded that the benefit of this public display to all is not sufficient to justify the offensiveness of this display to some."[14]

Governor Ray then created the Indian Advisory Council for the Office of the State Archaeologist. Pearson even became the council's chair. The hostile state archaeologist was replaced by Duane Anderson, a sympathetic former museum director who worked hard to earn Pearson's trust and respect.

Despite this progress, Iowa law still provided no jurisdiction over the discovery and disposition of ancient human remains. Although Governor Ray had insisted that Native American remains deserved dignity, no laws ensured that all Indian graves would be afforded the same protection as non-Indian graves.

In 1975 a large unmarked cemetery was found during another highway project. Both Pearson and Anderson arrived at the scene. Quickly they reached a decision. Rather than allowing the bulldozer to expose the Native American skeletons, they called for more careful archaeological excavation first. Pearson approved an "autopsy" of the ancient remains—for basic identification, analysis, and reporting—to be conducted at a nearby college. Nine days later, when the analysis had been completed, the remains were respectfully reburied. The emergency had precipitated a surprisingly good compromise. Archaeologists got data; Native Americans got the reburial. This showed how some advocates for both Native rights and scientists were willing to engage and consider the other side. Not everyone saw repatriation as a zero-sum game. The stage was set for a more comprehensive solution to the reburial problem.

Anderson cajoled his archaeological colleagues. Pearson coaxed her network of American Indian activists. Governor Ray invited Pearson to speak before the Iowa legislature. Negotiations continued until finally, in May 1976, the Iowa Burial Code was amended.

The amendments now provided funds to recover newly discovered graves, gave the state archaeologist jurisdiction over human remains older than 150 years old, established new cemeteries for the reburial of ancient remains, and extended the "violation of sepulcher" section of the Iowa Code to ancient cemetery sites. With this new law, Native Americans compromised to allow limited study, while archaeologists conceded to reburials and that all ancient skeletons be under the jurisdiction of the state. More than a decade before the first federal legislation, the State of Iowa found the first real solution to the repatriation controversy. Every Native American would be given the same respect as everyone else.

23. TIMELESS LIMBO

We don't know whose ancestors these are, but we do know we share the belief that they belong back in the ground. Reburial is much better than having those remains sitting on shelves somewhere.

Ernest House Jr. (Ute Mountain Ute), Executive Secretary of the Colorado Commission of Indian Affairs[1]

As a scientist, I would hate to see one of the most complete North American skeletal remains be put back into the ground for political reasons.

James Chatters, archaeologist, reflecting on the Kennewick Man, in 2015[2]

When I told Fred Dayhoff and Steve Terry my decision to leave the Calusa remains as culturally unaffiliated, they said they wanted to read my formal report. I mailed it. Several weeks later, I received a letter back. "We are heartened by the Museum's acknowledgment of our stance on this," they wrote, even though they disagreed with my conclusion.[3]

In my report, I explored the question of the museum's moral right to the Calusa remains. Although Mary and Francis Crane did not violate any laws when they accepted the remains into their collection, Florida state law now makes buying and selling the dead illegal.[4] It also makes any unauthorized excavation into burial mounds a felony.[5] Although the Calusa would of course have been unaware

that their bones would one day end up in museums, it seemed to me that they would have objected to the removal of their own human remains and burial objects. In 1567 Juan Rogel, a Spanish missionary who lived among the Calusa, wrote about their "fundamental beliefs" including:

> They say that each person has three souls. One is the little pupil of the eye; another is the shadow that each one casts; and the last is the image of oneself that each one sees in a mirror or in a calm pool of water. And when a person dies, they say that two of the souls leave the body and that the third one, which is the pupil of the eye, remains in the body always. And thus they go to the burial place to speak with the deceased ones and ask their advice.[6]

If we can reasonably guess the wishes of a people—that they would not want their graves disturbed—then why would we disregard those wishes just because they lack living descendants? Although it could be suggested that we are not obligated to respect a culture that no longer exists, it seemed to me that all of us would want *our* wishes honored even when we're no longer around, even if our culture becomes "extinct." It's a question of whether we genuinely respect those who came before us. I considered the arguments of the philosopher Geoffrey Scarre. "Humanity deserves our respect wherever we find it," he said. "To treat human remains without due regard to who they once were is to show disrespect to those [people], and to humanity itself."[7]

The Calusa did not give their consent to be excavated. In research on living subjects, contemporary ethical standards require the informed consent of participants. Today in the United States, even in death your body can only be used for science, medicine, or display (in the case of the infamous traveling exhibit *Body Worlds*) with your consent. If your consent is unknown, the decision is left to your next of kin, or absent that, the state, which has strict regulations on how bodies can be used. I could not think of an ethical argument to disregard these same standards for Native American remains.[8] NAGPRA

itself articulates this view of consent, which only gives a museum "right of possession" of affiliated remains if "the original acquisition of Native American human remains . . . were excavated, exhumed, or otherwise obtained with full knowledge and consent of the next of kin or the official governing body of the appropriate culturally affiliated Indian tribe."[9] Why should museums not consider consent just because the remains are unaffiliated?

Furthermore, there is a *chance* the Miccosukee are those descendants, and Dayhoff made clear to me that the Miccosukee share the belief of the spiritual power that remains attached to the body in death. The Miccosukee, he told me, do not want to claim the Calusa but feel obliged to help their spirits and ensure that the dead do not harm the living.

What I also thought about, but didn't include in my report, was Maria Pearson's story. I thought about the differential treatment of Native American remains through the centuries, and Pearson's battle to ensure that all Native Americans would receive equal protection under the law. Perhaps some would instead see Pearson's battle as a way to assert Native power. Even today some continue to frame repatriation claims as just politics.[10] Some archaeologists have criticized Native Americans for overemphasizing a "past-present continuity" to legitimize group identities, in order to make successful repatriation claims.[11] However, these archaeologists ignore that it was only because of their objections that NAGPRA included the compromise definition of cultural affiliation, which forces tribes to squeeze their shapeless beliefs into the law's rigid framework.

Repatriation is unquestionably politicized. That the issue was forced onto the national stage in the early 1970s by one of the country's most activist pan-Indian organizations—the American Indian Movement—ensured that heightened politics would infuse the controversy. But in the most naked sense, the issue *had* to be political: it involved a struggle to seek power in government. The laws and structures of twentieth-century America had disempowered Native Americans. The only recourse was to shift the levers of power through protest and political action. Moreover, it would be

disingenuous to ignore the political interests of archaeologists and curators, who also have much to lose or gain in the repatriation debates.[12]

But repatriation is not *mere* politics. Archaeologists and curators study human remains because they really do believe skeletons have important stories to tell. In turn, Native American traditionalists hold deep-seated cultural beliefs about life and death. As Michelle D. Hamilton has discussed with the Cherokee, their "opposition against the anthropological study of the remains of their dead stems from a complicated avoidance proscription based on cultural theories of pollution and corruption, as well as a deeper conviction that it is degenerate behavior to disturb the dead and runs counter to moral behavior."[13] This statement has little to do with politics and everything to do with beliefs about the forces of the universe— their presence in bones and their impact on the living. To return bones is fundamentally not a political act, but a moral one.

This ideal is not foreign to Western values. It is the lesson of the *Iliad*, in which Achilles refuses to bury Hector after killing him, instead dragging and mistreating his body for days. It is the premise of our legal frameworks surrounding rights to the dead. It is why as early as 1789, New York established the Anatomy Acts, "to prevent the odious practice of digging up and removing bodies . . . for the purpose of dissection."[14] It is why the United States government spends millions of dollars every year to find the human remains of the 83,000 missing soldiers from past wars. It is why New York City continues to store the thousands of fragments from unidentified human remains recovered from the wreckage of the World Trade Center—the last vestiges of more than 1,000 9/11 victims whose remains have never been identified. Western society, too, understands the power of the dead.

I am an archaeologist. A scientist. I know how much the field has to teach us about the past. I have seen the past comes alive through objects. But the value of my profession, I thought with the Calusa case, does not trump all other human obligations. In a multicultural society, we have a duty to ensure that our own beliefs do not un-

justly impinge on the freedom of others to pursue theirs. For me, it is a question of how we can try to respect cultural difference.

I concluded that the Denver Museum should try to return the Calusa to the Miccosukee, after all, even though they were culturally unaffiliated. But given that NAGPRA still didn't include regulations for culturally unidentified remains, we were left with only one legal choice—a long and uncertain path, to show the Calusa the respect they deserved.

o o o

When the seven scientist and Native American representatives comprising the NAGPRA Review Committee met for the first time in 1992, one of the first issues they turned to was resolving the status and disposition of culturally unaffiliated remains.[15] There was deep disagreement. No one could even agree on the scale of the problem. One review committee member, Martin E. Sullivan, a museum director, estimated, on the basis of the Smithsonian's holdings, that upward of 95 percent of the human remains could ultimately be affiliated.[16] Phillip L. Walker, another committee member and biological anthropologist, more presciently suggested the percentage would be far lower.

The National Park Service archaeologist overseeing the meeting, Francis McManamon, warned that the hardest cases would be "where you've got long gaps between a modern group that may have a legitimate claim and an older culture or an older Indian group that is only known archaeologically from hundreds or thousands of years ago." William Tallbull, the Northern Cheyenne leader and a committee member, acknowledged that taking unidentified remains was spiritually "risky." But he gently suggested it was appropriate to rebury them. Tallbull spoke about discovering in a museum collection the skeleton of an elderly man who had lived 7,000 years ago. "I talked to that old man for a long time," Tallbull shared. He told him, "I'm doing this to help you, your people, your descendants, your past people, the full tribe." When Tallbull reburied him,

a whirlwind came from the south—a positive sign because that is where the spirits dwell. "I felt really good," Tallbull said, "because I had apparently done the right thing." None of the committee members reacted to Tallbull's story.

After years of fraught dialogue, in 1995 the Review Committee disseminated draft recommendations for culturally unidentifiable human remains. The committee's key principle was that "ultimately, decisions about what happens to the remains of Native American individuals from anywhere in the United States and associated funerary objects should rest in the hands of Native Americans."[17] The committee acknowledged the value of scientific analyses of remains, but that these "values do not provide or confer a right of control over Native American human remains that supersedes the spiritual and cultural concerns of Native American people."[18] A map of every tribe's geographic homelands and history could be compiled and overlaid with the location data of the unidentified remains, or lists of the remains would be sent to the tribes. Individual tribes or "broad regional associations" could then make claims, to be reviewed by the National Park Service and Review Committee.

At a 1995 oversight hearing in Congress, Native leaders made it clear that they believed all Native American remains should be reburied. As Cecil Antone, of the Gila River Indian Community, testified, according to Arizona state law, the geographically closest tribe to where unidentifiable remains are found are allowed to rebury them. "There have been cases in Arizona where that has occurred," he said, "because ultimately the purpose of repatriation is to bring back the ancestors and rebury them, no matter where they are at. Even though they are not identified, they are human beings."[19] Jesse Taken Alive, of the Standing Rock Sioux Tribe, North Dakota, echoed these sentiments:

With regard to unidentifiable remains, we can believe that those remains dating back 500 years or more are American Indians. They are Native Americans and don't have to be studied any more. . . . If those remains were not Native American, there would have been a monu-

mental court case, but they are American Indians, and we're asking for their return. Take them out of those boxes. Take them off those shelves. Give them back to the people and let us decide how that should be done, because, after all, as American Indians, as Indigenous people, those are our ancestors.

A NAGPRA Review Committee member and the director of the Peabody Essex Museum, Dan Monroe, testified that while many scientists emphasized how much could be learned from human remains, "Native Americans almost unanimously argue that they are culturally and otherwise affiliated with these remains and that their religious and cultural beliefs dictate that the remains be returned and reburied." The 1995 draft regulations largely responded to the broad beliefs held by Native Americans.

But the Society for American Archaeology objected to the draft proposal.[20] Forming a task force and soliciting feedback from members, the SAA concluded that the draft was "premature," since the law had not been in force long enough to gain an understanding of the process and impacts of repatriation. SAA representatives argued that these regulations could only be established by Congress, not the Review Committee. The SAA insisted that NAGPRA only allows for those most closely affiliated tribes to make decisions about remains. As one prominent archaeologist wrote, "Allowing one set of people to dictate the treatment of relics that belong to another runs directly contrary to the ideal that motivated NAGPRA in the first place."[21]

The Denver Museum staff also objected to the Review Committee's recommended language. "The proposed wording is a major expansion of the NAGPRA, which complicates the process greatly," Bob Pickering wrote to Raylene Decatur, who had replaced John Welles as museum director. "It puts museums on some shaky legal ground."[22] The Denver Museum was invited to sign a joint letter with the Field Museum, Harvard Peabody, and other leading museums to present a "united voice." But Decatur felt that their draft letter was not "tough enough." The Denver Museum sent testimony to the Review Committee, arguing that institutions should not even

consult with tribes until all bones have been scientifically analyzed to determine their true ethnicity.[23]

The Review Committee was inundated with objections from 129 museums and tribes. The first proposal was scraped.

The next year, the Review Committee released a revised draft with clarifications.[24] This version proved just as contentious. Along with numerous other organizations, the SAA acknowledged that "it will be very difficult to develop a process for determining the disposition of unidentifiable remains upon which all constituencies can agree," but insisted that the proposed draft wouldn't "provide a workable solution."[25] The SAA didn't offer an alternative solution, but advised the Review Committee not pursue "a narrow view focusing on repatriation as the sole option."

Over the next decade, more draft recommendations, principles, and regulations were issued—and lambasted.[26] In 2007 yet another draft regulation sought to comprehensively address previous comments; it laid out a process of consultation for all stakeholders to find a negotiated agreement and allowed for regional meetings to be organized on a case-by-case basis. The reaction from archaeologists was immediate and extreme. The SAA president, Dean Snow, wrote that the proposed regulations "are radical, mutually contradictory, costly, illogical, and unworkable. Above all they are illegal."[27] Former SAA president Keith Kintigh added that the proposed regulations required that archaeologists "now play 'hard ball,' " and he warned that "we must be prepared to fight it in every way we can."[28]

The SAA's official public comments exclaimed that the regulation was "bizarre and ill-advised," "an unfortunate exercise in regulatory arrogance," which would lead to an "incalculable" loss to science and human heritage.[29] Specifically, the SAA's leadership was upset that the proposed regulation would compel museums to consult with all potential claimants, even those with a potentially "weak claim to Indian identity." The regulation would result in remains returned to those who merely showed a "cultural relationship" to the region in which the human remains were found or simply to the region in which the museum is located. The regulation problematically left "cultural relationship" undefined, leaving mu-

seums and tribes only to guess at how to interpret it. The SAA, recalling the kinds of predictions museums made in the months before NAGPRA, argued that the proposed regulation would require so much consultation that it would "be both impossible to meet and financially ruinous to attempt." The SAA continued to insist that only Congress could establish new regulations for culturally unidentifiable remains.[30]

The SAA was not alone in its objections. Even the Review Committee unanimously passed a motion expressing its concern about how the draft regulation deviated from their recommendations. As Rosita Worl, the Tlingit anthropologist and longtime Review Committee member, would observe, the draft regulations "don't seem to be acceptable by anyone."[31]

Yet the failure to arrive at new regulations only highlighted the depth and scope of the problem presented by the law's requirements for inventories and the process to determine cultural affiliation. Without a process for these unaffiliated remains to be claimed, they stood, as the legal scholar Rebecca Tsosie wrote, in a "timeless limbo."[32] Many remains were left unaffiliated because institutions holding skeletons had yet to even document what they held in their collections—inventories were fifteen years overdue. For example, a General Accountability Office investigation determined that 53 percent of the Department of Interior's museum collections, which total 78 million objects, were not yet cataloged, and that the DOI "had little idea" what additional collections were held in other museums that belonged to the agency.[33] The GAO further estimated that approximately 80 percent of human remains found to be unidentifiable "could reasonably be culturally affiliated" if the law had been appropriately followed.[34] (In other words, of the 115,000 unaffiliated remains, some 92,000 should have been affiliated.) The fact that nearly 15 percent of remains originally designated as culturally unaffiliated had been changed to affiliated after closer evaluation demonstrated that many museums had too often originally miscategorized remains.[35]

The reasons for the lack of affiliations are many. Many museums

did not invest the resources to properly inventory their collection, and the affiliation process does not require new or exhaustive research but is only based on available evidence.[36] In other cases, museums kept poor records or sloppily combined human remains in storage. Most determinations were made without consulting tribes, sometimes with minimal staff time committed to the work, and it is assumed that many museum staff members, trained as scientists, have been skeptical of tribal sources of evidence, such as oral tradition, which are supposed to receive equal consideration under the law. Some Native activists suspect, more darkly, that the high percentage of unaffiliated remains is an easy way for museums to prevent repatriations and reinforce colonialist control over Native history. Still other remains came from known tribes—but those tribes are believed to have gone extinct.

o o o

Is it possible that some skeletons are from so remote a past that they can never be connected to living peoples? Are some skeletons from such distant times that they might not even be considered "Native American"?

These are the questions that were sparked one summer day in 1996, when two college students noticed a skeleton eroding out of the bank of the Columbia River, near Kennewick, Washington.[37] At first, the police considered the site a crime scene, but archaeological excavation and examination revealed the man had been buried there about 9,300 years ago. The U.S. Army Corps of Engineers, the government agency responsible for compliance with NAGPRA in this case, concluded that the remains were culturally affiliated with a consortium of five local tribes—the Colville, Nez Perce, Umatilla, Wanapum, and Yakima.

However, scientists wanted to study "Kennewick Man," as they named the skeleton, declaring him to be "the most important skeleton ever found in North America."[38] Near-complete skeletal remains from this distant age are exceedingly rare, and they felt that

the remains could answer vital questions about the first people to live in North America. But the tribes insisted that the man—whom they called *Oyt.pa.ma.na.tit.tite*, the Ancient One—should be reburied. To prevent the repatriation, eight archaeologists and biological anthropologists filed a lawsuit: *Bonnichsen et al. v. the United States*. In 2004, after nine years in the courts, the U.S. ninth circuit of appeals upheld a previous ruling that kept the skeleton in the hands of scientists.

The court's most important ruling was that Kennewick Man was not even "Native American" under the law. The government had originally concluded that the 9,300-year-old individual was Indigenous because he predated European arrival and so was necessarily Native American. The judge, however, focused on NAGPRA's definition of "Native American": "of, or relating to a tribe, people, or culture that is indigenous to the United States."[39] The use of the present tense "is" led the judge to conclude that Congress intentionally restricted NAGPRA to human remains that "bear some relationship to a *presently* existing tribe, people, or culture to be considered Native American."[40] Although the five tribes claimed the remains as an "ancestor" based on their oral traditions, the judge was not convinced that the remains bore a relationship to them. He instead focused on studies of the cranial structure, which suggested that the skeleton was most closely related to Indigenous peoples in Polynesia and Japan. He also accepted that the Columbia Plateau culture, documented archaeologically, did not seem to begin until about 2,000 years ago. He dismissed the Native American oral traditions as unlikely to have bridged the last 9,000 years.[41] Since the remains do not bear a relationship to a *presently* existing tribe, then they were not legally those of a Native American. The judge ruled that since Kennewick Man was not Native American, he is not subject to NAGPRA but is "federal property" under the Archaeological Resources Protection Act and could be scientifically studied.[42]

When Congress was debating repatriation legislation, many, even tribal allies, were skeptical of claims for ancient skeletons. Senator John Melcher, who authored the first repatriation bill, originally

stated, "In general those are older remains [obtained by archaeologists], gathered for study to piece together the millennium of our unknown beginning. We do not intend in any way to interfere with this study and science in the bill."[43] Senator Daniel Inouye said that he did not anticipate the Senate bill, S. 1980, would affect remains more than 150 years old.[44] He even laughed at the idea of "anyone claiming something 5,000 years old."

Yet many felt that the Kennewick judgment distorted a basic definition of who is (and was) Native American. In 2005 Senator John McCain proposed a simple amendment to NAGPRA. The words "or was" would be added to the definition of Native American. This small correction would ensure that ancient skeletons be considered Native American under the law (although this change would not guarantee repatriation because they would still have to be culturally affiliated).

Even the SAA supported the amendment, arguing in its amicus brief in the Kennewick case, that "requiring demonstration of a relationship to present-day Native peoples in order to categorize remains or items as Native American is contrary to the plain language of the statue, is inconsistent with a common-sense understanding of the term, and would lead to the absurd result of excluding from the law historically documented Indian tribes that have no present-day descendants."[45] (The SAA supported legally defining Kennewick Man as "Native American," but did not think the five tribes were culturally affiliated.) Other organizations, such as the American Association of Physical Anthropologists, did not object to the amendment but asked that it be delayed until the regulations for culturally unidentifiable remains were established.[46] The amendment never made it to the Senate floor.[47]

The result of the Kennewick Man lawsuit and the failure to amend NAGPRA suggested that few ancient skeletons would be returned under the law. As the legal scholar Rebecca Tsosie wrote, "The tribes have a burden to show a significant genetic or cultural connection to remains . . . a very stringent standard, virtually impossible to meet in cases involving ancient remains."[48] The research

on Kennewick Man, now stored at the Burke Museum in Seattle, continued.

Ten years after *Bonnichsen et al. v. the United States* concluded, forty-eight scholars published a 680-page tome titled *Kennewick Man: The Scientific Investigation of an Ancient American Skeleton.*[49] He stood about five feet seven inches tall. He was stocky, weighing about 160 pounds. He was right-handed, and analysis of his arm bones affirmed he threw something a lot—probably a spear. When he was a teenager, someone threw a spear at him, which missed his abdominal cavity. The stone point embedded in his hip. Likely, with the care of someone, he survived the wound and his hip healed so completely that he would not even have limped. He seems to have eaten almost exclusively marine animals, such as fish, seals, and sea lions. When he was about forty years old, he died and was deliberately buried, laid out with his left side facing the river and his head upstream.

The researchers persisted in their belief that Kennewick Man had no connections to any living populations. Based on the shape of his skull and skeletal structure, they concluded his closest living relatives appear to be the Moriori, who live on a remote archipelago 420 miles southeast of New Zealand, and the Ainu people of Japan. "Just think of Polynesians," said Douglas Owsley, one of the lead researchers. The archaeologists devised an elaborate theory to accommodate this evidence. They hypothesized that around 15,000 years ago, a group of coastal Asians, the ancestors of the Japanese Jōmon culture, traveled along the shore of Beringia until they reached Alaska and into the interior of North America.

These conclusions were widely celebrated, the scientists hailed as "a small band of heroic anthropologists and archaeologists."[50] And perhaps that is how these results and the scientists would have always been remembered by some. But another small band of scientists and Native Americans decided to study Kennewick Man's DNA.

Less than a year after the 680-page book was published, a paper in *Nature* reported that a 0.2-gram flake of Kennewick Man's finger bone produced a genomic sequence.[51] His DNA revealed that he is more closely related to Native Americans than anyone else.

Several tribal members of the Colville, one of the claimant tribes, donated their own DNA to the study—a not entirely unsurprising contribution given that as early as 1998 a tribal representative, Marla Big Boy, said, "The Colville Tribe is not against science. We are against the use of science to discriminate and disenfranchise Native American tribes."[52] The tribe's participation has even inspired some to ask whether the Kennewick case could, ironically, come to presage a more collaborative approach to the past with scientists. It is notable that the research done on the skeleton, which resulted in the 2014 book, was conducted against the wishes of the tribes. In contrast, the DNA researchers "spent time explaining their goals and methods, and brought tribe members . . . for lab visits in hopes of winning their trust."[53]

The Colville, situated 200 miles from where the skeleton was found, proved to be among the most closely related tribes to the Ancient One. The DNA findings suggest that Kennewick Man does not require theoretical gymnastics to explain the arrival of Native Americans in North America, but fits the prevailing theory of Paleoindian origins.[54]

The governor of Washington State soon wrote to the U.S. Army Corps of Engineers asking for the repatriation of the Ancient One.[55] This latest research makes a clear case for the man's Native affinities and greatly bolsters the tribe's claim of cultural affiliation. Its broader implications are that it should be possible to culturally affiliate even the oldest known skeletons found in the United States. After the DNA results were published, the Corps quickly restarted consultation with the tribes and suggested that the time had come to bury the remains. "We expect challenges, so we're going to have to be very careful about how we do our reviews," Gail Celmer, an archaeologist with the Corps, said. "We have a long road ahead of us."[56]

Exceeding even the governor's efforts, Washington Senator Patty Murray introduced a bill to Congress, Bring the Ancient One Home Act.[57] The inadequacies of NAGPRA have compelled the tribes and sympathetic politicians to try to give Kennewick Man his own federal law.

o o o

Although *Bonnichsen et al. v. the United States* would seem to have un-
dermined the Denver Museum's efforts to return culturally unaf-
filiated remains, in practice the case's impact has been limited. In
fact, an ad hoc procedure for the return of unaffiliated remains had
been used for years, and returns continued unabated even after the
Kennewick case.

Essentially, the procedure involved a museum reaching consen-
sus with intertribal consortia, then seeking the permission of the
Review Committee, which in turn would make a recommenda-
tion to the U.S. Secretary of the Interior, who has the sole author-
ity to make a final decision on the proposed agreement. Ignoring
the drama surrounding the process to develop the final regulations,
many tribes and museums worked together. The process, however,
was often long and tedious. For example, in 1998 seventeen tribes
met with officials at the University of Nebraska and claimed nearly
1,700 unidentifiable remains. For the tribes, "this repatriation rep-
resented the end of a long struggle to assert their right to posses-
sion of human skeletal remains with which they shared a common
heritage."[58] Yet getting permission from the proper authorities took
years. "Why does it have to take so long?" asked Judi Morgan, exec-
utive director of the Nebraska Commission on Indian Affairs. "Why
don't they just give us the remains back? It seems pretty simple."[59] In
Colorado, state officials held 130 consultations over four years with
forty-seven tribes that are historically tied to Colorado to create a
protocol to deal with culturally unidentifiable remains.[60]

This process for the unidentifiable took too long and held no
guarantees. But museums and tribes across the country felt it im-
portant enough to pursue that, between 1994 and 2010, institutions
and government agencies—from Grand Canyon National Park to
the Detroit Institute of Arts—asked the Secretary of the Interior
eighty-two times for permission to return more than 4,000 cultur-
ally unaffiliated human remains. Every request was approved.

In 2007, shortly after I arrived at the Denver Museum, my col-

leagues and I resolved that we were obliged to address, through consultation, the future of the ninety-three culturally unaffiliated Native American human remains left in our collection. At that time, our goal was not necessarily repatriation, but to consult with tribes and try to negotiate mutually agreeable solutions. We were seeking *consent* for any decision about stewardship that might be taken. We would start consultations close to home, around the Rocky Mountains, and then work east until we ended in Florida and finally try to resolve the fate of the Calusa remains.

In 2008 we received a grant from the National Park Service to address thirty-seven unidentifiable remains from the Rocky Mountain region. Over the next year, we consulted with eighty-four tribes. We first focused on sixteen individuals and seventeen associated funerary objects that came from the southern Rocky Mountains. A massive intertribal consultation meeting, held using satellite technology to connect four locations, resulted in four Pueblo tribes— Acoma, Hopi, Zia, and Zuni—offering to shoulder the responsibility for repatriation and reburial. We quickly followed up with all the tribes that could not attend the meeting, gained their consent, and then submitted a formal request to the Review Committee. I presented our case before the Review Committee in Sarasota, Florida, in 2009, and received unanimous approval. Five months later, we received a letter from the U.S. Secretary of the Interior granting his permission. After we published a notice in the *Federal Register*, for the first time the Denver Museum was ready to return culturally unidentifiable remains.

Consultations for the twenty-one individuals and seventy-five associated funerary objects from the eastern Rocky Mountains followed a similar but even more circuitous route. (These were some of the human remains the Cheyenne and Arapaho claimed in 1999, but they were put aside by the museum to focus on the scalp from Sand Creek and then forgotten.) During the intertribal consultation, it became clear that while everyone wanted the remains reburied, no single tribe was willing to step forward to take the lead because it might be perceived as "taking" others' relatives. And yet because the

spiritual responsibility of reburial is so great, no tribe was willing to ask another to undertake this task. Finally, it was agreed that the Ute Mountain Ute, because of their reservation in Colorado, would take the lead, if no other tribe came forward with a claim. But another problem arose. One of the individuals had been labeled "Cheyenne/Arapaho." There was no obvious reason why these remains were labeled as such—it seemed like a random curatorial guess—but the tribes took it seriously and asked us to first consult with the Cheyenne and Arapaho. At the end of 2009, representatives from these tribes arrived in Denver, viewed the remains, then returned home to speak with their elders and chiefs. A month later, they informed us that the Cheyenne and Arapaho would not claim them as affiliated but wanted to take the lead in reburying them as unaffiliated. The Utes promptly acquiesced.

We prepared another request to meet with the Review Committee. On March 15, 2010, the exact day I submitted the disposition agreement with the Cheyenne and Arapaho to the National NAGPRA program, the Department of the Interior made a major announcement. It was releasing a final draft of the regulations for culturally unidentifiable remains. Everything was about to change.

24. BEFORE WE JUST GAVE UP

*I have little hope that the interests of science and knowledge will win out
against the emotionalism of the other side. It's a shame,
and no one knows the ramifications of this for the future.*

Fred H. Smith, Illinois State University[1]

Do we have to be dead and dug up from the ground to be worthy of respect?

José Ignacio Rivera (Apache/Nahuatl)[2]

Several months before I interviewed Fred Dayhoff in his Florida home, he had tried to retire. As a consultant, he was only charging the tribe enough to cover his expenses, and NAGPRA work is emotionally exhausting. It is not rewarding like many jobs. "You see what you accomplish," he says, "and that's it." For the Miccosukee, repatriation is not about healing but simply about trying to set things right. Because they avoid the dead, few Miccosukee are even aware of Fred's efforts on their behalf. "No one knows what I do," he says. "How could it help them heal?"

Fred is also ill, stricken with chronic lymphocytic leukemia. "By tribal standards I've put myself at risk," he explains. "Bad things can happen. The Miccosukee had predicted it." He unfolds his arms to show me scars from cancer. "They said I'd have sores on my arms from handling the old bones."

Still, the Miccosukee chairman refused to accept Fred's resignation.

"What do you mean I can't retire?" Fred asked him. "I'm not a captive."

"Well, since you live here," the chairman replied, "you kind of are."

Fred expects that when he no longer helps the Miccosukee comply with NAGPRA, repatriation will come to an end for the tribe. He once hoped a younger Miccosukee who is a Christian could take over. Then again, he now reflects, probably not. "His aunt or uncle won't let him touch the dead because he could then harm the whole clan. So one day soon no one here will answer museums' requests. It will just stop." The persistence Fred showed with the Denver Museum now made sense. He has been trying to accomplish as much as he can before he's gone.

When I told Fred and Steve Terry my decision that the Calusa were culturally unidentified under NAGPRA, they were less angry than I had expected. Perhaps I shouldn't have been surprised. Although NAGPRA still inspired conflict, in the last twenty-five years, museums and tribes have shown that repatriation does not have to be divisive. The Denver Museum was not alone in trying to find creative ways to find mutually agreeable solutions. Respect had become a virtue that underpinned most attempts to comply with the law. Although millions of funerary objects and more than 100,000 Native American remains continue to sit on museum shelves, tens of thousands have been returned because of meaningful conversations between anthropologists and Indians. Today it is no longer controversial that a professional like Lynn S. Teague, a retired curator at the Arizona State Museum, could write in a textbook that "the argument that contributions to science might yield some result beneficial to society as a whole does not justify ignoring the dignity of the deceased and their relatives, as defined in their own terms."[3]

When I ask Fred if NAGPRA has been a successful law, he doesn't hesitate. "Yes, it has been, beyond my wildest dreams,"

he says. "The regulations for culturally unaffiliated remains have helped a lot. Before we just gave up."

o o o

On March 15, 2010, the final draft of the regulations for culturally unidentifiable human remains was released. A sixty-day comment period followed, sparking heated debate and media attention. The final regulation again drew the old battle lines of pre-NAGPRA days.

The regulations—which are a "rule" that falls under a section of NAGPRA's code of regulations titled 10.11—basically require museums to consult with any Indian tribe or Hawaiian organization that claims remains taken from the tribe's use area. Similar to affiliated remains, which have a hierarchy of rights to them, the rule prioritizes claims from those whose reservation or trust land the remains come from. Next in line are those who have "aboriginal lands" (lands recognized by a court judgment, treaty, act of Congress, or presidential Executive Order) from where the remains were taken. If none of those tribes choose to claim the remains, they can be transferred to any other federally recognized tribe, or a museum may ask the Secretary of the Interior for permission to return the remains to non-federally recognized tribes or under state burial laws. In short, the new rule requires museums to consult with tribes on culturally unidentifiable remains and return them when claimed, unless the museum can show it holds "right of possession."

Although the Department of the Interior expressed optimism that the new rule would bring resolution to the unidentifiable remains issue, the rule has been roundly criticized.

Museums and scientific organizations—ranging from the National Museum of the American Indian to the American Association of Physical Anthropologists—in near unison argued against the new rule's legality and practical effects. Many archaeologists have come to accept NAGPRA but argue that the new rule "impermissibly expands the scope of the act."[4] They suggested that NAGPRA initially limited repatriation to affiliated remains to reflect a carefully

crafted balance between Native and scientific interests. A former SAA president published an op-ed in the *New York Times*, arguing that science should be given the time to establish cultural affiliation, both so that the remains would go to the true descendants and that we'd learn more about history and culture.[5] The past ten living presidents of the SAA wrote a letter to the current one, urging her to "take a strong stand opposing" the regulations.[6] Surprisingly, she wrote a letter at least supporting the consultation requirements in the new rule but wanted changes to make the rule consistent with NAGPRA's processes. A letter signed by twelve anthropology professors at the University of Tennessee even went so far as to conclude that the new rule would be "an injustice" not to scientists but to Native people because it would destroy their heritage.[7] Still others simply emphasized that returning remains would undermine our understanding of Native American history. The Smithsonian's Bruce D. Smith declared that the new rule "will result in an incalculable loss to science."[8] Scientists publicly intimated that they were ready to file a lawsuit to stop the regulations from taking effect.[9]

Native American tribes and organizations argued that the proposed rule was reasonable but still did not go far enough in addressing the problems presented by collections of human remains. Many were infuriated that the new rule did not require museums to return any funerary objects associated with these remains—a violation of the "right of sepulture," which protects graves from the looting of burial goods.[10] Essentially, museums would have to return the skeletons but could keep the artifacts they were buried with. Responding to the critiques of archaeologists, Native American advocates argued for the Department of the Interior's right to establish the regulations. They insisted that NAGPRA was a human rights law, which necessarily entailed the reburial of all human remains. Still others felt the regulations were unfair to federally unrecognized tribes; even though a federally unrecognized tribe might have a closer relationship with a set of ancestral remains, the rule compels a museum to give them first to a federally recognized tribe (if claimed by one) because tribal and aboriginal lands are prioritized above

non-federal tribal claims.[11] Many insisted that the notion of Native Americans without relatives was a Western legal construct. "There is no such thing as an unaffiliated remain," as Richard Black, a Sac and Fox representative in Missouri, said. "Unaffiliated is just a fancy scientific term to make us work harder to get them."[12]

o o o

The central disagreement comes down to whether "one interprets NAGPRA principally as a repatriation law designed to return human remains to tribal organizations or as legislation reflecting a compromise between Native American interests and those of the scientific community."[13] Even after twenty-five years of implementing federal repatriation law, the new regulations made clear that the different sides could not agree on a most basic question: Who is NAGPRA really for?

Native advocates have forcefully argued against the idea that NAGPRA seeks to balance disparate interests. They insist that NAGPRA is Indian law, intended to give them equal rights.[14] Unlike all other major federal heritage laws that were placed in the United States Code Title 16 (Conservation), NAGPRA was intentionally placed in the United States Code Title 25 (Indians). This fact has significant legal repercussions, given that Indian legislation is "to be construed liberally in favor of the Indians, with ambiguous provisions interpreted to their benefit."[15] As Suzan Shown Harjo half joked, when discussing the burdens NAGPRA would place on scientists, "This is not the National Museums Relief Act. This is the bill to bring some measure of justice to us and to end our national state of mourning."[16]

The Society for American Archaeology's past president Keith Kintigh, however, insists that NAGPRA was a compromise. "The fundamental principle guiding all of SAA's repatriation actions," Kintigh writes, "has *not* been, as critics would have it, to minimize repatriation, but instead to achieve the balance of traditional cultural interests and scientific interests."[17] The SAA's past leadership

insists that the SAA "worked intensively" with Congress, met with
Native leaders to develop "a lengthy set of joint recommendations,"
"endorsed the bill" in a letter signed by both scientific and Native
organizations, and wrote directly to "President Bush urging him
to sign the bill."[18] Although the SAA objected to certain provisions
of different proposed bills, the SAA found the final two bills—H.R.
5237 and S. 1980—"positive and workable."[19] It might be added
that even some Native American legal scholars have written that
NAGPRA reflects a compromise.[20]

The Klamath sociologist Clayton Dumont labels this version of
history as "happy talk." He analyzed the 1,700 pages of the con-
gressional record and found the "consistent, determined, and nearly
universal efforts" of archaeologists and their allies "first to kill and
then to weaken repatriation legislation."[21] Dumont suggests that it
was only by the spring of 1990 when museums and scientific organi-
zations shifted political tactics from preventing legislation to "mini-
mizing a law that was now clearly inevitable."[22] This marked the be-
ginning of a focus on balance and compromise, which targeted the
language of cultural affiliation—leaving museums in control over
"how cultural affiliation would be determined, and by whom, and
completely removing from the legislation language pertaining to
the return of remains that could be designated *by them* as 'culturally
unidentifiable.'"[23] In Dumont's view, this demonstrates that archae-
ologists were not interested in true balance, but in political games-
manship to win the upper hand.

o o o

One problem with arguing about Congress's intent with NAGPRA
is that there are 435 U.S. representatives and 100 senators, coming
and going over the four years it took for NAGPRA to become law.
Senator John McCain said, "I believe this bill represents a true com-
promise. . . . In the end, each party had to give a little in order to
strike a true balance."[24] But Senator Daniel Inouye said, "The bill
before us today is not about the validity of museums or the value of
scientific inquiry. Rather it is about human rights."[25]

No doubt, the SAA's representatives are honest in their recollections. For a century, archaeologists and curators had near exclusive rights to Native American heritage found on federal land. The shift the discipline made to acknowledge the rights of descendants was revolutionary. To even acknowledge that some "data" should be deaccessioned from collections and "destroyed" through reburials meant surrendering cherished ideals of archaeological preservation. Many archaeologists and curators labored to find a true balance between the conflicting ethics of their profession and the rights of Native Americans.

From the viewpoint of tribes and descendants, NAGPRA could only be about civil rights, religious freedom, human rights. As Rebecca Tsosie has argued, "The interest-balancing approach is inappropriate to a resolution of the issue of 'culturally unidentifiable' Native American human remains because it perpetuates the human rights abuses that created this problem in the first place."[26] For more than a century, Native Americans—mostly helplessly—watched archaeologists harvest the remains of their ancestors. It was a long, hard struggle to get archaeologists and curators to listen, to understand. Despite archaeologists' earnest beliefs about compromise, the word "balance" appears nowhere in NAGPRA or its regulations.[27] Even into the 1990s, the mood in museums was too often fearful, resentful, confrontational. Thanks to Kennewick Man and other conflicts, many Native Americans continue to see archaeologists as determined to appropriate a heritage that is not theirs. Native Americans believe the "balance" that archaeologists herald is a strategic attempt to undermine their basic rights.

From my view, I can see how far archaeologists and curators have come over the years, but also how far we still have to go.

Even if we accept the idea of NAGPRA as a balance of Native and scientific interests, the status quo is not a "balanced" solution. After twenty years of the federal law, only 27 percent of the remains in U.S. collections had been affiliated. Simply letting museums unilaterally decide to keep more than 115,000 skeletons is certainly not "balanced." On my reading of the new regulations, there is nothing that precludes "balanced" disposition agreements in which scien-

tific studies are allowed. The regulations do not require transfer of possession—or even reburial. If tribes granted permission, research could still be undertaken. The main difference now would be that scientists would be accountable to Native communities, rather than simply pursuing research exclusively on their own terms as they have done for too long.

When the final draft regulations were released, the Denver Museum prepared a response. The Denver Museum's lawyer, Lynda Knowles, was invited to be on a conference call with the other major natural history museums in the United States. It soon became clear that the other museums were unwilling or unable to join the Denver Museum in supporting the regulations. For the formal response, over five pages, six colleagues responsible for NAGPRA at the Denver Museum and myself analyzed the regulation and concluded that it "is positive, fair, legal, and consistent with Congressional intent."[28] We suggested that given how much work it had taken to culturally affiliate less than 30 percent of the human remains in collections, "it is obvious that progress has been protracted, painful, and incremental." If anything, we concluded, the new rule was too tentative because it "does not go far enough in compelling museums to proactively address the crisis they have helped create." From what I read, no other museum wrote in support of the regulation.

This letter reversed the stance that the Denver Museum took in 1995, when it insisted that science be privileged even above consultation with tribes. Much had changed. The museum had for many years resisted repatriation but ultimately saw that it would have to join the process. The museum experienced the regret of having owned human remains—scalps among them—that helped perpetrate a great injustice against Native Americans. The museum moved beyond a half decade of reluctance to let things go. It was time to help usher in a new era of respect.

The regulations for 10.11 became law on May 14, 2010. There finally was a clear path to send the Calusa home.

o o o

Fred Dayhoff and I began to work on returning the Calusa remains as "culturally unaffiliated." We had long anticipated having to pursue repatriation through the lengthy process of seeking permission from the Secretary of the Interior, but when the regulations were finalized in May 2010, we had a straightforward legal means to return the Calusa. I worked with Fred to lay out an argument that the Calusa remains could be claimed because they were removed from Seminole and Miccosukee aboriginal territory—in other words, although they were not lineal descendants or culturally affiliated, the Calusa remains were still the modern Seminole's and Miccosukee's responsibility because they lived in and shared the same traditional lands. The Seminole deferred to the Miccosukee for the final claim and reburial. We wrote and published a notice in the *Federal Register*, announcing our intent to return three Calusa individuals and 106 associated funerary objects—shell and coral fragments, pottery sherds, animal bones—to the Miccosukee.[29]

Over the last five years since the new regulations have taken effect, a total of 203 notices have been published in the *Federal Register* for 2,420 sets of human remains and 145,848 associated funerary objects.[30] Despite the dire warnings spread by some archaeologists, museums have not been emptied since 2010. The fact that only about 2.1 percent of the culturally unidentifiable remains in museums have been claimed so far is because the new rule still requires lengthy and thoughtful consultations. Many tribes are also reluctant to claim unidentified remains because they do not want to risk burying enemies. Yet another limitation is that tribes struggle to find a safe, permanent location for reburials. At the current rate of repatriation, under the new rule, all of the unidentifiable human remains in American museums would not be returned for another 238 years.

The dire predictions that "the delicate cooperative balance between Native Americans and scientists that was forged by the passage of NAGPRA" would be "shattered" with the new regulations now seem overwrought.[31] Still, the regulations have had an impact. In the case of the University of California at Davis, the new rule prompted them to reevaluate their human remains, 90 percent

of which had been deemed culturally unidentifiable.[32] Harvard's Peabody Museum began to work on a claim for 500 remains; the University of Michigan began plans to transfer 1,580 remains to a coalition of thirteen tribes; and the Phoebe A. Hearst Museum of Anthropology hired four staff members to reevaluate upward of 10,000 sets of culturally unidentifiable remains in their collections.[33] The new regulations have provided an important way for dozens of tribes and museums—from the Arizona State Museum to the American Museum of Natural History—to return culturally unaffiliated remains.

As for the Denver Museum, in the summer of 2011, more than a decade after the Miccosukee claim was first made for the Calusa remains, I mailed a twenty-pound box containing a Calusa skull, bones, and artifacts to Fred's home in Florida.

<p style="text-align:center">o o o</p>

Fred Dayhoff said he wanted to wait until winter to rebury the Calusa, once the mosquitoes abated. He didn't tell me exactly where the human remains would go. But one day soon, Fred would set out from his home. He would drive south toward the Keys, until he arrived at a park protected by a government agency. He would walk into the wild, tropical forest with a box of bones.

Maria Pearson also had one day set out to locate a final resting place for the young woman who had changed her life in 1971—and who had changed the national conversation about the Indian living and the dead. The young woman, archaeologists later said, perhaps belonged to the Potawatomi Tribe. Maria was Yankton Sioux, a different people. It didn't matter to Maria. The young woman was a Native American. Even more, she was a human being. The young woman deserved the dignity of a quiet, protected place until that day when her bones disintegrated into the earth's dust.

Fred's arms would ache. The box would grow heavy. Twenty pounds would seem to double during the long hike. Although winter, it would still be hot, humid. Sweat would soak through Fred's

clothes, his pants clinging to his legs. But he wouldn't mind. It was his job. It was his responsibility, one he hadn't wanted but had accepted. After a long while Fred would stop, take off his cowboy hat to catch his breath. Perhaps he would stare up at the amber light shimmering through the canopy of trees and breathe in the stillness. The quiet would envelop him. He would realize that this is a beautiful place. As important, also remote: far from the threat of the living.

The first time the young Potawatomi woman was reburied, she was placed back in the Glenwood Cemetery. But once the new burial areas were created by the 1976 Iowa law, Maria decided that the young woman should join other potential kin. One day Maria traveled to the far western edge of Iowa—where one of the regional cemeteries for burying Native Americans had been established. In a quiet ceremony, a small group of supporters buried the young woman again, for the final time. Alongside the bones Maria laid the things that had originally been buried with her. A bone comb missing most of its teeth, an iron awl with a bone handle in a crumbling metal box. Slowly, the grave was again filled with dirt.

Fred would not bury the Calusa remains. The Miccosukee don't bury their dead. The dead are traditionally left on the surface, exposed to the elements. Fred would put the remains in what he would think a respectful final repose. The head to the west. The feet to the east. He would then take from his pocket a bundle of scented grasses and a lighter. The flame would catch the dried plants, until curls of smoke would rise up dissolving into a sweetness that filled the air. Fred would then turn to leave. Although his burden would be lighter, he would not feel happiness or relief. He would feel just a sense of finality. He was not a relative, not even a Native American. He was just trying to honor the beliefs of the living, the Miccosukee, and to respect the Calusa, the people who came before.

There is little in common between us. The ashes of our ancestors are sacred and their final resting place is hallowed ground, while you wander far from the graves of your ancestors, and seemingly without regret. . . . Let [the white man] be just and deal kindly with my people, for the dead are not altogether powerless.

Chief Seattle, to Governor Isaac Stevens in 1855[1]

We have to move from the ethics of conquest to the ethics of collaboration.

Martin Sullivan, museum director[2]

CONCLUSION

I lead a small group of Native Americans through Crane Hall, hurrying past the exhibit cases on Native America. At times I feel embarrassed with Native visitors here, knowing the permanent exhibit has changed little since its completion in 1978. Some of the labels are outdated. Some of the dioramas haven't held up well. To get to the storage room, we have to pass by one with manikins, presenting Seminole culture, that is particularly disturbing. A baby's face is all wrong, looking like a very old, worn-out man instead of a human child.

This particular group lives on a reservation far away. They have never been to Denver, never been to the museum. But they had heard it might hold the bones of their ancestors. So they came. Some had come calmly. Others had arrived angry, like the victims of some terrible crime, perhaps imaging their own bodies lying disassembled on a museum shelf.[3] Even after our successes, every new consultation sets off the tremors of history, a search for the epicenter of cultural misunderstanding.

We arrive at the hidden entrance to the storeroom holding the Native American skeletal remains. We shuffle in. I unlock the first steel cabinet and peel the doors back. I feel a fleeting moment of satisfaction. All the shelves are empty except one, which holds a single box covered in muslin and topped with a small bundle of sage. Af-

ter nearly twenty-five years since NAGPRA's passage, nearly all the museum's human remains are gone. The work is nearly over.

The empty cabinet pulls my thoughts to change—particularly how museums create the illusion that nothing ever changes. Curators are magicians; the effect is permanence. Museums create a facade that makes everything appear preserved forever. The dioramas we just passed freeze a moment in Native Americana—no real past or future, just the perpetual now—as if Indians have always worn colorful traditional clothes and lived in thatch huts. Artifacts are presented in sterile cases as timeless objects of art, as if their meaning as beautiful things is obvious, universal, never ending. But of course this is a fiction. Native Americans have changed, as have museums. No object inherently belongs in a museum.

Things perish. So do ideas. In 1978, when the Zuni launched the first major national repatriation effort, many museum professionals feared that the return of objects spelled the end of the museum enterprise. Actually, the fearmongers were right. Repatriation did kill the museum. More exactly, repatriation extinguished the old idea that museums could preserve and present Native American culture without any input from Native Americans themselves. In the last forty years, the far majority of museums have changed from institutions that resisted repatriation, to regretting their complicity in many collections unjustly taken, to reluctantly complying with repatriation laws, to respecting Native spiritual and cultural beliefs about their ancestors and cultural treasures. Repatriation ended one period for American museums and ushered in a new one. Repatriation has given American museums a second life.

The struggle now is to find what comes after, how museums can remake themselves into institutions that serve their role of stewardship while working with the people they represent. The question now is: What's next?

o o o

Although not much has changed about Crane Hall since 1978, one thing that has changed is that certain sacred objects cannot be seen

in display cases. Visitors won't see anything like a Zuni Ahayu:da, an Arapaho scalp, the Chief Shakes Killer Whale robe, or a Calusa burial. They instead see a vacant place where a sacred object was once displayed with a sign that reads: "This object has been repatriated." We are intentionally leaving these empty spaces as a symbol of change, an object lesson on repatriation, shown by the absence of an object.

More subtly, but profoundly, museum professionals are no longer the exclusive keepers of culture. Visitors to the Denver Museum can see a temporary exhibit on the representation of Native Americans that I co-produced with Jami Powell, an Osage tribal member and anthropology student. Many visitors also saw the poignant piece by James Luna, a celebrated Luiseño performance artist, who transformed Crane Hall for several weeks into an installation about his personal search for family and identity. Behind the scenes, my staff and I have worked for several years to create a collaborative database with the Zuni tribal museum, in which Zunis contribute their stories and interpretations of the objects in the Denver Museum. The database was just one part of a larger effort to engage Native Americans, which includes student internships, scholarships, fellowships, workshops, and a film festival designed for and in partnership with Native community members.[4] These shifts are part of an international movement to turn museums from places of conquest to places of collaboration.

The Denver Museum's database project is directed by the Zuni tribe's own A:shiwi A:wan Museum & Heritage Center. This is a tribal museum, run by and for the Zuni people. It is another place that affirms how museums have changed since the repatriation debates began in earnest four decades ago. While museums were often distant places divorced from Native American communities, now some two hundred tribes have built museums of their own. These institutions demonstrate Native Americans are not against museums—only museums that violate their sense of dignity. Jim Enote, the director of the A:shiwi A:wan Museum & Heritage Center, once told me that he believes museums have a vital role to play as "mediating spaces"—places that confront the hard questions of

our past, places to work through our differences, places to imagine a different collective future.

Repatriation itself has been a key theme in the plot to shift museums into a mediating space. Through the years I have learned that repatriation is not a dispute about material things, body parts, or sacred objects. Repatriation is about people—their views of faith and science, morality and mortality. NAGPRA doesn't decide who owns the past. Rather, the law establishes an arena and set of rules—a "mediating space"—in which people must negotiate their interests. NAGPRA is not a decree. It is a debate.

The debate is over meaning. The battle over the War Gods was not really about who gets to control the pieces. Rather, it was a struggle over whether the pieces were living beings or art objects. Most everyone could agree that the Ahayu:da should be preserved. The disagreement was whether keeping them under glass in a museum or returning them to an open-air shrine was preserving their core value. Similarly, is the Killer Whale Flotilla Robe a commodity that could be sold by an individual or a clan object that serves as a totem to the entire clan? Is a Calusa skull suffused with power, the shadow of a soul, or an artifact for scientific study?

The debate is over history. Repatriation asks us to understand past wrongs and try to fix them in the present. The terrible massacre along Sand Creek transformed body parts into museum objects. Addressing the repatriation claims of the Cheyenne and Arapaho came in the context of much larger questions about our collective memory of this terrible event. Although it might be hard to find someone who would defend the museum's keeping the scalp of a murder victim, there still were no easy answers about how to return these remains, whether its return could heal the wounds of history. In other contexts, the thefts of cultural property, although often instigated by outsiders, were often perpetuated by insiders. Repatriation has made the Tlingit confront the choices of their own clan members, sometimes their own family members.

The debate is about the future. A key question is whether we believe there is a future for Native American culture. If there is a

future, then the use of cultural objects plays a vital role. The Tlingit and Zuni demonstrate that the very existence of their culture depends on their cultural treasures. If there is a future, then Native American communities benefit from knowing that none of their ancestors haunt the halls of museums—that all Native Americans are accorded equal protection under the law.

Who owns the past? This is the question that often frames these battles. And yet these debates have shown the limits of this question. It presumes that all objects of history are pieces of property. Yet, for the Zuni, the Ahayu:da are living beings that cannot really be owned. This question assumes there are clear winners and losers. Yet, for the Miccosukee, the Calusa skulls and skeletal fragments are bound to harm everyone, themselves as much as non-Indians who meddle in graves, and even the non-Indians who return them to their final repose. These debates show, ultimately, that we must move beyond the battles of ownership to a more collaborative model of stewardship. None are the exclusive keepers of the past. All of us share in this responsibility.

We have much to lose by working against one another, and much to gain by working together. It is significant that so many repatriated objects have gone back into the safety of museums as holding places. This shows that the question is not about the physical presence of objects in museums, but about giving communities control over their own culture.

In 1996, the same year that Kennewick Man, the fiercely disputed 9,300-year-old human remains, was discovered in Washington, a skeleton, older by 1,000 years, was discovered at On-Your-Knees Cave in Alaska. There the researchers (including a Denver Museum curator) took a deeply respectful and non-confrontational approach. Through a twelve-year partnership, the human remains were fully studied and published with the consent of Native peoples. Two hundred local Tlingit even submitted their DNA for comparative analysis. The remains were eventually reburied during a two-day festival celebrated by scientists, government officials, and Native Americans. That a compromise could be successful had already been proven

by Maria Pearson and Duane Anderson, as well as by Gordon Yellowman with his approach to the so-called Sandman. Repatriation has pushed scores of archaeologists to work more closely with Native Americans than ever before.[5] "We do have common ground," Walter Echo-Hawk predicted in 1994. "If we build on that, we may create a new science of North American archaeology."[6]

"Unless museums willingly respond to these concerns," the archaeologist David Hurst Thomas said in 1989 about the repatriation debate, "we will be put right out of business."[7] Thankfully, most museums did respond, eventually, and brought together two sets of views and values that had seemed irreconcilable. Even some physical anthropologists have acknowledged that NAGPRA increased the number of Native American skeletons studied from about 30 percent to 100 percent, that the law has provided important new funding and full inventories "unprecedented in the history of osteology," and that the law offers radical new possibilities for partnerships.[8] No museum has yet gone out of business because of repatriation. Instead, the entire discipline is shifting to become more inclusive to Native Americans, more respectful of their interests, more concerned than ever before with not just preserving the past of Native Americans but helping to ensure their future.[9]

Ironically, repatriation, one of the most divisive controversies across Native America in the last generation, does not have to be a wedge. It can be a bridge between cultures.

○ ○ ○

An elder asks if the lights can be turned off. I flip the switch and we are engulfed in blackness. He strikes a match and, for a moment, his lined face is haloed in red. The bundle of sage catches. Sweet smoke fills the room. The elder begins singing a long prayer to the dead. At first it is as soft as a lullaby, but soon grows into a crescendo so loud that the metal cabinets reverberate like an accompanying drumbeat.

The song slows, then dissipates, absorbed by the walls. Quiet. Stillness.

In that moment, in the darkness both alone and together, I wonder if I'm wrong.

This group did not come to debate me about who owns the past. They came to show that they had not forgotten their ancestors, to acknowledge that these remains belong to real human beings. Their prayer is not a counter-argument to science; it is a complement to science, because scientists too, ultimately, want to give these remains meaning. Their prayer is just another way of trying to understand and memorialize the humanity imbued in these bones.

Yes, I consider, repatriation can resolve the clash of cultures; it can be a form of justice; it can provide a new future for museums and Native America. But we humans, even with our vast diversity of beliefs, none want our humanity to recede to nothingness.

We want to be respected. We want to be honored. We want to be remembered.

A NOTE ON THE TERMS AMERICAN INDIAN, NATIVE AMERICAN, ETC.

Among the most confused words in the English language are those in the phrase "American Indian."

The English origins of the word "India" can be found in Latin and Greek, which originally meant "region of the Indus River." The Indus River flows 2,000 miles from Tibet to the Arabian Sea. By 500 years ago, India became the common shorthand to describe the entire subcontinent of southern Asia.

When Christopher Columbus sighted land in 1492, he carried with him a letter of introduction to the Chinese emperor and a passport in Latin attesting to his travels on behalf of the Spanish sovereign *ad partes Indie*—"towards the regions of India."[1] Columbus referred in Spanish to the people he met as *Indios* in the mistaken theory he had arrived at the periphery of India. In 1507 Europeans (although "Europe" as a coherent geopolitical concept didn't exist then) added the term "America" to the nomenclature to describe the New World (although not "new" at all to those Indios) when a cartographer published a map naming the Western Hemisphere in honor of the Italian explorer Amerigo Vespucci.[2]

Malcolm X's aphorism "We didn't land on Plymouth Rock— Plymouth Rock landed on us" comes to mind. The millions of people living across the Western Hemisphere in 1492 did not choose

to be named Indians; rather, it was a label forced on them by their
conquerors. Most of these people had names for themselves that
translate into English simply as "the People." Most people, it would
seem, prefer to think of themselves simply as people.

During the tumultuous 1960s, activists began to protest the use
of "Indian" to describe the people aboriginal to North America
because of the term's historical confusion and racial baggage. (Ac-
cording to one dictionary, more than 500 modern phrases include
"Indian," most connoting stupidity or dishonesty, e.g., Indian
giver.[3]) Alternative terms proliferated. In the United States, "Na-
tive American" emerged as the most popular substitute. The phrases
"Indigenous peoples" and "Native peoples" became common to
describe the descendants of the local, often tribal cultures that Eu-
ropean explorers met starting the in the late 1400s, including those
across the Americas, Australia, Oceania, Africa, and Asia.

In Canada the language got even more complex. "Aboriginal"
and "First peoples" became terms to describe all of the country's
Indians, Inuit (the contemporary term for Eskimo; Inuit means "the
People" in the Inuktitut language), and Métis (people of mixed Ab-
original and non-Aboriginal heritage). The term "First Nation" re-
placed the word "Indian." But First Nation does not include the In-
uit or Métis, because historically these latter two groups had unique
legal and political statuses. For similar reasons in the United States,
Alaskan Natives and Native Hawaiians are often not regarded,
strictly speaking, as Native Americans.

Confused?

In my personal experience, these terms are mostly interchange-
able; their use varies by context. The I-word is not too different
from the N-word in that regard. To some, the term "Indian" is of-
fensive to utter aloud, unless you happen to be one. Among family,
an American Indian might refer to herself as Indian, but in a more
formal context with strangers refer to herself as Native American.
Still, not all of these terms have caught on. One friend, a member
of the Tohono O'odham Nation in Arizona, came to my museum
through our Visiting Indigenous Fellowship Program. While in

Denver he discovered great joy by introducing himself with this program's label, which was clearly strange for him. "Hello!" he would say with a broad smile. "I'm an Indigenous fellow!"

Yet others challenge the term "Native American" for its racial underpinnings. Some, such as the Pawnee historian Roger Echo-Hawk, have argued that racialist categories—such as white, black, Asian, and Native American—should be dispensed with altogether.[4] Anthropologists agree that the modern races are not "real"—in the sense that there is no scientific evidence to meaningfully classify people based on physical characteristics stereotypically used, such as skin color. Since our modern concept of race is a fiction created by colonialist powers over the last 500 years, Echo-Hawk argues that we should avoid even thinking about Native Americans as any kind of coherent group. Instead we should only talk about cultural identities, such as tribal affiliation. Echo-Hawk insists that he is a Pawnee (a cultural identity) but not a Native American (a racial identity).

In fact, most of the Native Americans I know do not very often refer to themselves as Native Americans. Their identities are expressed through their tribal memberships, or even more specifically through their clan lineages, the villages where they live, or their religious or cultural positions within their communities. Although there are many shared historical experiences that unite Native Americans, under the single term "Native American" are millions of people from hundreds of different cultural groups, who dwell in vastly different geographies, speak mutually unintelligible languages, and hold radically different beliefs. Some of these groups are even historic enemies. For good reason, many Native Americans see little relevance of the term "Native American" in their lives.

To embrace this breathtaking confusion, throughout the book, I interchangeably use Indian, American Indian, Native, and Native American. The reason for my lexical agnosticism is that there is simply not yet a good enough reason to use one term to the exclusion of the others. Every term here has as much potential to illuminate as to offend, to hinder our understanding of who we're talking about, and to perpetuate racialist thinking.

So, while I do use these terms to describe the aboriginal peoples (and their descendants) who inhabited the Americas in 1492, I also just try to avoid these terms altogether. Wherever possible I use tribal affiliations or the cultural identities (such as clan membership) that people have expressed to me. Although mainly, whenever I am using any of these terms, in my mind I am thinking of them first as the subjects of these terms think of themselves: as people.

ACKNOWLEDGMENTS

Like a museum exhibit, which may appear to be the result of a single person's efforts but in fact is a collective effort, this book has my name on the cover but is the product of many people's time, work, and support.

To begin with, I could not have had the chance to research and write this book without the encouragement of so many colleagues at the Denver Museum of Nature & Science. I am indebted to Steve Nash, George Sparks, Kirk Johnson, and Scott Sampson. Additional important contributions to the Denver Museum's work on repatriation have been made by Isabel Tovar, Melissa Bechhoefer, Steve Holen, Lynda Knowles, Heather Thorwald, Kelly Tomajko, and Jami Powell. I was assisted in administrative logistics and background research for this book by Cecily Harms, Sam Schiller, Meadow Nook, Laurie Edwards-Ryer, Linda Gregonis, Veronika Hall, Rene Payne, Kris Haglund, and especially Carla Bradmon, Katherine Honda, and Kathryn Young.

Research for this project was supported by a grant from the Wenner-Gren Foundation for Anthropological Research (Grant No. 8101). The grant application and its implementation were greatly aided by Quetzil Castañeda, Tom Boellstorff, Ann Perez de Tejada, Jill Viehweg, Eric Hemenway, Joe Watkins, Roger Anyon, Sonya Atalay, Clay Dumont, Terry Redding, Mary Elizabeth Moss, Julia Huddleston, Jeff Campbell, Thomas Killion, John Lukavic, and

Kurt Dongoske. I am extremely grateful to all of those who contributed to the project by consenting to an interview, including Perry Tsadiasi, Arden Kucate, Jim Enote, Theresa Pasqual, Connie Hart Yellowman, George Old Crow, Lawrence Hart, Karen Little Coyote, Joe Big Medicine, Karen Wilde, Craig Moore, Alexa Roberts, Rhonda Brewer, Ben Didrickson, Jerrie Clark, Marsha Hotch, Nora M. Dauenhauer, Ray Dennis Jr., Ryntha Johnson, Joyce Herold, and Robert B. Pickering. Particularly generous with their time and patient explanation were Octavius Seowtewa, Gordon Yellowman Sr., Harold Jacobs, and Fred Dayhoff.

It would not have been possible to write this book without a fellowship leave from the Denver Museum and the generous award of a Fellowship from the National Endowment for the Humanities (Grant No. FB-56147-12). During my leave I was hosted by the Department of Anthropology at the University of Denver. I am extremely grateful to the faculty and staff there for making me feel so at home, and in particular the kind assistance of Dean Saitta, Orla McInerney, and Christina Kreps. Drafts of various book sections were read and greatly improved by T. J. Ferguson, George Nicholas, Tom Killion, Daniel Henry, Andréa Giron, Lynn Colwell, and Soumontha Chanthaphonh. In particular, Torran Anderson read every word—and often every rewritten word—bringing his wisdom to the project.

Having never written a "trade press" book for a popular audience, I was especially lucky to have as partners Wendy Strothman and Lauren MacLeod, of the Strothman Agency, who were highly capable and genuinely enthusiastic literary agents. The University of Chicago Press was also a wonderful collaborator. I am grateful to their editorial, production, and marketing staff, especially James Whitman Toftness, Erin DeWitt, and Carrie Adams. Two anonymous reviewers provided very helpful comments. And I am particularly grateful to Susan Bielstein for her support and her keen editorial insights, which made the book far better than when it first landed on her desk. I am hopeful that I learned enough in the process that my next book manuscript will require far less red ink.

NOTES

Throughout the book, I present sections of dialogue drawn from published sources, interviews, and archival documents. In many cases, I located audio or video recordings, transcripts, or multiple accounts of the same exchange, which allowed me to re-create scenes with fidelity. But some of the dialogue was reconstructed from people's memories or written notes from meetings, which understandably vary in quality and reliability; it was impossible to corroborate exact quotes (although I only present re-created dialogue from trustworthy sources). In these cases, the dialogue is probable, but unverified.

ASL Alaska State Library Historical Collections
DAM Denver Art Museum Archives
DMNS Denver Museum of Nature & Science Archives
HSF Human Studies Film Archives, Smithsonian Institution
WML E. Richard Hart Archives, J. Willard Marriott Library, University of
 Utah

INTRODUCTION

1. Suzan Shown Harjo, "Last Rights for Indian Dead," *Los Angeles Times*, September 16, 1989.

2. Jeff Gottlieb, "Battle of the Bones," *Washington Post*, July 25, 1989.

3. Roger Atwood, *Stealing History: Tomb Raiders, Smugglers, and the Looting of the Ancient World* (New York: St. Martin's Press, 2004); Russell Chamberlin, *Loot! The Heritage of Plunder* (New York: Facts on File, 1983); Jeanette Greenfield, *The Return of Cultural Treasures* (Cambridge: Cambridge University Press, 1989); Brian Hole, "Playthings for the Foe: The Repatriation of Human Remains in New Zealand," *Public Archaeology* 6, no. 1 (2007): 5–27; Tiffany Jenkins, *Keeping Their*

Marbles: How the Treasures of the Past Ended Up in Museums . . . and Why They Should Stay There (Oxford: Oxford University Press, 2016).

4. Tamara L. Bray and Thomas W. Killion, eds., *Reckoning with the Dead: The Larsen Bay Repatriation and the Smithsonian Institute* (Washington, DC: Smithsonian Institute Press, 1994); Tamara L. Bray, ed., *The Future of the Past: Archaeologists, Native Americans, and Repatriation* (New York: Garland, 2001); Sangita Chari and Jaime M. Lavallee, eds., *Accomplishing NAGPRA: Perspectives on the Intent, Impact, and Future of the Native American Graves Protection and Repatriation Act* (Tucson: University of Arizona Press, 2013); Gerald T. Conaty, ed., *We Are Coming Home: Repatriation and the Restoration of Blackfoot Cultural Confidence* (Edmonton: AU Press, 2015); Roger C. Echo-Hawk and Walter R. Echo-Hawk, *Battlefields and Burial Grounds: The Indian Struggle to Protect Ancestral Graves in the United States* (Minneapolis: Lerner Publications, 1994); Thomas W. Killion, ed., *Opening Archaeology: Repatriation's Impact on Contemporary Research and Practice* (Santa Fe, NM: SAR Press, 2008); Kathleen S. Fine-Dare, *Grave Injustice: The American Indian Repatriation Movement and NAGPRA* (Lincoln: University of Nebraska Press, 2002); Cressida Fforde, *Collecting the Dead: Archaeology and the Reburial Issue* (London: Duckworth, 2004); Cressida Fforde et al., eds., *The Dead and Their Possessions: Repatriation in Principle, Policy, and Practice* (New York: Routledge, 2002); Greg Johnson, *Sacred Claims: Repatriation and Living Tradition* (Charlottesville: University of Virginia Press, 2007); Cara Krmpotich, *The Force of Family: Repatriation, Kinship, and Memory on Haida Gwaii* (Toronto: University of Toronto Press, 2014); C. Timothy McKeown, *In the Smaller Scope of Conscience: The Struggle for National Repatriation Legislation, 1986–1990* (Tucson: University of Arizona Press, 2013); Devon A. Mihesuah, ed., *Repatriation Reader: Who Owns American Indian Remains?* (Lincoln: University of Nebraska Press, 2000); Tony Platt, *Grave Matters: Excavating California's Buried Past* (Berkeley, CA: Heyday, 2011); David Hurst Thomas, *Skull Wars: Kennewick Man, Archaeology, and the Battle for Native American Identity* (New York: Basic Books, 2000); Ann M. Tweedie, *Drawing Back Culture: The Makah Struggle for Repatriation* (Seattle: University of Washington Press, 2002); Joe Watkins, *Sacred Sites and Repatriation* (New York: Chelsea House Publishers, 2006).

5. Douglas Cole, *Captured Heritage: The Scramble for Northwest Coast Artifacts*, rev. ed. (Norman: University of Oklahoma Press, 1995), p. xix.

6. William Bradford and Edward Winslow, *Mourt's Relation; or, Journal of the Plantation Plymouth* (Boston: John Kimball Wiggin, 1865), p. 34.

7. Stephen T. Asma, *Stuffed Animals and Pickled Heads: The Culture and Evolution of Natural History Museums* (Oxford: Oxford University Press, 2003).

8. Robert E. Bieder, *Science Encounters the Indian, 1820–1880: The Early Years of American Ethnology* (Norman: University of Oklahoma Press, 1986); Ann Fabian, *The Skull Collectors: Race, Science, and America's Unburied Dead* (Chicago: Univer-

sity of Chicago Press, 2010); Shepard Krech III and Barbara A. Hail, eds., *Collecting Native America, 1870–1960* (Washington, DC: Smithsonian Institution Press, 1999).

9. Orin Starn, *Ishi's Brain: In Search of Americas Last "Wild" Indian* (New York: Norton, 2005); Nancy Scheper-Hughes, "Ishi's Brain, Ishi's Ashes: Anthropology and Genocide," *Anthropology Today* 17, no. 1 (2001): 12–18.

10. James Riding In, "Repatriation: A Pawnee's Perspective," in *Repatriation Reader: Who Owns American Indian Remains?*, ed. Devon A. Mihesuah, pp. 106–22 (Lincoln: University of Nebraska Press, 2000). See also Edward Halealoha Ayau, "Native Burials: Human Rights and Sacred Bones," *Cultural Survival Quarterly* 24, no. 1 (2000): 34–37; Bowen Blair, "American Indians vs. American Museums: A Matter of Religious Freedom," *American Indian Journal* 5, no. 6 (1979): 3–6; Karen Coody Cooper, *Spirited Encounters: American Indian Protest Museum Policies and Practices* (Lanham, MD: AltaMira Press, 2008); Vine Deloria Jr., "Secularism, Civil Religion, and the Religious Freedom of American Indians," in *Repatriation Reader: Who Owns American Indian Remains?*, ed. Devon A. Mihesuah, pp. 169–79 (Lincoln: University of Nebraska Press, 2000); Jan Hammil and Larry J. Zimmerman, eds., *Reburial of Human Skeletal Remains: Perspectives from Lakota Spiritual Men and Elders* (Vermillion, SD: American Indians Against Desecration and University of South Dakota Archaeology Laboratory, 1983); James Riding In, "Without Ethics and Morality: A Historical Overview of Imperial Archaeology and American Indians," *Arizona State Law Journal* 24, no. 1 (1992): 11–34; and Steve Talbot, "Desecration and American Indian Religious Freedom," *Journal of Ethnic Studies* 12, no. 4 (1985): 1–18.

11. Douglas J. Preston, "Skeletons in Our Museums' Closets: Native Americans Want Their Ancestors' Bones Back," *Harper's* 278, no. 1665 (1989): 66–75, pp. 68–69.

12. The law also applies to Native Hawaiian and Alaskan Indians. However, to simplify, throughout the book, when discussing NAGPRA, "Native Americans" or "American Indians" are used to represent all these different groups. See "A Note on the Terms American Indian, Native American, Etc."

CHAPTER ONE

1. Clayton W. Dumont Jr., "Contesting Scientists' Narrations of NAGPRA's Legislative History Rule 10.11 and the Recovery of 'Culturally Unidentifiable' Ancestors," *Wicazo Sa Review* 26, no. 1 (2011): 5–41, p. 17.

2. Cole, *Captured Heritage*, p. 287.

3. This description of Culin is based on Steven Conn, *Museums and American Intellectual Life, 1876–1926* (Chicago: University of Chicago Press, 1998); Diana Fane, ed., *Objects of Memory and Myth: American Indian Art at the Brooklyn Museum*

(Brooklyn: The Brooklyn Museum, 1991); Diana Fane, "New Questions for 'Old Things': The Brooklyn Museum's Zuni Collection," in *The Early Years of Native American Art History: The Politics of Scholarship and Collecting*, ed. Catherine Berlo, pp. 62–87 (Seattle: University of Washington Press, 1992); Adele Merenstein, "The Zuni Quest for Repatriation of the War Gods: An Alternative Basis for Claim," *American Indian Law Review* 17, no. 2 (1993): 589–637; William Merrill and R. Ahlborn, "Zuni Archangels and Ahayu:da: A Sculptured Chronicle of Power and Identity," in *Exhibiting Dilemmas: Issues of Representation at the Smithsonian*, ed. Amy Henderson and Adrienne L. Kaeppler, pp. 176–205 (Washington, DC: Smithsonian Institution Press, 1997); and Robert Oppenheim, "Fictional Displacements: Stewart Culin's Heaven and Earth," *Anthropology and Humanism* 36, no. 2 (2011): 164–77.

4. *The Brooklyn Museum Quarterly*, 1924, p. 92.

5. At the time, the Brooklyn Museum was called the Brooklyn Institute of Arts and Sciences.

6. Jesse Green, ed., *Zuni: Selected Writings of Frank Hamilton Cushing* (Lincoln: University of Nebraska Press, 1979); Curtis M. Hinsley, "Ethnographic Charisma and Scientific Routine: Cushing and Fewkes in the American Southwest, 1879–1893," in *Observers Observed: Essays on Ethnographic Fieldwork*, ed. George W. Stocking Jr., pp. 53–69 (Madison: University of Wisconsin Press, 1983); Edmund J. Ladd, "Cushing among the Zuni—A Zuni Perspective," *Gilgrease Journal* 2, no. 2 (1994): 20–35; Nancy J. Parezo, "Cushing as Part of the Team: The Collecting Activities of the Smithsonian Institution," *American Ethnologist* 12, no. 4 (1985): 763–74.

7. "The War Gods at TBM," Diana Fane, October 18, 1990, Box 37, WML.

8. Triloki Nath Pandey, "Anthropologists at Zuni," *Proceedings of the American Philosophical Society* 116, no. 4 (1972): 321–37, p. 327; Kurt E. Dongoske and Davis Nieto Jr., *Anshe K'yan'a: Zuni Traditional Places Located within the Fort Wingate Military Depot Activity, McKinley County, New Mexico* (Zuni, NM: Zuni Cultural Resource Enterprise, 2005), p. 67.

9. Tisa Wenger, *We Have a Religion: The 1920s Pueblo Indian Dance Controversy and American Religious Freedom* (Chapel Hill: University of North Carolina Press, 2009), p. 64.

10. This description and Culin quotes come from Fane, "New Questions for 'Old Things,'" p. 73.

11. Stewart Culin, "Report on the Department of Ethnology," in *Report for the Year 1904*, ed. Frederic A. Lucas, pp. 19–24 (Brooklyn: Museums of the Brooklyn Institute of Arts and Sciences, 1905), p. 23.

12. Darlis A. Miller, *Matilda Coxe Stevenson: Pioneering Anthropologist* (Norman: University of Oklahoma Press, 2007), p. 131.

13. On the conditions at Zuni, see Edmund J. Ladd, "The Zuni Ceremonial System: The Kiva," in *Kachinas in the Pueblo World*, ed. Polly Schaafsma, pp. 17–21 (Albuquerque: University of New Mexico, 1994), p. 19; Pandey, "Anthropologists at Zuni," p. 326; and "Report to the Zuni Tribal Council on Thirteen War Gods and Associated Shrine Offerings in the Collection of the Brooklyn Museum," T. J. Ferguson, October 8, 1990, p. 41, Box 36, WML. On the population of Zuni in 1900, see William R. Merriam, *Census Reports, Volume 1: Twelfth Census of the United States Taken in the Year 1900* (Washington, DC: United States Census Office, 1901), p. 274. On the history of droughts in New Mexico, see David Gutzler, "Drought in New Mexico: History, Causes, and Future Prospects," in *Water Resources of the Lower Pecos Region, New Mexico: Science, Policy, and a Look to the Future*, ed. P. Johnson et al. (Socorro, NM: New Mexico Bureau of Geology and Mineral Resources, 2003), p. 103.

14. "Report to the Zuni Tribal Council on Thirteen War Gods and Associated Shrine Offerings in the Collection of the Brooklyn Museum," T. J. Ferguson, October 8, 1990, p. 41, Box 36, WML.

15. Diana Fane, "The Language of Things: Stewart Culin as Collector," in *Objects of Memory and Myth: American Indian Art at the Brooklyn Museum*, ed. Diana Fane, pp. 13–27 (Brooklyn: The Brooklyn Museum, 1991), p. 22.

16. Diana Fane, "The Southwest," in *Objects of Memory and Myth*, ed. Fane, pp. 45–158, p. 60.

17. All quotes in this paragraph are in "Report to the Zuni Tribal Council on Thirteen War Gods and Associated Shrine Offerings in the Collection of the Brooklyn Museum," T. J. Ferguson, October 8, 1990, pp. 34–35, Box 36, WML.

18. Fane, "The Southwest," p. 60.

19. Culin, "Report on the Department of Ethnology," p. 22.

20. Ibid.

21. "Report to the Zuni Tribal Council on Thirteen War Gods and Associated Shrine Offerings in the Collection of the Brooklyn Museum," T. J. Ferguson, October 8, 1990, pp. 11, 47, Box 36, WML.

22. Ibid., p. 38. See also "The War Gods at TBM," Diana Fane, October 18, 1990, Box 37, WML.

CHAPTER TWO

1. Jane H. Hill, "The Zuni Language in Southwestern Areal Context," in *Zuni Origins: Toward a New Synthesis of Southwestern Archaeology*, ed. David A. Gregory and David R. Wilcox, pp. 22–38 (Tucson: University of Arizona Press, 2007).

2. Roberto Suro, "Zunis' Effort to Regain Idols May Alter Views of Indian Art," *New York Times*, August 13, 1990.

3. This version parallels Frank Hamilton Cushing, *Zuñi Folk Tales* (New York: G. P. Putnam's Sons, 1901), p. 368. A number of additional publications have outlined the creation and role of the War Gods, including T. J. Ferguson et al., "Repatriation at the Pueblo of Zuni: Diverse Solutions to Complex Problems," in *Repatriation Reader: Who Owns American Indian Remains?*, ed. Devon A. Mihesuah, pp. 239–65 (Lincoln: University of Nebraska Press, 2000), pp. 239–40; Edmund J. Ladd, *The Zuni* (Austin, TX: Raintree Steck-Vaughn, 1999); Triloki Nath Pandey, "Zuni Oral Tradition and History," in *Zuni and the Courts*, ed. E. Richard Hart, pp. 15–20 (Lawrence: University Press of Kansas, 1995), p. 16; Richard E. Hart, ed., *Zuni and the Courts: A Struggle for Sovereign Land Rights* (Lawrence: University Press of Kansas, 1995), p. 267; William L. Merrill et al., "The Return of the Ahayu:da: Lessons for Repatriation from Zuni Pueblo and the Smithsonian Institution," *Current Anthropology* 34, no. 5 (1993): 523–67, pp. 524–25. On the origins and ceremonials of the Bow Priests, see Ruth L. Bunzel, "Introduction to Zuñi Ceremonialism," in *Forty-Seventh Annual Report of the Bureau of American Ethnology for the Years 1929–1930*, pp. 467–1086 (Washington, DC: Smithsonian Institution, 1932), pp. 525–27; and Matilda Coxe Stevenson, "The Zuñi Indians: Their Mythology, Esoteric Fraternities, and Ceremonies," in *Twenty-Third Annual Report of the Bureau of American Ethnology for the Years 1901–1902*, pp. 3–608 (Washington, DC: Government Printing Office, 1904), pp. 49–51, 320–22, 330, 597–606.

4. T. J. Ferguson and Wilfred Eriacho, "Ahayu:da: Zuni War Gods," *Native Peoples* 4, no. 1 (1990): 6–12, p. 7.

5. Chip Colwell, "The Sacred and the Museum: Repatriation and the Trajectories of Inalienable Possessions," *Museum Worlds* 2, no. 1 (2014): 10–24; Neil G. W. Curtis, "Universal Museums, Museum Objects and Repatriation: The Tangled Stories of Things," *Museum Management and Curatorship* 21, no. 2 (2006): 117–27.

6. Several key sources talk about this period and the estimated number of artifacts to have left Zuni. Curtis M. Hinsley, "Collecting Cultures and Cultures of Collecting: The Lure of the American Southwest, 1880–1915," *Museum Anthropology* 16, no. 1 (1992): 12–20; Parezo, "Cushing as Part of the Team"; and Nancy J. Parezo, "The Formation of Ethnographic Collections: The Smithsonian Institution in the American Southwest," *Advances in Archaeological Method and Theory* 10 (1987): 1–47.

7. David L. Browman and Stephen Williams, *Anthropology at Harvard: A Biographical History, 1790–1940* (Cambridge, MA: Peabody Museum Press, 2013), p. 201.

8. Almazan Tristan Almazan and Sarah Coleman, "George Amos Dorsey: A Curator and His Comrades," in *Curators, Collections, and Contexts: Anthropology at*

the Field Museum, 1893–2002, Fieldiana New Series No. 36, Publication No. 1525, ed. Stephen E. Nash and Gary M. Feinman, pp. 87–97 (Chicago: Field Museum of Natural History, 2003), p. 89. On Dorsey's relationship with Culin, see Don D. Fowler, *A Laboratory for Anthropology: Science and Romanticism in the American Southwest, 1846–1930* (Albuquerque: University of New Mexico Press, 2000), p. 228.

9. Bunzel, "Introduction to Zuñi Ceremonialism," pp. 479, 491, 494; Stevenson, "The Zuñi Indians," pp. 154–55.

10. Miller, *Matilda Coxe Stevenson.*

11. "Report to the Zuni Tribal Council on Thirteen War Gods and Associated Shrine Offerings in the Collection of the Brooklyn Museum," T. J. Ferguson, October 8, 1990, p. 35, Box 36, WML.

12. Miller, *Matilda Coxe Stevenson*, p. 129.

13. This and next quote are from photocopies of the notes, see Box 36, WML.

14. Stevenson, "The Zuñi Indians," p. 204. See Pandey, "Anthropologists at Zuni," pp. 327–28.

15. Merrill et al., "The Return of the Ahayu:da," p. 523.

16. Bunzel, "Introduction to Zuñi Ceremonialism," p. 525. For the folkloric tales of the War Gods, see Cushing, *Zuñi Folk Tales*, pp. 175–84, 365–84.

17. "The War Gods at TBM," Diana Fane, October 18, 1990, Box 37, WML.

18. Merrill et al., "The Return of the Ahayu:da," p. 540.

19. "Famous Ethnologist Dead," *Washington Post*, April 11, 1900. On Zuni beliefs about Cushing's death, see "Zuni Encounters with Anthropologists," http://southwestcrossroads.org/record.php?num=3 (accessed July 27, 2013).

CHAPTER THREE

1. Interview of Mary W. A. Crane by Rebecca M. Spanger, August 16, 1979, DMNS.

2. Arthur Frederick Jones, "Basquaerie Raises a Mighty Dog: Mr. and Mrs. Francis V. Crane Spread the Name and the Fame of the Great Pyrenees," *American Kennel Gazette* 51, no. 8 (1934).

3. Interview of Mary W. A. Crane by Rebecca M. Spanger, August 16, 1979, DMNS.

4. Joyce Herold, "Grand Amateur Collecting in the Mid-Twentieth Century: The Mary W. A. and Francis V. Crane American Indian Collection," in *Collecting Native America, 1870–1960*, ed. Shepard Krech III and Barbara A. Hail, pp. 259–91 (Washington, DC: Smithsonian Institution Press, 1999), pp. 265–70.

5. Werner Muensterberger, *Collecting: An Unruly Passion* (Princeton, NJ: Princeton University Press, 1994).

6. Susan M. Pearce, *On Collecting: An Investigation into Collecting in the European Tradition* (London: Routledge Press, 1995).

7. Marjorie Barrett, "Museum Unveils Collection of Indian Handiwork," *Rocky Mountain News*, February 15, 1974.

8. DMNS has operated under different names during its 115-year history; in 1968 it was called the Denver Museum of Natural History. For consistency, it is referred to only as the Denver Museum of Nature & Science. Much of this history is from the interview of Mary W. A. Crane by Rebecca M. Spanger, August 16, 1979, DMNS. In addition to Mary Crane's interview, some of this history is also covered in DMNH Annual Report, 1968, p. 18; *Bear Pause* 11, no. 7 (1982), DMNS; Susan Marsh, "Denver Museum Acquires Rich Indian Collection," *New York Times*, August 3, 1969; Clarence Sallee, "American Indian Museum Being Moved to Colorado," *Miami Herald*, August 9, 1968; and "Denver Museum Given Rare Indian Artifacts," *Denver Post*, June 30, 1968.

9. Herold, "Grand Amateur Collecting in the Mid-Twentieth Century," p. 260.

10. Ibid., p. 275, emphasis in original.

11. For the best description of the museum, see ibid., pp. 282–86.

12. Interview of Mary W. A. Crane by Rebecca M. Spanger, August 16, 1979, DMNS.

13. M. Barrett, "A Topnotch Tourist Attraction," *Rocky Mountain News*, May 30, 1971.

14. Marsh, "Denver Museum Acquires Rich Indian Collection."

15. Woodard's Indian Trading Post, Collector and Vendor Files, DMNS.

16. Mr. and Mrs. Albert Miller, Box 11, Folder 44, Collector and Vendor Files, DMNS.

17. Taos Book Shop, Box 11, Folder 44, Collector and Vendor Files, DMNS.

18. Letter from Claire Morrill to Mary Crane, November 2, 1968, Crane Correspondence Files, DMNS.

CHAPTER FOUR

1. N. Scott Momaday, *In the Presence of the Sun: Stories and Poems, 1961–1991* (Albuquerque: University of New Mexico Press, 2009), p. 77.

2. Norman Feder, *American Indian Art* (New York: Abrams, 1971). Several sources for the history that follows are available, such as Merrill et al., "The Return of the Ahayu:da"; Ferguson et al., "Repatriation at the Pueblo of Zuni"; Suro, "Zunis' Effort to Regain Idols May Alter Views of Indian Art."

3. Elizabeth C. Childs, "Museums and the American Indian: Legal Aspects of Repatriation," *Council for Museum Anthropology Newsletter* 4, no. 4 (1980): 4–27, p. 5.

4. Elsie Clews Parsons, "War God Shrines of Laguna and Zuni," *American Anthropologist* 20, no. 3 (1918): 381–405, pp. 393, 397.

5. Gail Levin, "American Art," in *"Primitivism" in 20th Century Art*, ed. William Rubin (New York: The Museum of Modern Art, 1984), p. 462; Francis Naumann, *Conversion to Modernism: The Early Work of Man Ray* (New Brunswick, NJ: Rutgers University Press, 2003), p. 102.

6. James Clifford, *The Predicament of Culture* (Cambridge, MA: Harvard University Press, 1988), p. 209; David Penney, "Native Art," in *American Indian Nations: Yesterday, Today, and Tomorrow*, ed. George Horse Capture et al., pp. 51–58 (Lanham, MD: AltaMira Press, 2007), p. 52.

7. Elizabeth Hutchinson, *The Indian Craze: Primitivism, Modernism, and Transculturation in American Art, 1890–1915* (Durham, NC: Duke University Press, 2009), p. 222.

8. Suro, "Zunis' Effort to Regain Idols May Alter Views of Indian Art."

9. Ferguson and Eriacho, "Ahayu:da," p. 8.

10. This early demand of the return of cultural property has been documented by John R. Welch, "The White Mountain Apache Tribe Heritage Program: Origins, Operations, and Challenges," in *Working Together: Native Americans and Archaeologists*, ed. Kurt E. Dongoske et al., pp. 67–83 (Washington, DC: Society for American Archaeology, 2000), p. 70.

11. Florence Hawley Ellis, "The Hopi: Their History and Use of Lands," in *Hopi Indians*, Garland American Indian Ethnohistory series, pp. 25–278 (New York: Garland, 1974), p. 217.

12. Edmund Carpenter, *Two Essays: Chief and Greed* (North Andover, MA: Persimmon Press, 2005), pp. 102–12; Cooper, *Spirited Encounters*, pp. 68–69; Clara Sue Kidwell, "Every Last Dishcloth: The Prodigious Collecting of George Gustav Heye," in *Collecting Native America, 1870–1960*, ed. Shepard Krech III and Barbara A. Hail, pp. 232–58 (Washington, DC: Smithsonian Institution Press, 1999); Ann McMullen, "Re-Inventing George Heye: Nationalizing the Museum of the American Indian and Its Collections," paper presented at the Contesting Knowledge: Museums and Indigenous Perspectives Symposium, Newberry Library, Chicago, 2007; Elizabeth Sackler et al., "The Power of Publicity," *News & Notes: American Indian Ritual Object Repatriation Foundation* 5, no. 1 (1998): 1, 3. See also "Indian Tribe's Hope to Regain Sacred Thunderbird Boosted," *Washington Post*, July 14, 1937; "Dusty Redskins May Not Get Thunderbird Back After All," *Washington Post*, July 29, 1937; "Indians' Talisman Returns to Tribe," *New York Times*, December 7, 1937; "The Sacred Bundle," *New York Times*, December 8, 1937; "Indian Chiefs Visit President at White House," *New York Times*, January 14, 1938; and "A Sacred Bundle Returned to Indians of North Dakota," *New York Times*, January 15, 1938.

13. Fine-Dare, *Grave Injustice*, p. 78; William N. Fenton, "Return of Eleven Wampum Belts to the Six Nations Iroquois Confederacy on Grand River, Can-

ada," *Ethnohistory* 36, no. 4 (1989): 392–410, pp. 398–401; Richard W. Hill Sr., "Regenerating Identity: Repatriation and the Indian Frame of Mind," in *Archaeology of the Iroquois: Selected Readings and Research Sources*, ed. Jordan E. Kerber, pp. 410–21 (Syracuse, NY: Syracuse University Press, 2007); Elisabeth Tooker, "A Note on the Return of Eleven Wampum Belts to the Six Nations Iroquois Confederacy on Grand River, Canada," *Ethnohistory* 45, no. 2 (1998): 219–36; Watkins, *Sacred Sites and Repatriation*, pp. 19–20. See also "Indians Disputing State on Wampum," *New York Times*, March 25, 1967; "Iroquois Are Seeking Return of Wampum Belts Held by State Museum," *New York Times*, April 17, 1970; and "Rockefeller Signs Bill Allowing Return of Wampum to Indians," *New York Times*, July 2, 1971.

14. Merrill et al., "The Return of the Ahayu:da," p. 547. See also Edmund J. Ladd, "An Explanation: Request for the Return of Zuni Sacred Objects Held in Museums and Private Collections," in *Explorations: Zuni and El Morro*, p. 32 (Santa Fe: Annual Bulletin of the School of American Research, 1983).

15. Ferguson et al., "Repatriation at the Pueblo of Zuni," p. 241.

16. Letter from Edison Laselute to Richard Conn, received January 26, 1978, DAM.

17. Letter from Otto Karl Back to Clark Field, November 25, 1953, DAM.

18. Ferguson and Eriacho, "Ahayu:da," p. 10.

19. See Memo "Implications to the Museum of the Zuni Tribe Requests," Tom Maytham, April 14, 1978, DAM.

20. Notes from Collections Committee, May 8, 1978, DAM.

21. Letter from Tom Maytham to the Trustees of the Denver Art Museum, July 7, 1978, DAM.

22. Anne S. Canfield, "Ahayu:da: Art or Icon?" *Native Arts* (July 1980): 1, 24–26, p. 24.

23. Letter to John L. Marion from Allen Kallestewa, Victor Niiha, Blair Amesoli, Sextra Cellicion, Alonzo Hustito, Juan Qualo, Mike Leekela, and Perry Tsadiasi, October 9, 1978, Box 36, WML.

24. "Calendar of Zuni War Gods Repatriation from 1978 to 1987, Using Correspondence, Notes, and Other Documents in the Files of T. J. Ferguson," February 11, 1990, Box 36, WML.

25. Merrill et al., "The Return of the Ahayu:da," p. 536. See also "Stolen Zuni Statue Recovered," *Denver Post*, December 25, 1978.

26. Harmer Johnson, "Auction Block," *American Indian Art* (Spring 1979): 28–29, p. 29.

27. Letter from John A. Tucker Jr. to Maggie Gover, December 11, 1978, Box 36, WML.

28. "Calendar of Zuni War Gods Repatriation from 1978 to 1987, Using Cor-

respondence, Notes, and Other Documents in the Files of T. J. Ferguson," February 11, 1990, Box 36, WML.

29. Ibid.

30. Merrill et al., "The Return of the Ahayu:da," p. 537.

31. "Calendar of Zuni War Gods Repatriation from 1978 to 1987, Using Correspondence, Notes, and Other Documents in the Files of T. J. Ferguson," February 11, 1990, Box 36, WML.

32. This meeting is described in, and quoted from, ibid.

33. Letter to DAM Board of Trustees from Victor Niiha, Juan Qualo, Blair Amesoli, Mike Leekela, Dexter Cellicion, and Perry Tsadiasi, December 28, 1978. Summarized in "Calendar of Zuni War Gods Repatriation from 1978 to 1987, Using Correspondence, Notes, and Other Documents in the Files of T. J. Ferguson," February 11, 1990, Box 36, WML.

34. "Visit of Zuni Group on January 10, 1979," Dick Conn, December 26, 1978, DAM.

35. "Zuni Request for Return of the War God," Tom Maytham, December 22, 1978, DAM.

36. For a description of this meeting see "Calendar of Zuni War Gods Repatriation from 1978 to 1987, Using Correspondence, Notes, and Other Documents in the Files of T. J. Ferguson," February 11, 1990, Box 36, WML.

37. "Zuni War God," Dick Conn, January 3, 1979, DAM.

38. Minutes of Meeting of the Board of Trustees of the Denver Art Museum, January 10, 1979, DAM.

39. Quotes in this paragraph from Irene Clurman, "Zuni War God Spurs Clash," *Rocky Mountain News*, February 14, 1979.

40. Childs, "Museums and the American Indian," p. 14.

41. Ibid., p. 4.

42. "Calendar of Zuni War Gods Repatriation from 1978 to 1987, Using Correspondence, Notes, and Other Documents in the Files of T. J. Ferguson," February 11, 1990, Box 36, WML.

43. Letter from Sherman E. Lee to Thomas N. Maytham, February 20, 1979, DAM.

44. Letter from E. Donald Kaye to Thomas Maytham, February 15, 1979, DAM.

45. Letter from Richard Conn to Tony Hillerman, September 26, 1989, DAM.

46. Letter from Priscilla Giddings Buffalohead to Thomas Maytham, February 17, 1979, DAM.

47. R. Gibson Jr., "Give It Back," *Colorado Daily*, February 26, 1979.

48. "Zuni War God Belongs to Zunis," *Colorado Daily*, February 22, 1979.

49. "Editorial: The Zuni God," *Rocky Mountain News*, February 15, 1979.

50. Merrill et al., "The Return of the Ahayu:da," p. 537.

51. This phone call exchange is documented in "Calendar of Zuni War Gods Repatriation from 1978 to 1987, Using Correspondence, Notes, and Other Documents in the Files of T. J. Ferguson," February 11, 1990, Box 36, WML.

52. Kyle MacMillan, "Mayer's Vision, Charity Helped DAM Flourish," *Denver Post*, March 4, 2007.

53. Letter from Helen Arndt to Thomas Maytham, February 16, 1979, DAM.

54. "Calendar of Zuni War Gods Repatriation from 1978 to 1987, Using Correspondence, Notes, and Other Documents in the Files of T. J. Ferguson," February 11, 1990, Box 36, WML.

55. Minutes of Meeting of the Board of Trustees of the Denver Art Museum, March 21, 1979, DAM.

56. "Denver Art Museum News Release," dated March 30, 1979, Material Resource Files, DMNS. See also "The Art Museum Gives In," *Straight Creek Journal*, April 5, 1979.

57. "Calendar of Zuni War Gods Repatriation from 1978 to 1987, Using Correspondence, Notes, and Other Documents in the Files of T. J. Ferguson," February 11, 1990, Box 36, WML.

58. Letter from LaDonna Harris to the Denver Museum, October 11, 1979, DAM.

59. Letter from Joyce Herold to W. H. Van Duzer, July 12, 1978, IA. Anthropology, Box 11, FF 19, 1978, DMNS.

60. All quotes in this passage are from the interview of Mary W. A. Crane by Rebecca M. Spanger, August 16, 1979, DMNS.

CHAPTER FIVE

1. Fergus M. Bordewich, *Killing the White Man's Indian: Reinventing Native Americans at the End of the Twentieth Century* (New York: Anchor, 1997), p. 190.

2. Merrill et al., "The Return of the Ahayu:da," p. 532.

3. David Firestone, "Rescue in Manhattan: A Zuni God Goes Home," *New York Newsday*, May 27, 1988.

4. Ferguson et al., "Repatriation at the Pueblo of Zuni," pp. 245–46.

5. Ibid., p. 243.

6. Merrill et al., "The Return of the Ahayu:da," p. 544.

7. Canfield, "Ahayu:da," p. 24.

8. Suro, "Zunis' Effort to Regain Idols May Alter Views of Indian Art."

9. This biographical sketch comes from the interview transcript of Joyce Herold, interviewed by Malcolm Stevenson, August 2008, DMNS.

10. Joyce Herold, "Comment," *Current Anthropology* 34, no. 5 (1993): 559–60, p. 559.

11. "Museum Returns Carvings to Zunis," *Indian Trader*, April 1991; "Six Zuni War Gods Go from Museum to Tribe," *Denver Post*, March 24, 1991; "Zunis Recover Six War Gods," *Albuquerque Journal*, March 21, 1991.

12. Ferguson et al., "Repatriation at the Pueblo of Zuni," p. 249.

13. Herold, "Comment," p. 560.

14. Merrill et al., "The Return of the Ahayu:da," p. 547.

15. Firestone, "Rescue in Manhattan."

16. Ferguson et al., "Repatriation at the Pueblo of Zuni," p. 252.

17. Ibid., p. 254.

18. Ibid. See also Bordewich, *Killing the White Man's Indian*, p. 190; Ferguson and Eriacho, "Ahayu:da," p. 11; Sarah Harding, "Culture, Commodification, and Native American Cultural Patrimony," in *Rethinking Commodification: Cases and Readings in Law and Culture*, ed. Martha M. Ertmann and Joan C. Williams, pp. 137–55 (New York: New York University Press, 2005), p. 150; and Merrill et al., "The Return of the Ahayu:da," p. 547.

19. Ron Wolf, "Zunis Seek Return of War God from Museum," *Straight Creek Journal*, February 15, 1979.

20. Canfield, "Ahayu:da," p. 26.

21. Elaine Heumann Gurian, *Civilizing the Museum: The Collected Writings of Elaine Heumann Gurian* (London: Routledge, 2006), p. 45.

22. Michael Haederle, "War Gods Finally at Peace," *Los Angeles Times*, August 12, 1991.

23. Ferguson et al., "Repatriation at the Pueblo of Zuni," p. 262.

24. Letter from Frederick J. Dockstader to Robert E. Lewis, received June 25, 1990, Box 37, WML.

25. David Colker, "Southwest Museum Reports More Losses," *Los Angeles Times*, January 6, 1990; David Colker, "Ex-Director Convicted of Stealing Items from Museum," *Los Angeles Times*, March 11, 1993; David Colker, "Ex-Museum Head Gets Jail, to Pay Restitution in Thefts," *Los Angeles Times*, May 22, 1993.

26. Merrill et al., "The Return of the Ahayu:da," p. 549.

27. John Robbins, "Notice of Intent to Repatriate," *Federal Register* 66, no. 115 (2001): 32373–74.

CHAPTER SIX

1. Thomas LeRoy Larson, "The Zuni War God: Ahayu:da" (master's thesis, University of California, 1989), p. 52.

2. The museum representatives in Europe did not want their names to be used.

3. Ferguson et al., "Repatriation at the Pueblo of Zuni," p. 242; personal communication, Nancy Bruegeman, April 3, 2014.

4. Steve Chawkins, "Native American Skulls Repatriated to California from

England," *Los Angeles Times*, May 20, 2012; Neil G. W. Curtis, "Repatriation from Scottish Museums: Learning from NAGPRA," *Museum Anthropology* 33, no. 2 (2010): 234–48; Stacey R. Jessiman, "The Repatriation of the G'psgolox Totem Pole: A Study of Its Context, Process and Outcome," *International Journal of Cultural Property* 18, no. 3 (2011): 365–91; Neillian MacLachlan, "Sacred and Secular: An Analysis of the Repatriation of Native American Sacred Items from European Museums" (master's thesis, University of Aberdeen, 2010).

5. On the history of the Ethnologisches Museum in Berlin, see Viola König, "Zeitgeist and Early Ethnographic Collecting in Berlin," *RES: Anthropology and Aesthetics* 52 (Fall 2007): 51–58.

6. Andrew Zimmerman, *Anthropology and Antihumanism in Imperial Germany* (Chicago: University of Chicago Press, 2001), p. 153.

7. Chamberlin, *Loot!*; Greenfield, *The Return of Cultural Treasures*; Merryman, *Thinking about the Elgin Marbles*.

8. Lynn H. Nicholas, *The Rape of Europa: The Fate of Europe's Treasures in the Third Reich and the Second World War* (New York: Vintage Books, 1994); Elizabeth Simpson, ed., *The Spoils of War: World War II and Its Aftermath* (New York: Harry N. Abrams, 1997).

9. Rachel Donadio, "Zuni Petition European Museums to Return Sacred Objects," *New York Times*, April 8, 2014.

10. "The British Museum Policy: De-accession of Objects from the Collection," Section 3.5.

11. Tom Mashberg, "Paris Judge Orders Hearing on Auction Sale of Hopi Artifacts," *New York Times*, April 9, 2013. See also Rebecca Tsosie, "NAGPRA and the Problem of 'Culturally Unidentifiable' Remains: The Argument for a Human Rights Framework," *Arizona State Law Journal* 44 (2012): 809–904, p. 811.

12. Tom Mashberg, "Auction of Hopi Masks Proceeds after Judge's Ruling," *New York Times*, April 12, 2013.

13. Letter from Pieter Hovens to the Zuni Tribal Council, November 6, 1991, WML.

CHAPTER SEVEN

1. In addition to the citations below, the history of the massacre is drawn from Donald J. Berthrong, *The Southern Cheyenne* (Norman: University of Oklahoma Press, 1963), pp. 195–223; Jeff Broome, "The 1864 Hungate Family," *Wild West* 19, no. 1 (2006): 48–63; Jerome A. Greene and Douglas D. Scott, *Finding Sand Creek: History, Archaeology, and the 1864 Massacre Site* (Norman: University of Oklahoma Press, 2013); George Bird Grinnell, *The Fighting Cheyennes* (Norman: University of Oklahoma Press, 1956), pp. 165–80; Thom Hatch, *Black Kettle: The Cheyenne Chief Who Sought Peace but Found War* (Hoboken, NJ: Wiley, 2004); Stan Hoig,

The Sand Creek Massacre (Norman: University of Oklahoma Press, 1974); John H. Moore, *The Cheyenne* (Cambridge, MA: Blackwell, 1996), p. 98; Helmer R. Rurkey, "The Site of the Murder of the Hungate Family by Indians in 1864," *Colorado Magazine* 12, no. 4 (1935): 139–42; and Duane Schultz, *Month of the Freezing Moon: The Sand Creek Massacre, November 1864* (New York: St. Martin's Press, 1990).

2. Robert Claiborne Pitzer, *Three Frontiers: Memories, and a Portrait of Henry Littleton Pitzer, as Recorded by His Son Robert Clairborne Pitzer* (Muscatine, IA: Prairie Press, 1938), p. 163.

3. Deborah Frazier, "The Echoes of Sand Creek Indian Massacre," *Rocky Mountain News*, December 3, 1995.

4. Bruce Cutler, *The Massacre at Sand Creek: Narrative Voices* (Norman: University of Oklahoma Press, 1995), p. 26.

5. David E. Stannard, *American Holocaust: The Conquest of the New World* (Oxford: Oxford University Press, 1992), p. 132.

6. Robert L. Perkin, *The First Hundred Years: An Informal History of Denver and the Rocky Mountain News* (Garden City, NY: Doubleday, 1959), p. 264.

7. Dee Brown, *Bury My Heart at Wounded Knee: An Indian History of the American West* (New York: Bantam, 1970), p. 79.

8. Frazier, "The Echoes of Sand Creek Indian Massacre."

9. Story and quotes in J. W. Forney, *Report of the Joint Committee on the Conduct of the War, at the Second Session Thirty-Eighth Congress* (Washington, DC: Government Printing Office, 1865), p. 27.

10. "Scenes at Sand Creek," *Rocky Mountain News*, January 26, 1881.

11. Perkin, *The First Hundred Years*, p. 276.

CHAPTER EIGHT

1. Paul C. Rosier, *Native American Issues* (Westport, CT: Greenwood Press, 2003), p. 105.

2. Daniel G. Brinton, "The Aims of Anthropology," *Science* 19, no. 12 (1895): 241–52, p. 244.

3. On Melcher's biography see Andrew R. Dodge and Betty K. Koed, *Biographical Dictionary of the United States Congress, 1774–2005* (Washington, DC: Government Printing Office, 2005), p. 1571.

4. This story is based on McKeown, *In the Smaller Scope of Conscience*; and Preston, "Skeletons in Our Museums' Closets."

5. Burkhard Bilger, "Bringing Back the Bones," *Oklahoma Today* (May–June 1993): 39–47, p. 39.

6. "The Forgotten Indians," *Atlanta Journal*, November 16, 1986.

7. Iveing Molotsky and Warren Weaver Jr., "Of Bones," *New York Times*, October 25, 1986.

8. This legislative history is told in abridgment by T. Boyd, "Disputes Regarding the Possession of Native American Religious and Cultural Objects and Human Remains: A Discussion of the Applicable Law and Proposed Legislation," *Missouri Law Review* 55 (1990): 883–936; and Jack F. Trope and Walter R. Echo-Hawk, "The Native American Graves Protection and Repatriation Act: Background and Legislative History," in *Repatriation Reader: Who Owns American Indian Remains?*, ed. Devon A. Mihesuah, pp. 123–68 (Lincoln: University of Nebraska Press, 2000). It is told in detail by McKeown, *In the Smaller Scope of Conscience.*

9. Roger Billotte, "American Indians Protest Anthro. Studies," *Rocky Mountain Collegian*, September 28, 1971; Troy R. Johnson, *The Occupation of Alcatraz Island: Indian Self-Determination and the Rise of Indian Activism* (Urbana: University of Illinois Press, 1996), p. 233; Bert Simon, "Confusion Remains After Indian Invasion," *Rocky Mountain Collegian*, September 29, 1971; Bert Simon, "Challenges Issued and Bones Returned at Thurs. Meeting," *CSU Collegian*, October 1, 1971; "Indian Group Think They Have Grave Robbing Case Against CSU," *Greeley Daily Tribune*, September 28, 1971.

10. Vine Deloria Jr., *God Is Red: A Native View of Religion* (Golden, CO: Fulcrum, 2003), p. 10.

11. Vernon Bellecourt, "American Indian Movement (AIM) Explains Stand," *Denver Post*, November 28, 1972.

12. Johnson, *The Occupation of Alcatraz Island*, p. 230.

13. On the arguments in this paragraph, see, for example, Bowen Blair, "Indian Rights: Native Americans Versus American Museums: A Battle for Artifacts," *American Indian Law Review* 7, no. 1 (1979): 125–54; Vine Deloria Jr., "A Simple Question of Humanity: The Moral Dimensions of the Reburial Issue," *NARF Legal Review* 14, no. 4 (1989): 1–12; Walter Echo-Hawk, "Museum Rights vs. Indian Rights: Guidelines for Assessing Competing Legal Interests in Native Cultural Resources," *NYU Review of Law and Social Change* 14 (1986): 437–53; Devon A. Mihesuah, "American Indians, Anthropologists, Pothunters, and Repatriation: Ethical, Religious, and Political Differences," *American Indian Quarterly* 20, no. 2 (1996): 229–37; Polly Quick, ed., *Proceedings: Conference on Reburial Issues* (Washington, DC: Society for American Archaeology, 1985); John E. Peterson II, "Dance of the Dead: A Legal Tango for Control of Native American Skeletal Remains," *American Indian Law Review* 15, no. 1 (1990/1991): 115–50; Amalia Rosenblum, "Prisoners of Conscience: Public Policy and Contemporary Repatriation Discourse," *Museum Anthropology* 20, no. 3 (1996): 58–71; and Nathalie F. S. Woodbury, "When My Grandmother Is Your Database: Reactions to Repatriation," *Anthropology Newsletter* 33, no. 3 (1992): 6.

14. Deloria, *God Is Red*, p. 10; Jerome L. Thompson, "We Do Not Own or Control History, We Are Merely Its Stewards—The Saga of the West Des Moines Burials," *Journal of the Iowa Archaeological Society* 52, no. 1 (2005): 55–59, p. 57.

15. Frances Kruger et al., "Exhibits: An Evolution," *Denver Museum of Nature & Science Annals* 4 (2013): 65–103, p. 82.

16. "Denver Museum Collections and American Indians," from Jane Day to John Welles, January 30, 1990, 501-11-13-96.3, Repatriation, Native American Artifacts, DMNS.

17. Quotes in this paragraph from interview of Skip Neal by Veronica Dolan on May 20, 1974, Arminta P. Neal, Subject Files 1974, N–Z, Neal.7, DMNS.

18. Arthur C. Aufderheide, *The Scientific Study of Mummies* (Cambridge: University of Cambridge Press, 2004), p. 299.

19. Red Fenwick, "Volatile Element Added to 'Indian Problem,'" *Denver Post*, March 18, 1973.

20. Interview of Skip Neal by Veronica Dolan on May 20, 1974, Arminta P. Neal, Subject Files 1974, N–Z, Neal.7, DMNS.

21. JoAllyn Archambault, "Native Communities, Museums and Collaboration," *Practicing Anthropology* 33, no. 2 (2011): 16–20. On the council, see also Barbara Haddad Ryan, "Unique Project Stresses Indian Insights," *Rocky Mountain News,* November 24, 1978; Michael Taylor, ed., *Moccasins on Pavement: The Urban Indian Experience: A Denver Portrait* (Denver: Denver Museum of Natural History, 1978); *Bear Pause* 6, no. 14 (1978), DMNS; and DMNH Annual Report, 1978, DMNS.

22. Letter from Henry W. Toll Jr. to Robert L. Akerley, September 27, 1972, Accession Files, DMNS.

23. Jane E. Buikstra, "A Specialist in Ancient Cemetery Studies Looks at the Reburial Issue," *Early Man* 3 (1981): 26–27; Jane E. Buikstra, "Reburial: How We All Lose—An Archaeologist's Opinion," *Museum Anthropology* 7, no. 2 (1983): 2–5; Clement W. Meighan, "Archaeology: Science or Sacrilege," in *Ethics and Values in Archaeology*, ed. Ernestene L. Green, pp. 208–23 (New York: Free Press, 1984); Clement W. Meighan, "Archaeology and Anthropological Ethics," *Anthropology News* 26, no. 9 (1985): 20; Clement W. Meighan, "Burying American Archaeology," in *Archaeological Ethics*, 2nd ed., ed. Karen D. Vitelli and Chip Colwell-Chanthaphonh, pp. 167–70 (Lanham, MD: AltaMira, 2006); D. J. Mulvaney, "Past Regained, Future Lost: The Kow Swamp Pleistocene Burials," *Antiquity* 65 (1991): 12–21; Thomas P. Myers, "In Defense of Principles: Indian Skeletal Remains in Museums," *Museum Anthropology* 8, no. 4 (1984): 5–6; Frank A. Norwick, "The Reburial Controversy in California," *Museum Anthropology* 6, no. 3 (1982): 2–6; Douglas W. Owsley, "Human Bones from Archaeological Context: An Important Source of Information," *Council for Museum Anthropology Newsletter,* April 1984, pp. 2–8; Christy G. Turner, "What Is Lost with Skeletal Reburial," *Quarterly Review of Archaeology* 7, no. 1 (1986): 1–3; Douglas Ubelaker and Lauryn Guttenplan Grant, "Human Skeletal Remains: Preservation or Reburial?" *Yearbook of Physical Anthropology* 32 (1989): 249–87; Elizabeth Weiss, *Reburying the Past:*

The Effects of Repatriation and Reburial on Scientific Inquiry (New York: Nova Science Publishers, 2008).

24. Michelle Hibbert, "Galileos or Grave Robbers? Science, the Native American Graves Protection Repatriation Act, and the First Amendment," *American Indian Law Review* 23, no. 2 (1999): 425–58.

25. E. J. Neiburger, "Profiting from Reburial," *Nature* 344 (1990): 297, p. 297.

26. Sara Lowen, "Indians and Smithsonian Clash Over Fate of Remains," *Orange County Register*, June 5, 1988.

27. Rogers Worthington, "Where Archaeologists See Discovery, Indians See Only Lost Souls," *Chicago Tribune*, July 24, 1988.

28. Duane C. Anderson et al., "The Lewis Central School Site (13PW5): A Resolution of Ideological Conflicts at an Archaic Ossuary in Western Iowa," *Plains Anthropologist* 23 (1978): 183–219; Duane Anderson, "Reburial: Is It Reasonable?" *Archaeology* 38, no. 5 (1985): 48–51; Roger Anyon, "Protecting the Past, Protecting the Present: Cultural Resources and American Indians," in *Protecting the Past*, ed. George S. Smith and John E. Ehrenhard, pp. 215–22 (Boca Raton, FL: CRC Press, 1991); Kurt E. Dongoske, "The Native American Graves Protection and Repatriation Act: A New Beginning, Not the End, for Osteological Analysis—A Hopi Perspective," *American Indian Quarterly* 20, no. 2 (1996): 287–96; T. J. Ferguson, "Application of New Mexico State Dead Body and Indigent Burial Statues to a Prehistoric Mummified Body," in *American Indian Concerns with Historic Preservation in New Mexico*, ed. Barbara Holmes, pp. 45–51 (Albuquerque: New Mexico Archaeological Council, 1982); T. J. Ferguson, "Archaeological Values in a Tribal Cultural Resource Management Program at the Pueblo of Zuni," in *Ethics and Values in Archaeology*, ed. Ernestene L. Green, pp. 224–35 (New York: Free Press, 1984); Robert F. Heizer, "A Question of Ethics in Archaeology: One Archaeologist's View," *Journal of California Anthropology* 1, no. 2 (1974): 145–51; Elden Johnson, "Professional Responsibilities and the American Indian," *American Antiquity* 38, no. 2 (1973): 129–30; Anthony L. Klesert and Alan S. Downer, eds., *Preservation on the Reservation: Native Americans, Native American Lands, and Archaeology*, Navajo Nation Papers in Anthropology Number 26 (Window Rock, AZ: Navajo Nation Archaeology Department and Navajo Nation Historic Preservation Department, 1990); Anthony L. Klesert and Michael J. Andrews, "The Treatment of Human Remains on Navajo Lands," *American Antiquity* 53, no. 2 (1988): 310–20; Randall H. McGuire, "The Sanctity of the Grave: White Concepts and American Indian Burials," in *Conflict in the Archaeology of Living Traditions*, ed. Robert Layton, pp. 167–84 (London: Routledge, 1989); Gene A. Marsh, "Walking the Spirit Trail: Repatriation and Protection of Native American Remains and Sacred Cultural Items," *Arizona State Law Journal* 24, no. 1 (1992): 79–133; Michael Tymchuk, "Skeletal Remains: In Defense of Sensitivity

and Compromise," *Council for Museum Anthropology Newsletter* 8, no. 3 (1984): 2–8; Joseph C. Winter, "Indian Heritage Preservation and Archaeologists," *American Antiquity* 45, no. 1 (1980): 121–31; Larry J. Zimmerman and Robert Alex, "Digging Ancient Burials: The Crow Creek Experience," *Early Man* 3, no. 3 (1981): 3–10; Larry J. Zimmerman, " 'Tell Them about the Suicide': A Review of Recent Materials on the Reburial of Prehistoric Native American Skeletons," *American Indian Quarterly* 10 (1986): 333–43; Lawrence J. Zimmerman, "Made Radical by My Own," in *Conflict in the Archaeology of Living Traditions*, ed. Robert Layton, pp. 60–67 (London: Unwin Hyman, 1989).

29. Roderick Sprague, "American Indians and American Archaeology," *American Antiquity* 39, no. 1 (1974): 1.

30. Jane Gross, "Stanford Agrees to Return Ancient Bones to Indians," *New York Times*, June 23, 1989.

31. Kara Swisher, "Skeletons in the Closet," *Washington Post*, October 3, 1989.

32. Larry J. Zimmerman, "Webb on Reburial: A North American Perspective," *Antiquity* 61 (1987): 462, p. 462. See also Larry J. Zimmerman and John B. Gregg, "A History of the Reburial Issue in South Dakota," *South Dakota Archaeology* 13 (1989): 89–100; and Larry J. Zimmerman, "Archaeology, Reburial, and the Tactics of a Discipline's Self-Delusion," *American Indian Culture and Research Journal* 16, no. 2 (1992): 37–56.

33. Geoffrey A. Clark, "NAGPRA and the Demon-Haunted World," *SAA Bulletin* 14, no. 5 (1996): 3, p. 3.

34. Steven Shackley, "Relics, Rights, and Regulations," *Scientific American* March (1995): 115.

35. Gottlieb, "Battle of the Bones."

36. Phillip Walker, "Bioarchaeological Ethics: A Historical Perspective on the Value of Human Remains," in *Biological Anthropology of the Human Skeleton*, ed. M. Anne Katzenberg and Shelley R. Saunders, pp. 3–40 (New York: John Wiley & Sons, 2008), pp. 16–17.

37. Leslie Berger, "Case Tests Law on Study of Indian Graves," *Los Angeles Times*, November 14, 1990. See also "Grave-Robbing Case Dropped," *Santa Cruz Sentinel*, November 23, 1990.

38. The remainder of this chapter is based on McKeown, *In the Smaller Scope of Conscience*, pp. 71–72. A slightly different version appears in Robert W. Preucel, "An Archaeology of NAGPRA: Conversations with Suzan Shown Harjo," *Journal of Social Archaeology* 11, no. 2 (2011): 130–43.

39. Greenfield, *The Return of Cultural Treasures*, p. 179; Richard Hill Sr., "Reflections of a Native Repatriator," in *Mending the Circle: A Native American Repatriation Guide*, ed. Barbara Meister, pp. 81–96 (New York: American Indian Ritual Object Repatriation Foundation, 1996), p. 86; Robert H. McLaughlin, "The

American Archaeological Record: Authority to Dig, Power to Interpret," *International Journal of Cultural Property* 7, no. 2 (1998): 342–75, pp. 354, 372; John C. Ravesloot, "On the Treatment and Reburial of Human Remains: The San Xavier Bridge Project, Tucson, Arizona," *American Indian Quarterly* 14, no. 1 (1990): 35–50; José Ignacio Rivera, "The Reburial of Our Ancestors: A Moral, Ethical, and Constitutional Dilemma for California," *News from Native California* 3, no. 6 (1989): 12–13, p. 12. See also Rogers Worthington, "Where Archaeologists See Discovery, Indians See Only Lost Souls"; Jane Gross, "Stanford Agrees to Return Ancient Bones to Indians," *New York Times*, June 23, 1989; and Swisher, "Skeletons in the Closet."

40. Walter R. Echo-Hawk, "Tribal Efforts to Protect Against Mistreatment of Indian Dead: The Quest for Equal Protection of the Laws," *NARF Legal Review* 14, no. 1 (1989): 1–5.

41. Brian Fagan, "Black Day at Slack Farm," *Archaeology* 41, no. 4 (1988): 15–16, 73.

42. Robert M. Peregoy, "Nebraska's Landmark Repatriation Law: A Study of Cross-Cultural Conflict and Resolution," *American Indian Culture and Research Journal* 16, no. 2 (1992): 139–95; Robert M. Peregoy, "Nebraska Lawmakers Enact Precedent-Setting Indian Burial Legislation," *NARF Legal Review* 14, no. 4 (1989): 15.

43. Felicity Barringer, "Major Accord Likely on Indian Remains," *New York Times*, August 20, 1989.

44. Peregoy, "Nebraska's Landmark Repatriation Law," p. 187.

45. For Harjo's biography, see Mary Englar, *The Cheyenne: Hunter-Gatherers of the Northern Plains* (Mankato, MN: Capstone Press, 2004), p. 43.

46. Preucel, "An Archaeology of NAGPRA," p. 132. See also Cooper, *Spirited Encounters*, p. 99.

47. Greene and Scott, *Finding Sand Creek*, p. 46.

48. William Grace, *The Army Surgeon's Manual: For the Use of Medical Officers, Cadets, Chaplains, and Hospital Stewards* (New York: Bailliere Brothers, 1864), p. 101.

49. Daniel Smith Lamb, *A History of the United States Army Medical Museum, 1862–1917* (Washington, DC: United States Army Medical Museum, 1917), p. 50.

50. Echo-Hawk and Echo-Hawk, *Battlefields and Burial Grounds*, p. 26. And see Lamb, *A History of the United States Army Medical Museum*, p. 148.

51. James Riding In, "Six Pawnee Crania: Historical and Contemporary Issues Associated with the Massacre and Decapitation of Pawnee Indians in 1869," *American Indian Culture and Research Journal* 16, no. 2 (1992): 101–19, p. 107.

52. Franklin Ellis, *History of Cattaraugus County, New York* (Philadelphia: L. H. Everts, 1879), p. 13; Benita Eisler, *The Red Man's Bones: George Catlin, Artist and Showman* (New York: W. W. Norton, 2013), p. 14.

53. Henry Rowe Schoolcraft, *Notes on the Iroquois; or, Contributions to the Statistics, Aboriginal History, Antiquities, and General Ethnology of Western New York* (New York: Batlett and Welford, 1846), p. 27.

54. Robert E. Bieder, "The Representations of Indian Bodies in Nineteenth-Century American Anthropology," in *Repatriation Reader: Who Owns American Indian Remains?*, ed. Devon A. Mihesuah, pp. 19–36 (Lincoln: University of Nebraska Press, 2000), p. 20. On this history, see also Robert E. Bieder, "The Collecting of Bones for Anthropological Narrative," *American Indian Culture and Research Journal* 16, no. 2 (1992): 21–36; Robert E. Bieder, "A Brief Historical Survey of the Expropriation of American Indian Remains," in *Readings in American Indian Law: Recalling the Rhythm of Survival*, ed. Jo Carrillo, pp. 164–71 (Philadelphia: Temple University Press, 1998); Andrew Gulliford, "Bones of Contention: The Repatriation of Native American Human Remains," *Public Historian* 18, no. 4 (1996): 119–43; Thomas, *Skull Wars*; and Gerald Vizenor, "Bone Courts: The Rights and Narrative Representation of Tribal Bones," *American Indian Quarterly* 10, no. 4 (1986): 319–31.

55. Georges Louis Leclerc, *Historie Naturelle: Générale et Particulière, Translated into English*, vol. 3 (Edinburgh: William Creech, 1780), p. 170; Thomas Jefferson, *Notes on the State of Virginia* (Piccadilly: John Stockdale, 1787), pp. 338–42. For an analysis of this debate, see Robert F. Berkhofer, *The White Man's Indian: Images of the American Indian from Columbus to the Present* (New York: Vintage, 1978), pp. 42–44; and Antonello Gerbi, *The Dispute of the New World: The History of a Polemic, 1750–1900* (Pittsburgh: University of Pittsburgh Press, 1973), p. 261.

56. Reginald Horsman, "Scientific Racism and the American Indian in the Mid-Nineteenth Century," *American Quarterly* 27, no. 2 (1975): 152–68; Samuel J. Redman, *Bone Rooms: From Scientific Racism to Human Prehistory in Museums* (Cambridge, MA: Harvard University Press, 2016).

57. Lamb, *A History of the United States Army Medical Museum*, p. 56.

58. Edward Lurie, *Louis Agassiz: A Life in Science* (Chicago: University of Chicago Press, 1960), p. 338.

59. On the remains collected for the Army Medical Museum, see Greene and Scott, *Finding Sand Creek*, p. 46; George A. Otis, *List of the Specimens in the Anatomical Section of the United States Army Medical Museum* (Washington, DC: Army Medical Museum, 1880), pp. 123, 125; and J. Stuart Speaker et al., *Arapaho Repatriation: Human Remains* (Repatriation Office, Smithsonian Institution, National Museum of Natural History, 1993), p. 21.

60. William T. Billeck and Jasmine High, *Reassessment of Human Remains from the Sand Creek Massacre Site Obtained by Lt. Bonsall and Assistant Surgeon Forwood in the Collections of the National Museum of Natural History, Smithsonian Institution* (Repatriation Office, Smithsonian Institution, National Museum of Natural History, 2012), p. 9.

CHAPTER NINE

1. Killion was first hired as a case officer, and then promoted to the manager position. This story comes from Thomas W. Killion, "A View from the Trenches: Memories of Repatriation at the National Museum of Natural History, Smithsonian Institution," in *Opening Archaeology: Repatriation's Impact on Contemporary Research and Practice*, ed. Thomas W. Killion, pp. 133–50 (Santa Fe: SAR Press, 2008), pp. 134–38.

2. Bray and Killion, *Reckoning with the Dead*.

3. Killion, "A View from the Trenches," p. 135. The story that follows about the initial consultations is from Thomas W. Killion et al., *Naevahoo'ohtseme: Cheyenne Repatriation: The Human Remains* (Repatriation Office, Smithsonian Institution, National Museum of Natural History, 1992).

4. Killion et al., *Naevahoo'ohtseme*, p. 2.

5. Killion, "A View from the Trenches," p. 136.

6. This story told here combines my interview with Yellowman, with Thomas Harney and Dan Agent, "Cheyenne Ancestors Interred in Concho, Okla.," *Smithsonian Runner*, September/October 1993; Connie Hart Yellowman, " 'Naevahoo'ohtseme'—We Are Going Back Home: The Cheyenne Repatriation of Human Remains—A Woman's Perspective," *St. Thomas Law Review* 9 (1996): 103–16. Of note, the phrase *Naevahoo'ohtseme* was first drawn from Wayne Leman, "Naevahoo'ohtseme/We Are Going Back Home, Cheyenne Histories and Stories Told by James Shoulderblade and Others," *Algonquin and Iroquoian Linguistics Memoir* 4, no. 17 (1987).

7. In addition to the published sources, the description of this repatriation comes from the video *The Long Journey Home*, c. 1990, HSF.

8. Ron Jackson, "Chief's Battle to Reclaim Past Continues," *Canku Ota: A Newsletter Celebrating Native America*, June 17, 2000.

9. Michael Haederle, "Burying the Past," *American Archaeology* (Fall 1997): 18.

10. "NAGPRA at 10," *Museum News*, September/October 2000.

CHAPTER TEN

1. "The Sand Creek Battle—'High Officials' Checkmated," *Rocky Mountain News*, January 4, 1865.

2. Unless otherwise cited, these pieces of testimony can be found in *The War of the Rebellion: A Compilation of the Official Records of the Union and Confederate Armies*, 4 series, 128 volumes (Washington, DC: Government Printing Office, 1880–1901).

3. Eric Gorski, "Sand Creek Massacre Descendants Seek Justice 148 Years Later," *Denver Post*, December 30, 2012.

4. See the testimony of Captain L. Wilson, 1st Colorado cavalry, in J. R. Doolittle, *Condition of the Indian Tribes: Report of the Joint Special Committee* (Washington, DC: Government Printing Office, 1867), p. 96.

5. See the testimony of Sergeant Lucien Palmer, 1st Colorado cavalry, in ibid., p. 74; and the testimony of Corporal Amos C. Miksch, 1st Colorado cavalry, in ibid., pp. 74–75.

6. "Local and Miscellaneous," *Rocky Mountain News*, December 13, 1864.

7. "The Battle of Sand Creek," *Rocky Mountain News*, December 17, 1864.

8. "Arrival of the Third Regiment," *Rocky Mountain News*, December 22, 1864.

9. Schultz, *Month of the Freezing Moon*, p. 146.

10. Helen Hunt Jackson, *A Century of Dishonor: A Sketch of the United States Government's Dealings with Some of the Indian Tribes* (New York: Harper and Brothers, 1881), p. 345.

11. "Local and Miscellaneous," *Rocky Mountain News*, December 28, 1864.

12. "Local and Miscellaneous," *Rocky Mountain News*, January 11, 1865. Foy is confirmed on Third Cavalry, Company F, roster in "Colorado Cavalry, Third Regiment Roster," www.kclonewolf.com/History/SandCreek/sc-documents /sc-colorado-third-regiment.html (accessed February 12, 2014).

13. Thomas J. Noel, "Rewriting the Past for the Present: Public Monuments and Political Correctness, the Colorado State Capitol and Sand Creek," in *Preserving Western History*, ed. Andrew Gulliford (Albuquerque: University of New Mexico Press, 2005), p. 192.

14. "Treaty with the Cheyenne and Arapaho, 1865," http://digital.library .okstate.edu/kappler/vol2/treaties/che0887.htm#mn4 (accessed February 26, 2014).

15. Forney, *Report of the Joint Committee on the Conduct of the War*, p. 26.

16. Moore, *The Cheyenne*, p. 124.

17. On some of these claims, which were contested at the time, see Doolittle, *Condition of the Indian Tribes*, pp. 74, 75; and Forney, *Report of the Joint Committee on the Conduct of the War*, pp. 26, 48. For historical analyses of them, see Ari Kelman, *A Misplaced Massacre: Struggling over the Memory of Sand Creek* (Cambridge, MA: Harvard University Press, 2013), pp. 10, 12, 15, 18; and Hoig, *The Sand Creek Massacre*, p. 166.

18. Perkin, *The First Hundred Years*, p. 274.

19. Kelman, *A Misplaced Massacre*, p. 37.

20. Francis P. McManamon, "Notice of Inventory Completion," *Federal Register* 63, no. 140 (1998): 39292–93. On Downing's life, see Jerome C. Smiley, *History of Denver* (Denver: Sun Publishing Company, 1901), p. 409.

21. "The Soldiers' Sand Creek Vindication Ticket," *Rocky Mountain News*, October 23, 1865.

22. This brief sketch of Jacobs comes from William B. Jacobs, Biographical Files, DMNS; see also "Colorado State Archives," www.colorado.gov/dpa/doit /archives/military/trans/j.htm (accessed May 21, 2014).

23. Cuneo's biographical information here is based on files at the DMNS,

which include his diary and interviews with descendants. Also see "George Cuneo Dies Here in 91st Year," *Rocky Mountain News*, February 10, 1939.

24. Letter from George J. Turee to F. H. Douglas, October 16, 1939, Crane Correspondence Files, DMNS.

25. Letter from Erich Kohlberg to Mr. and Mrs. Crane, July 7, 1956, Crane Correspondence Files, DMNS.

26. Letter from Erich Kohlberg to Mr. and Mrs. Crane, July 21, 1956, Crane Correspondence Files, DMNS.

27. Letter from Erich Kohlberg to Mr. Crane, August 4, 1956, Crane Correspondence Files, DMNS.

28. Letter from Francis Crane to Erich Kohlberg, September 4, 1956, Crane Correspondence Files, DMNS; see bill on October 24, 1956, Crane Correspondence Files, DMNS.

29. Frazier, "The Echoes of Sand Creek Indian Massacre." The version of this story published by Frazier differs in details from the version Joe Big Medicine told me. See also Larry McMurtry, *Oh What a Slaughter: Massacres in the American West, 1846–1890* (New York: Simon and Schuster, 2005), p. 92.

CHAPTER ELEVEN

1. Suzan Shown Harjo, "Last Rites for Indian Dead Treating Remains Like Artifacts Is Intolerable," *Los Angeles Times*, September 16, 1989.

2. Unless otherwise noted, this section and the next are based on McKeown, *In the Smaller Scope of Conscience*.

3. Ibid., p. 167.

4. Ibid., p. 82.

5. Ibid., p. 92.

6. Ibid.

7. Letter from Jon N. Halverson to John G. Welles, August 2, 1990, 501-06-01-93, Box 2, Repatriation, DMNS.

8. Signed statement, August 16, 1990, 501-06-01-93, Box 5, Repatriation-Old, DMNS.

9. Letter from Lewis I. Sharp and John G. Welles to Timothy E. Wirth, September 25, 1990, 141-03-23-95, Repatriation Bill S. 1980-HR. 5237, DMNS.

10. Chip Colwell-Chanthaphonh et al., "'A Museum Here Founded': A Summative History," *Denver Museum of Nature & Science Annals* 4 (2013): 11–64, p. 45.

11. Memo from John G. Welles on conversation with Jonathan Haas, July 19, 1990, 141-03-23-95, Repatriation Bill S. 1980, Law HR. 5237, DMNS.

12. Memo from Jonathan Haas to Aldona Jonaitis et al., July 27, 1990, 141-03-23-95, Repatriation Bill S. 1980, Law HR. 5237, DMNS.

13. Denver Museum Collections and American Indians, from Jane Day to John Welles, January 30, 1990, 501-11-13-96.3, Repatriation, Native American Artifacts, DMNS.

14. Statements on Human Remains and Sacred Objects, 501-11-13-96.3, Repatriation, Native American Artifacts, DMNS.

15. Denver Museum of Natural History Policy Statement Concerning Requests for Reinternment of Human Remains and Grave Objects and Requests for Return or Loan of Ceremonial Objects, July 25, 1990, 141-01-21-97.3, NAGPRA 1994, DMNS.

16. Letter from John G. Welles to Geoffrey Platt Jr., April 5, 1990, 501-11-13-96.3, Repatriation, Native American Artifacts, DMNS.

17. Denver Museum of Natural History repatriation policy statement meeting notes, June 28, 1990, 501-06-01-93, Box 2, Repatriation, DMNS.

18. Ibid.

19. McKeown, *In the Smaller Scope of Conscience*, p. 168.

20. Keith Kintigh, "Repatriation We Can Live With," *Bulletin of the Society for American Archaeology* 9, no. 1 (1991): 2–3.

21. McKeown, *In the Smaller Scope of Conscience*, p. 162.

22. Ibid., p. 163.

23. Letter to President George H. W. Bush from Eugene Sterud (American Anthropological Organization), William Stini (American Association of Physical Anthropologists), Martha Sharp Joukowsky (Archaeological Institute of America), Jack Trope (Association on American Indian Affairs), Walter Echo-Hawk and Henry Sockbeson (Native American Rights Fund), Eric Hertfelder (National Conference of State Historic Preservation Officers), Gay Kingman (National Congress of American Indians), J. Jackson Walter (National Trust for Historic Preservation), Nellie Longsworth (Preservation Action), Jeremy A. Sabloff (Society for American Archaeology), Roderick Sprague (Society for Historical Archaeology), and Mark Lynott (Society of Professional Archaeologists), November 2, 1990, Box 37, WML.

24. See Felicity Barringer, "Bush Weighs Bill on Tribal Remains," *New York Times*, November 4, 1990.

25. C. Timothy McKeown, "Implementing a 'True Compromise': The Native American Graves Protection and Repatriation Act after Ten Years," in *The Dead and Their Possessions: Repatriation in Principle, Policy, and Practice*, ed. Cressida Fforde et al., pp. 108–32 (New York: Routledge, 2002); C. Timothy McKeown and Sherry Hutt, "In the Smaller Scope of Conscience: The Native American Graves Protection and Repatriation Act Twelve Years After," *UCLA Journal of Environmental Law and Policy* 21 (2003): 153–212.

26. Sangita Chari, "Journeys to Repatriation: 15 Years of NAGPRA Grants,"

Museum Anthropology 33, no. 2 (2010): 210–17; Sherry Hutt, "Illegal Trafficking in Native American Human Remains and Cultural Items: A New Protection Tool," *Arizona State Law Journal* 24, no. 1 (1992): 135–50; Roberto Iraola, "A Primer on the Criminal Penalty Provisions of the Native American Graves Protection and Repatriation Act," *American Indian Law Review* 28, no. 2 (2004): 431–45.

27. C. Timothy McKeown, " 'A Willingness to Listen to Each Side': The Native American Graves Protection and Repatriation Review Committee," *Museum Anthropology* 33, no. 2 (2010): 218–33.

28. This description of first five years based on monthly and departmental annual reports in IA-147-05-07, DMNS.

29. See the form letter in the NAGPRA files, DMNS.

30. Mary Voelz Chandler, "Reclaiming the Past," *Rocky Mountain News*, May 29, 1994.

31. Barbara Isaac, "An Epimethean View of the Future at the Peabody Museum," *Federal Archaeology* 7, no. 3 (1995): 27–29, p. 28.

32. Barbara Isaac, "Implementation of NAGPRA: The Peabody Museum of Archaeology and Ethnology, Harvard," in *The Dead and Their Possessions: Repatriation in Principle, Policy, and Practice*, ed. Cressida Fforde et al., pp. 160–70 (New York: Routledge, 2002), p. 160.

33. See also Bruce Bernstein, "Repatriation and Collaboration: The Museum of New Mexico," *Museum Anthropology* 15, no. 3 (1991): 19–21; Michael J. Fox, "Repatriation: Mutual Benefits for Everyone," *Arizona State Law Journal* 24, no. 1 (1992): 7–9; Haederle, "Burying the Past"; and Dan L. Monroe, "Repatriation: A New Dawn," *Museums Journal* 93, no. 3 (1993): 29–31.

34. Department of Anthropology Annual Report, IA-147-05-07, DMNS.

35. Chandler, "Reclaiming the Past."

36. Cheyenne and Arapaho Repatriation File, Department of Anthropology, DMNS.

37. Bill Donovan, "Return of Artifacts Would Tax Navajo Resources," *Arizona Republic*, June 2, 1994.

38. Letter from Robert B. Pickering to Richard Conn, May 14, 1993, 141-03-23-95, DMNH, Repatriation 1993, DMNS.

39. This chronology and quotes are from the NAGPRA Files, DMNS.

40. Killion, "A View from the Trenches," 137. See also Kim Akerman, " 'You Keep It—We Are Christians Here': Repatriation of the Secret Sacred Where Indigenous World-Views Have Changed," in *The Long Way Home: The Meaning and Values of Repatriation*, ed. Paul Turnbull and Michael Pickering, pp. 175–82 (New York: Berghahn Books, 2010).

41. The details of this story come from my interview with Gordon Yellowman, as well as Mary Pierpont, "Cheyenne Warrior Can Finish Spiritual Journey," *Indian Country Today*, December 13, 2000; Mary Jane Warde, "Alternative

Perspectives on the Battle of Wolf Creek of 1838," *Indigenous Nations Studies Journal* 2, no. 2 (2001): 3–14; "Forensic Art," https://harveypratt.com/historic _reconstruction.php (accessed September 17, 2013). For other examples of how NAGPRA can encourage skeletal analysis before repatriation, see Robert L. Cast et al., "Claiming Respect for Ancestral Remains: Repatriation and the Caddo Nation of Oklahoma," *Anthropology News* 51, no. 3 (2010): 7–8; Dongoske, "The Native American Graves Protection and Repatriation Act"; Stephen D. Ousley et al., "Federal Repatriation Legislation and the Role of Physical Anthropology in Repatriation," *Yearbook of Physical Anthropology* 48 (2005): 2–32; and Laura Peers, "Repatriation: A Gain for Science?" *Anthropology Today* 20, no. 6 (2004): 3–4.

42. Pierpont, "Cheyenne Warrior Can Finish Spiritual Journey."

43. Peter J. Powell, *Sweet Medicine: The Continuing Role of the Sacred Arrows, the Sun Dance, and the Sacred Buffalo Hat in Northern Cheyenne History* (Norman: University of Oklahoma Press, 1969), p. xviii.

44. These numbers concerning allegations of non-compliance and civil penalties come from personal communication with Timothy McKeown, December 2013.

CHAPTER TWELVE

1. Stan Hoig, *The Cheyenne* (New York: Chelsea House, 2006), p. 100.

2. Rick Hill, "Repatriation Must Heal Old Wounds," in *Reckoning with the Dead: The Larsen Bay Repatriation and the Smithsonian Institute*, ed. Tamara L. Bray and Thomas W. Killion, pp. 184–86 (Washington, DC: Smithsonian Institute Press, 1994), p. 185.

3. Russell Thornton, "Repatriation as Healing the Wounds of the Trauma of History: Cases of Native Americans in the United States of America," in *The Dead and Their Possessions: Repatriation in Principle, Policy, and Practice*, ed. Cressida Fforde et al., pp. 17–24 (New York: Routledge, 2002), p. 21.

4. "Australian Government Policy on Indigenous Repatriation," http://arts .gov.au/sites/default/files/indigenous/repatriation/repatriation-policy.pdf (accessed February 26, 2014).

5. Frazier, "The Echoes of Sand Creek Indian Massacre."

6. Kelman, *A Misplaced Massacre*, p. 264.

7. Ibid., p. 65. See also "Sand Creek Landowner Battles Massacre Legacy," *Rocky Mountain News*, January 26, 1992.

8. See Jim Hughes, "Burials at Sand Creek," *Denver Post*, August 7, 2005; Kelman, *A Misplaced Massacre*, pp. 263–67; Bobbie Whitehead, "Northern Cheyenne Indian Nation Seeks Donations for Sand Creek Massacre Project," *Indian Country Today*, January 25, 2008; and "Repatriation Held at Sand Creek," *Cheyenne-Arapaho Tribal Tribune*, August 1, 2008.

9. Willow Belden, "Methodist Church to Apologize for Sand Creek Mas-

sacre," *Wyoming Public Media*, December 1, 2011; Doug Benton, "Modern Indians Find New Battlegrounds," *CSU Collegian*, October 11, 1971; Joey Bunch, "Song, Prayer at Sand Creek," *Denver Post*, November 29, 2002; Alan Dumas, "The Agony and the Infamy," *Rocky Mountain News*, October 12, 1997; Eric Gorski, "Sand Creek Massacre Descendants Seek Justice 148 Years Later," *Denver Post*, December 30, 2012; Frazier, "The Echoes of Sand Creek Indian Massacre"; Deborah Frazier, "138 Years After Sand Creek," *Rocky Mountain News*, November 30, 2002; Weston Gentry, "Run of Healing, Remembrance," *Denver Post*, November 27, 2011; Elizabeth Hernandez, "Gov. Hickenlooper Apologizes to Descendants of Sand Creek Massacre," *Denver Post*, December 3, 2014; Noel, "Rewriting the Past for the Present," 192–94; Heath Urie, "Longmont to Rename Street," *Denver Post*, December 29, 2004; Larry J. Zimmerman, "Plains Indians and Resistance to 'Public' Heritage Commemoration of Their Pasts," in *Cultural Heritage and Human Rights*, ed. Helaine Silverman and D. Fairchild Ruggles, pp. 144–58 (New York: Springer, 2007), p. 154; "Sand Creek Landowner Battles Massacre Legacy," *Rocky Mountain News*, January 26, 1992.

10. Carol Berry, "Sand Creek Decisions Create Hope," *Indian Country Today*, December 10, 2010. On repatriation and object care outside the legal requirements of NAGPRA, see Edward M. Luby and Melissa K. Nelson, "More than One Mask: The Context of NAGPRA for Museums and Tribes," *American Indian Culture and Research Journal* 32, no. 4 (2008): 85–105.

11. For example, "The Comancheria Collection," http://issuu.com/dreamedia /docs/catalog_148_comancheria/1 (accessed July 9, 2014).

12. 25 USC 3001.2(3)(A). On the Chief White Antelope blanket, see Duane Anderson, "The Chief White Antelope Blanket," *Tribal Art* 29 (2002): 110–11; Duane Anderson, "Collaborations with Native Peoples in the American Southwest and Midwest: 1967–2007," in *Sharing Knowledge and Cultural Heritage: First Nations of the Americas*, ed. Laura Van Broekhoven, et al., 91–104 (Leiden: Sidestone Press, 2010); and Casey Reed and Duane Anderson, "A Closer Look at the Chief White Antelope Blanket," *Tribal Art* 46 (2007): 112–25.

CHAPTER THIRTEEN

1. Rosita Worl, "Tlingit," in *Living Our Cultures, Sharing Our Heritage: The First Peoples of Alaska*, ed. Aron L. Crowell et al., 200–225 (Washington, DC: Smithsonian Books, 2010), p. 201.

2. Cole, *Captured Heritage*, p. 189.

3. Sergei Kan, "Friendship, Family, and Fieldwork: One Anthropologist's Adoption by Two Tlingit Families," in *Strangers to Relatives: The Adoption and Naming of Anthropologists in Native North America*, ed. Sergei Kan, pp. 185–217 (Lincoln: University of Nebraska Press, 2001), p. 205.

4. Marsha Herbst, "Vandals Spray Anti-Native Slogan on Juneau-Douglas High School Wall," *Juneau Empire*, February 22, 2004.

5. All quotes from this article are found in Nora Marks Dauenhauer, "Tlingit *At.óow*: Traditions and Concepts," in *The Spirit Within: Northwest Coast Native Art from the John H. Hauberg Collection*, ed. Helen Abbott et al., pp. 20–29 (Seattle: Seattle Art Museum, 1995).

6. Rosita Worl, "Tlingit At.oow: Tangible and Intangible Property" (PhD diss., Harvard University, 1998), p. 66.

7. Thomas F. Thornton, *Being and Place among the Tlingit* (Seattle: University of Washington Press, 2008), p. 59.

8. On the Russians in Alaska, see Andrei Val'terovich Grinev, *The Tlingit Indians in Russian America, 1741–1867* (Lincoln: University of Nebraska Press, 2005); and John David Ragan, *Explorers of Alaska* (New York: Chelsea House, 1993).

9. This early history of trade and collecting is based on Cole, *Captured Heritage*; Aldona Jonaitis, *Art of the Northwest Coast* (Seattle: University of Washington Press, 2006); and E. S. Lohse and Frances Sundt, "History of Research: Museum Collections," in *Handbook of North American Indians: Northwest Coast*, vol. 7, ed. William C. Sturtevant, 88–97 (Washington, DC: Smithsonian Institution, 1990).

10. W. D. Howells, "A Sennight of the Centennial," *Atlantic Monthly* 38 (1876): 92–107, p. 103.

11. Cole, *Captured Heritage*, p. 88.

12. Ibid., p. 101.

13. Jessiman, "The Repatriation of the G'psgolox Totem Pole," p. 368.

14. Cole, *Captured Heritage*, p. 191.

15. Ibid., p. 193.

16. E. L. Keithahn, *Monuments in Cedar* (New York: Bonanza Books, 1963), p. 105.

17. Franz Boas, *A Franz Boas Reader: The Shaping of American Anthropology, 1883–1911* (Chicago: University of Chicago Press, 1974), p. 106.

18. Robert Joseph, "Introduction: An Elder's Perspective," in *Listening to Our Ancestors: The Art of Native Life along the North Pacific Coast*, ed. Robert Joseph, pp. 9–13 (Washington, DC: Smithsonian Institution Press, 2005), p. 10. For the cultural life of the potlatch, see Mary Giraudo Beck, *Potlatch: Native Ceremony and Myth on the Northwest Coast* (Anchorage: Alaska Northwest Books, 1993); Dauenhauer, "Tlingit *At.óow*"; Sergei Kan, *Symbolic Immortality: The Tlingit Potlatch of the Nineteenth Century* (Washington, DC: Smithsonian Institution Press, 1989); and Worl, "Tlingit."

19. Cheryl Shearer, *Understanding Northwest Coast Art* (Seattle: University of Washington Press, 2000), p. 9.

20. Aldona Jonaitis, *Art of the Northern Tlingit* (Seattle: University of Washington Press, 1986), p. 67.

21. Ibid., p. 68.

22. Cole, *Captured Heritage*, p. 249.

23. Douglas Cole and Ira Chaikin, *An Iron Hand upon the People: The Law Against the Potlatch on the Northwest Coast* (Seattle: University of Washington Press, 1990), p. 123.

24. Keithahn, *Monuments in Cedar*, p. 105.

25. George T. Emmons, "The Whale House of the Chilkat," *Anthropological Papers of the American Museum of Natural History* 19, no. 1 (1916): 3.

26. Frederica de Laguna, "Field Work with My Tlingit Friends," in *Celebration 2000: Restoring Balance through Culture*, ed. Susan W. Fair and Rosita Worl, pp. 21–40 (Juneau, AK: Sealaska Heritage Foundation, 2000), p. 39.

27. Cole, *Captured Heritage*, p. 223.

28. Ibid., p. 244.

CHAPTER FOURTEEN

1. This section describing the 1940 ceremony is largely based on E. L. Keithahn, *The Authentic History of Shakes Island and Clan* (Wrangell, AK: Wrangell Sentinel, 1940); Keithahn, *Monuments in Cedar*, p. 106; and Judith Ostrowitz, *Privileging the Past: Reconstructing History in Northwest Coast Art* (Seattle: University of Washington Press, 1999), pp. 20–42. See also Patricia A. Neal, "The Last Great Potlatch," *Wrangell Sentinel*, 1990; Winifred Williams, "Chief Shakes Assumes Title Won in Ancient War," *Wrangell Sentinel*, May 31, 1940; Winnie Williams, "Colorful Ceremony Marks Coronation of Chief Shakes VII," *Wrangell Sentinel*, June 7, 1940; "First Potlatch Invitation Goes to President," *Wrangell Sentinel*, April 5, 1940; "24-Year Regency Will End as Kudanake Becomes Chief at Ceremony June 3 and 4," *Wrangell Sentinel*, April 5, 1940; "Potlatch Away to Flying Start Keithahn Reports," *Wrangell Sentinel*, April 12, 1940; "1500 Visitors Here to Attend First Potlatch," *Wrangell Sentinel*, June 7, 1940; "Dedication Is Feature of Potlatch Event," *Wrangell Sentinel*, June 7, 1940; "Potlatch Banquet of Chief Shakes Grand Success," *Wrangell Sentinel*, June 7, 1940; "Governor Becomes Tribal Brother of Shakes; Named 'Kush,'" *Wrangell Sentinel*, June 7, 1940; "Chief Thanks People for the Fine Support during Potlatch," *Wrangell Sentinel*, June 7, 1940; "Every Inch a Chief," *Wrangell Sentinel*, June 7, 1940; "Wrangell Folk Entertain during Potlatch," *Wrangell Sentinel*, June 7, 1940; and "Colorful Ceremony to Mark Inauguration of Chief of Wrangell Tlingit Indians," *Indians at Work* 7, no. 10 (June 1940): 14.

2. Vivian F. Martindale, "Lingítx Haa Sateeyí, We Who Are Tlingit: Contemporary Tlingit Identity and the Ancestral Relationship to the Landscape" (PhD diss., University of Alaska, 2008), p. 181.

3. Williams, "Colorful Ceremony Marks Coronation of Chief Shakes VII."

4. Neal, "The Last Great Potlatch."

5. On the history of Chief Shakes, also see Suzanne J. Crawford and Dennis F. Kelley, *American Indian Religious Traditions: An Encyclopedia* (Santa Barbara, CA: ABC-CLIO, 2005), p. 783; Frederica de Laguna, "Tlingit," in *Handbook of North American Indians*, vol. 7, pp. 203–28 (Washington, DC: Smithsonian Institution, 1990), p. 220; George Thornton Emmons, *The Tlingit Indians* (Seattle: University of Washington Press, 1991), p. 44; Walter R. Goldschmidt and Theodore H. Haas, *Haa Aaní, Our Land: Tlingit and Haida Land Rights and Use* (Juneau, AK: Sealaska Heritage Foundation, 1998), p. 73; Grinev, *The Tlingit Indians in Russian America*, p. 239; and Eric Wolf, *Europe and the People without History* (Berkeley: University of California Press, 1982), p. 189. See also letter from Edward K. Thomas to Joyce Herold, December 21, 2001, Tlingit NAGPRA Files, DMNS.

6. James R. Gibson, *Otter Skins, Boston Ships, and China Goods: The Maritime Fur Trade of the Northwest Coast, 1785–1841* (Quebec: McGill-Queen's University Press, 1992), p. 167.

7. Emmons, *The Tlingit Indians*, pp. 408–9; "A [skookum] paper for Shaikes [Shakes], the Stickeen Chief, with comment on his character," George Shakes, Tlingit Chief, Letters received, 1879–1898, MS004-06-04, ASL.

8. Ostrowitz, *Privileging the Past*, p. 32.

9. Sergei Kan, *Memory Eternal: Tlingit Culture and Russian Orthodox Christianity through Two Centuries* (Seattle: University of Washington Press, 1999), p. 302; Rosita Worl, "History of Southeastern Alaska since 1867," in *Handbook of North American Indians: Northwest Coast*, vol. 7, ed. William C. Sturtevant, pp. 149–58 (Washington, DC: Smithsonian Institution, 1990), p. 152.

10. Emily Lehua Moore, " 'For Future Generations': Transculturation and the Totem Parks of the New Deal, 1938–1942" (PhD diss., University of California at Berkeley, 2012), p. 158. See also "Pro Tem Chief for 24 Years Is Getting Indian Title at 76," *Lexington Herald*, April 23, 1940.

11. Robert W. Preucel and Lucy F. Williams, "The Centennial Potlatch," *Expedition* 47, no. 2 (2005): 9–19, p. 12.

12. Shannon Haugland, "Chilkat Blanket Gets Warm Welcome Home," *Daily Sitka Sentinel*, November 6, 2008.

13. "Venerable Indian, 76, Takes Over Tribe Rule after Long Regency," *Kingsport Times*, April 3, 1940.

14. Moore, "For Future Generations," p. 158.

15. "Colorful Ceremony to Mark Inauguration of Chief of Wrangell Tlingit Indians."

16. Dave Kiffer, "William Paul Was the 'Father of Native Land Claims,'" *Sit News*, February 16, 2009. See also Polly Miller, *Lost Heritage of Alaska: The Adventure and Art of the Alaskan Coastal Indians* (Cleveland: World Publishing, 1967),

p. 226; and Fred Paul, *Then Fight for It! The Largest Peaceful Redistribution of Wealth in the History of Mankind* (Victoria, BC: Trafford, 2003), pp. 41–44.

17. Worl, "Tlingit," p. 210.

18. Donald Craig Mitchell, *Sold American: The Story of Alaska Natives and Their Land, 1867–1959* (Hanover, NH: University Press of New England, 2003), p. 214.

19. Daniel McCool et al., *Native Vote: American Indians, the Voting Rights Act, and the Right to Vote* (Cambridge: Cambridge University Press, 2007), pp. 10–11.

20. "Indians Break Old Tradition, Invite Roosevelt to Alaska," *Cumberland Evening Times*, April 3, 1940.

21. Moore, "For Future Generations," p. 158.

22. "Death Takes Widow of Alaska Chieftain," *Oregonian*, February 24, 1937.

23. Ostrowitz, *Privileging the Past*, p. 33.

24. Alison K. Hoagland, "Totem Poles and Plank Houses: Reconstructing Native Culture in Southeast Alaska," in *Shaping Communities*, ed. Carter L. Hudgins and Elizabeth Collins Cromley, pp. 174–85 (Knoxville: University of Tennessee, 1997), p. 175; Keithahn, *Monuments in Cedar*, p. 117.

25. Ostrowitz, *Privileging the Past*, p. 33.

26. Martindale, "Lingítx Haa Sateeyí," p. 181.

27. Paul, *Then Fight for It!*, p. 66.

28. Moore, "For Future Generations," p. 158.

29. "Wrangell Indians Invite White Chiefs, Brothers, to Big Potlatch, in June," *Fairbanks Daily News*, April 2, 1940.

30. "1500 Visitors Here to Attend First Potlatch."

31. Ostrowitz, *Privileging the Past*, p. 38. See also Greg Knight, "A Shakes Renovation Year in Review," *Wrangell Sentinel*, 9 May 2013.

32. Martindale, "Lingítx Haa Sateeyí," p. 184.

33. Shearer, *Understanding Northwest Coast Art*, p. 63.

34. Letter from Edward K. Thomas to Joyce Herold, December 21, 2001, Tlingit NAGPRA Files, DMNS.

35. On the Chilkat blanket, see George T. Emmons, "The Chilkat Blanket," *Memoirs of the American Museum of Natural History* 3 (1907): 329–401; and Cheryl Samuel, *The Chilkat Dancing Blanket* (Seattle: Pacific Search Center, 1982).

36. Maureen Milburn, "The Politics of Possession: Louis Shotridge and the Tlingit Collections of the University of Pennsylvania Museum University Museum, Philadelphia" (PhD diss., University of British Columbia, 1997), p. 159.

37. Norman Feder, *Indian Art of the Northwest Coast* (Denver: Denver Art Museum, 1962); Erna Gunther, *Art in the Life of the Northwest Coast Indians* (Portland: Portland Art Museum, 1966), pp. 92, 222, 239.

38. Letter from Edward K. Thomas to Joyce Herold, December 21, 2001, Tlingit NAGPRA Files, DMNS.

39. Cole, *Captured Heritage*, p. 280; Bill Holm, *Spirit and Ancestor: A Century of Northwest Coast Indian Art at the Burke Museum* (Seattle: University of Washington Press, 1987), p. 20; Greg Knight, "Wrangell's Tlingit Art on Display at Two Museums," *Wrangell Sentinel*, September 20, 2012; Miller, *Lost Heritage of Alaska*, p. 253.

40. Feder, *Indian Art of the Northwest Coast*.

41. "Historic 'Bird Rattle' Is Stolen," *Seattle Times*, October 15, 1964.

42. Ben Murray, "Traditional Rattle Seized, Returned to Southeast," *Juneau Empire*, June 11, 2002.

43. "Chief Shakes Tlingit Rattle," www.bonhams.com/auctions/19418 /lot/4129/ (accessed May 2, 2014); "Snuff Box from the Chief Shakes Collection, purchased in 1933 from Mary Shakes by W.C. Water," http://issuu.com/skinner inc/docs/2596b_indian (accessed April 16, 2014).

44. Signed statement by Michael R. Johnson and Sharon M. Johnson, October 26, 1973, giving history of "Chief Shakes Chilkat Blanket," Accession files, DMNS.

45. Keithahn, *Monuments in Cedar*, p. 96.

46. "Committees for Wrangell Potlatch Are Selected," *Wrangell Sentinel*, April 5, 1940; "Rare Exhibits Planned for Potlatch Days," *Wrangell Sentinel*, April 19, 1940.

47. Katherine Kuh, "Alaska's Vanishing Art," *Saturday Review* (October 22, 1966): 25–31, p. 28; Moore, "For Future Generations," pp. 158–59.

48. "Jonathan DeWitt Dies in Ketchikan," *Daily Sitka Sentinel*, August 31, 2001.

49. "Chief Shakes," *Alaska Magazine*, September 1970.

CHAPTER FIFTEEN

1. Étienne Dumont, ed., *Bentham's Theory of Legislation* (London: Oxford University Press, 1914), p. 152.

2. Unless otherwise cited, this opening description of April 22, 1984, is based on Marilee Enge, "Battle Over a Birthright," *Anchorage Daily News*, April 4, 1993.

3. This history is recounted in Marilee Enge, "Master Carver," *Anchorage Daily News*, April 5, 1993.

4. The description of the four posts and Rain Wall is based on Emmons, *The Tlingit Indians*, p. 62.

5. Jonaitis, *Art of the Northern Tlingit*, p. 133.

6. George T. Emmons, "The Whale House of the Chilkat," *American Museum Journal* 16 (1916): 451–64, p. 463.

7. Cole, *Captured Heritage*, p. 260.

8. Ibid., p. 194.

9. Maureen Milburn, "Louis Shotridge and the Objects of Everlasting Es-

teem," in *Raven's Journey: The World of Alaska's Native People*, ed. Susan A. Kaplan and Kristin Barsness, pp. 54–77 (Philadelphia: University Museum, University of Pennsylvania, 1986), p. 60.

10. On Gordon's biography and career, see Eleanor M. King and Bryce P. Little, "George Byron Gordon and the Early Development of the University Museum," in *Raven's Journey*, ed. Kaplan and Barsness.

11. Jonaitis, *Art of the Northern Tlingit*, p. 6.

12. "Louis V. Shotridge," http://penn.museum/collections/shotridge/shotridgebio.html (accessed January 4, 2014).

13. Milburn, "Louis Shotridge and the Objects of Everlasting Esteem," p. 66.

14. Cole, *Captured Heritage*, p. 261.

15. Milburn, "The Politics of Possession," p. 215.

16. Elizabeth Seaton, "The Native Collector: Louis Shotridge and the Contests of Possession," *Ethnography* 2, no. 1 (2001): 35–61, p. 39.

17. Miller, *Lost Heritage of Alaska*, pp. 251–52.

18. Milburn, "The Politics of Possession," p. 216.

19. Both quotes in ibid., p. 228.

20. Ibid., p. 220.

21. Edmund Carpenter, "Introduction," in *Indian Art of the Northwest Coast: A Dialogue on Craftsmanship and Aesthetics*, ed. Bill Holm and Bill Reid, pp. 9–27 (Houston: Institute for the Arts, Rice University, 1976), p. 22.

22. Cole, *Captured Heritage*, p. 263.

23. Ibid., p. 264.

24. Ibid., p. 266.

25. Milburn, "The Politics of Possession," p. 233.

26. Carpenter, "Introduction," p. 22; Cole, *Captured Heritage*, p. 266; Miller, *Lost Heritage of Alaska*, p. 252.

27. This description of Johnson is from Marilee Enge, "To Sell or Not?" *Anchorage Daily News*, April 4, 1993.

28. "After a Court Fight, Old Totems Return to an Alaskan Village," *New York Times*, October 17, 1984.

29. On the Holy Grail reference, see Enge, "Battle Over a Birthright"; on the *Mona Lisa* reference, see Enge, "Master Carver"; on the King Tut reference, see M. L. Lyke, "Legal Tangle Keeps NW Coast Indian Treasures Locked Up," *Seattle Post-Intelligencer*, February 10, 1992.

30. Enge, "To Sell or Not?"

31. Barry Harem, "The Curse of the Tlingit Treasures," *Connoisseur* (March 1991): 86–91, 117, p. 90.

32. Worl, "Tlingit At.oow," p. 211.

33. Letter from Howard B. Roloff to Mary Crane, February 16, 1976, Correspondence Files, DMNS.

34. Cole, *Captured Heritage*, p. 310.

35. *Johnson v. Chilkat Indian Village*, 457 F. Supp. 384 (D. Alaska 1978).

36. Enge, "To Sell or Not?"

37. Ibid.

38. Ibid.

39. Marilee Enge, "Whose Laws?" *Anchorage Daily News*, April 8, 1993.

40. Michael R. Johnson to Mary Crane, October 14, 1975, Correspondence Files, DMNS. See also letter from Simeoni & Company to Michael R. Johnson, October 20, 1975, Correspondence Files, DMNS; and letter from Mary Crane to Howard B. Roloff, November 2, 1975, Correspondence Files, DMNS.

41. Ibid.

42. Dean Katz, "A Struggle for a People's Culture," *Seattle Times*, December 21, 1986.

43. Carpenter, "Introduction," p. 23.

44. Enge, "Whose Laws?"

45. Ibid.

46. "Tribal Judge Order Tlingit Totems Home," *Anchorage Daily News*, November 5, 1993.

47. Marilee Enge, "Clan's Artifacts Returned, Klukwan Celebrates End of Legal Battle," *Anchorage Daily News*, October 4, 1994; Linda Keene, "Return of Stolen Alaskan Totems Ends 10-Year Saga of Greed," *Dallas Morning News*, October 30, 1994; "After a Court Fight, Old Totems Return to an Alaskan Village," *New York Times*, October 17, 1984.

48. Keene, "Return of Stolen Alaskan Totems Ends 10-Year Saga of Greed."

CHAPTER SIXTEEN

1. Letter from Harold Jacobs to Joyce Herold, December 11, 1991, Tlingit NAGPRA Files, DMNS.

2. Memo from Joyce Herold to John Welles and Jon Haverson, March 18, 1992, Tlingit NAGPRA Files, DMNS.

3. Kan, *Symbolic Immortality*.

4. Notes from telephone call with Michael R. Johnson, September 5, 1996, Correspondence Files, DMNS.

5. Letter from Robert B. Pickering to Harold Jacobs, May 7, 1992, Tlingit NAGPRA Files, DMNS.

6. Letter from Harold Jacobs to Joyce Herold, October 1, 1992, Tlingit NAGPRA Files, DMNS.

7. Letter from Robert B. Pickering to Harold Jacobs, January 3, 1994, Tlingit NAGPRA Files, DMNS.

8. Letter from Edward K. Thomas to Robert Pickering, January 5, 1994, Tlingit NAGPRA Files, DMNS.

9. This phrase has been used in print by at least one anti-repatriation commentator; see Steven Vincent, "Indian Givers," in *Who Owns the Past? Cultural Policy, Cultural Property, and the Law*, ed. Kate Fitz Gibbon, pp. 33–43 (New Brunswick, NJ: Rutgers University Press, 2005).

10. Quotes in this paragraph in letter from Harold Jacobs to Joyce Herold, February 26, 1992, Tlingit NAGPRA Files, DMNS.

11. Letter from Harold Jacobs to Robert Pickering, July 13, 1994, Tlingit NAGPRA Files, DMNS.

12. Notes from telephone call from Harold Jacobs to Joyce Herold, July 11, 1994, Tlingit NAGPRA Files, DMNS.

13. "A Resolution of the Dak'laweidi Killer Whale House of Angoon Authorizing the Central Council of Tlingit and Haida Indian Tribes of Alaska to Formally Act on Its Behalf for Repatriation of Clan Objects Returning to Dak'laweidi Killer Whale House of Angoon Under the NAGPRA of 1990," dated May 9, 1996, Tlingit NAGPRA Files, DMNS.

14. Letter from Edward K. Thomas to the Denver Museum of Natural History, May 31, 1996, Tlingit NAGPRA Files, DMNS.

15. Letter from Robert B. Pickering to Edward K. Thomas, May 31, 1996, Tlingit NAGPRA Files, DMNS.

16. Letter from Edward K. Thomas to Robert B. Pickering, July 25, 1996, Tlingit NAGPRA Files, DMNS.

17. Quotes in "Crane's Last Stand?" *Museum Quarterly* 3, no. 1 (1994).

18. Letter from Ben Sherman to John Welles, May 2, 1994, 141-01-21-97.3, NAGPRA 1994, DMNS.

19. Letter from Ben Sherman to Bob Pickering, November 2, 1993, 141-03-23-95, DMNH: Repatriation 1993, DMNS.

20. Quotes in this paragraph from this meeting are in Collections and Research Division/Trustee and Legal Committee Meeting, May 5, 1994, NAGPRA files, DMNS.

21. For example, see D. Hurtado, "Native American Graves Protection and Repatriation Act: Does It Subject Museums to an Unconstitutional 'Taking'?" *Hofstra Property Law Journal* 6 (1993): 1–83.

22. Memo: Davis, Graham, and Stubbs meeting, John G. Welles, February 25, 1994, NAGPRA files, DMNS.

23. Memo: Inquiries Regarding NAGPRA, from John G. Welles to Division and Department Heads, April 6, 1994, 141-01-21-97.3, NAGPRA 1994, DMNS.

24. Quotes in this paragraph from "Notes taken by John G. Welles at the Association of Science Museum Directors annual workshop in Atlanta, February 5–6, 1994," IA.501-03-31-98.2, FF4, DMNS.

25. Letter from the Six Nations Council of Chiefs, December 29, 1974, IA.Taylor.29, FF 22, DMNS.

26. The history in this paragraph is covered by Fine-Dare, *Grave Injustice*, p. 78; Fenton, "Return of Eleven Wampum Belts," pp. 398, 401; Tooker, "A Note on the Return of Eleven Wampum Belts."

27. Inter-Office Correspondence Memo from Joyce Herold, April 10, 1978, IA.Anthropology, Box 7, FF 23, 1978, DMNS.

28. Ramon Gonyea and Rick Hill, "Medicine Masks of the Hodenosaunees," *Regional Conference of Historical Agencies Newsletter* 11, no. 4 (1981): 1–5, p. 1.

29. Ibid., p. 2.

30. Ibid.

31. DMNH 1978 Annual Report, DMNS. See also "Indian Masks New to Exhibit," *Denver Post*, May 19, 1978.

32. "Outside Funding Request, Iroquois Medicine Man Visit," April 10, 1978, IA.Anthropology, Box 7, FF 23, 1978, DMNS.

33. Letter from Tah-Da-Dah-Ho to Michael Spock, March 19, 1981, IA.Taylor 30, FF15, DMNS.

34. Gonyea and Hill, "Medicine Masks of the Hodenosauness," p. 2.

35. For this and rest of paragraph, see "Memo: Denver Museum Collections and American Indians," from Jane Day to John Welles, January 30, 1990, 501-11-13-96.3, Repatriation, Native American Artifacts, DMNS.

36. Chandler, "Reclaiming the Past."

37. Jane Day and Bob Akerley, "Valuable Artifact Returned to Canada," *Bear Pause* 15, no. 2 (1986), DMNS.

38. Kristine A. Haglund, "The Unexplored Facets of Repatriation," paper for panel discussion "Implications of Repatriation for Museums and Archives," Society of American Archivists, September 2, 1993, 141-03-23-95, DMNH: Repatriation 1993, DMNS.

39. Catherine Bell et al., "Recovering from Colonization: Perspectives of Community Members on Protection and Repatriation of Kwakwaka'wakw Cultural Heritage," in *First Nations Cultural Heritage and Law: Case Studies, Voices, and Perspectives*, ed. Catherine Bell and Val Napoleon, pp. 33–91 (Vancouver: UBC Press, 2008); Cooper, *Spirited Encounters*, pp. 73–75; Ira Jacknis, "Repatriation as Social Drama: The Kwakiutl Indians of British Columbia, 1922–1980," in *Repatriation Reader: Who Owns American Indian Remains?*, ed. Devon A. Mihesuah, pp. 266–81 (Lincoln: University of Nebraska Press, 2000); Mary Jane Lenz, "Epilogue: Learning to See from Within," in *Listening to Our Ancestors: The Art of Native Life along the North Pacific Coast*, ed. Robert Joseph, pp. 178–85 (Washington, DC: Smithsonian Institution Press, 2005); Miora G. Simpson, *Making Representations: Museums in the Post-Colonial Era* (London: Routledge Press, 1996), pp. 153–57.

40. For these repatriations, see Childs, "Museums and the American Indian," p. 19; Greenfield, *The Return of Cultural Treasures*, p. 179; Kathleen Lowrey and Pauline Turner Strong, "Two Indigenous Americas," in *The Sage Handbook of So-*

cial Anthropology, vol. 1, ed. Richard Fardon et al., pp. 465–86 (London: Sage, 2012); McLaughlin, "The American Archaeological Record," pp. 354, 372; and Robin Ridington and Dennis Hastings, *Blessings for a Long Time: The Sacred Pole of the Omaha Tribe* (Lincoln: University of Nebraska Press, 1997).

41. Letter from Edward K. Thomas to Joyce Herold, December 21, 2001, Tlingit NAGPRA Files, DMNS.

42. Affidavit by Cynthia DeWitt Paul, December 20, 2001, Tlingit NAGPRA Files, DMNS.

CHAPTER SEVENTEEN

1. Melissa Griffiths, "When Auction Looks to Tlingit Art, the Sacred Goes on Sale," *Juneau Empire*, May 16, 2014.

2. Julie Cruikshank, *The Social Life of Stories: Narrative and Knowledge in the Yukon Territory* (Lincoln: University of Nebraska Press, 1998), p. 147.

3. This chapter's long quotations from the 2002 consultation is taken from videotapes that recorded the consultation. In several places, I have compressed and edited the dialogue for brevity and clarity. Tape C02-23 through Tape C02-26, DMNS.

4. "The Resolution of the Raven House of the Lukaax.ádi of Haines Authorizing the Central Council Tlingit and Haida Indian Tribes of Alaska to Formally Act on Its Behalf for Repatriation of Clan Property Under the NAGPRA of 1990 or the NMAI Act of 1989," October 11, 2001, Tlingit NAGPRA Files, DMNS.

5. "Denver Museum Repatriates Tunic and Raven Headdress," *Juneau Empire*, January 9, 2008.

6. Song translation in "The Resolution of the Raven House of the Lukaax .ádi of Haines Authorizing the Central Council Tlingit and Haida Indian Tribes of Alaska to Formally Act on Its Behalf for Repatriation of Clan Property Under the NAGPRA of 1990 or the NMAI Act of 1989," October 11, 2001, Tlingit NAGPRA Files, DMNS.

7. Letter from Michael R. Johnson to Mary Crane, January 30, 1976, Correspondence Files, DMNS.

8. Nora Marks Dauenhauer and Richard Dauenhauer, ed. *Haa Kusteeyí, Our Culture: Tlingit Life Stories* (Seattle: University of Washington Press, 1994), p. 225.

9. See Chip Colwell-Chanthaphonh, "Repatriation and the Burdens of Proof," *Museum Anthropology* 36, no. 2 (2013): 108–9; and Steven Platzman, "Objects of Controversy: The Native American Right to Repatriation," *American University Law Review* 41 (1992): 517–58, pp. 555–57.

CHAPTER EIGHTEEN

1. Nora Marks Dauenhauer, "Poems," in *The Alaska Native Reader: History, Culture, Politics*, ed. Maria Sháa Tláa Williams, pp. 339–50 (Durham, NC: Duke University Press, 2009), p. 341.

2. A video of the ceremony is available in the DMNS.

3. Memo from Joyce Herold to Heidi Lumberg, December 16, 1997, Tlingit NAGPRA Files, DMNS.

4. Kan, "Friendship, Family, and Fieldwork."

5. Joyce Herold, "Vitae for NAGPRA, Repatriation, and American Indian Museums," Department of Anthropology, DMNS.

6. Letter from Robert Pickering to Harold Jacobs, October 31, 1997, Tlingit NAGPRA Files, DMNS.

7. Quotes in e-mails between Robert Pickering and Harold Jacobs, August 5–18, 1998, Tlingit NAGPRA Files, DMNS.

8. E-mail from Harold Jacobs to Joyce Herold, May 13, 2000, Tlingit NAGPRA Files, DMNS.

9. Memo: Access to Collections, from Jonathan Haas to Ben Bronson, Chip Stanish, and John Terrell, May 18, 1994. NAGPRA files, DMNS.

10. Francis P. McManamon, "Notice of Inventory Completion," *Federal Register* 63, no. 97 (1998): 27746–47.

11. Harold Jacobs, "Denver Museum Has Cooperated in Returning Relics," *Denver Post*, September 18, 2003.

12. For the article and quotes, see Joyce Herold, "The Spirit of Repatriation: Ten Years of NAGPRA at DMNS," *Member's Monthly* 2, no. 5 (2001): 6.

13. Interview transcript of Joyce Herold interviewed by Malcolm Stevenson, August 2008, DMNS.

14. Herold, "The Spirit of Repatriation."

15. Dauenhauer and Dauenhauer, *Haa Kusteeyí*, p. 250.

16. Ibid., p. 236.

17. Nora Dauenhauer and Richard Dauenhauer, eds., *Haa Tuwunáagu Yís, for Healing Our Spirit: Tlingit Oratory* (Juneau, AK: Sealaska Heritage Foundation, 1990), p. 529.

18. Dauenhauer and Dauenhauer, *Haa Kusteeyí*, p. 225.

19. Clement W. Meighan, "Indians Sell Sacred 'Repatriated' Artifacts in Arizona," *American Committee for Preservation of Archaeological Collections Newsletter* (October 1994): 1.

20. The description of this *koo.éex* is based on interviews and Shannon Haugland, "Chilkat Blanket Gets Warm Welcome Home," *Daily Sitka Sentinel*, November 6, 2008; Greg Knight, "Rededication: Shakes Tribal House Rises Again," *Wrangell Sentinel*, May 9, 2013; "Museum Cultural Object Returned for Celebra-

tion," http://burkemuseum.blogspot.com/2009/01/all-in-days-work.html (accessed May 22, 2014); and two pamphlets titled "Return of the Chief Shakes Killer Whale Flotilla Robe" and "Át Yánwoonei, Káachxana.aak'wx (It Was Completed in Wrangell)," Tlingit NAGPRA Files, DMNS.

21. Katy Human, "Bones of Contention Go Home," *Denver Post*, September 2, 2007.

22. John S. Swanton, *Tlingit Myths and Texts*, Bureau of American Ethnology Bulletin 39 (Washington, DC: Smithsonian Institution, 1904), pp. 409–10.

23. Kan, *Symbolic Immortality*, p. 69.

24. Holm, *Spirit and Ancestor*, p. 198.

25. On the Tlingit's struggles with other museums, see Jennifer L. Putnam, "NAGPRA and the Penn Museum: Reconciling Science and the Sacred," *Concept* 37 (2014): 1–21.

CHAPTER NINETEEN

1. Dick Foster, "Tribes Claim Past Held Hostage," *Rocky Mountain News*, November 5, 1989.

2. Ryan M. Seidemann, "Altered Meanings: The Department of the Interior's Rewriting of the Native American Graves Protection and Repatriation Act to Regulate Culturally Unidentifiable Human Remains," *Temple Journal of Science, Technology & Environmental Law* 28, no. 1 (2009): 1–47, p. 19.

3. William C. Sturtevant and Jessica R. Cattelino, "Florida Seminole and Miccosukee," in *Handbook of North American Indians*, vol. 14, ed. Raymond D. Fogelson, pp. 429–49 (Washington, DC: Smithsonian Institution, 2004), p. 444.

4. Sudhin Thanawala, "Tribes Retrieve Remains from Researchers, Agencies," *Washington Post*, January 16, 2012.

5. Keith W. Kintigh, "NAGPRA, SAA, and Culturally Unidentifiable Human Remains," *SAA Archaeological Record* 8, no. 2 (2008): 5–6, p. 6.

6. For this story, see Sherry Hutt and C. Timothy McKeown, "Control of Cultural Property as Human Rights Law," *Arizona State Law Journal* 31, no. 2 (1999): 363–89, pp. 367–68. For the appeals ruling, see *Newman v. State*, 174 So. 2d 479-Fla: Dist. Court of Appeals, 2nd Dist. 1965. See also Miller Davis, "It Takes A Heap O' Livin' Creatures to Make a House a Home," *Miami News*, March 7, 1962; "Student Given Jail Term for Taking Skull," *Ocala Star-Banner*, May 2, 1962; and "Seminole Patriarch Will Lie in Paleface Ground," *Kingsport Times*, May 30, 1966.

CHAPTER TWENTY

1. Aleš Hrdlička, *The Anthropology of Florida*, Publications of the Florida State Historical Society (Deland: Florida State Historical Society, 1922), p. 70.

2. Ronald P. Rohner, "Franz Boas: Ethnographer on the Northwest Coast,"

in *Pioneers of American Anthropology: The Uses of Biography*, ed. June Helm, pp. 149–212 (Seattle: University of Washington Press, 1966), p. 172.

3. See Jordan Jacobs, "Repatriation and Reconstruction," *Museum Anthropology* 32, no. 2 (2009): 83–98; and Matthew Liebmann, "Postcolonial Cultural Affiliation: Essentialism, Hybridity, and NAGPRA," in *Archaeology and the Postcolonial Critique*, ed. Matthew Liebmann and Uzma Z. Rizvi, pp. 73–90 (Lanham, MD: AltaMira Press, 2008).

4. This section is based on Julian Granberry, *The Calusa: Linguistic and Cultural Origins and Relationships* (Tuscaloosa: University of Alabama Press, 2011); William E. McGoun, *Prehistoric Peoples of South Florida* (Tuscaloosa: University of Alabama Press, 1993); William H. Marquardt, "Calusa," in *Handbook of North American Indians*, vol. 14, ed. Raymond D. Fogelson, pp. 204–12 (Washington, DC: Smithsonian Institution, 2004); William H. Marquardt, "The Emergence and Demise of the Calusa," in *Societies in Eclipse: Archaeology of the Eastern Woodlands Indians, A.D. 1400–1700*, ed. David S. Brose et al. (Washington, DC: Smithsonian Institution, 2001); Darcie A. MacMahon and William H. Marquardt, *The Calusa and Their Legacy: South Florida People and Their Environments* (Gainesville: University Press of Florida, 2004); and Randolph J. Widmer, *The Evolution of the Calusa: Nonagricultural Chiefdom on the Southwest Coast of Florida* (Tuscaloosa: University of Alabama Press, 1988).

5. Marquardt, "Calusa," p. 210.

6. This section on the Seminole is based on Sturtevant and Cattelino, "Florida Seminole and Miccosukee," p. 429; and Brent Richards Weisman, *Unconquered People: Florida's Seminole and Miccosukee Indians* (Gainesville: University of Florida Press, 1999).

7. Sturtevant and Cattelino, "Florida Seminole and Miccosukee," p. 431.

8. Ibid., p. 438; Weisman, *Unconquered People*, p. 129.

9. Marquardt, "Calusa," p. 211.

10. Weisman, *Unconquered People*, p. 82.

11. Granberry, *The Calusa*, p. 2.

12. Weisman, *Unconquered People*, p. 73.

13. Frances Densmore, *Seminole Music, Bureau of American Ethnology Bulletin 161* (Washington DC: Smithsonian Institution, 1956), p. 59.

14. This story of Cushing is based on Frank Hamilton Cushing, "Exploration of Ancient Key Dweller Remains on the Gulf Coast of Florida," *American Philosophical Society, Proceedings* 35 (1897): 329–448; Green, *Zuni*, pp. 12–15; J. W. Powell, "In Memoriam: Frank Hamilton Cushing: Remarks by J. W. Powell," *American Anthropologist* 2, no. 2 (1900): 360–67; and Widmer, *The Evolution of the Calusa*, pp. 37–38.

15. Hrdlička, *The Anthropology of Florida*, p. 51.

16. William H. Marquardt, "The Development of Cultural Complexity in Southwest Florida: Elements of a Critique," *Southeastern Archaeology* 5, no. 1 (1986): 63–70, p. 63.

17. Cushing, "Exploration of Ancient Key Dweller Remains," p. 353.

18. Frank H. Cushing, "Scarred Skulls from Florida," *American Anthropologist* 10, no. 1 (1897): 17–18.

19. These arguments are based on Brenda J. Baker et al., "Repatriation and the Study of Human Remains," in *The Future of the Past: Archaeologists, Native Americans, and Repatriation*, ed. Tamara L. Bray, pp. 69–90 (New York: Garland, 2001); Buikstra, "A Specialist in Ancient Cemetery"; Buikstra, "Reburial"; M. M. Houck et al., "The Role of Forensic Anthropology in the Recovery and Analysis of Branch Davidian Compound Victims: Assessing the Accuracy of Age Estimations," *Journal of Forensic Science* 41, no. 5 (1996): 796–801; Patricia M. Landau and D. Gentry Steele, "Why Anthropologist Study Human Remains," in *Repatriation Reader: Who Owns American Indian Remains?*, ed. Devon A. Mihesuah, pp. 74–94 (Lincoln: University of Nebraska Press, 2000); Debra L. Martin et al., *Bioarchaeology: An Integrated Approach to Working with Human Remains* (New York: Springer, 2013); Christopher M. Stojanowski and Ryan M. Seidemann, "A Reevaluation of the Sex Prediction Accuracy of the Minimum Supero-Inferior Femoral Neck Diameter for Modern Individuals," *Journal of Forensic Science* 44, no. 6 (1999): 1215–18; and Phillip V. Tobias, "On the Scientific, Medical, Dental, and Educational Value of Collections of Human Skeletons," *International Journal of Anthropology* 6, no. 3 (1991): 277–80.

20. Virginia Morell, "An Anthropological Culture Shift," *Science* 264 (1994): 20–22, p. 21.

21. Hrdlička, *The Anthropology of Florida*, p. 132.

22. Widmer, *The Evolution of the Calusa*, p. 48.

23. On the Antiquities Act of 1906, see Chip Colwell-Chanthaphonh, "The Incorporation of the Native American Past: Cultural Extermination, Archaeological Protection, and the Antiquities Act of 1906," *International Journal of Cultural Property* 12, no. 3 (2005): 375–91; and David Harmon et al., eds., *The Antiquities Act: A Century of American Archaeology, Historic Preservation, and Nature Conservation* (Tucson: University of Arizona Press, 2006).

24. Norman L. Cantor, *After We Die: The Life and Times of the Human Cadaver* (Washington, DC: Georgetown University Press, 2010).

25. Ruth Richardson, *Death, Dissection, and the Destitute*, 2nd ed. (Chicago: University of Chicago Press, 2000).

26. All quotes in this paragraph from Joseph Henry, ed., *Annual Report of the Board of Regents of the Smithsonian Institution, Showing the Operations, Expenditures, and Condition of the Institution for the Year 1861* (Washington, DC: Government Printing Office, 1862), p. 392.

27. The opening to this section is based on "Indian Tribes in the Florida Keys, Part 2," www.keysnet.com/2014/04/11/496064/indian-tribes-in-the-florida-keys .html (accessed June 27, 2014); and "Keys Historeum," www.keyshistory.org (accessed June 27, 2014).

28. This part of the story is recounted in Memo: "Re: Photos of Plantation Digs," January 3, 1985; letter from Hilda and Hugh Davis to George B. Stevenson, November 15, 1961, NAGPRA files, DMNS; letter from Dan D. Laxson to George B. Stevenson, January 4, 1962; letter from George B. Stevenson to Frank M. Setzler, February 15, 1962, NAGPRA files, DMNS; and letter from Frank M. Setzler to George B. Stevenson, March 7, 1962, NAGPRA files, DMNS.

29. On the difficulties of reconstructing separated collections to comply with NAGPRA, see Margaret M. Bruchac, "Lost and Found: NAGPRA, Scattered Relics, and Restorative Methodologies," *Museum Anthropology* 33, no. 2 (2010): 137–56; and Deanne Hanchant, "Practicalities in the Return of Remains: The Importance of Provenance and the Question of Unprovenanced Remains," in *The Dead and Their Possessions: Repatriation in Principle, Policy, and Practice*, ed. Cressida Fforde et al., pp. 312–16 (New York: Routledge, 2002).

CHAPTER TWENTY-ONE

1. Clement W. Meighan, "Some Scholar's Views on Reburial," *American Antiquity* 57, no. 4 (1992): 704–10, p. 706.

2. 25 USC 3001.2(2). For discussions of how cultural affiliation has been applied, see Michael A. Adler and Susan B. Bruning, "Navigating the Fluidity of Social Identity: Collaborative Research into Cultural Affiliation in the American Southwest," in *Collaboration in Archaeological Practice: Engaging Descendant Communities*, ed. Chip Colwell-Chanthaphonh and T. J. Ferguson, pp. 35–54 (Lanham, MD: AltaMira Press, 2008); April M. Beisaw, "Memory, Identity, and NAGPRA in the Northeastern United States," *American Anthropologist* 112, no. 2 (2010): 244–56; Chip Colwell-Chanthaphonh and Jami Powell, "Repatriation and Constructs of Identity," *Journal of Anthropological Research* 68, no. 2 (2012): 191–222; Kurt E. Dongoske et al., "Archaeological Cultures and Cultural Affiliation: Hopi and Zuni Perspectives in the American Southwest," *American Antiquity* 62, no. 4 (1997): 600–608; and John R. Welch and T. J. Ferguson, "Putting Patria Back into Repatriation: Cultural Affiliation Assessment of White Mountain Apache Tribal Lands," *Journal of Social Archaeology* 7, no. 2 (2007): 171–98.

3. This section unless otherwise cited is largely drawn from Johnson, *Sacred Claims*; and McKeown, *In the Smaller Scope of Conscience*.

4. This quote and next from Joseph Chamberlain, "AAM Policy Regarding the Repatriation of Native American Ceremonial Objects and Human Remains," *Aviso* (March 1988): 2, 4–5, p. 5.

5. Preston, "Skeletons in Our Museums' Closets," p. 75, emphasis in original.

6. Johnson, *Sacred Claims*, p. 83. See also Roger Anyon and Russell Thornton, "Implementing Repatriation in the United States: Issues Raised and Lessons Learned," in *The Dead and Their Possessions: Repatriation in Principle, Policy, and Practice*, ed. Cressida Fforde et al., pp. 190–98 (New York: Routledge, 2002), p. 193.

7. Morell, "An Anthropological Culture Shift," p. 20.

8. Foster, "Tribes Claim Past Held Hostage."

9. Eliot Marshall, "Smithsonian, Indian Leaders Call a Truce," *Science* 245 (1989): 1184–86, p. 1184.

10. Ibid.

11. Laurent Carpentier, "French Museums Face a Cultural Change over Restitution of Colonial Objects," *Guardian*, November 3, 2014.

12. 20 USC 80q-9(c).

13. McKeown, *In the Smaller Scope of Conscience*, p. 78.

14. Foster, "Tribes Claim Past Held Hostage."

15. Johnson, *Sacred Claims*, p. 65. See also Keith W. Kintigh, "Repatriation as a Force of Change in Southwestern Archaeology," in *Opening Archaeology: Repatriation's Impact on Contemporary Research and Practice*, ed. Thomas W. Killion, pp. 195–207 (Santa Fe: SAR Press, 2008), p. 199; and McKeown, *In the Smaller Scope of Conscience*, p. 141.

16. Keith Kintigh, "A Perspective on Reburial and Repatriation," *Bulletin of the Society for American Archaeology* 8, no. 2 (1990): 6–7.

17. Johnson, *Sacred Claims*, p. 72.

18. Ibid.

19. Patty Gerstenblith, "Cultural Significance and the Kennewick Skeleton: Some Thoughts on the Resolution of Cultural Heritage Disputes," in *Claiming the Stones, Naming the Bones: Cultural Property and the Negotiation of National and Ethnic Identity*, ed. Elazar Barkan and Ronald Bush, pp. 162–97 (Los Angeles: Getty Research Institute, 2002), p. 173.

20. Matthew H. Birkhold, "Tipping NAGPRA's Balancing Act: The Inequitable Disposition of 'Culturally Unidentified' Human Remains Under NAGPRA's New Provision," *William Mitchell Law Review* 37, no. 4 (2010): 2046–96.

21. "SAA Written Statement on H.R. 5237, H.R. 1646, and H.R. 1381, For the House Committee on Interior and Insular Affairs, July 17, 1990, presented by Keith W. Kintigh," http://rla.unc.edu/saa/repat/ (accessed June 1, 2015).

22. "Report of the Panel for a National Dialogue on Museum/Native American Relations, February 28, 1990," *Museum Anthropology* 14, no. 1 (1990): 6–13, p. 6.

23. This quote and next from Lynne Goldstein et al., "Report of the Panel for a National Dialogue on Museum/Native American Relations: A Minority View," *Museum Anthropology* 14, no. 1 (1990): 15–16, p. 15.

24. This paragraph is based on McKeown, *In the Smaller Scope of Conscience*, p. 65.

25. Seidemann, "Altered Meanings," p. 5.

26. This paragraph is based on McKeown, *In the Smaller Scope of Conscience*, p. 65.

27. Trope and Echo-Hawk, "The Native American Graves Protection and Repatriation Act," p. 143.

28. 25 USC 3006.8(c)(5).

29. Jon Daehnke and Amy Lonetree, "Repatriation in the United States: The Current State of the Native American Graves Protection and Repatriation Act," *American Indian Culture and Research Journal* 35, no. 1 (2011): 87–97, p. 93.

30. Letter from Steve Terry to Elizabeth Montour, February 8, 2000, Miccosukee NAGPRA Files, DMNS.

31. 43 CFR 10.12(b)(i); 25 USC 3003(b)(2).

32. Letter from Steve Terry to Susan Irwin-Savage, December 5, 2000, Miccosukee NAGPRA Files, DMNS.

CHAPTER TWENTY-TWO

1. "The Forgotten Indians," *Atlanta Journal*, November 16, 1986.

2. "Controversy Over Bones," *Des Moines Register*, July 11, 1971.

3. This section and quotes, some edited, are from Maria D. Pearson, "Give Me Back My People's Bones: Repatriation and Reburial of American Indian Skeletal Remains in Iowa," *Journal of the Iowa Archaeological Society* 52, no. 1 (2005): 7–12. See also David Mayer Gradwohl et al., eds., "Still Running: A Tribute to Maria Pearson, Yankton Sioux," *Journal of the Iowa Archaeological Society* 52, no. 1 (2005).

4. Nathalie Angier, "About Death, Just Like Us or Pretty Much Unaware?" *New York Times*, September 1, 2008.

5. Paul Pettitt, *The Palaeolithic Origins of Human Burial* (New York: Routledge, 2010), pp. 63, 79, 81.

6. Avril Maddrell and James D. Sidaway, eds., *Deathscapes: Spaces for Death, Dying, Mourning and Remembrance* (Surrey: Ashgate, 2010).

7. William Engelbrecht, *Iroquoia: The Development of a Native World* (Syracuse, NY: Syracuse University Press, 2005), p. 178.

8. Dongoske, "The Native American Graves Protection and Repatriation Act"; E. A. Kennard, "Hopi Reactions to Death," *American Anthropologist* 39, no. 3 (1937): 491–96.

9. Morris Edward Opler, "The Lipan Apache Death Complex and Its Extensions," *Southwestern Journal of Anthropology* 1, no. 1 (1945): 122–41.

10. Riding In, "Without Ethics and Morality," p. 13.

11. Cushing, "Exploration of Ancient Key Dweller Remains on the Gulf Coast of Florida."

12. Marquardt, "The Emergence and Demise of the Calusa," p. 167. See also Marquardt, "Calusa," p. 210.

13. Duane Anderson and Joseph A. Tiffany, "Beginnings: Maria Pearson and Her Role in the Formulation of Iowa's Burial Law and the Development of the Indian Advisory Committee of the Office of the State Archaeologist of Iowa," *Journal of the Iowa Archaeological Society* 52, no. 1 (2005): 29–35, pp. 29–30, 35.

14. Jerome L. Thompson, "We Do Not Own or Control History," p. 58.

CHAPTER TWENTY-THREE

1. Tina Griego, "A Long Time Coming for Reburial," *Denver Post*, July 14, 2009.

2. Ewen Callaway, "Genome Results Rekindle Legal Row: 'Kennewick Man' Sequencing Shows Native American Roots," *Nature* 522 (2015): 404–5, p. 405.

3. Letter from Fred Dayhoff and Steve Terry to Chip Colwell, Miccosukee NAGPRA Files, DMNS.

4. Florida Title XLVI Chapter 872.01.

5. Florida Title XLVI Chapter 872.02(1).

6. MacMahon and Marquardt, *The Calusa and Their Legacy*, p. 83.

7. Geoffrey Scarre, "Archaeology and Respect for the Dead," *Journal of Applied Philosophy* 203 (2003): 237–49, p. 243. See also Justin Colquhoun, "Reburying the Dead: The Effects of NAGPRA on Our Relationships and Obligations to the Deceased," *Anthropology of Consciousness* 11, no. 1 (2000): 64–69.

8. John Alan Cohan, "An Examination of Archaeological Ethics and the Repatriation Movement Respecting Cultural Property (Part One)," *Environs: Environmental Law and Policy Journal* 27, no. 1 (2003): 349–442, pp. 405–6; Chip Colwell and Stephen E. Nash, "Repatriating Human Remains in the Absence of Informed Consent," *SAA Archaeological Record* 15, no. 1 (2015): 14–16.

9. 25 USC 3001.2(13).

10. Callaway, "Genome Results Rekindle Legal Row," p. 405.

11. Liv Nilsson Stutz, "Claims to the Past: A Critical View of the Arguments Driving Repatriation of Cultural Heritage and Their Role in Contemporary Identity Politics," *Journal of Intervention and Statebuilding* 7, no. 2 (2013): 170–95. See also Tiffany Jenkins, *Contesting Human Remains in Museum Collections: The Crisis of Cultural Authority* (London: Routledge, 2011).

12. Clayton W. Dumont Jr., "The Politics of Scientific Objections to Repatriation," *Wicazo Sa Review* 18, no. 1 (2003): 109–28; D. S. Pensley, "The Native American Graves Protection and Repatriation Act (1990): Where the Native Voice Is Missing," *Wicazo Sa Review* 20, no. 2 (2005): 37–64; Steve Russell, "Law and Bones: Religion, Science, and the Discourse of Empire," *Radical History Review* 99, (Fall 2007): 214–26.

13. Michelle D. Hamilton, "Adverse Reactions: Practicing Bioarchaeology among the Cherokee," in *Under the Rattlesnake: Cherokee Health and Resiliency*, ed. Lisa J. Lefler, pp. 29–60 (Tuscaloosa: University of Alabama Press, 2009), p. 36.

14. Michael Sappol, *A Traffic of Dead Bodies: Anatomy and Embodied Social Identity in Nineteenth-Century America* (Princeton, NJ: Princeton University Press, 2002), p. 123. For this paragraph, see also Caroline Alexander, "Across the River Styx: The Mission to Retrieve the Dead," *New Yorker* (October 25, 2004): 44–51; Chip Colwell-Chanthaphonh, "The Disappeared: Power Over the Dead in the Aftermath of 9/11," *Anthropology Today* 27, no. 3 (2011): 5–11; Kieran McEvoy and Heather Conway, "The Dead, the Law, and the Politics of the Past," *Journal of Law and Society* 31, no. 4 (2004): 539–562, pp. 554–61; and Tsosie, "NAGPRA and the Problem of 'Culturally Unidentifiable' Remains," pp. 877–78.

15. This section unless otherwise cited is largely drawn from Johnson, *Sacred Claims*.

16. This paragraph and next are from "NAGPRA Review Committee Meeting, April 29–May 1, 1992," https://irma.nps.gov/App/Reference/Profile /2193294 (accessed November 12, 2014).

17. Veletta Canouts, "Draft Recommendations Regarding the Disposition of Culturally Unidentifiable Human Remains and Associated Funerary Objects," *Federal Register* 60, no. 118 (1995): 32163–65, p. 32163.

18. Ibid.

19. "Implementation of the Native American Graves Protection and Repatriation Act, Hearing Before the Committee on Indian Affairs, United States Senate, December 5, 1995," www.archive.org/stream/implementationofn1996unit /implementationofn1996unit_djvu.txt (accessed June 4, 2015). See also Joe Watkins, "Becoming American or Becoming Indian? NAGPRA, Kennewick and Cultural Affiliation," *Journal of Social Archaeology* 4, no. 1 (2004): 60–80.

20. "Comments on Draft Recommendations by the NAGPRA Review Committee Regarding the Disposition of Culturally Unidentifiable Remains by the SAA Task Force on Repatriation, 09/26/1995," http://saa.org/Aboutthe Society/GovernmentAffairs/RepatriationIssues/RepatriationArchive/NAGPRA ReviewCommitteeIssuesandDocuments/tabid/1410/Default.aspx (accessed June 27, 2015).

21. Shackley, "Relics, Rights, and Regulations," p. 115.

22. Quotes in this paragraph are from Memo: "Latest Proposed NAGPRA Regulation Wording and Our Response, from Bob Pickering to Raylene Decatur," September 22, 1995, DMNS.

23. "Denver Museum of Natural History's Anthropology Department Position Statement on Unaffiliated Human Remains," 141-01-21-97.3, NAGPRA 1994, DMNS.

24. Veletta Canouts, "Draft Recommendations Regarding the Disposition of Culturally Unidentifiable Human Remains and Associated Funerary Objects," *Federal Register* 61, no. 162 (1996): 43071–73.

25. This and next quote from "Society for American Archaeology Comments on Draft Recommendations by the NAGPRA Review Committee Regarding the Disposition of Culturally Unidentifiable Remains by William A. Lovis and William D. Lipe, 10/06/1996," http://saa.org/AbouttheSociety/Government Affairs/RepatriationIssues/RepatriationArchive/NAGPRAReviewCommittee IssuesandDocuments/tabid/1410/Default.aspx (accessed June 20, 2015).

26. See Tsosie, "NAGPRA and the Problem of 'Culturally Unidentifiable' Remains," p. 834.

27. Dean R. Snow, "President's Briefing on NAGPRA," *SAA Archaeological Record* 8, no. 1 (2008): 1, 45, p. 1.

28. Kintigh, "NAGPRA, SAA, and Culturally Unidentifiable Human Remains," p. 6.

29. All quotes in this paragraph come from "Society for American Archaeology Statement on Department of Interior Proposed Rule for the Disposition of Culturally Unidentifiable Human Remains and Funerary Objects, November 10, 2007," http://rla.unc.edu/saa/repat/ (accessed June 3, 2015).

30. See also Robert H. McLaughlin, "NAGPRA, Dialogue, and the Politics of Historical Authority," in *Legal Perspectives on Cultural Resources*, ed. Jennifer R. Richman and Marion P. Forsyth, pp. 185–201 (Walnut Creek, CA: AltaMira Press, 2004), pp. 195–96.

31. Seidemann, "Altered Meanings," p. 18.

32. Rebecca Tsosie, "Native Nations and Museums: Developing an Institutional Framework for Cultural Sovereignty," *Tulsa Law Review* 45, no. 1 (2009): 3–22, p. 13.

33. GAO, *Report to Congressional Requesters: Native American Graves Protection and Repatriation Act* (Washington, DC: United States Government Accountability Office, 2010), p. 17. On federal agencies' failure to comply with NAGPRA, see also Lucus Ritchie, "Indian Burial Sites Unearthed: The Misapplication of the Native American Graves Protection and Repatriation Act," *Public Land & Resources Law Review* 26 (2005): 71–96.

34. "NAGPRA Review Committee Meeting Minutes (May 23–24, 2009)," www.cr.nps.gov/nagpra/REVIEW/meetings/RMS039.pdf (accessed July 3, 2015).

35. Birkhold, "Tipping NAGPRA's Balancing Act," p. 2060.

36. For these myriad reasons, see Beisaw, "Memory, Identity, and NAGPRA in the Northeastern United States," p. 253; Isaac, "Implementation of NAGPRA," pp. 163, 166; Andrew Lawler, "Grave Disputes," *Science* 330, no. 6001

(2010): 166–70, p. 168; James Riding In, "Graves Protection and Repatriation: An Unresolved Universal Human Rights Problem Affected by Institutional Racism," in *Human Rights in Global Light: Selected Papers, Poems, and Prayers, SFSU Annual Human Rights Summits, 2004–2007*, pp. 37–42 (San Francisco: Treganza Museum Anthropology Papers 24 and 25, 2008); James Riding In et al., "Protecting Native American Human Remains, Burial Grounds, and Sacred Places," *Wicazo Sa Review* 19, no. 2 (2004): 169–83, p. 181; and Tsosie, "Native Nations and Museums."

37. Heather Burke et al., eds., *Kennewick Man: Perspectives on the Ancient One* (Walnut Creek, CA: Left Coast Press, 2008); James C. Chatters, *Ancient Encounters: Kennewick Man and the First Americans* (New York: Simon & Schuster, 2001); Roger Downey, *The Riddle of the Bones: Politics, Science, Race and the Story of Kennewick Man* (New York: Springer-Verlag, 2000); Thomas, *Skull Wars*.

38. Douglas Preston, "The Kennewick Man Finally Freed to Share His Secrets," *Smithsonian Magazine*, September 2014, www.smithsonianmag.com /history/kennewick-man-finally-freed-share-his-secrets-180952462/?no-ist =&preview=_page%3D3&page=1 (accessed June 1, 2015). See also Elizabeth Weiss, "Kennewick Man's Funeral: The Burying of Scientific Evidence," *Politics & the Life Sciences* 20, no. 1 (2001): 13–18.

39. 25 USC 3001.2(9).

40. Jennifer A. Hamilton, *Indigeneity in the Courtroom: Law, Culture, and the Production of Difference in North American Courts* (New York: Routledge, 2009), p. 83, emphasis in original.

41. Francis P. McManamon, "Kennewick Man," in *The Oxford Companion to Archaeology*, ed. Neil Asher Silberman, pp. 178–82 (Oxford: Oxford University Press, 2012), p. 182.

42. Tsosie, "NAGPRA and the Problem of 'Culturally Unidentifiable' Remains," p. 828.

43. McKeown, *In the Smaller Scope of Conscience*, p. 12. See also Ryan M. Seidemann, "Time for a Change? The Kennewick Man Case and Its Implications for the Future of the Native American Graves Protection and Repatriation Act," *West Virginia Law Review* 106, no. 1 (2003): 149–76, pp. 165–69.

44. This quote and next in McKeown, *In the Smaller Scope of Conscience*, p. 93.

45. "Statement of the Society for American Archaeology, Presented by Keith W. Kintigh, Senate Committee on Indian Affairs, Oversight Hearing on the Native American Graves Protection and Repatriation Act, July 28, 2005," http://rla.unc.edu/saa/repat/ (accessed June 3, 2015). See also Heather J. H. Edgar et al., "Contextual Issues in Paleoindian Repatriation," *Journal of Social Archaeology* 7, no. 1 (2007): 101–22; Robert L. Kelly, "Kennewick Man Is Native American," *SAA Archaeological Record* 4, no. 5 (2004): 33–37.

46. "Statement of the American Association of Physical Anthropologists, Presented by Patricia M. Lambert, Senate Committee on Indian Affairs, Oversight Hearing on the Native American Graves Protection and Repatriation Act, July 28, 2005," http://rla.unc.edu/saa/repat/ (accessed June 19, 2015).

47. Zoe E. Niesel, "Better Late than Never? The Effect of the Native American Graves Protection and Repatriation Act's 2010 Regulations," *Wake Forest Law Review* 86 (2011): 837–65, p. 855.

48. Tsosie, "NAGPRA and the Problem of 'Culturally Unidentifiable' Remains," p. 829.

49. Douglas W. Owsley and Richard L. Jantz, eds., *Kennewick Man: The Scientific Investigation of an Ancient American Skeleton* (College Station: Texas A&M Press, 2014).

50. Vincent Carroll, "The Kennewick Man Finally in Full Focus," *Denver Post*, September 6, 2014.

51. Morten Rasmussen et al., "The Ancestry and Affiliations of Kennewick Man," *Nature*, June 18, 2015. On questions of genomics, race, and repatriation, particularly for very ancient remains, see Jessica Bardill, "Native American DNA: Ethical, Legal, and Social Implications of an Evolving Concept," *Annual Review of Anthropology* 43 (2014): 155–66; Eric Beckenhauer, "Redefining Race: Can Genetic Testing Provide Biological Proof of Indian Ethnicity?" *Stanford Law Review* 56, no. 1 (2003): 161–91; Suzanne J. Crawford, "(Re)Constructing Bodies: Semiotic Sovereignty and the Debate over Kennewick Man," in *Repatriation Reader: Who Owns American Indian Remains?*, ed. Devon A. Mihesuah, pp. 211–38 (Lincoln: University of Nebraska Press, 2000); Allison M. Dussias, "Kennewick Man, Kinship, and the 'Dying Race': The Ninth Circuit's Assimilationist Assault on the Native American Graves Protection and Repatriation Act," *Nebraska Law Review* 84, no. 1 (2005): 55–161; Roger C. Echo-Hawk, *NAGPRA and the Future of Racial Sovereignties* (Seattle: Amazon Digital Services, 2011); Peter N. Jones, "Using Genetic Material in Cultural Affiliation Studies: Cautions and Limitations for NAGPRA Cases," *Anthropology News* 51, no. 3 (2010): 6–7; Arion T. Mayes, "These Bones Are Read: The Science and Politics of Ancient Native America," *American Indian Quarterly* 34, no. 2 (2010): 131–56; S. Alan Ray, "Native American Identity and the Challenge of Kennewick Man," *Temple Law Review* 79, no. 1 (2006): 89–154; Will R. Ripley, "You're Not Native American—You're Too Old: *Bonnichsen v. United States* Exposes the Native American Graves Protection and Repatriation Act," *Journal of Gender, Race and Justice* 9 (2005): 137–60; Kimberly Tall Bear, "DNA, Blood, and Racializing the Tribe," *Wicazo Sa Review* 18, no. 1 (2003): 81–107; Jace Weaver, "Indian Presence with No Indians Present: NAGPRA and Its Discontents," *Wicazo Sa Review* 12, no. 2 (1997): 13–30; and Larry J. Zimmerman, "Public Heritage, a Desire for a 'White' History

of America, and Some Impacts of the Kennewick Man/Ancient One Decision," *International Journal of Cultural Property* 12, no. 2 (2005): 261–70.

52. Watkins, "Becoming American or Becoming Indian?," p. 72.

53. Andrew Lawler, "Can a Skeleton Heal Rift between Native Americans, Scientists?" *National Geographic*, July 15, 2015. See also John Travis, "Honoring His Ancestor by Studying His DNA," *Science* 330, no. 6001 (2010): 172.

54. Stuart J. Fiedel, "The Kennewick Follies: 'New' Theories about the Peopling of the Americas," *Journal of Anthropological Research* 60, no. 1 (2004): 75–110.

55. Sandi Doughton, "Inslee to Corps: Give Kennewick Man to Tribes," *Seattle Times*, June 23, 2015.

56. Callaway, "Genome Results Rekindle Legal Row," 405. See also Chip Colwell, "How Should the Ancient One's Story End?," *Denver Post*, May 15, 2016.

57. Jonathan Halvorson, "Bill to Bring Kennewick Man Back to Columbia Basin Tribes," *NBC Right Now*, August 19, 2015.

58. Niesel, "Better Late than Never?," p. 837. See also Peregoy, "Nebraska's Landmark Repatriation Law."

59. Jodi Rave Lee, "Unclear Policy Holds Up Repatriation Fate of Bones Is Still Uncertain," *Lincoln Journal Star*, April 7, 2000.

60. Griego, "A Long Time Coming for Reburial."

CHAPTER TWENTY-FOUR

1. Rob Capriccioso, "Scientists Ponder NAGPRA Lawsuit," *Indian Country Today*, April 14, 2010.

2. Rivera, "The Reburial of Our Ancestors," p. 12.

3. Lynn S. Teague, "Respect for the Dead, Respect for the Living," in *Human Remains: Guide for Museums and Academic Institutions*, ed. Vicki Cassman et al., pp. 245–59 (Lanham, MD: AltaMira Press, 2007), p. 245.

4. GAO, *Report to Congressional Requesters: Native American Graves Protection and Repatriation Act*, p. 75.

5. Robert L. Kelly, "Bones of Contention," *New York Times*, December 13, 2010. See also Chip Colwell-Chanthaphonh, "Native American Remains," *New York Times*, December 26, 2010.

6. Letter from Dean Snow et al. to Margaret Conkey, April 11, 2010, copy in NAGPRA files, DMNS.

7. On the response to this line of argument, see Russell Thornton, "Who Owns Our Past? The Repatriation of Native American Human Remains and Cultural Objects," in *Studying Native America: Problems and Prospects*, ed. Russell Thornton, pp. 385–415 (Madison: University of Wisconsin Press, 1998), p. 393.

8. "Letter from Bruce D. Smith, Smithsonian Inst. et al., to Ken Salazar,

Sec'y of the Interior, Dep't of the Interior (May 17, 2010)," www.friendsofpast
.org/nagpra/2010NAGPRA/Smith517.pdf (accessed July 1, 2015).

9. Capriccioso, "Scientists Ponder NAGPRA Lawsuit." See also Joe Duggan,
"Returning What's Theirs," *Lincoln Journal Star*, October 10, 2010.

10. John Alan Cohan, "An Examination of Archaeological Ethics and the Re-
patriation Movement Respecting Cultural Property (Part Two)," *Environs: Envi-
ronmental Law and Policy Journal* 28, no. 1 (2004): 1–115, p. 9.

11. Birkhold, "Tipping NAGPRA's Balancing Act."

12. Scott Lauck, "The Spirits Can Rest," *Missouri Lawyers Media*, February 20,
2011.

13. Daehnke and Lonetree, "Repatriation in the United States," p. 93.

14. Sherry Hutt, "If Geronimo Was Jewish: Equal Protection and the Cul-
tural Property Rights of Native Americans," *Northern Illinois University Law Re-
view* 24, no. 3 (2004): 527–62.

15. Sherry Hutt and Jennifer Riddle, "The Law of Human Remains and Buri-
als," in *Human Remains: Guide for Museums and Academic Institutions*, ed. Vicki Cass-
man et al., pp. 223–43 (Lanham, MD: AltaMira Press, 2007), p. 236.

16. Native American Grave and Burial Protection Act (repatriation); Native
American Repatriation of Cultural Patrimony Act; and Heard Museum Report:
Hearing Before the Select Committee on Indian Affairs, United States Senate,
One Hundred First Congress, Second Session, on S. 1021 . . . and S. 1980 . . .
May 14, 1990, Washington, DC, on file, DMNS.

17. Kintigh, "NAGPRA, SAA, and Culturally Unidentifiable Human Re-
mains," p. 5.

18. Keith Kintigh and Vincas P. Steponaitis, "Letter to the Editor," *SAA Ar-
chaeological Record* 15, no. 3 (2015): 3, p. 3.

19. William A. Lovis et al., "Archaeological Perspectives on the NAGPRA:
Underlying Principles, Legislative History, and Current Issues," in *Legal Per-
spectives on Cultural Resources*, ed. Jennifer R. Richman and Marion P. Forsyth,
pp. 165–84 (Walnut Creek, CA: AltaMira Press, 2004), p. 173.

20. Riding In, "Repatriation," p. 111; Trope and Echo-Hawk, "The Native
American Graves Protection and Repatriation Act."

21. Dumont, "Contesting Scientists' Narrations of NAGPRA's Legislative
History Rule 10.11 and the Recovery of 'Culturally Unidentifiable' Ancestors,"
p. 10.

22. Ibid., p. 20.

23. Ibid., emphasis in original.

24. Thomas, *Skull Wars*, p. 231. See also John McCain, "Repatriation: Balanc-
ing Interests," *Arizona State Law Journal* 24, no. 1 (1992): 5–6.

25. Dumont, "Contesting Scientists' Narrations of NAGPRA's Legislative

History Rule 10.11 and the Recovery of 'Culturally Unidentifiable' Ancestors," p. 30. Contradictorily, Inouye also has said that NAGPRA represents a balance between these interests: Daniel K. Inouye, "Repatriation: Forging New Relationships," *Arizona State Law Journal* 24, no. 1 (1992): 1–3, p. 2. See also McKeown and Hutt, "In the Smaller Scope of Conscience," pp. 211–12.

26. Tsosie, "NAGPRA and the Problem of 'Culturally Unidentifiable' Remains," p. 813.

27. Fine-Dare, *Grave Injustice*, p. 161.

28. "Denver Museum of Nature & Science Statement on the NAGPRA Disposition of Culturally Unidentifiable Human Remains Final Rule (43 CFR 10.11)," NAGPRA Files, DMNS.

29. Sherry Hutt, "Notice of Inventory Completion," *Federal Register* 76, no. 50 (2011): 14061–62.

30. "Notices of Inventory Completion Using the CUI Rule 10.11," www.nps.gov/nagpra/ONLINEDB/CUIRule10.11.pdf (accessed July 1, 2015).

31. Seidemann, "Altered Meanings," p. 60.

32. Dylan Brown, "The Spoils of War: NAGPRA 25 Years Later," *Indian Country Today*, June 9, 2015. See also Megon Noble, "Beyond 10.11: Repatriation of Culturally Unidentifiable Remains from Areas Unknown," *SAA Archaeological Record* 15, no. 1 (2015): 17–20.

33. Sudhin Thanawala, "Tribes Retrieve Remains from Researchers, Agencies," *Washington Post*, January 16, 2012.

CONCLUSION

1. Frederic James Grant, *History of Seattle, Washington* (New York: American Publishing and Engraving Co., 1891), pp. 435–36.

2. Morell, "An Anthropological Culture Shift," p. 22.

3. On the care of human remains pending claims, see Gary S. McGowan and Cheryl J. LaRoche, "The Ethical Dilemma Facing Conservation: Care and Treatment of Human Skeletal Remains and Mortuary Objects," *Journal of the American Institute for Conservation* 35, no. 2 (1996): 109–21.

4. Chip Colwell-Chanthaphonh et al., "Anthropology: Unearthing the Human Experience," *Denver Museum of Nature & Science Annals* 4 (2013): 283–35, pp. 325–26.

5. Chip Colwell-Chanthaphonh and T. J. Ferguson, eds., *Collaboration in Archaeological Practice: Engaging Descendant Communities* (Lanham, MD: AltaMira Press, 2008); Kurt E. Dongoske et al., eds., *Working Together: Native Americans and Archaeologists* (Washington, DC: Society for American Archaeology, 2000); T. J. Ferguson and Chip Colwell-Chanthaphonh, *History Is in the Land: Multivocal Tribal Traditions in Arizona's San Pedro Valley* (Tucson: University of Arizona Press,

2006); T. J. Ferguson, "Improving the Quality of Archaeology in the United States through Consultation and Collaboration with Native Americans and Descendant Communities," in *Archaeology and Cultural Resource Management: Visions for the Future*, ed. Lynne Sebastian and William D. Lipe, pp. 169–93 (Santa Fe: School for Advanced Research Press, 2009); Jordan E. Kerber, ed., *Cross-Cultural Collaboration: Native Peoples and Archaeology in the Northeastern United States* (Lincoln: University of Nebraska Press, 2006); Michael Newland, "Climate Change, Archaeology, and Tribal Collaboration: A View from California," *SAA Archaeological Record* 15, no. 1 (2015): 33–35; John C. Ravesloot, "The Road to Common Ground," *Federal Archaeology* 7, no. 3 (1995): 36–38; Stephen W. Silliman, ed., *Collaborating at the Trowel's Edge: Teaching and Learning in Indigenous Archaeology* (Tucson: University of Arizona Press, 2008); Nina Swidler et al., eds., *Native Americans and Archaeologists: Stepping Stones to Common Ground* (Walnut Creek, CA: AltaMira Press, 1997); Kelly D. Wiltshire, "Changes in Mindset: The Development of Collaborative Research Methodology," *Archaeological Review from Cambridge* 26, no. 2 (2011): 31–43.

6. Morell, "An Anthropological Culture Shift," p. 22.

7. Preston, "Skeletons in Our Museums' Closets," p. 72.

8. Jerome C. Rose et al., "NAGPRA Is Forever: Osteology and the Repatriation of Skeletons," *Annual Review of Anthropology* 25 (1996): 81–103, p. 81.

9. Morris Abraham et al., "Implementing NAGPRA: The Effective Management of Legislated Change in Museums," *Management Decision* 40, nos. 1–2 (2002): 35–50; Melissa F. Baird and Ruthann Knudson, "In the Spirit of Old Friends: Reflections on Repatriation at Agate Fossil Beds National Monument, Nebraska," *Heritage of the Great Plains* 42, no. 2 (2009): 35–48; Kimberly Christen, "Following the Nyinkka: Relations of Respect and Obligations to Act in the Collaborative Work of Aboriginal Cultural Centers," *Museum Anthropology* 30, no. 2 (2007): 101–24; Mille Gabriel and Jens Dahl, eds., *Utimut: Past Heritage—Future Partnerships—Discussions on Repatriation in the 21st Century*, Document No. 122 (Copenhagen: Greenland National Museum & Archives, 2008); Sara L. Gonzalez and Ora Marek-Martinez, "NAGPRA and the Next Generation of Collaboration," *SAA Archaeological Record* 15, no. 1 (2015): 11–13; Cecily Harms, "NAGPRA in Colorado: A Success Story," *University of Colorado Law Review* 83, no. 2 (2012): 593–632; Dorothy Lippert, "Not the End, Not the Middle, but the Beginning: Repatriation as a Transformative Mechanism for Archaeologists and Indigenous Peoples," in *Collaboration in Archaeological Practice: Engaging Descendant Communities*, ed. Chip Colwell-Chanthaphonh and T. J. Ferguson, pp. 119–30 (Lanham, MD: AltaMira Press, 2008); Susan Rowley, "The Reciprocal Research Network: The Development Process," *Museum Anthropology Review* 7, nos. 1–2 (2013): 22–43; Tim Sullivan et al., "NAGPRA: Effective Repatriation Programs

and Cultural Change in Museums," *Curator* 43, no. 3 (2010): 231–60; Joe E. Watkins, "The Repatriation Arena: Control, Conflict, and Compromise," in *Opening Archaeology: Repatriation's Impact on Contemporary Research and Practice*, ed. Thomas W. Killion, pp. 161–77 (Santa Fe: SAR Press, 2008); Rosita Worl, "NAGPRA: Symbol of a New Treaty," *Federal Archaeology* 7, no. 3 (1995): 34–35; Larry J. Zimmerman, "Multivocality, Descendant Communities, and Some Epistemological Shifts Forced by Repatriation," in *Opening Archaeology: Repatriation's Impact on Contemporary Research and Practice*, ed. Thomas W. Killion, pp. 91–107 (Santa Fe: SAR Press, 2008).

A NOTE ON THE TERMS AMERICAN INDIAN, NATIVE AMERICAN, ETC.

1. Samuel Eliot Morison, *The Great Explorers: The European Discovery of America* (Oxford: Oxford University Press, 1978), p. 383.

2. Norman J. W. Thrower, *Maps and Civilization: Cartography in Culture and Society*, 3rd ed. (Chicago: University of Chicago Press, 2008), p. 71.

3. "Indians," http://dictionary.reference.com/browse/indians (accessed November 21, 2014).

4. Roger Echo-Hawk, *The Magic Children: Racial Identity at the End of the Age of Race* (Walnut Creek, CA: Left Coast Press, 2010); Echo-Hawk, *NAGPRA and the Future of Racial Sovereignties*.

INDEX

Page numbers in italics indicate illustrations.

Abrams, George, 172
AC.35B, 113, 119
Acoma, 249
Adams, Robert McCormick, 82, 83, 87, 88, 220
afterlife, concepts of, 228, 229
Agassiz, Louis, 87
Ahayu:da (Zuni War Gods), 16, 267; art world views of, 33–34; auctions of, 38–39; collections of, 19, 24; Cranes' acquisition of, 30–32; culturally appropriate returns of, 39–40; Cushing's, 57–58; Denver Art Museum, 36–37, 40–44; at Denver Museum of Nature & Science, 44–45; in Europe, 55–59, 60–61; manufacture of, 21–22; recovering, 34–38, 48–54, 174; shrines to, 13–14, *18*, 24–25, 47
AIM. *See* American Indian Movement
AIRFA. *See* American Indian Religious Freedom Act
Akaka, Daniel, 222

Akerley, Robert, 30
Alaña, Joseph Javier, 229–30
Alaska, 137, 139, 147
Alaskan Natives, 272. *See also* Tlingit
Alaska State Museum, Tlingit clan regalia in, 132, 193
Alexander, Clarence "Pop," 214
altars, War God, 14, 22
American Association of Museums, 106–7, 218
American Association of Physical Anthropologists, 245
American Indian, as term, 271–74. *See also various cultural groups; tribes*
American Indian Art, 33
American Indian Movement (AIM), 76–77, 78–79, 232, 236
American Indian Religious Freedom Act (AIRFA), 42
American Museum of Natural History, 104, 138, 164
Americans for Indian Opportunity, 44

ancestors, ancestral spirits, 1, 2, 6, 20, 192, 202; responsibility for, 218–19, 228, 239–40

Anderson, Duane, 232, 233, 268

Angoon, AK, 166, 186

Antelope, Joe, 92

Anthony, Scott J., 72, 99

antiquarianism, 6

Antiquities Act (1906), 212

Antone, Cecil, 239

Apaches, 35, 229

Apalachee Indians, 209

Arapaho, 250; dispersal of, 98–99; peace talks, 71–72; and Sand Creek Massacre, 68–70

Archaeological Resources Protection Act, and Kennewick Man, 244

archaeologists: and NAGPRA, 172, 257; on repatriation legislation, 103, 104, 106–7; on unaffiliated remains, 219, 221, 241–42, 244, 253–54

archaeology, 233; AIM actions against, 76–77; Calusa, 210–12, 214–15, 224; as colonial, 77–78; looting and, 83, 85–87; Native American opposition to, 5, 6

Arizona State Museum, 6, 79, 83

Army Medical Museum, human remains in, 84–85, 86

Arrowsmith, Rex, 58

artifacts, from Zuni, 22–23

art world, War Gods and, 33–34, 35

A:shiwi A:wan Museum and Heritage Center, 265–66

at.óow, 135–36, 140, 186; reclaiming, 179–84; repository for, 190–93; selling of, 136–37, 151–52, 159

auctions: of massacre trophies, 127; of Zuni War Gods, 38–39

Australia, 122

balance, restoration of, 25, 35, 41

Bear Clan, Ma'a'sewi manufacture, 21–22, 34

Bellecourt, Clyde, 76, 77

Bellecourt, Vernon, 77

Bennett, George, 179, 183; on clan ownership, 181–82

Bent's Old Fort, and Sand Creek Massacre remains, 120, 123

Big Boy, Marla, 247

Big Man's Shirt (Lingit Tlein Kudas'), 190, 191

Big Medicine, Joe, 94, 102, 121; and Sand Creek Massacre repatriations, 122–23

biological anthropologists, and Kennewick Man, 244

Bishop Museum, repatriation legislation, 105

Black, Richard, 255

Blackfeet, 85

Black Kettle, 69, 71, 72, 73

blood relationships, and human remains repatriation, 219–20

Boas, Franz, 132, 139, 205

bodies, mutilation of Sand Creek, 96–97

Bones Bill, 75–76

Bonnichsen et al. v. the United States, 244, 248

Bonsall, Samuel W., 84, 87

Bowen, James, 165

Bow Priesthood, 16, 21, 31, 34, 57; recovering War Gods, 38–39, 40; sacred objects of, 17–18; War Gods shrine, 24, 36

Bradley, James (X'a.áxch; Keishísh'), 152, 196

Bratley, Jesse H., 224

Breeden, Philip, 60

Bridge of Respect Act, 75–76, 218

Bring the Ancient One Home Act, 247
British, in southeastern United States, 207, 209
British Museum, Parthenon Marbles, 3, 58–59
Brooklyn Museum, 7, 17, 47; Northwest Coast art, 141, 142; Stewart Culin at, 15–16; Zuni War Gods at, 19, 38
Brown, Steve, 167
Buffalo, Connie, 102
Buffalo and Erie County Historical Society, 172
bundles: Hidatsa sacred, 35; Navajo medicine, 175; Northern Cheyenne sacred, 74
Bunzel, Ruth L., 25
Bureau of Ethnology, 23, 210
Bureau of Indian Affairs, 16, 36, 144, 148, 149
burial mounds, Calusa, 211–12, *214*, 229–30
burials, 76, 94; customs, 227–30; discrimination in treatment of, 225–26; respect for, 239–40
Burke Museum (Seattle), 152, 196, 246
Bush, George H. W., 107, 108

Cacaydayat, 151
Cahill, Luke, 84
Calusa, 205, 206–7, 209, 238; archaeology, 210–12, 214–15; as non-affiliated, 201, 204, 216, 217, 223–24; repatriation of, 260–61; treatment of the dead, 229–30, 234–35
Campbell, Ben Nighthorse, 88, 123; on unaffiliated remains, 221–22
Camp Weld Council, *71*
Canada, 174, 272; potlatch in, 139, 140–41, 175

Cannon, James D., 96
canoe, war (Shakes), 151
Cape Mudge, Kwagiulth Museum at, 175
Carpenter, Edmund, 164, 169
Cellicion, Dexter, 36
Celmer, Gail, 247
cemeteries, 227–28; in Iowa, 225–26, 233, 261
Central Council Tlingit and Haida Tribes of Alaska, 168
ceremonials, for reburial, 93–94
Cheyenne, 109, 250; dispersal of, 98–99; and museum collections, 114–15; peace talks, 71–72; repatriation and, 91–94; and Sand Creek Massacre, 68–70, 99–100
Cheyenne and Arapaho Tribes, 89, 250; and human remains, 113, 116–17
Cheyenne Peace Chiefs, 91
Chilkat, 155; Whale House carvings, 156–57
Chilkat blankets, 151
Chilkat Indian Village v. Michael R. Johnson, 164, 170
Chinook Indian Nation, 78
Chivington, John, 69–70, 71, 72, 98
Chivington, CO, 98, 124
Christianity, Tlingit and, 39, 147
Churchill, Amy K., 152–53
citizenship, Native American, 147–48
Civilian Conservation Corps (CCC), Native arts promotion, 148–49
clan houses: Klukwan, 154–56, *157*; Shakes Island, 148–49
clans, 168, 177; communal property of, 135–36, 139–40, 156, 158–59, 161–64, 165, 169–70, 179–84
Clark, Arthur C., 36
Clark, J. C., 147

Clark, Jerri, 190
Clatsop County Historical Society, 78
Cleveland Art Museum, 42
Cole, Douglas, 141, 162
collaboration, tribe-museum, 114,
 262, 265
collections, collecting, 4, 15, 214;
 Chief Shakes items, 151–52;
 Crane, 27–30; Hrdlička's, 212; of
 Indian trophies, 100–101, 127; of
 Klukwan Whale House carvings,
 154–55, 156–58, 159–61, 163–64;
 of Northwest Coast art, 137–38,
 141–42, 169; of sacred objects, 18–
 19; spiritual dangers of, 77–78; at
 Zuni, 16–19
Colley, Samuel G., 96
Collier, John, 148
colonialism, archaeology and, 77–78
Colony, OK, 95
Colorado, 98, 248; Indian hostilities
 in, 70–71; peace talks in, 71–72;
 Sand Creek Massacre in, 68–70
Colorado Commission of Indian Af-
 fairs, 118
Colorado Daily, on War Gods, 42–43
Colorado Historical Society, Sand
 Creek Massacre scalp in, 100, 120,
 123
Colorado State University, AIM
 protest at, 76–77
Colville, and Kennewick Man, 243,
 247
Comcomly, Chief, 78
Cometsevah, Laird, 122, 123
communal property: Tlingit objects
 as, 135–36, 151–52, 153, 158–59,
 161–63, 164–65, 168, 169–70, 177,
 179–84; Zuni War Gods as, 34, 35,
 39, 41–42

computer tracking system, Denver
 Museum of Nature & Science,
 189
Concho, OK, Sand Creek Massacre
 victims at, 67–68, 126–27
Conn, Richard: Zuni War God re-
 turn, 36, 40, 41
Convention on the Means of Prohib-
 iting and Preventing the Illicit
 Import, Export and Transfer of
 Ownership of Cultural Prop-
 erty, 60
Corn Mountain (Dowa Yalanne),
 19, 30
Coy, Roy E., 29, 30, 32
Coyote Café, 82, 88
Crane, Francis, 26, 27, 215, 234; acqui-
 sition of War Gods, 30–32; as col-
 lector, 27–30; Cuneo collection
 acquisition, 101–2
Crane, Mary Winslow Allen, 26, 27,
 215, 234; acquisition of War Gods,
 30–32; as collector, 27–30; Cuneo
 collection acquisition, 101–2; on
 repatriation, 45, 52; Tlingit art,
 162, 169
Crane Collection, 45, 48, 78, 101–2,
 104
Crane Hall, 79, 172–73, 264–65
craniology, 86–87
Cranmer, Dan, 140, 175
Creek, in Florida, 207
crests, totemic, 168, 195
Cuba, Calusa refugees in, 207, 209
Culin, R. Stewart, 14–15, 24, 47;
 Northwest Coast art collection,
 141–42; at Zuni, 16–19, 25
cultural affiliation: determining, 218–
 19; NAGPRA and, 217, 220
cultural properties, 60

Cuneo, George A., Indian trophies, 100, *101*, 102

Cushing, Frank H., 24, 229; Calusa archaeology, 210–11; War God made by, 25, 57–58; at Zuni, 15, 23, 25

customary law, 219

Dakla'weidi Clan, 195; Killer Whale Hat and, 166–67, 170

Dakota Sioux, 110

DAM. *See* Denver Art Museum

Daniel, Z. T., 85

databases: collaborative, 265; for NAGPRA compliance, 109–10, 111

Dauenhauer, Nora Marks, 134–35, 136, 178, 179, 192; and Raven Headdress, 180, 181, 182

Davis, Hilda Curry, *214*, 215

Davis, Hugh N., Jr., *214*, 215

Day, Jane, 106

Dayhoff, Fred, 199, 200, 201, 216, 217, 234, 251; and Calusa remains, 236, 260–61; and NAGPRA, 202–4, 223, 252–53

deaccessioning process, 37, 49, 59, 120, 257

dead: care for, 227–30; respect for, 237, 239–40; treatment of, 235–36

dealers, in Tlingit artifacts, 160–61, 162, 163, 164, 169. *See also* collectors

Declaration on the Rights of Indigenous Peoples (DRIP), 60

Deer Clan (Zuni), 21–22

DeHaven, Millie Shotridge, 161, 162

Dennis, Raymond, Jr.: and Tlingit clan regalia, 191–92, 193, 196

Denver Art Museum (DAM), 105, 110; Northwest Coast art at, 142, 152;

War God return and, 33, 36–38, 40, 41–44, 54

Denver Indian Community, 79

Denver Museum of Nature & Science (DMNS), 1, 263-64; Calusa skeletal remains, 223–24; Crane Collection at, 29, 30, 104; and human remains issues, 78–80, 105–6; Iroquois False Face masks in, 172–74; Killer Whale Flotilla Robe, 152, 153, 176–77; Killer Whale Hat in, 166, 167; and NAGPRA process, 109–11, 113, 114, 116–20, 123, 179–84, 188–90, 258; repatriation policy, 170–72; Tlingit clan regalia in, 133, 192; Tlingit relationships with, 186–88; on unaffiliated human remains, 240–41, 248–50, 259–60; and Zuni War Gods, 44–45, 48–49, 53

DeWitt, Jonathan, 153

Didrickson, Ben, 195

disposition, of sacred objects, 52–53

DMNS. *See* Denver Museum of Nature & Science

DNA research, 6, 212; of Kennewick Man, 246–47

Dockstader, Frederick J., 53

Dog Soldier Society rituals, 75

Dorsey, George, 23

Dowa Yalanne (Corn Mountain), 19, 30

Downer, Alan, 113

Downing, Jacob, 100, 120

DRIP. *See* Declaration on the Rights of Indigenous Peoples

Dumont, Clayton, 256

Eastern Shoshone, 110

Echo-Hawk, Walter, 81, 88, 106, 219, 268, 275

Elgin, Lord, 58–59
Emancipation Proclamation, and
 Tlingit slaves, 146
"Embezzlement and Theft from
 Indian Tribal Organizations" (18
 USC 1163), 39
Emmons, George T., 138, 141, 156, 158
enfranchisement, Native American,
 147–48
England, War Gods in, 59
Ethnologisches Museum (Berlin), War
 Gods in, 57–59
Evans, John, 70–71
Everglades, human remains in, 203–4
"extinction," of tribes, 205–6, 213

facial reconstructions, 114, 115
False Face Society, masks from, 172–74
FBI, War God confiscation, 39
Feller, John, 133, 135, 176–77, 195;
 and Killer Whale Flotilla Robe,
 183–84, 194
Ferguson, T. J., 34, 39, 41, 43, 47
Field Museum, 82, 104, 105, 188
First Nations, 272
First Seminole War, 207–8
Florida: archaeology of, 209–11;
 Calusa in, 206–7; human remains
 laws, 234; Miccosukee in, 199–
 200; Seminole in, 207–8
food shortages, at Zuni, 18–19
Fort Lyon, 72
Fort Wingate, 16
Foy, Joseph A., 98
France, 59, 60
Frog House (Klukwan), 162
Frost, Emma, 153

Gaanaxteidi Clan, 155; factions, 161–
 63; and Klukwan Whale House,
 157, 158, 163–65

Galaxy Fraternity, 21, 22
GAO. See General Accountability
 Office
General Accountability Office (GAO),
 242
George, Cyril, 186
Germany, Ahayu:da in, 55–57
Gerow, Bert, 219
Gila River Indian Community, 239
Glenwood, IA, cemetery near,
 225–26
Gordon, George B., 157
Grand Canyon, Zuni ancestors in, 20
Grand Council of the Haudeno-
 saunee, 173
grants: NAGPRA, 108, 114; NPS,
 116–17
grave robbing, 76, 85; in Florida, 203,
 204
graveyards, Sand Creek massacre vic-
 tims in, 67–68, 125, 126–27
Gray, Clara Bradley, 196
Greece, Parthenon Marbles, 3, 58–59
Gruening, Ernest (Kush), 150
Gushklin, 144

Haas, Jonathan, 188
Haines, 151, 158, 190
Haisla First Nation, totem pole
 return, 56
Hall, Tex: on kinship, 218–19
Halliday, William M., 140, 141
Ham House, Mathias, 78
Hammil, Jan, 81
Hammond, Austin, 180, 190; and
 Sheldon Museum, 191–92
Harjo, Patty, 79
Harjo, Suzan Shown, 81, 83–84, 106,
 220, 255; on Sand Creek skulls,
 87–88
Hart, Lawrence, 122; and Sand Creek

Massacre remains, 91, 92–93; and Smithsonian, 114–15

Hart, Richard, 34

hats, Tlingit clan, 166

Haudenosaunee (Iroquois nations), 35, 229; False Face masks and, 172–74

healing, repatriation and, 121–22

Heap of Birds, Alfrich, 117

Hearst Museum of Anthropology, Phoebe A., 260

Herold, Joyce, 28, 45, 48, 49, 117, 166, 172, 186, 187, 189; and NAGPRA claims, 193–94; Tlingit objects, 167–68, 170, 181–84

Heye, George Gustav, 35, 100; North-west Coast art, 138, 140, 175

Hidatsa, 35

Hillers, John K., 23

Holen, Steven R., 119, 120, 224

Hopi, 229, 249; sacred objects, 35, 60, 175

Hotch, Clarence, 154, 156, 162, 163

Hotch, Joe, 160, 161, 162, 163, 165

Hotch, Marsha, 195

Hotch, Victor, 160, 161, 162, 163

Hovens, Pieter, 60–61

Howells, William Dean, 137–38

Hrdlička, Aleš, 75, 89, 205, 211, 212

human remains, 75, 108, 202, 233; ancient, 243–47, 267–68; Calusa, 260–61; at Denver Museum of Nature & Science, 78–79, 105–6, 113–14; from Glenwood, IA, cemetery, 226–27, 232; hierarchy of rights to, 212–13; inventories of, 242–43; in museums, 77–78, 82–83, 86–87; repatriation of, 203–4; research on, 115–16; from Sand Creek Massacre, 84–85, 87–88, 89–93, 119–20, 123–24; scientific analysis, 211–12; unaf-filiated, 200–201, 221–24, 234–35, 238–42, 248–50, 253–55, 259–60; as universal value, 80–81

human rights, 5, 77, 104, 221; NAGPRA and, 7, 254, 256, 257

Hungate family, 70, 99

Hustito, Alonzo, 33, 41

Hustito, Charles, 33, 34

Indian Advisory Council (Iowa), 232

Indian Removal Act, 208

inheritance, Tlingit matrilineal, 147

Inouye, Daniel, 104, 107, 219, 245, 256

Inuit, 82, 272

Iowa, 232; human remains in, 78, 226–27, 233

Iowa Burial Code, 233

Iowa Department of Transportation, Glenwood project, 226–27, 232

Iowa State Archaeologist, 226

Iowa State Historical Society, 232

Iroquois Council of Chiefs, 172

Iroquois nations (Haudenosaunee), 35, 229; False Face masks and, 172–74

Ishi, 5

Jackson, Andrew, 207, 208

Jacobs, Annie, 166, 167

Jacobs, Emma, 100

Jacobs, Ernie, 167

Jacobs, Harold, 134, 176, 195; Killer Whale Hat claim, 166, 167, 168, 170, 185–86; and Raven Head-dress, 180–81; relationships with Denver Museum of Nature & Science staff, 187–88, 192; on Tlingit potlatches, 131, 132–33

Jacobs, Mark, Jr., 180; and Chilkat tunic, 169–70; Killer Whale Flotilla Robe, 183–84; and Killer Whale

Jacobs, Mark, Jr. (*continued*)
 Hat, 166–67, 168, 185–86; relation-
 ships with Denver Museum of
 Nature & Science, 186–87
Jacobs, Mark, Sr.: Chilkat tunic, 169
Jacobs, William B., 100, 102, 120
Jefferson, Thomas, 86
Jicarilla Apache, 110
Jimerson, Avery, Sr.: Iroquois False
 Face masks, 172, 173
Johnson, Estelle DeHaven, 162–63
Johnson, Michael R., 152, 153, 166,
 168, 169, 182, 182; Klukwan Whale
 House artifacts, 154, 156, 160–61,
 162–63, 165
Johnson, Ryntha, 179, 186, 187
Johnson v. Chilkat Indian Village, 163
Jones, Charley (Shakes VII; Ku-
 danake), 143–44, *145*; and Killer
 Whale Flotilla Robe, 152, 176–77,
 186; leadership, 146, 147–48;
 Shakes Island ceremony, 149–50
Joseph, Robert, 139
Juneau, racism in, 134

Kaagwaantaan Clan, 158
Kaajísdu.áxch, 149, 155
Kan, Sergei, 168, 186
Keeler, Minnie Paji, 226–27
Keepers of the Sky. *See* Ahayu:da
Kéet S'aaxw, 166, 167, 170
Kéet Xaa Naaxein (Killer Whale
 Flotilla Robe), 133, 135, *145*, 150–
 51, 186; changing ownership of,
 152–53; return of, 189, 193, 194,
 195, 196; Tlingit claim for, 176–77,
 183–84
Keithahn, Ed, 149
Kennewick Man, 257, 267; claims for,
 244–47; scientific importance of,
 243–44

*Kennewick Man: The Scientific Investi-
 gation of an Ancient Skeleton*, 246
Key Marco, archaeology at, 210–11
Killer Whale Clan, 186
Killer Whale Flotilla Robe. *See* Kéet
 Xaa Naaxein
Killer Whale Hats, 196; Dakla'weidi
 Clan, 166, 170; repatriation of,
 185–86
Killion, Tom: on Cheyenne negotia-
 tions, 114–15; on Sand Creek Mas-
 sacre remains negotiations, 90–91,
 92; at Smithsonian Repatriation
 Office, 89–90
kinship: institutional concepts of,
 219–20; Native American concepts
 of, 218–19
Kintigh, Keith, 106, 107, 220, 221, 241,
 255–56
Klee, Paul: and War Gods, 34
Klukwan, 151; clan factions in, 161–
 63; tribal court, 164–65; Whale
 House objects, 154–55, 156–57,
 158, 159–64
Knowles, Lynda, 258
Kodiak Island, 89
Kohlberg, Erich: and Cuneo collec-
 tion, 101–2
kokko, 62–63
Königliches Museum für Völkerkunde
 (Royal Museum of Ethnology), 57
koo.éex, 139–40, 186, 193
Kremmling, CO, 102
KSHI, 40
Kudanake. *See* Jones, Charley
Kwagiulth Museum, 175
Kwakwaka'wakw, 139, 140

Ladd, Edmund J., 35, 41
LaFrance, Timothy: Zuni War God
 return, 36, 41, 42, 44

Laguna, Frederica de, 141
land swindles, Zuni, 210
Laselute, Edison, 36, 41
law, tribal vs. U.S., 147–48
Laxson, Dan D., 215
leadership, Tlingit, 143–44
Left Hand, 69
legislation, repatriation, 103–7
Lewis County Historical Society, 78
Lipan Apache, 229
Little Coyote, Karen, 127
Logan, John A., 210
looting, 5, 127
Los Angeles County Museum, 105
Lower Creek, 207
Łúkaax.ádi Clan, 178, 179, 190, 191
Luna, James, 265

Ma'a'sewi, 21–22, 41
Mahooty, Chester, 41
Man Ray, *Totem*, 33
Marathon, FL, 29, 215
markets, for Zuni War Gods, 33–34, 47
Marks, Emma, 136
Marquardt, William, 209
Martza, Barton, 36, 37
masks: Hopi, 175; Iroquois False Face, 172–73; Zuni, 17
massacre sites, looting of, 127. *See also* Sand Creek Massacre
Mayer, Frederick, 43
Maytham, Thomas, 52; and War God return, 36, 37, 38, 40, 42, 44
McCain, John, 104, 107, 222, 245, 256
McCannon, John, 73
McManamon, Francis, 238
Meares Island, stone bowl from, 174
Meighan, Clement, 219
Melcher, John, 74; on ancient skeletons, 244–45; Bridge of Respect Act, 75–76, 218

Menil, Adelaide de, 164, 169
Menominee, 110
Merrill, William, 38
Meskwaki chief, 232
Métis, 272
Miccosukee Tribe of Indians of Florida, 199, 209; and Calusa remains, 201, 216, 217, 238; and Fred Dayhoff, 251–52; and NAGPRA, 202–3, 223, 236
Miksch, Amos C., 97
Millicent Rogers Museum, 44
missionaries, 146
Miwok, 110
Modern Art, and War Gods, 33–34
Mohawk, 78
moieties, Tlingit, 139
Monroe, Dan, 240
Montana, 74–75, 85, 98
Monticello, burial mound at, 86
morality, treatment of the dead and, 237
Morgan, Judi, 248
Morrill, Claire, 31, 32
Mudshark House (Naanya.aayí Clan), 151
mummies, display of, 78–79
Murray, Patty, 247
Museum für Völkerkunde (Berlin), War God in, 25, 34
Museum of Anthropology (Vancouver), 56
Museum of Comparative Zoology (Harvard), 87
Museum of Ethnography (Stockholm), 56
Museum of the American Indian, 100, 138, 175; burial goods displayed in, 83–84
museums, 4, 6, 35, 175, 257; Cheyenne collections in, 114–15; human

museums (*continued*)
 remains in, 77–81, 82–83, 86–87;
 under NAGPRA, 59, 109–11;
 and NAGPRA repatriated items,
 190–93; Northwest Coast art, 138,
 141; pre-NAGPRA repatriation
 responses, 46–47; as protectors/
 preservers, 52–53; and repatria-
 tion, 174–76, 264; and repatriation
 issues, 42, 48–49; repatriation
 legislation, 104–5, 106–7
Museum Volkenkunde (Netherlands),
 Ahayu:da in, 60–61
mutilations: by Cheyenne, 100; of Sand
 Creek Massacre victims, 96–97

Naanya.aayí Clan, 144, 146, 147, 194,
 195; at.óow of, 149, 150, 151–52
NAGPRA. *See* Native American
 Graves Protection and Repatria-
 tion Act
NAGPRA Review Committee, 216,
 222–23; on unaffiliated remains,
 238–39, 240–42, 248
Naranjo, Tessie: on reburial rituals,
 93–94
National Congress of the American
 Indian, 83
National Museum of Canada, 140–41
National Museum of Man, 175
National Museum of Natural His-
 tory. *See* Smithsonian Institution
 National Museum of Natural
 History
National Museum of the American
 Indian (NMAI), 132
National Museum of the American
 Indian Act, 88, 89, 103, 220; on
 unaffiliated remains, 221–22
National NAGPRA Program, 118
National Park Service (NPS): repatria-

tion grants, 116–17, 249; and Sand
 Creek Massacre site, 122–23
Native American Advisory Council, 79
Native American Graves Protection
 and Repatriation Act (NAGPRA),
 7, 46, 47, 59, 88, 117, 135, 176,
 203–4, 220, 245; compliance with,
 118–19; consultation, 178–79; as
 debate, 266–67; and Denver Mu-
 seum of Nature & Science, 170–
 72, 188–90, 189, 193–94, 224; items
 under, 190–93; and Kennewick
 Man, 243, 244; museum opera-
 tions under, 109–11; museums un-
 der, 235–36; purpose of, 255–58;
 repatriation process, 48–49, 107–8,
 116, 119–20, 122, 123–24; and
 rights to human remains, 212–13;
 success of, 252–53; Tlingit claims
 under, 167–70, 174, 179–84, 185–
 86; tribes and, 111–13; on unaffili-
 ated human remains, 200–201, 217,
 222–23, 240–42, 250, 253–55
Native American Rights Fund, 36
Native American(s), 6, 111, 237, 273;
 concepts of affiliation, 218–19.
 See also various clans; cultures; tribes
Native Hawaiians, 272
Navajo Community College, 175
Navajo Nation, 110, 113, 175
Neal, Arminta "Skip," 30, 48, 78–79
Nebraska, 83
Neiburger, E. J., 80
Netherlands, War Gods in, 60–61
Neumann, Loretta, 103, 104
Newcombe, Charles F., 156–57
New Deal program, and Shakes Island
 clan house, 148–49
New York, 78
New York State Museum, 175
Nez Perce, 81, 243

Niiha, Victor, 41
Nisga'a Tribe, 144, 151
NMAI. *See* National Museum of the
 American Indian
Nolan Center, James & Elsie, 194–95
North Dakota, 83
Northern Arapaho Tribe, 99, 119
Northern Cheyenne, 98; sacred
 bundle, 74–75
Northwest Coast: art, 137–38, 141–42,
 160; cultural destruction, 140–41;
 potlatch in, 139–40
Norton, Charles J., 54
Norton, Gayle, 117–18
Norwick, Frank, 82
Nuu-chah-nulth Nation, 174

objects, 4; used in repatriation, 92
offerings: War God manufacture, 21;
 Zuni War Gods shrine, 13–14,
 24–25
Oklahoma, 67–68, 99
Omaha Tribe, sacred pole, 175
Onís-Adams Treaty, 208
Onondaga Reservation, 35
On-Your-Knees Cave, 267–68
oral tradition and, 219
Oregon, 78
Osceola, John, 204
Otis, George A., 86, 87
ownership: communal, 135–36, 153,
 156, 158–59; of skeletal remains,
 75–76; of Tlingit at.óow, 151–52,
 163–65, 179–84; of War Gods, 34,
 35, 39, 41–42
Owsley, Douglas, 115, 212

Panel for a National Dialogue on
 Museum/Native American Rela-
 tions, 104
Pan-Indian movement, 218

Parthenon (Elgin) Marbles, 58–59
parties (potlatches), Tlingit, 131–33
Paths of Life exhibit (Arizona State
 Museum), 6
Paul, Cynthia DeWitt, 176
Pawnees, 85, 229
Peabody Essex Museum, 240
Peabody Museum (Harvard), 53, 104,
 110, 175, 240, 260
peace conference, 1864 Denver, 71–72
Pearson, John, 225–26, 227
Pearson, Maria (Running Moccasins),
 81, 110, 225, 226–27, 233, 236, 268;
 and Glenwood burial, 230–32, 260
Pepper, William, 210
Peregoy, Bob, 81
Perkin, Robert L., 99
Peywa, Gordon, 36
Philadelphia centennial exhibition,
 137–38
Pickering, Bob (Robert B.), 48, 49, 51,
 111, 113, 117, *187*; on Killer Whale
 Hat claim, 168–69, 185–86; on
 repatriation, 170–71, 176, 188, 240
Pilgrims, grave looting, 5, 108
pipes, sacred, 75
Pitt Rivers Museum (Oxford), 25
Plains Cree, 110
Plains tribes, return of objects to, 56
poles, Omaha sacred, 175
Ponce de León, Juan, 207
Portland Art Museum, 152
Potawatomi Tribe, burial from, 260,
 261
potlatches, 175; Canadian ban on,
 140–41; communal property at,
 135–36; cultural role of, 139–40;
 Klukwan Whale House, 155–56;
 for returned objects, 192, 193–
 96; Tlingit, 131–33, 143–44, 146,
 149–50

Powell, Jami, 265

Powell, John Wesley, 23

power: of ancestral spirits, 3, 116, 202; of the dead, 229–30; of objects, 183; of War Gods, 36, 41

Powwow, in Colony, OK, 95

Pratt, Harvey Phillip, 115

primitive art, 34, 36, 42, 142

property: communal, 139–40, 153, 156, 169–70, 177–84; Killer Whale Hat, 168, 185–86; Whale House objects, 163–65

Prussian-Brandenburg Kingdom's Royal Cabinet, 57

psychology, postcolonial, 121–22

punishment, by War Gods, 25

racism, in Juneau, 134

Rain Screen (Klukwan Whale House), 155, 156, 159–60, 165

Rasmussen, Axel, 148, 151–52

Raven Headdress/Hat (Yeil Shádaa), 179–81, 190, 191

Raven House (Yéil Hít), 179, 190, 191, 193

Raven moiety (Tlingit), 139, 195–96

Ray, Ella Maria, 117, 119

Ray, Robert D., 231, 232, 233

reburial: of ancient skeletons, 244, 267; ceremonies for, 93–94; of human remains, 78, 226, 233; scholarly objections to, 80–82; of unaffiliated remains, 238–40

Redcherries, Mildred, 97

Redoubt St. Dionysius, 144

regalia, Tlingit clan, 132

religion, vs. science, 81–82

religious freedom, 6, 8, 77, 83, 257

repatriation, 1–2, 6, 35, 44, 51, 175, 187, 264, 266; Cheyenne and, 91–92;

controversies of, 3–4, 80–82; culturally appropriate, 39–40; healing and, 121–22; international, 56–57; intertribal issues in, 7–9; legislation, 103–5; Miccosukee, 203–4; museum policies, 106, 170–71; NAGPRA process, 48–49, 107–8, 116–17, 119–20, 122, 123–24, 168–69; politicization of, 236–37; pre-NAGPRA requests for, 46–47; process of, 126–27; Tlingit claims for, 174, 176–77; of unaffiliated remains, 218, 248–50, 253–55, 259–60

respect, 269; for the dead, 230, 235–36, 237

rituals, for reburial, 93–94

Rocky Mountain News, on Zuni War God, 41–42, 43

Rogel, Juan, 235

Roloff, Howard B., 162, 169

Roosevelt, Franklin D., 149–50

Rosebud Sioux, 223

Royal Ontario Museum, 175

Russians, 144

Sabloff, Jeremy, 103

Sacred Arrow Keepers, 123

Sacred Arrows (Cheyenne), 117

sacred objects, 60; collectors and, 30–31; manufacture of, 21–22; recovery of, 35, 56; ritual destruction of, 52, 53; Zuni, 17–19, 23–24

sacred storage space, Denver Museum of Nature & Science, 189

Sand Creek Cheyenne Descendants of Oklahoma, Inc., 90

Sand Creek Massacre, 69–70, 72–73, 98; desecration of the dead, 96–97; human remains from, 84–85,

89–90, 92–93, 119–20; negotiations over remains from, 90–92; scalps from, 99–101, 102; skulls from, 76, 84, 87; victims' graves, 67–68

Sand Creek Massacre National Historic Site, 120, 125, *126*; relocating, 122–23; repatriation of remains at, 123–24

Sand Creek Massacre National Historic Site Establishment Act, 123

Sand Creek Spiritual Healing Run, 124

Sandman, 115–16, 268

Santa Fe, repatriation meeting in, 82, 83

scalping, scalps, 96; from Sand Creek Massacre, 68, 98, 99–101, 102, 113, 119–20, 123

scholarly community, on repatriation and reburial, 80–82

science: and human remains analysis, 115–16; and Kennewick Man, 244, 245; vs. religion, 81–82; and unaffiliated remains, 253–54

Scotland, 56

Second Seminole War, 208

Select Committee on Indian Affairs (U.S. Senate), 74

Seminoles, 207, 210, 224; termination policy, 208–9

Seowtewa, Octavius, 51; on Ahayu:da, 21, 22, 53, 55–56; on Ahayu:da in Europe, 57–58, 59, 60, 61–62

Sewid, Jimmy, 175

shagóon, 195

Shakes, George, 147

Shakes, Mary, 147, 148; sale of at.óow, 151–52

Shakes Island, 143; clan house and totem poles on, 148–49; potlatch on, 149–50, 193–96

Shakes lineage, 144, 146, 153, 183; at.óow, 151–52, 195–96

Shakes IV, 144

Shakes VI, 146, 147, 148

Shakes VII. *See* Jones, Charley

Shakes VIII, 196

Shakes IX, 153

Shakinaw, William, 148

Sheldon Museum and Cultural Center, repatriated Tlingit artifacts in, 190–93

Sherman, Ben, 171

Sherman, William Tecumseh, 84

Shotridge, George, 155, 157

Shotridge, Louis: as museum curator, 157–58; and Whale House, 158–60, 161

shrines, Zuni War God, 13–14, *18*, 19, 24–25, 33, 34, 36, 44, 47, 52, 54

skeletal remains, 113, 203, 215; analysis of, 86–87, 211–12; Calusa, 223–24, 260–61; in museums, 82–83; at Smithsonian, 75–76

skulls: Calusa, 211, 212, 215; collections of, 85, 86–87, 213; from Sand Creek, 76, 84, 87

slaves, Tlingit, 146

smallpox epidemics: 138, 207; at Zuni, 17

Smith, Bruce D., 254

Smith, James G. E., 47

Smith, John S., 96–97

Smith's Museum, 27

Smithsonian Institution National Museum of Natural History, 5, 17, 47, 137, 138, 173, 213; human remains in, 87–88; negotiations

Smithsonian Institution National Museum of Natural History (*continued*) with Cheyenne, 114–15; Northern Cheyenne sacred bundle in, 74–75; repatriation, 82, 83, 219–20; Sand Creek Massacre remains in, 90–91, 92–93; Zuni artifacts in, 22–23, 38, 40

Smithsonian Repatriation Office, 89, 90–91, 92

Snow, Dean, 241

Society for American Archaeology (SAA), 81, 245; on NAGPRA, 255–56; on repatriation, 106, 107, 218, 221; on unaffiliated remains, 222, 240, 241–42, 254

Sotheby Parke-Bernet, Zuni War God auction, 38–39, 47

soul, beliefs about, 81, 86, 137, 228–30, 235

Soule, Silas, 123

Southeast Museum of the North American Indian, 29, 215

Southwest Museum of the American Indian, 53–54

Spanish, in Florida, 207

Spanish Indians, 209, 217

Sparks, Mildred Hotch, 162

spiritual power, and repatriation, 116, 131

Spotted Elk, Clara, 75–76

Standing In The Water, 69

Standing Rock Sioux Tribe, unaffiliated burials, 239–40

Stanford University, 82, 219

Stevenson, George B., *214*, 215

Stevenson, James, 23, 24

Stevenson, Matilda Coxe, 17, 23, 24

Sturtevant, William C., 38

Sullivan, Martin E., 238

Tabor, Robert, 119

Taken Alive, Jesse, 239–40

Tall Bull, Chief, 74–75

Tallbull, William, 74, 75, 238–39

Tallman, Maurice H., 214

Tallman Site, *214*, 215

Tamaree, William, 148

Taos Book Shop, 31, 32

termination policy, Seminoles and, 208–9

Terry, Steve, 216, 217, 223, 234, 252

thefts, 58, 174; attempted, 158–60; of Zuni War Gods, 14–16, 24, 25, 33, 35, 36, 53–54, 61

Third Colorado Regiment, Sand Creek Massacre and, 71, 72–73, 96–98

Third Seminole War, 208

Thomas, Bill, 154–55, 156, 162, 163, 165

Thomas, David Hurst, 268

Thompson, Gilbert, 24

Thornton, Russell, postcolonial psychology, 121–22

Three Affiliated Tribes, responsibility for ancestors, 218–19

Tlingit, 134, 267; CCC programs, 148–49; clan art, 131–32, 136–37, 154–55, 160–63, 166–67; communal property, 135–36, 158–59, 169–70, 179–84; and Denver Museum of Nature & Science, 186–88; Killer Whale Flotilla Robe, 150–51; Killer Whale Hat, 167–70, 185–86; modern impacts on, 138–39; NAGPRA claims, 174, 176–77; potlatches, 131–33, 139–40, 143–44, 149–50, 193–96; Shakes lineage in, 144–45, 146–47; tribal law vs. U.S. law, 147–48

Tohono O'odham, 83, 272–73
Totem (Man Ray), 33
totem poles, 56, 149
tourism, 138, 203
treaties, 60, 69, 98
Treaty of Little Arkansas, 98
tribal court, Klukwan, 164–65
Tribal Resolution M70-78-991, 36
tribes, 4: "extinction" of, 205–6, 213,
 243; in Montana, 74–75; and
 NAGPRA process, 111–13, 169,
 257. *See also by name*
Trope, Jack, 106
trophies, 127; collections of, 100–*101*;
 from Sand Creek Massacre, 96, 97,
 98, 99
Tsadiasi, Perry, 13, 20–21, 25, 56; War
 God returns, 47, 49, *50*, 51, 52
Tsikewa, William, Sr., 51
Tsimshian Tribe, 144, 151
Tsosie, Rebecca, 242, 245
tunic, Chilkat-style, 169
Turre, George, 100

Udall, Morris, 104, 107
Umatilla, 243
U'mista Cultural Centre, 175
United Indian Nations (Oklahoma),
 90
UN treaties, 60
University of California, Davis,
 259–60
University of Idaho, 81
University of Iowa Museum of Art, 44
University of Michigan, 82, 260
University of Nebraska, 123, 248
University of Oklahoma, 115
University of Pennsylvanian Museum
 of Archaeology and Anthropol-
 ogy, 15, 104–5, 157–58

University of Tennessee, on unaffili-
 ated remains, 254
University of Washington, 82
U.S. Army, grave robbing, 84, 85
U.S. Army Corps of Engineers, and
 Kennewick Man, 243, 247
U.S. Attorney, War God confiscation,
 39
U.S. Congress, 7, 42, 123, 256; Bridge
 of Respect Act/Bones Bill, 75–76;
 repatriation legislation, 103–5
U.S. Department of Interior, 242,
 248; NAGPRA complaints, 117–18
U.S. Department of Justice, 47
U.S. Senate, 74, 220
Ute Mountain Ute, and unaffiliated
 remains, 250
Uyuyewi, 21–22, 33

Vander Wagen, Andrew, 19
Van Stone, James, 52
Vindication Ticket, 100

Walker Philip L., 82, 238
wampum, wampum belts: recovery
 of, 35, 172, 175
Wampum Bill, 35
Wanapum, and Kennewick Man, 243
War Gods. *See* Ahayu:da
Warhol, Andy: War God owned by,
 34, 47, 51
Warhol Foundation, 47
Washington, Kennewick Man repa-
 triation, 247
Waters, Walter C.: and Chief Shakes
 items, 151–52
weaving, Chilkat-style blankets, 151
Welles, John G., 103, 105, 106, 171
Welsh, MN, 77
West, Richard, 91, 94, 121

Western American Indian Chamber,
 171
Whale House (Klukwan): carvings in,
 154–55, 156–57, 158, 160–61, 162–
 65; condition of, 161–62; protec-
 tion of, 159–60
Wheelwright Museum of the
 American Indian, 44, 175
White Antelope, 68, 69, 70, 92, 97,
 124, 127
Wiisheyksh, 144
Wilde, Karen, 118, 119
Wind River Reservation, 119
Winnebago, 110
Winnipeg Art Gallery, 56
Wolf Creek, Battle of, 115
Wolf-Eagle moiety (Tlingit), 139, 180,
 194, 195
Woodard, Tom, 30
Worl, Rosita, 136, 241
World Trade Center, 125, 237
Wrangell, 149, 189
Wrangell Chamber of Commerce,
 Shakes Island restoration, 149,
 150
Wrangell Harbor, Tlingit in, 144, 146
Wrangell Museum, 194
Wrangell Potlatch, Inc., 149
Wrangell Stikine Kwaan Mourning
 Song, 132
Wyoming, Northern Arapaho in, 99

Xetsuwu, 155

Yakima, and Kennewick Man, 243
Yankton Sioux, ceremonial objects,
 110
Yéil Hít (Raven House), 179, 190, 191,
 193
Yéil Shádaa (Raven Headdress), 179–
 81, 190, 191
Yeilxaak, 159
Yellowman, Connie Hart, 91, 93, 94,
 95, 108
Yellowman, Gordon, 67–68, 94, 95,
 268; and Denver Museum of
 Nature & Science, 111–12, 113–14,
 116–17; and NAGPRA, 108–9,
 110, 123; and Sandman case,
 115–16
Young, S. Hall, 146

Zia, and unaffiliated remains, 249
Zuni, 15, 20, 47, 62–63, 210, 249, 264,
 267; Ahayu:da manufacture,
 21–22; collaborative databases,
 265–66; collecting at, 16–19,
 22–24; culturally appropriate
 repatriation, 39–40; recovering
 the War Gods, 34–38, 46, 48–54,
 56–57; War Gods in Europe, 57–
 59; War Gods shrine, 13–14, 19,
 24–25